MAYA

TREASURES OF AN
ANCIENT CIVILIZATION

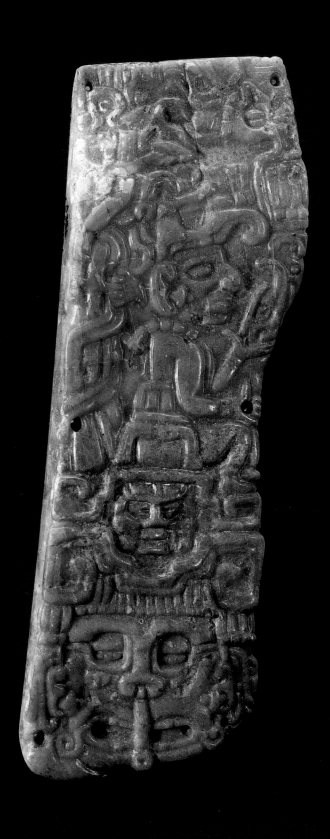

MAYA

TREASURES OF AN ANCIENT CIVILIZATION

TEXT Flora S. Clancy, Clemency C. Coggins,
T. Patrick Culbert, Charles Gallenkamp,
Peter D. Harrison, and Jeremy A. Sabloff

GENERAL EDITORS Charles Gallenkamp
and Regina Elise Johnson

PHOTOGRAPHS Stuart Rome

HARRY N. ABRAMS, INC., PUBLISHERS, NEW YORK
in association with
THE ALBUQUERQUE MUSEUM

PROJECT DIRECTOR: Margaret L. Kaplan
PROJECT EDITOR: Susan Shapiro
DESIGNER: Judith Henry

Library of Congress Cataloging in Publication Data
Main entry under title:
Maya: treasures of an ancient civilization.
 Bibliography: p.
 Includes index.
 1. Mayas—Art—Exhibitions. 2. Indians of Central
America—Art—Exhibitions. I. Coggins, Clemency.
II. Clancy, Flora S. III. Culbert, T. Patrick.
IV. Gallenkamp, Charles. V. Johnson, Regina Elise.
VI. Albuquerque Museum.
F1435.3.A7M33 1985 709'.7281'074018961 84–24598
ISBN 0–8109–1826–9
ISBN 0–8109–2300–9 (Albuquerque Museum; pbk.)

Printed and bound by Amilcare Pizzi, S.p.A., Milan, Italy

Front cover: Turtle flange bowl. Tikal, Petén, Guatemala
Back cover: Standing goddess. Jaina, Campeche, Mexico
Frontispiece: Jade plaque. Altun Ha, Belize (No. 82)
Page 7: Effigy censer. Mayapán, Yucatán, Mexico (No. 179)
Page 8: Tetrapod bowl. Tikal, Petén, Guatemala (No. 44)
Page 10: Fragment of an effigy censer. Mayapán, Yucatán,
Mexico (No. 185)

Figure 13 is reprinted from *The Ancient Maya* by Sylvanus G. Morley,
3rd edition, revised by George W. Brainerd, with the permission
of Stanford University Press. Copyright © 1946, 1947, 1956, and
1983 by the Board of Trustees of Leland Stanford Junior University.
Figure 22 is after Robert E. Smith renderings. From *Indian Art of
Mexico and Central America* by Miguel Covarrubias,
Alfred A. Knopf, Inc., 1957.

This exhibition was organized by The Albuquerque Museum in association with the Instituto Nacional de Antropología e Historia in Mexico, the Instituto de Antropología e Historia de Guatemala, and the Department of Archaeology in Belize. It was funded by The Albuquerque Museum Foundation; the Economic Development and Tourism Department, State of New Mexico; the City of Albuquerque; and the National Endowment for the Arts, a Federal agency.

International air transportation provided by Cargo Development Group, a subsidiary of Continental Air Lines, Inc.

Itinerary
American Museum of Natural History, New York (April 26–July 28, 1985); Los Angeles County Museum of Natural History, California (August 27–November 3, 1985); Dallas Museum of Art, Texas (December 15, 1985–February 16, 1986); Royal Ontario Museum, Toronto (March 22–June 15, 1986); Nelson-Atkins Museum of Art, Kansas City (July 19–September 7, 1986); The Albuquerque Museum, New Mexico (November 16, 1986–February 8, 1987).

Contributors to the Exhibition

Museo Nacional de Antropología, Mexico City

Museo Regional de Antropología, Mérida, Yucatán

Mr. and Mrs. Manuel Barbachano, Mexico City

Recinto Prehispanico, Fundación Cultural Televisa A.C., Mexico City

Kurt Stavenhagen Collection, Mexico City

Museo Nacional de Arqueología y Etnología, Guatemala City

Museo Sylvanus G. Morley, Tikal, Guatemala

Department of Archaeology, Ministry of Trade, Industry and Consumer Protection, Belmopan, Belize

The Peabody Museum of Archaeology and Ethnology, Harvard University

The American Museum of Natural History, New York

The Brooklyn Museum, New York

Dumbarton Oaks, Center for Pre-Columbian Studies, Washington, D.C.

The Royal Ontario Museum, Toronto

The Art Institute of Chicago

Thomas Gilcrease Institute of American History and Art, Tulsa

Anonymous Lender

Contributors to the Catalogue

JAMES C. MOORE
Director
The Albuquerque Museum

MARIO VASQUEZ
Director
Museo Nacional de Antropología, Mexico City

EDNA NUNEZ DE RODAS
Director
Instituto de Antropología e Historia de Guatemala

WINNEL BRANCHE
Acting Archaeological Commissioner
Department of Archaeology, Belmopan, Belize

FLORA S. CLANCY
University of New Mexico

CLEMENCY C. COGGINS
Peabody Museum of Archaeology and Ethnology, Harvard University

T. PATRICK CULBERT
University of Arizona

CHARLES GALLENKAMP
Exhibition Coordinator
MAYA: Treasures of an Ancient Civilization

PETER D. HARRISON
University of New Mexico

JEREMY A. SABLOFF
University of New Mexico

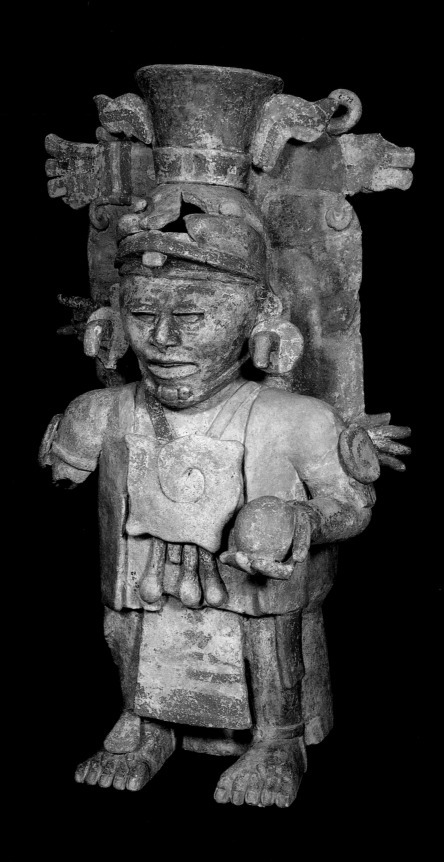

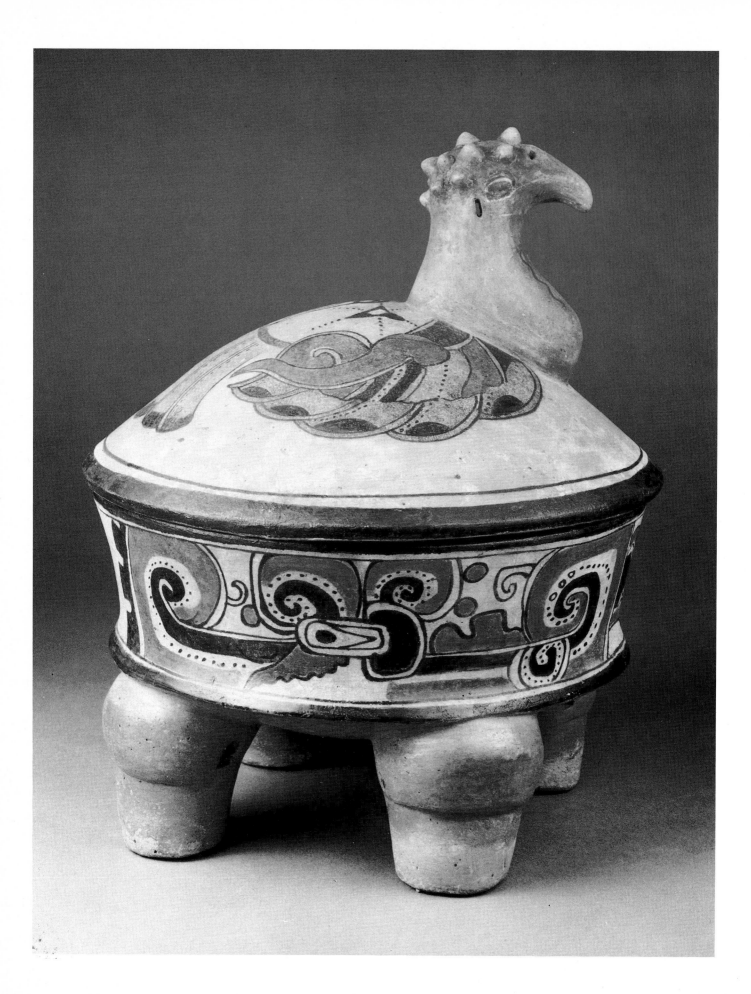

Contents

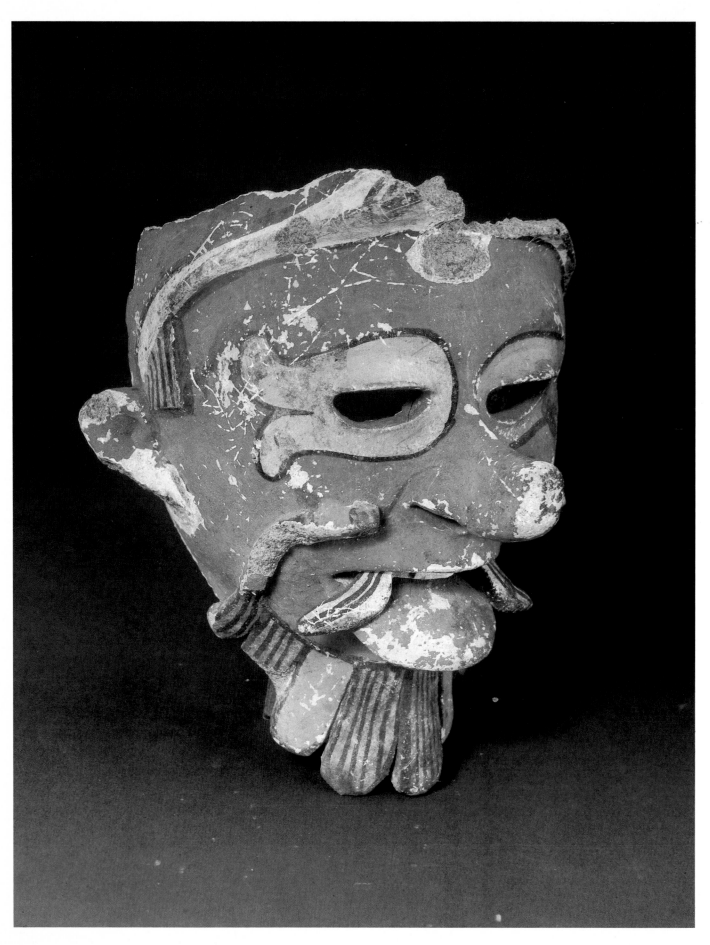

Foreword

When John Lloyd Stephens described the Maya ruins of Copán in 1839, his writings reflected a tremendous sense of awe but also conveyed a feeling of disappointment:

The beauty of the sculpture, the solemn stillness of the woods, disturbed only by the scrambling of monkeys and the chattering of parrots, the desolation of the city, and the mystery that hung over it, created an interest higher, if possible, than I had ever felt among the ruins of the Old World. . . . I made up my mind, with a pang of regret, that we must abandon the idea of carrying away any materials for antiquarian speculation, and must be content with having seen them ourselves.

Ever since the European rediscovery of these ancient sites, we have been driven by the dual and sometimes conflicting impulses to understand the secrets of those early civilizations and to remove many of the artifacts from their original context for study and aesthetic delectation. Maya archaeology has made tremendous advances since Stephens's day, and in the wake of his disappointment at leaving the material behind, over the years others have been highly successful in removing artifacts from remote locations under difficult circumstances of environment and climate. Although some of this activity has gone on under controlled and documented conditions, the collecting of Maya artifacts has too often proceeded in undocumented fashion. Thus, our success in acquisition has at times outstripped our ability to build a clear and systematic body of knowledge about the ancient Maya, and numerous mysteries remain to be solved.

MAYA: *Treasures of an Ancient Civilization* is intended to bring into wide public view a survey of the achievements of what have been generally acknowledged to be the most advanced ancient people in the New World. The goal of modern research in this area is to better understand the contexts of Maya civilization; this has long been a vexing problem which yields ever so slowly to archaeological, art historical, and anthropological investigation, but recent advances in our knowledge of settlement patterns, agricultural practices, hieroglyphic decipherment, historical events, and commerce are bringing together many new pieces of this complex puzzle.

There have been three basic contextual premises in the planning of this MAYA exhibition. The first is the notion that "treasures" are not simply objects made of intrinsically valuable materials, but are conceptual products revealing the life and mind of their makers. Therefore, while some objects are exquisite in both material and craftsmanship, others are quite unpretentious and mundane; indeed, the juxtaposition of the two is often indicative of original context, even in royal tombs.

Secondly, to a viewer whose roots are European, the presentation of this exhibition is based on the idea that the Maya are a "rediscovered"

civilization and our understanding of them is unavoidably linked to the history of archaeology in the region. There is, to our eyes, an apparent gap between modern times and the ancient people who have been the focal point of Maya studies.

The third premise is that we must try to understand and control our contemporary relationship to the artistic production of the ancient Maya. It is somewhat ironic that archaeology provides us with evidence that much of this production was traded in prehistoric times, yet the knowledge that archaeology can reveal to us is often lost by the fact that these objects have once again become commercial items of a very high order on the international art market. Part of the impetus behind the organization of this exhibition was to begin to demystify the artistic achievements of this extraordinary culture at a critical point in the development of scholarship in the field. At the same time, when many innovative theories are resulting from exciting new discoveries, much of the very fabric of this study is still being endangered by the unsystematic removal of work from its archaeological context by looters stimulated by the market for Pre-Columbian antiquities.

In addition, the demand for this art has resulted in the production of much work of spurious authenticity. While it might be assumed that there are many artifacts that remain to be excavated in the future, at least one class of objects—the great public monuments, or stelae—has been threatened to the point of near extinction. Indeed, these monuments provide some of the most useful keys to understanding the complexities of Maya history, social organization, and culture; however, these vitally important "documents" need to be studied in context in order to yield meaningful results.

Much attention has been directed toward this problem over the past two decades and this has had some bearing on the point of view in selecting the objects for this exhibition. It was the decision of the curatorial committee to limit the inclusion of pieces to the national holdings of Guatemala, Mexico, and Belize; registered collections in Mexico; and pieces accessioned before 1970 into American and Canadian public collections. This decision has, of course, somewhat limited the scope of available material. On the other hand, it has provided a useful focus for the ideas expressed in the 1970 UNESCO Convention on the Means of Prohibiting and Preventing the Illicit Import, Export and Transfer of Ownership of Cultural Property. Our position in this has simply been to use the UNESCO Convention as a watershed; it is not meant to serve as a specific guideline on what constitutes adequate documentation or to take any particular position regarding questions of total embargo or selective export-import controls. We do feel strongly that there is a pressing need for continued open discussion of these issues and eventual movement toward solutions which satisfy public concerns in both exporting and importing countries.

This project has been an international effort realized through the cooperation of many individuals, organizations, and governments. We are particularly indebted to Charles Gallenkamp, who served as coordinator of the MAYA exhibition, and to the committee of scholars who assisted so tirelessly with research, the selection of objects, and the preparation of this catalogue: Dr. Flora S. Clancy, Dr. Clemency C. Coggins, Dr. T. Patrick Culbert, Dr. Peter D. Harrison, and Dr. Jeremy A. Sabloff. In addition, we thank Dr. J. J. Brody and Dr. Mary Elizabeth Smith of

the University of New Mexico for their contribution as advisers to the project, and our appreciation goes to Jon D. Freshour for his work as the exhibition's special registrar.

For their crucial role in the development of the project, we are deeply grateful to Senators Jeff Bingaman and Pete Domenici, and Representatives Manuel Lujan, Bill Richardson, and Joe Skeen of the New Mexico congressional delegation; Astrid Gallindo Sardoz, Mexican Consul, Albuquerque; Jeff Beckelman and William Bachmann, Albuquerque Convention and Visitors Bureau; Lee Benjamin, Lisa McDowell, and B. B. Casso, Albuquerque Hispano Chamber of Commerce; Roy Bidwell and Bud Mulcock, Greater Albuquerque Chamber of Commerce; Alex Mercure and Diane Baker, Economic Development and Tourism Department, State of New Mexico; Dr. Donald M. Kerr, Dr. D. F. Sundberg, and Dr. Charles R. Barnett, Los Alamos National Laboratories; Dr. Leonard Napolitano and Albert E. Utton, University of New Mexico; Don Strel and Ellen Bradbury, Museum of New Mexico; George Ewing and Jill Cooper, Office of Cultural Affairs, State of New Mexico; Dr. Richard M. Leventhal, State University of New York, Albany; Dr. James Cramer and Harvey Monroe, The Albuquerque Museum Foundation; and Charlton Heston, Beverly Hills, California.

For assistance in negotiating loans we are indebted to the Honorable John Gavin, Ambassador to Mexico, and Sidney L. Hamolsky, Cultural Affairs Officer, U.S. Embassy in Mexico; Paul Taylor, Chargé d'Affaires, John Davis Hamill, Cultural Attaché, and Ana Maria Rodas, Cultural Assistant, U.S. Embassy in Guatemala. We are also grateful to Ambassador Jorge Espinosa de los Reyes of Mexico and Ambassador Federico Fahsen of Guatemala. We are deeply indebted to all lenders—both public and private—who have helped to ensure the quality and scope of this exhibition. Our thanks go to the other institutions and individuals who have worked with us, and in particular to the following:

Mexico: Lic. Bernardo Sepúlveda, Secretary of Foreign Affairs; Mtro. Mario Vásquez, Director, Museo Nacional de Antropología, Mtra. Marcia Castro-Leal, Director of the Department of Archaeology, and Mtra. Amalia Cardós de Méndez, Curator of the Maya Collection; Dr. Peter Schmidt, Director, Museo Regional de Antropología de Yucatán, Mérida; Lic. José Luis Sierra, Director of the Regional Center of the Instituto Nacional de Antropología e Historia, Mérida; Françoise Reynaud, Assistant Director, Museo Rufino Tamayo; Andrés Henestrosa, President, Pablo García Sainz, General Director, and Ma. del Socorro Velázquez, Assistant to the President, Fundación Cultural Televisa A.C.; Dr. Rudolfo Stavenhagen. We especially acknowledge the generous support and assistance provided by Dr. Enrique Florescano, Director General of the Instituto Nacional de Antropología e Historia, and his assistant, Adela Prieto.

Guatemala: Lic. Fernando Andrade, Minister of International Affairs; Licda. Eugenia Tejada de Putzeys, Minister of Education; Licda. Edna Núñez de Rodas, Director, and Guillermo Folger and Rafael Morales, Instituto de Antropología e Historia; Licda. Dora de Gonzáles, Director, and Rudolfo Yaquian, Museo Nacional de Arqueología y Etnología; José Rudolfo Sánchez, Administrator, and José María Márques, Tikal National Park.

Belize: The Honorable George C. Price, Prime Minister; Winnel Branche, Acting Archaeological Commissioner, Department of Archaeology; and Alice Craig.

North America: Dr. Gordon Ekholm, Dr. Craig Morris, Belinda Kaye, Department of Anthropology, and George Gardner, Curator of Exhibitions and Graphics, American Museum of Natural History, New York; Dr. C. C. Lamberg-Karlovsky, Director, Dr. Garth Bawden, Acting Director, Dr. Gordon R. Willey, Lea S. McChesney, Administrator of Exhibitions, Peabody Museum of Archaeology and Ethnology, Harvard University, Cambridge; Dr. Elizabeth Boone, Director, Center for Pre-Columbian Studies, Dumbarton Oaks, Washington, D.C.; Dr. Diana Fane, Curator, Department of African, Oceanic, and New World Cultures, The Brooklyn Museum, New York; Dr. David M. Pendergast, Curator, Department of New World Archaeology, Peta Daniels, Technician, Royal Ontario Museum, Toronto, Canada; Dr. Richard Townsend, Curator, Department of Africa, Oceania, and the Americas, The Art Institute of Chicago. We also wish to thank numerous staff members at the American Museum of Natural History, Los Angeles County Museum of Natural History, Dallas Museum of Art, The Royal Ontario Museum, and the Nelson-Atkins Museum of Art, Kansas City. In Albuquerque, the staff and volunteers of the Museum and The Albuquerque Museum Foundation have exercised a special effort throughout the project.

Our sincere thanks go to Mayor Harry E. Kinney and City Councillors Patrick J. Baca, Nadyne C. Bicknell, Fred Burns, Vincent E. Griego, Fran J. Hill, Thomas W. Hoover, Adele Hundley, Ken Schultz, and Robert M. White. We are most grateful to Governor Toney Anaya, Lt. Governor Mike Runnels, and their staffs; former Governor and Mrs. Bruce King; and members of the New Mexico State Legislature. Also of great assistance were Nina K. Wright, Caroline L. Goldsmith, Ellyn Berk, and Karen Hughes of Arts and Communications Counselors in New York.

Finally, we wish to thank the citizens of Mexico, Guatemala, and Belize for allowing a portion of their national heritage to be shared with their northern neighbors. We hope that MAYA: *Treasures of an Ancient Civilization* will contribute to a greater understanding of those ancient roots which we all share to some degree as residents of this hemisphere.

James C. Moore
Director
The Albuquerque Museum

A Message from Guatemala

The history of Pre-Columbian America is largely unknown. For many years historians considered only those aspects of history which related to the Old World as worthy of study, ignoring or scorning all that was not already recognized as important by European scholars.

The "scientific" interest in Pre-Columbian cultures was stimulated by two amateurs—John Lloyd Stephens and Frederick Catherwood—when they traveled to Central America in 1839 in search of answers to intriguing questions posed by the written accounts of their predecessors. Since then, archaeologists have brought to light important information concerning these cultures. With regard to Guatemala, archaeological evidence and findings document the great cultural and scientific advances made by the past inhabitants of our land. Even so, this information has not yet yielded a complete and orderly record of the events, personalities, and circumstances which make up our history.

As is the case today, ancient Guatemala was inhabited by diverse peoples, each with distinct customs, beliefs, traditions, and commercial, social, and political relationships that eventually underwent drastic changes, probably caused by the struggle for power, which culminated in crisis and institutional breakdown. The MAYA exhibition organized by The Albuquerque Museum presents a fascinating panorama of Maya culture, which developed primarily in the Petén lowlands and the southern highlands, where evidence has been found that speaks eloquently of the artistic and scientific activities which flourished there—products of deeply rooted religious beliefs and of a complex politico-religious structure.

In contributing to this exhibit, we, the people of Guatemala, send a heartfelt message to those art collectors and dealers who encourage the destruction of our cultural heritage and therefore rob us of that which is most valuable to our people—our history. It is regrettable that this has become a common practice among numerous individuals willing to participate in the wholesale theft and unauthorized removal of cultural artifacts from countries which they label as "underdeveloped" due to the lack of economic resources. Technological and economic underdevelopment can be overcome, but the damage to a culture is irreversible.

The United States and Guatemala have recently entered into an agreement which will help ensure the protection of the cultural heritage of both nations. We extend our appreciation to the Government of the United States and to those individuals whose efforts have culminated in this treaty. We believe that mutual respect is the essence of brotherhood and the surest road to peace among all peoples.

Edna Núñez de Rodas
Director
Instituto de Antropología e Historia de Guatemala

A Message from Mexico

From the beginning, the Instituto Nacional de Antropología e Historia in Mexico viewed with special interest the idea of participating in MAYA: *Treasures of an Ancient Civilization*, an important exhibition organized by The Albuquerque Museum in cooperation with the governments of Mexico, Guatemala, and Belize, and various institutions in the United States and Canada. This exhibit offers a rich and comprehensive overview of Maya art, featuring objects selected by specialists from many hundreds of examples. Its scope ranges from the earliest origins of Maya culture to the culmination of this extraordinary civilization, a period of approximately three thousand years.

In agreeing to cooperate in the development of this project, the Instituto Nacional de Antropología e Historia—which is responsible for preserving the archaeological patrimony of Mexico—considered this exhibition an excellent means of focusing public attention on the great cultural wealth left to us by the ancient Maya and imparting information about Maya civilization to large numbers of people in a wide geographical area. In addition, the exhibit provides an opportunity to explore the cultural contexts in which these works of art were created and to better understand the efforts of scientists to unravel and interpret the many enigmas surrounding the peoples of ancient Mesoamerica.

Furthermore, MAYA symbolizes the bonds of friendship that unite Mexico, Guatemala, Belize, and the United States and Canada. It represents one of the high points in the cultural development of Pre-Columbian America and reflects the ingenuity and remarkable achievements of our native heritage. Conscious of the extreme importance of not only protecting and conserving the cultural patrimony of Mexico as a treasure in itself, but also as an essential basis for our national identity, the Instituto Nacional de Antropología e Historia and its Museo Nacional de Antropología also wished to demonstrate, by its participation in this magnificent exhibition, the work accomplished by its scholars in bringing to light the glories of Maya civilization. We also want to affirm through this event that relations between nations based on mutual respect and understanding as neighbors form the strongest basis for maintaining international cooperation; it is our best hope for keeping peace among all peoples.

Mario Vásquez
Director
Museo Nacional de Antropología
Mexico City

A Message from Belize

Belize is situated in the very heart of the Maya lowlands. It is not surprising, therefore, that many of the most beautiful remains of the ancient Maya have been unearthed in this country. Although in former years archaeological investigations have been carried out in Belize in a rather sporadic and sometimes informal manner, the past seven years have seen a substantial increase in the number and variety of projects. In turn, this accelerated research has revealed revolutionary findings and generated a number of new questions.

The existence of Maya ruins in the jungles of Belize has been known since the latter part of the nineteenth century. During the early decades of the present century, explorers conducted surveys and excavations at Maya sites throughout the country. They constantly photographed, sketched, recorded, and reported new sites and, during this early period, many artifacts found their way into institutions abroad. In later years, however, professional archaeologists have reinvestigated many of these same sites and gleaned substantial knowledge from the records of pioneer explorers.

So far the earliest known artifacts found anywhere in the Maya area were excavated by Norman Hammond at the site of Cuello near Orange Walk, Belize. We also know that the Maya were present in Belize throughout their history. There are many limestone caves in the area and we have yet to find one which does not contain evidence of Maya occupations. Hundreds of kilometers of canals, ditches, and terraces have been identified. *Chultuns* (storage pits) occur widely and many *sacbeob* (causeways) which once connected sites have been traced. The Maya did not restrict themselves to the tropical rain forest, but exploited coastal regions, swampy lowlands, and even ventured as far as a chain of islands sixty miles off the coast, where Maya ruins have recently been found.

In the southern portion of the country two sites, Lubaantun and Nimli Punit, were constructed, occupied, and deserted in the Terminal Classic period when other major centers were showing a trend toward demise. The site of Lamanai has yielded evidence of occupation from the Preclassic, the Postclassic, and Colonial periods. Investigations now being carried out are bringing to light exciting new information concerning the life-styles of the peasants, their settlements, and craft specializations.

One of the most spectacular finds in the entire Maya area was the famous jade head of the sun god, Kinich Ahau, which was excavated at Altun Ha by David Pendergast. The late Dennis Puleston also uncovered a unique artifact from his excavations in canals and raised fields in San Antonio, Belize. This was a chert ax with a wooden handle still intact. The preservation of wood is extremely rare in this climate, thus it was among the most exceptional finds ever made in Belize.

Although evidence of Maya civilization is both abundant and widespread throughout the country, and the sites and artifacts illustrate ex-

traordinary diversity, Belize is presently without a national museum. However, plans for such an institution are being made and it is our greatest hope that such a structure will soon materialize for the benefit of Belizans and visitors alike. Nevertheless, Belizans invite everyone interested in the Maya to visit our country. It is through an exhibition such as MAYA: *Treasures of an Ancient Civilization*, initiated by The Albuquerque Museum, that Belize is able to reach so many of you. We hope that the artifacts included in this show will bring both pleasure and increased knowledge of this once great civilization.

Winnel Branche
Acting Archaeological Commissioner
Department of Archaeology
Ministry of Trade, Industry and Consumer Protection
Belmopan, Belize

MAYA

TREASURES OF AN
ANCIENT CIVILIZATION

1 · THE ANCIENT MAYA

RECLAIMING A LOST LEGACY

Charles Gallenkamp

In their restless search for riches and new lands to conquer, the sixteenth-century Spanish explorers who first set foot in Mexico and Central America unexpectedly discovered an extraordinary mosaic of indigenous civilizations. Astounding splendors unfolded before them, especially the Aztec capital of Tenochtitlán (modern Mexico City) with its ornate temples, palaces, residential districts, gardens, and canals. Yet little did the conquistadores suspect that such "wonderful sights," as the chronicler Bernal Díaz described them, reflected an archaeological heritage that reached back thousands of years and encompassed a panoply of cultures ranging from primitive hunting-and-gathering peoples to the highly advanced civilizations of the Olmec, Zapotec, Teotihuacanos, Toltec, Mixtec, and Aztec.

Immediately to the south of these nations lay the territory occupied by the Maya—Guatemala, Belize, and the western edge of Honduras and El Salvador, as well as the present-day Mexican states of Yucatán, Quintano Roo, and Campeche (which comprise most of the Yucatán Peninsula), and eastern Chiapas and Tabasco (*Fig. 1*). Although linked to their neighbors by commerce and certain mutually shared cultural traits, the Maya represented the pinnacle of civilized attainments in Pre-Columbian America. The eminent scholar Sylvanus G. Morley once characterized the Maya as "the Greeks of the New World." Considering the brilliance of their artistic and intellectual achievements, his analogy was entirely justified. When one surveys the full range of their accomplishments, even the most dispassionate observer is tempted to resort to superlatives.

The geographical setting in which Maya civilization evolved is marked by extreme contrasts. Its southernmost limits are bordered along the Pacific littoral of Guatemala and El Salvador by a strip of flat alluvial plains about thirty-five to forty miles wide. Farther inland lies a chain of mountains which extend from east to west and is dotted with towering volcanic cones, fertile valleys, basins, steep-sided gorges, and lakes. To the north another belt of rugged mountains, metamorphic in composition and studded with pine and oak forests, stretches from central Chiapas across Guatemala, eventually giving way to an area of spectacular limestone formations. Unlike the hot, humid plains that parallel the Pacific coast, the climate in the highlands is generally mild; the mean temperatures usually range between 60 and 80 degrees F., and a rainy season which lasts from May through November brings daily thundershowers that are usually quite heavy, especially at higher elevations.

As one continues north, the highlands gradually open onto a densely

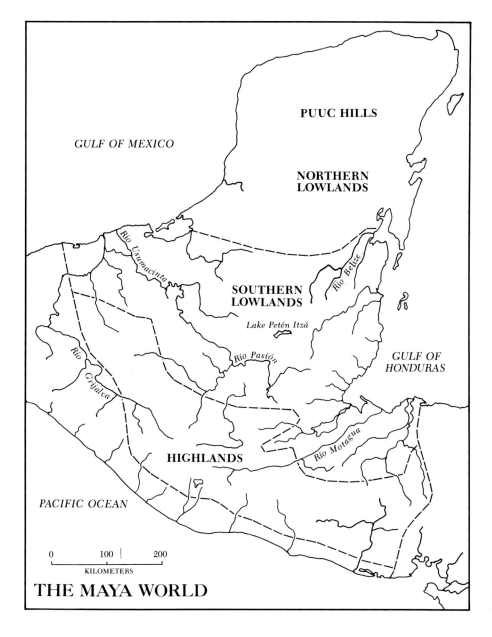

GULF OF MEXICO

PUUC HILLS

NORTHERN
LOWLANDS

Río Usumacinta

Río Belize

SOUTHERN
LOWLANDS

Lake Petén Itzá

Río Pasión

GULF OF
HONDURAS

Río Grijalva

Río Motagua

HIGHLANDS

PACIFIC OCEAN

0 100 | 200

KILOMETERS

THE MAYA WORLD

*Fig. 1. Geographical map of the Maya
region showing major subdivisions and
river systems.*

overgrown limestone plateau which constitutes the Maya lowlands—an
immense area covering the Petén district of Guatemala, Belize, western
Honduras, the Yucatán Peninsula, and parts of eastern Chiapas and Ta-
basco. Divided by archaeologists into the southern and northern low-
lands (a central subdivision is sometimes included), the elevation seldom
exceeds seven hundred feet above sea level, except for a single range of
peaks—the Maya Mountains in southern Belize—which rise to a maxi-
mum height of around three thousand feet. In the southern lowlands the
terrain is punctuated with hills, escarpments, grassy savannas, and sea-
sonal swamps *(bajos)*. A number of rivers drain the area; among the most
important are the Usumacinta, Chixoy, and Pasión in the west, and the
Motagua and Belize in the east. A series of lakes—Lake Petén Itzá is the
largest—extend from east to west across the central Petén.

Scattered over vast portions of the lowlands are dense rain forests, pri-
marily of mahogany, cedar, rubber, sapodilla, ceiba, breadnut *(ramon)*,
avocado, wild fig, and palm trees. As this region lies entirely within a

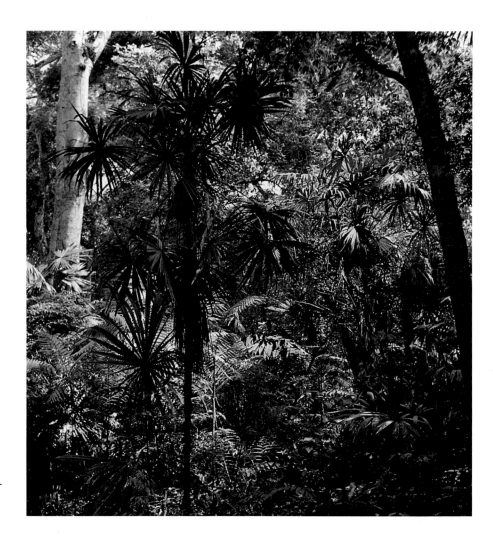

Fig. 2. *View of the rain forest in the central Petén district of Guatemala.*
Charles Gallenkamp

tropical zone *(Fig. 2),* it is subject to extreme humidity, heat, and drenching downpours which range from 50 to 160 inches a year, depending upon the specific sector. Temperatures average about 75 to 90 degrees F. during the rainy season (May to November), but readings of over 100 degrees are not uncommon in the dry months, when there are few clouds to block the sun.

In the northern lowlands the topography becomes almost completely flat. Except for occasional outcroppings of limestone, its featureless vistas are interrupted only by a string of low hills known as the Puuc, which stretch across northern Campeche and southwestern Yucatán. Due to a sharp decrease in rainfall in the northern Yucatán Peninsula, much of this area cannot support a true rain forest—especially near the coast, where semiarid conditions prevail—and the vegetation consists of low trees, thorny scrub, palmettos, and bushes. Nor are there many lakes and rivers in this region; its porous limestone surface quickly absorbs rainfall, and dependable sources of water are scarce except where the limestone crust has collapsed into underground drainage systems, thereby creating deep natural wells known as *cenotes.*

Among the many mammals in the lowlands are two types of monkeys (howler and spider), deer, jaguars, coatimundis, foxes, peccaries, agoutis, and tapirs. More than six hundred species of birds inhabit the region, along with numerous reptiles that include iguanas, crocodiles, rattle-

snakes, boa constrictors, and the highly venomous fer-de-lance. As every traveler quickly discovers, the area also swarms with a seemingly endless variety of insects, the most annoying being mosquitoes, scorpions, army ants, gnats, fleas, ticks, hornets, biting flies, and wasps.

Despite unfavorable climatic conditions, poor soils, and dense vegetation, it was in the lowlands that Maya civilization soared to its greatest heights, leaving behind evidence of extraordinary achievements in many fields of endeavor. As demonstrated by the objects illustrated in this exhibition catalogue, Maya architects, sculptors, potters, lapidaries, painters, and weavers produced some of the finest works of art ever created in the ancient world, works characterized by astonishing technical mastery, originality, and aesthetic impact. Even in the most inhospitable sections of the rain forest they erected splendid cities filled with terraced pyramids, temples, palaces, courtyards, monuments, and shrines—all constructed without metal tools, wheeled vehicles, or beasts of burden (*Fig. 3*). Roads and causeways, built of stone and paved with limestone cement (called *sacbeob* or white roads in Yucatecan), connected important ceremonial precincts within many cities and often extended for miles through the countryside, linking one center with another. Surrounding the cities were "support areas" consisting of clusters of thatched-roof peasants' dwellings, orchards, and extensive farmlands, where the Maya practiced agricultural techniques that ranged from a simple slash-and-burn (*milpa*) system to more intensive methods utilizing terraced hillsides and raised fields. A variety of crops were cultivated, including maize, beans, squash, amaranth, chili peppers, sweet potatoes, manioc, cotton, and tobacco.

Recent archaeological discoveries have shown that Maya sociopolitical structure was far more complex than previously suspected; that there was extensive interaction between cities (intermarriage among ruling families, economic ties, and possibly military alliances); and that certain major centers appear to have served as regional capitals, exerting a considerable amount of control over neighboring sites (see pp.40–41). Nor can there be any question that most of the larger Maya cities—once believed to have functioned exclusively as ceremonial centers—were urbanized in the sense that they served both religious and secular requirements, and that their inhabitants included members of the ruling elite and priesthoods along with craftsmen, merchants, and administrators. In addition, the Maya developed far-flung trade networks that operated via land, river, and coastal routes; and they reached a high degree of sophistication in the management of natural resources and the manufacture of household and elite goods.

Underlying virtually everything the Maya accomplished were religious and philosophical concepts that profoundly influenced the development of their civilization from very early times. At the center of this belief system was a perception of reality wherein time, space, the physical world, and the supernatural realm were continuous, interconnected parts of a universe in which humans and gods interacted on all levels of existence. Moreover, the Maya pantheon contained a bewildering array of gods who embodied a bizarre mixture of human and animal traits, gods who could alter their appearance and function, whose often dualistic nature made them capable of either munificent or vengeful acts. Every facet of life was ruled by these gods, and their worship necessitated an endless round of prayers, offerings, the burning of copal incense, self-

mutilation (primarily bloodletting with thorns, stingray spines, and knotted ropes passed through the tongue), and occasionally human sacrifice—not to mention the enormous outpouring of labor expended on the construction of temples, religious monuments, and shrines.

Nowhere was the ingenuity of the Maya more pronounced than in the fields of astronomy, calendrics, and hieroglyphic writing. Although there is persuasive evidence that the calendar and the system of writing used by the Maya originated elsewhere—either among the Olmec on the Gulf Coast of Mexico or in Oaxaca—it was in the Maya lowlands that these innovations reached their highest levels of development. As early as the fifth century B.C., hieroglyphic inscriptions appeared at Monte Albán and elsewhere in Oaxaca which, although different in certain respects from Maya writing, exhibit identical numerical symbols and similar calendrical data. A monument (Stela C) from the Olmec site of Tres Zapotes in Veracruz carries a date of 31 B.C. recorded in the same glyphic system used by the Maya, though we cannot be entirely sure that the Olmec and Maya computed time from the same chronological starting point. Assuming, however, that this was the case (as seems likely), two stelae from Chiapa de Corzo in Chiapas and El Baúl on the Pacific coast of Guatemala—both of which show strong Olmec influences—were carved in 36 B.C. and A.D. 36 respectively; and at another site on the Guatemalan coast, Abaj Takalik, several monuments have been excavated dating from the first and second centuries A.D. So far, the oldest known calendrical inscription from the Maya lowlands occurs on Stela 29 at Tikal and records a date equivalent to July 6, 292. Nevertheless, by this time the emphasis on calendrics and writing had shifted to the lowlands for reasons that are not fully understood, and it was here that their development reached its peak.

Using monuments, buildings, and crossed sticks to provide fixed lines of sight, astronomers made careful observations of the sun, moon, and Venus; and there is reason to believe they may have studied the movements of Mars, Jupiter, Mercury, and Saturn. We know they also devised tables for predicting lunar eclipses and came remarkably close to measuring the exact length of a lunation. One cannot help marveling at the degree of accuracy achieved by the Maya in their astronomical calculations. For example, they computed the length of the tropical year at 365.2420 days—incredibly close to its actual length of 365.2422 days—and their measurement of the synodical revolution of Venus was 584 days as compared to our figure of 583.92, though the Maya were aware of this error and periodically adjusted their calculations to correct it.

Information of this kind enabled the Maya to develop a precise calendrical system, one that served both practical and ritualistic purposes and exerted a tremendous influence over every aspect of life. It incorporated three different year measurements: a 360-day year (*tun*), containing 18 months of 20 days each; a 365-day "vague" year (*haab*) with 18 months plus an extra month of 5 days; and a 260-day sacred almanac (*tzolkin*). It was the 360-day year that was used in the Long Count, or Initial Series, calendar which constitutes one of the great intellectual achievements of Classic Maya civilization—a method of calculating time in recurring cycles of interrelated periods in much the same way as we record days, weeks, months, years, centuries, and millennia. Any given date could be recorded with the Long Count by computing the number of cycles which had elapsed since the starting point of Maya chronology—a date equal to

Fig. 3. Map of the Maya region showing the distribution of important archaeological sites.

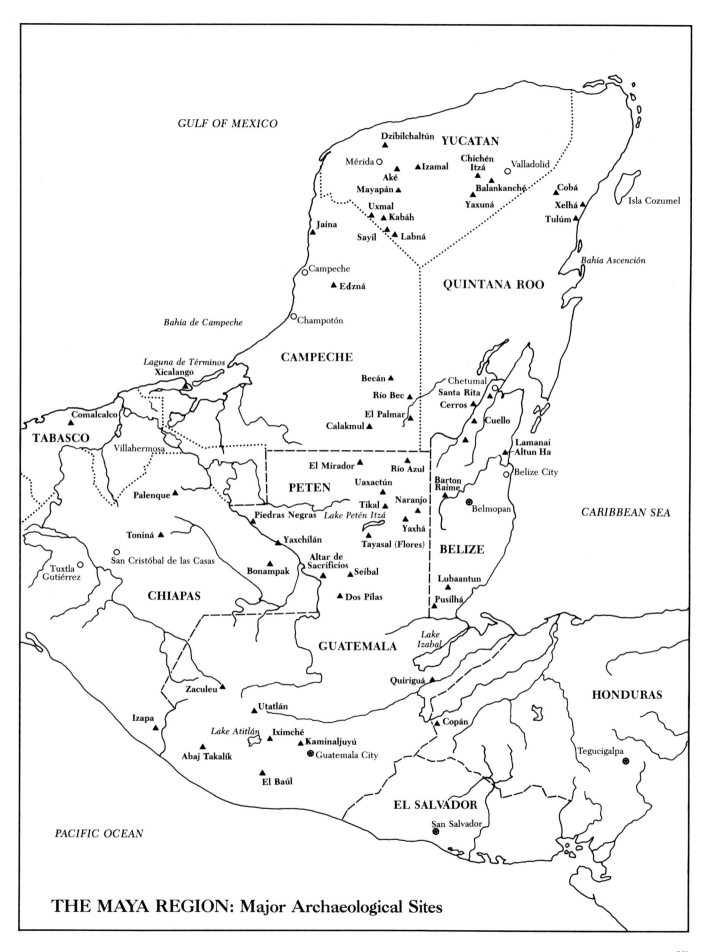

THE MAYA REGION: Major Archaeological Sites

GULF OF MEXICO

Dzibilchaltún ▲ YUCATAN

Mérida ○ ▲Izamal Chichén Itzá ▲ ○ Valladolid

Aké ▲ Balankanché ▲ ▲ Cobá

Mayapán ▲ Yaxuná ▲ Xelhá ▲

Uxmal ▲ Tulúm ▲

▲ Kabáh

Jaina ▲ Sayil ▲ ▲ Labná

○ Campeche QUINTANA ROO

▲ Edzná

○ Champotón Bahía Ascención

Bahía de Campeche

CAMPECHE

Laguna de Términos
Xicalango ▲

Becán ▲ Chetumal
Río Bec ▲ Santa Rita ○
Cerros ▲
El Palmar ▲ ▲ Cuello
Calakmul ▲

Comalcalco ▲ Lamanai ▲
Altun Ha ▲
TABASCO

Villahermosa El Mirador ▲ Río Azul ▲
PETEN Barton
Uaxactún ▲ Ramie
Palenque ▲ Tikal ▲ Naranjo ▲ ⊕ Belize City
Piedras Negras ▲ Lake Petén Itzá Belmopan ⊕ CARIBBEAN SEA

Toniná ▲ Yaxhá ▲
San Cristóbal de las Casas ○ Yaxchilán ▲ Tayasal (Flores) BELIZE

Tuxtla Altar de
Gutiérrez ○ Sacrificios ▲ ▲ Seibal
Bonampak ▲ Lubaantun ▲

CHIAPAS ▲ Dos Pilas Pusilhá ▲

Lake
Izabal
GUATEMALA

Quiriguá ▲ HONDURAS

Zaculeu ▲

▲ Utatlán ▲ Copán

Izapa ▲ Lake Atitlán Iximché ▲
Kaminaljuyú ▲ Tegucigalpa ⊕

Abaj Takalik ▲ ⊕ Guatemala City

El Baúl ▲

EL SALVADOR

PACIFIC OCEAN San Salvador ⊕

Isla Cozumel

3114 B.C. It was also possible to project dates far into the future, and inscriptions have been found extending back from 90 to 400 million years into the past (see p. 50).

An integral part of Maya calendrics was the Calendar Round, the correlation of the 365-day *haab* with the 260-day *tzolkin*, which was composed of a repeating sequence of twenty named days with the numbers 1 to 13. Since the meshing of these two cycles allowed for 18,980 possible combinations of days and numbers, the Calendar Round—the interval necessary for a particular combination of days and numbers to return to its original position—occurred only once every fifty-two years. Although the Calendar Round was widely used throughout Mesoamerica, it reached its greatest refinement in the Maya lowlands, and every Long Count inscription included the Calendar Round position on which a given date ended.

None of these calculations would have been possible had the Maya not possessed a sophisticated system of mathematics. Numbers from 1 to 19 were recorded in two ways: so-called "head-variant" numerals (glyphic symbols incorporating heads of humans and deities), and the more common bar-and-dot notation in which a bar represented 5 and a dot equaled 1, as illustrated below:

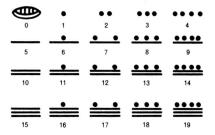

To write numbers above 19 a method of place notation was used which was somewhat similar to our decimal system. Instead of numerals that increased by multiples of ten to the left of a decimal point, the Maya had a vigesimal system in which numbers were placed in vertical columns, with each ascending position increasing by multiples of twenty (1, 20, 400, 8,000, 160,000, 3,200,000, 64,000,000). A bar-and-dot numeral placed in a given position automatically increased by its corresponding multiple, and the column was added to compute the total. To write 952, two bars and two dots (12) were placed in the first position, two dots and a bar in the second position to denote 140 (7 × 20 = 140), and two dots in the third position to indicate two units of 400, then the value of each position was added to read 952. Another intriguing feature of Maya mathematics was the fact that it incorporated the principle of the zero. Only two other cultures ever discovered this concept independently— the Babylonians and the Hindus—and it was not introduced into Europe until the Middle Ages. Yet the Maya made extensive use of the zero in both a numerical context and to indicate the "completion" of a mathematical calculation, and it was noted in their inscriptions by a shell, an open hand, or a glyph.

In order to record data of astronomical, calendrical, ritualistic, and historical importance, the Maya developed a hieroglyphic script noted for its complexity and aesthetic refinement. Because it was the only true written language ever invented in ancient America (unlike the rebus, or

picture writing, used elsewhere in Pre-Columbian Mexico), the system of writing devised by the Maya ranks among their greatest intellectual achievements, and its decipherment has been the object of intense efforts by scholars for over a century. Even today a considerable body of Maya glyphs remains undeciphered or only partially understood, although many inscriptions pertaining to calendrics, astronomy, mathematics, and ritualism can now be read; and recent breakthroughs are enabling epigraphers to decipher a significant number of historical texts involving ruling dynasties, military exploits, and political alliances.

The difficulties surrounding the decipherment of Maya hieroglyphs are due to several factors. To begin with, the glyphs are unrelated to any European or Oriental linguistic roots, thus there are no precedents to guide scholars in unraveling the meaning of Maya inscriptions. Notwithstanding years of intensive study, epigraphers could not agree on the exact nature of the glyphs—whether they were ideographic, logographic, syllabic, or alphabetic—or how they related to surviving Maya languages. Only recently, in fact, has it become clear that the hieroglyphs contain a mixture of all but alphabetic elements; and the relatively new discovery of phoneticism as a major aspect of Maya writing has opened a particularly promising avenue for future research.

Another problem arises from the structural complexity of the hieroglyphs. Each glyph is made up of a main or central element together with various affixes. The latter were used to modify the meaning of the central element, and they took the form of prefixes (attached above or to the left of the central element), postfixes (located below or to the right), and infixes (appearing inside the central element). More than eight hundred glyphic components have been identified and, generally speaking, the main or central elements signify logograms or ideograms while affixes denote phonetic and grammatical complements. Most glyphs could also be represented in two different ways: a "normal" form in which the central elements are composed of abstract or symbolic signs, and "head-variant" forms represented by heads of humans, animals, deities, and mythological creatures. We know that the hieroglyphs "evolved" over a period of time, causing new glyphs to appear and older ones to change or cease to be used. Also, there are significant differences between the glyphs inscribed in the surviving examples of Maya codices, or books, and those used on sculpture and ceramics.

Over the years archaeological explorations have revealed a profusion of hieroglyphic inscriptions on ceramics, ornaments, and sculpture, as well as on the lintels, doorjambs, walls, and stairways of buildings. In addition to these texts, three Maya codices dating from the Postclassic period somehow found their way to Europe after the Spanish Conquest and are now preserved in libraries in Dresden, Madrid, and Paris. Badly decayed fragments of several other codices have been excavated in tombs, and another example, the Grolier Codex, now at the Museo Nacional de Antropología in Mexico City, has been the subject of considerable controversy regarding its authenticity. Judging from archaeological and ethnohistoric evidence, the Maya probably produced a large number of these codices. They consisted of strips of paper made from the bark of the wild fig tree—several yards long and approximately eight or nine inches wide—which were bonded with a natural gum substance and coated with a thin layer of white lime. Each strip was folded back-to-back like a screen to make pages on which scribes drew figures and hiero-

glyphic inscriptions colored with vegetable and mineral pigments. We can only speculate as to the full range of information recorded in such books, although the three surviving examples are entirely esoteric in content: the finest of these, the Dresden Codex, contains a mixture of divinatory almanacs, eclipse tables, and data on the planet Venus; the Paris and Madrid manuscripts are devoted to ritualism, prophecy, and calendrical lore. Yet sixteenth-century Spanish chroniclers cite native books dealing with genealogy, history, science, and mythology.

Further insight into the nature of Maya literary traditions is suggested by certain post-Conquest documents—anonymous works written by Indians who sought to preserve their history and folklore after being taught by missionaries to read and write Spanish. One of the most important of these ethnohistoric sources is the *Popol Vuh*, an eloquently poetic recounting of the history, cosmology, and mythology of the Quiché Maya, who formerly dominated the Guatemala highlands. A similar work, the *Annals of the Cakchiquels*, records the traditional history of a neighboring highland people. And from Yucatán came the famous *Books of Chilam Balam*, named for a class of Jaguar Priests who were renowned as prophets. Originally there were a number of such books which bore the name of individual towns in which they were written, but unfortunately only a few have survived. Even so, they contain a wealth of information pertaining to history, mythology, rituals, medicine, prophecies, calendrics, and astrology. Apart from the literary and ethnographic value of these sources, they have also provided scholars with a valuable tool in reconstructing otherwise obscure aspects of Maya culture, and much of the information derived from such documents has proved useful in interpreting archaeological data.

By the time of the Spanish Conquest, the splendors of Classic Maya civilization had long since vanished. As early as A.D. 900, the once-thriving cities in the southern lowlands were largely abandoned in the aftermath of the puzzling and catastrophic "collapse" which began to overtake this region around A.D. 800, though the causes of this phenomenon remain only partially understood (see pp. 42–44). Even in the northern Yucatán Peninsula, where the Maya continued to flourish, drastic changes occurred after about A.D. 1000, and the centuries leading up to the Spaniards' arrival witnessed a marked decline in traditional, elite-oriented pursuits such as astronomy, calendrics, hieroglyphic writing, architecture, and art. Gradually these endeavors were superseded by an emphasis on militarism, commerce, and secularism, accompanied by increasing political instability and internecine warfare.

As one might expect, the tide of conquest and colonization which engulfed the area during the sixteenth century brought about the final demise of Maya culture. Inspired by religious fervor, the Catholic missionaries who followed in the wake of the conquistadores relentlessly demolished pagan temples, destroyed works of art, and sought to eradicate native priesthoods and religious rites. Given the equally disastrous effects of European diseases (especially smallpox) which ravaged the area, the enforced servitude of Indians to Spanish landowners, their conversion to Christianity, and the restructuring of native settlements according to European models, it is hardly surprising that the legacy of Maya civilization faded into virtual obscurity until it was resurrected by explorers and scientists.

Ironically, a number of important ethnographic studies of the Maya

were carried out by Spanish friars and chroniclers shortly after the Conquest. Foremost among these is a work entitled *Relación de las cosas de Yucatán* by Diego de Landa, a Franciscan bishop of Yucatán who was notorious for ruthless treatment of Indians and the destruction of a collection of Maya codices in the town of Maní. Here, on July 12, 1562, Landa publicly burned several dozen books of inestimable archaeological value because, as he later wrote, they "contained nothing in which there was not to be seen superstitions and lies of the devil. . . ." Yet sometime around 1566 he began working on his famous *Relación*, an encyclopedic treatise on Maya culture based upon his years of travel in Yucatán and information supplied by native informants. It has been suggested that he undertook this project as a guide for younger missionaries or to lessen official criticism of his harsh policies toward the Indians; but whatever his motive for writing the *Relación*, it constitutes the most exhaustive work on aboriginal life in Yucatán to emerge from the post-Conquest period. Along with detailed observations on history, warfare, religion, social customs, crafts, dress, and other aspects of Maya life, Landa provided invaluable notes and drawings pertaining to the structure of the Maya calendar. He even attempted to formulate an "alphabet" for reading the hieroglyphs, but due to serious errors in his approach it has been of only limited use in helping to decipher the glyphs.

Various other authors of the Colonial period also recorded ethnographic data on the Maya. Especially noteworthy was the research of a Dominican friar, Francisco Ximénez, who worked among the Quiché, Cakchiquel, and Tzutuhil peoples in Guatemala; and Antonio de Ciudad Real, a Franciscan whose extensive linguistic studies in Yucatán resulted in a massive dictionary of the Yucatec language, now known as the Motul dictionary. During the sixteenth and seventeenth centuries, a few Spanish travelers began visiting and reporting on archaeological sites, and in 1787 an army officer named Antonio del Río led an officially sanctioned expedition to the ruined city of Palenque in Chiapas, where he used explosives to "excavate" portions of its structures.

Nevertheless, except for haphazard explorations and occasional published accounts, Maya archaeology was shrouded in unscientific speculation until the mid-nineteenth century. As for the origins of the Maya, they, like all other Pre-Columbian peoples, were widely believed to have been the descendants of ancient colonists from Europe or Asia—particularly the Egyptians, Chaldeans, Phoenicians, Assyrians, Greeks, Romans, Scythians, Hindus, and Chinese. Even less plausible theories held that the Maya were immigrants from the lost continent of Atlantis (Plato's mythical utopia), or were survivors of the Lost Tribes of Israel who, according to the Old Testament, had supposedly made their way across the Atlantic after their expulsion from Samaria by the Assyrians about 721 B.C.

Finally, two celebrated books appeared which profoundly altered the course of Maya studies: *Incidents of Travel in Central America, Chiapas and Yucatan* (1841) and *Incidents of Travel in Yucatan* (1843). Written by a New York lawyer and traveler, John Lloyd Stephens, and illustrated with superb lithographs by the English artist Frederick Catherwood (*Figs. 4 and 5*), they recounted two journeys undertaken by these energetic explorers during which they visited a total of forty-two ruined cities scattered over a vast area, including such now-familiar sites as Copán, Quiriguá, Palenque, Chichén Itzá, Kabáh, and Uxmal. Rejecting the

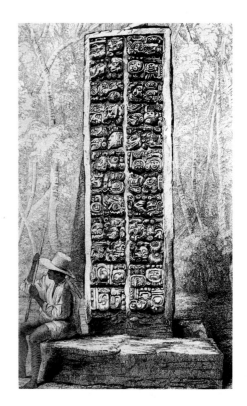

Fig. 4. Backside of Stela A at Copán, Honduras, from a lithograph by Frederick Catherwood.

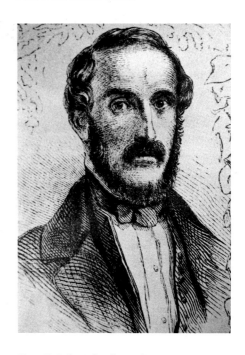

Fig. 5. John Lloyd Stephens. From Harper's Monthly Magazine, *January, 1859.*

theories of Old World origins so prevalent at the time, Stephens correctly surmised that the ruins he and Catherwood examined were once inhabited by ancestors of the contemporary Maya. "Opposed as is my idea to all previous speculation," he wrote, "I am inclined to think that they were constructed by the races who occupied the country at the time of the invasion by the Spaniards, or of some not very distant progenitors." With equally cogent insight, Stephens concluded that the history of these ruins was recorded in their hieroglyphic inscriptions as well as in post-Conquest native manuscripts, "precious memorials," as he called them, ". . . now mouldering in the library of a neighboring convent. . . ." Needless to say, Stephens's books, which ran through numerous printings, created both a sensation and a storm of controversy. Yet they quickly became landmarks in the history of Maya archaeology, and even today these works are among the most lucid and enjoyable books ever written on the subject.

Another major figure to appear at this time was a French priest, Charles Etienne Brasseur de Bourbourg, who began traveling in Central America in 1849. Brasseur's principal interest was literary, and throughout much of his career he labored diligently to prove that the Maya had reached these shores from Atlantis. In spite of his frequent flights of fancy, he displayed remarkable tenacity in recovering and publishing important historic documents. Among his many contributions, Brasseur found a missing section of the Madrid Codex while conducting research in Spain, and in 1864 he accidentally stumbled across the only surviving copy of Landa's *Relación*, thereby providing future scholars with one of their richest ethnohistoric sources.

By the 1870s a number of scholars had begun to tackle the problem of deciphering Maya hieroglyphs. In 1876 León de Rosny correctly read the glyphs for the cardinal directions. In 1882 Cyrus Thomas defined the order in which the inscriptions were meant to be read. Working with the Dresden Codex and Landa's *Relación*, Ernst Förstemann—a German librarian and student of ancient scripts—identified the system of place notation used in Maya mathematics, reconstructed the Venus tables in the Dresden Codex, and successfully deciphered the method by which Long Count dates were recorded. With Förstemann's research as a guide, J.T. Goodman, a newspaper publisher in California, was able to establish a correlation between the Maya and Gregorian calendars which is still used today, though it has been somewhat modified since Goodman's initial efforts. Many other pioneer epigraphers—J. E. Teeple, Charles P. Bowditch, Eduard Seler, Hermann Beyer, William Gates, J. Eric Thompson, to mention a few—contributed to our present knowledge of the hieroglyphic inscriptions; and with the addition of new breakthroughs and experimental approaches, there is reason to hope that the glyphs may someday be read in their entirety.

In 1883 Alfred P. Maudslay, a former British foreign service officer, launched a series of explorations that raised field research in the Maya area to an unprecedented standard of competence. Over a period of eleven years, Maudslay visited Tikal, Palenque, Yaxchilán, Chichén Itzá, Quiriguá, and Copán. Along with copious notes and measurements, he made a collection of exceptionally accurate casts of monuments (which are in better condition today than many of the originals) and took a large number of photographs using glass plates. Eventually the results of Maudslay's efforts appeared in a five-volume addition to an

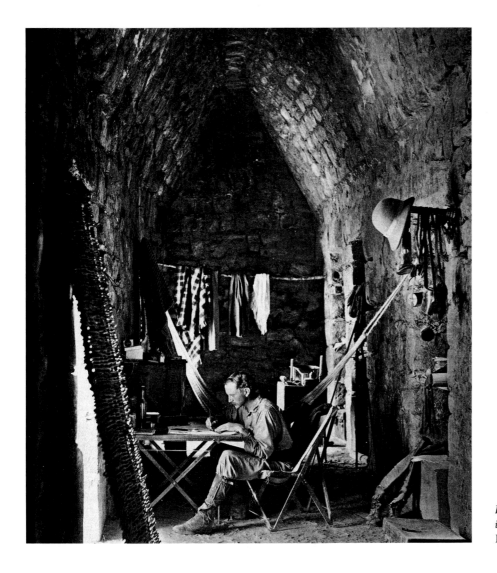

Fig. 6. Alfred P. Maudslay camped in a temple at Chichén Itzá, 1889. H. N. Sweet

exhaustive work on the natural history of the region, *Biologia Centrali-Americana* (1889–1902), which still constitutes one of the most outstanding reports on the subject ever published *(Fig. 6)*.

While Maudslay was conducting his research, an equally intrepid explorer, Teobert Maler, an Austrian who first came to Mexico with Maximilian's army, was busy surveying and photographing archaeological sites in various parts of the lowlands, particularly at Tikal, Piedras Negras, Seibal, Altar de Sacrificios, and Cobá. Although a number of Maler's reports were published by the Peabody Museum at Harvard University, he died in relative obscurity in 1917; and his work was little recognized by scholars despite the fact that Maler's contributions were of great importance in defining the extent of lowland Maya civilization, exploring previously unknown sites, and preserving a photographic record of many monuments and structures which are now badly decayed or destroyed by looters.

Maudslay and Maler were clearly the two most dominant figures in the early development of field research, but a host of other individuals, professional and amateur, were active during this period. A notable example was the French explorer Désiré Charnay, who in 1858 began a series of investigations of archaeological sites in Mexico and Central

America (including Uxmal, Yaxchilán, and Palenque) which produced the first photographs ever taken of Maya ruins and a widely read book, *The Ancient Cities of the New World* (1887). Another French antiquarian and mystic, Augustus Le Plongeon, traveled extensively in Yucatán and conducted superficial excavations at Chichén Itzá aimed at establishing a direct link between Maya and Egyptian civilizations. William H. Holmes, a respected archaeologist with the Bureau of American Ethnology in Washington, visited Yucatán in the 1890s to report on its ruins; an Irish physician, Thomas Gann, excavated at several locations in Honduras and Belize at the turn of the century; and three German explorers, Adolph Bastian, S. Habel, and Karl Sappir, conducted some of the earliest surveys of Maya sculpture and architecture. It was not, however, until 1913 that the first comprehensive treatise on art appeared as a *Memoir of the Peabody Museum*—Herbert J. Spinden's classic work, "A Study of Maya Art."

One of the most colorful of the pioneer researchers was Edward Herbert Thompson, a self-trained antiquarian from Massachusetts who was appointed United States consul in Yucatán in 1885. Apart from his official duties, Thompson engaged in archaeological studies, learned to speak fluent Yucatecan, and became an expert on native customs and folklore. Working under the auspices of the American Antiquarian Society and the Peabody Museum, he made a series of architectural casts at Uxmal and Labná that were displayed at the Chicago World's Fair in 1893. With the backing of a wealthy patron, he later purchased the hacienda on which the ruins of Chichén Itzá were situated and began an extensive survey of the site. His most celebrated discovery stemmed from his investigations of the Sacred Cenote (Well of Sacrifice), a large sinkhole into which, according to legend, human sacrifices laden with jade, gold, and other precious objects had been thrown to placate the rain god, Chac. Determined to test the validity of these accounts, Thompson brought in diving equipment and a dredge attached to a winch, and with the help of Indian assistants he began probing the well's murky depths. Thompson's daring exploit—denounced by skeptics as romantic and foolhardy—resulted in one of the most spectacular episodes in the history of Maya archaeology: his explorations yielded a veritable treasure of gold, jade, and turquoise, copper and bronze bells, sculpture, stone implements, ceremonial knives, pieces of copal incense, and a collection of human bones—undoubtedly the remains of sacrificial victims mentioned in the native legends. Eventually, however, the publicity surrounding his findings caused severe difficulties with the Mexican government, which charged Thompson with illegally removing antiquities from the country, and as a consequence his estate was attached and he died in relative poverty.

As the turn of the century approached, the emphasis in Maya archaeology shifted from the work of individual scholars and explorers to projects sponsored by institutions. During the 1890s, the Peabody Museum initiated the first large-scale excavation of a major site when it began digging at Copán. In 1914 the Carnegie Institution in Washington, D.C., inaugurated a far-reaching program of field research which included excavations at Uaxactún, Copán, Kaminaljuyú, Mayapán, and a project at Chichén Itzá that lasted from 1924 to 1933 under the supervision of Sylvanus Morley, who was already well known for his studies of Maya inscriptions. Important projects were also undertaken by the British

Museum, the Field Museum in Chicago, the Royal Ontario Museum, the governments of Mexico and Guatemala, and the Middle American Research Institute at Tulane University. One of the most significant excavations in recent years has been the Tikal Project carried out by the University of Pennsylvania—a prolonged, multidisciplinary venture that ran from 1956 to 1970 and drastically altered many previously held concepts.

For all that has been learned about the Maya, one cannot help feeling a sense of frustration over what is not yet known. Who were the Maya and where did they come from? We know that they were not a single homogeneous group but an amalgamation of peoples who spoke a number of related (though not necessarily mutually intelligible) languages. Yet when and by what means they first entered the area is not clear, though they had already established permanent villages by at least 2000 B.C. Nor do we understand the relationship, if any, between the Maya and hunting-and-gathering tribes who inhabited portions of the area between about 7000 and 2500 B.C., or the more ancient Paleo-Indians who may have preceded them. Numerous details concerning the rise of Preclassic culture are still obscure; there are obvious gaps in our knowledge of virtually every aspect of Classic civilization; and the causes of the subsequent collapse of the cities in the southern lowlands remain unsolved. Unfortunately, even the survival of numerous buildings, tombs, and works of art—which could shed so much light on these issues—is being seriously threatened by looters who ruthlessly destroy archaeological evidence in their zeal to supply a rapacious and illegal international art market.

Nevertheless, tremendous strides are being made in almost every phase of Maya archaeology. New methods of observation, excavation, and interpretation, aided by the latest scientific technology, continue to produce a flood of information. Nowhere is the axiom "archaeology in action" more evident, and the techniques by which the Maya are being resurrected from their former obscurity are hardly less fascinating than the splendors they are bringing to light. Scholars representing a variety of disciplines are attacking a broad spectrum of questions; and breakthroughs in the laboratory combined with discoveries in the field constantly reveal new information about the nature and scope of ancient Maya civilization.

2 · ANCIENT MAYA CIVILIZATION

AN OVERVIEW

Jeremy A. Sabloff

Ancient Maya civilization is often associated in the public mind with such adjectives as "mysterious," "exotic," or "unique." And, indeed, until relatively recently these adjectives aptly characterized our perception of this extraordinary culture and its rich archaeological legacy. Very little was known about its origin, history, and achievements beyond cursory observations and untested theories. Fortunately, modern scientific research has done much to dispel the aura of mystery that once surrounded the Maya, and within the last several decades our knowledge of the subject has been radically altered by new discoveries and insights, although many questions of fundamental importance remain unanswered or controversial.

Scarcely had their ruined cities begun to emerge from obscurity before the Maya attracted a great deal of attention from both professional scholars and laymen. Ever since Stephens's and Catherwood's travels through Central America and Yucatán in the 1840s (see pp. 29–30), the Maya's remarkable artistic and intellectual achievements in architecture, sculpture, hieroglyphic writing, astronomy, mathematics, and portable arts (such as ceramics and stone adornments) have excited widespread interest. In addition, the environment in which Maya civilization flourished offers a particular fascination when its forbidding nature—particularly in the tropical rain-forest zones—is juxtaposed with the breathtaking cultural attainments that occurred in this region.

Despite the fact that our knowledge of virtually every aspect of Maya civilization is growing rapidly, much still remains to be learned. It is important to keep in mind that the richness of Maya achievements does not translate directly into a broad understanding of Maya society—how it functioned and the ways in which it changed throughout history. Archaeological remains left by the Maya, no matter how awesome, are a static, incomplete record of a once dynamic, complex civilization. The process by which archaeologists link the artifacts and structures uncovered during excavations with the behaviors which produced this material record is a complicated one at best. For example, while we can delight in the aesthetic beauty of a multiroomed building, usually termed a "palace," we cannot automatically know what purpose this structure may have served centuries ago. Was it a residence for the elite? Did it house administrative workers? Or both? Archaeologists still cannot assume answers to these kinds of questions but must attempt, instead, to construct

plausible arguments that link various types of material remains with different behavioral models.

In their efforts to impart meaning to the often puzzling vestiges of Maya civilization, archaeologists have benefited from the existence of ancient hieroglyphic inscriptions, together with abundant historical documents (both native and European) dating from the period of the Spanish Conquest. Studies of contemporary Maya peoples also offer illuminating analogies with their Pre-Columbian ancestors and have yielded valuable insights into various aspects of their culture. Nevertheless, even with these rich sources of information, which are tremendously useful in enabling scholars to connect the archaeological record to specific behavioral factors, investigators must still proceed with caution. For instance, since most Maya farmers currently practice a shifting form of cultivation known as slash-and-burn agriculture, archaeologists presumed for years that the ancient Maya did likewise. Yet it has now been demonstrated that the Maya formerly utilized much more complex agricultural practices, including a variety of intensive techniques that could be adapted to different types of terrain and climatic conditions.

Similarly, other traditional assumptions have been challenged by new discoveries, and it is therefore essential to understand that many of the functions and meanings attached to the art and architecture discussed in this catalogue remain speculative and must await future confirmation or disproof. The same is true of the various reconstructions of Maya history outlined here and in the following essays. Readers should not, however, be discouraged by such uncertainty, but rather adopt the professionals' viewpoint: recognize that Maya archaeology is in a state of flux which holds exciting prospects for major scientific breakthroughs.

CHRONOLOGY

Maya civilization flourished in the greater Yucatán Peninsula and adjacent highlands (see *Fig. 3*) from at least as early as 300 B.C. until the Spanish Conquest in the sixteenth century, although its origin almost certainly reaches back considerably farther in time. The area known as the Maya lowlands covers approximately 150,000 square miles within the modern borders of Mexico, Guatemala, Belize, and Honduras (see pp. 20–23). This zone ranges from the lush tropical rain forests of the southern Yucatán Peninsula and the flat, brush-covered plains in the north to the volcanic uplands of southern Guatemala and the low, mountainous valleys of western Honduras. In terms of terrain, vegetation, and climate, the region forms a complex geographical mosaic, though within its boundaries are large sectors of *relative* environmental uniformity.

The chronology of Maya history has traditionally been divided into three periods: Preclassic, Classic, and Postclassic. Although many scholars tend to use these subdivisions as convenient glosses for sharply defined periods of time, such terms are fraught with larger implications which are not always compatible with the new discoveries and datings of recent years. Archaeologists can argue at great length about where to draw dividing lines in any typology (e.g., Where does "classicism" begin and end?), but it seems abundantly clear that present evidence calls for some reorganization of the traditional periods of Maya history. In order to accomplish this with a minimum of confusion to readers who may be accustomed to the previously accepted chronology cited above, and be-

CHRONOLOGY

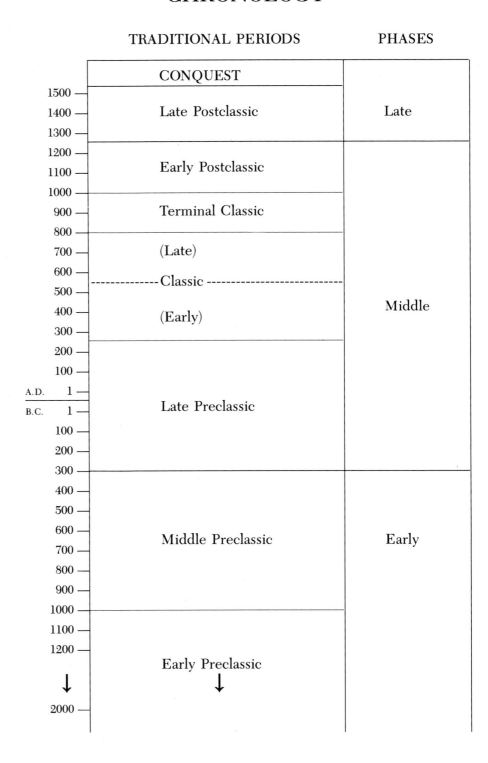

	TRADITIONAL PERIODS	PHASES
	CONQUEST	
1500 —	Late Postclassic	Late
1400 —		
1300 —		
1200 —	Early Postclassic	
1100 —		
1000 —		
900 —	Terminal Classic	
800 —		
700 —	(Late)	
600 —	--------------Classic--------------------------	Middle
500 —		
400 —	(Early)	
300 —		
200 —		
100 —		
A.D. 1 —		
B.C. 1 —	Late Preclassic	
100 —		
200 —		
300 —		
400 —		
500 —		
600 —	Middle Preclassic	Early
700 —		
800 —		
900 —		
1000 —		
1100 —		
1200 —	Early Preclassic	
↓	↓	
2000 —		

Fig. 7. The chronological divisions of Maya history.

cause, as already pointed out, so many aspects of Maya civilization are currently undergoing revisions, I have retained the traditional chronological periods as subdivisions in this essay, though I felt it was necessary to regroup these periods into Early, Middle, and Late phases (*Fig. 7*). The reasons for this reorganization in nomenclature should clearly emerge in the following discussion.

EARLY PHASE

Early to Middle Preclassic Period (2000–300 B.C.)

Recent research has shown that settled village life in the Maya lowlands may date back as far as 2000 B.C., if not earlier. Although there has been controversy surrounding this date, it is clear that Maya civilization in this region developed over many centuries from a simple agricultural base. During this time the number and size of villages steadily increased, resulting in the colonization of most of the lowlands by the beginning of the Christian era. With expanding populations and the spread of new settlements into different lowland environmental zones came a concomitant increase in contacts with neighboring groups and a growing cultural complexity in terms of social organization, art, and economy. The causal relationships responsible for these trends remain unclear despite the attention being focused on them, and the mere mention of some of the theories concerning the interaction of early Maya peoples in the lowlands still provokes debate among archaeologists. Fortunately, new discoveries promise important insights into these questions and have already drastically altered traditional views concerning this phase.

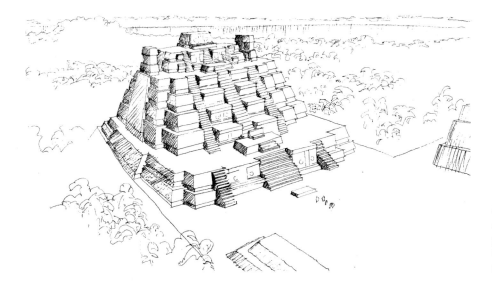

Fig. 8. Structure N10-43 at Lamanai, Belize, one of the largest Late Preclassic pyramids ever found in the lowlands. Courtesy David M. Pendergast, Royal Ontario Museum.

MIDDLE PHASE (300 B.C.–A.D. 1250)

Late Preclassic to Early Classic Period (300 B.C.–A.D. 250)

It was previously thought that most of the cultural features that have been used to define the Classic period—especially monumental architecture, hieroglyphic inscriptions, polychrome pottery, and large ceremonial centers—originally appeared some time in the first three centuries after Christ. The beginning of the Classic period was placed at A.D. 250, with the time leading up to this era labeled the Late Preclassic period (dated 300 B.C.–A.D. 250). But research carried out over the past several decades, and particularly in the 1970s, has proved conclusively that many of the elements of Classicism were present before A.D. 250. Excavations in northern Belize, at sites such as Cuello, Cerros, and Lamanai, as well as at Tikal and El Mirador in Guatemala, have revealed large centers with monumental architecture which existed in the lowlands at least as early as the Late Preclassic period (*Fig. 8*). At Cerros,

archaeological surveys and excavations have uncovered an important Late Preclassic site which maintained far-flung trading contacts apparently involving maritime commerce with other centers along the coast of the Yucatán Peninsula. By about 50 B.C., Cerros even underwent what excavators have termed an "urban renewal." It expanded greatly in size and seems to have followed a careful plan; indeed, one of its pyramids, with elaborate stucco decorations, reached nearly eighty feet above ground level.

Actually, however, rapidly growing sites like Cerros, Tikal, and El Mirador were not the economically or politically dominant centers in the Maya area at this time. Such power lay in the Maya highlands and adjacent Pacific slopes at the settlements of Kaminaljuyú (located within the present boundaries of Guatemala City), Izapa (Chiapas), Abaj Takalik (Guatemala), and Chalchuapa (El Salvador), to mention a few important centers. For one thing, these places controlled the trade in valuable resources such as obsidian and cacao. They also initiated the development of monumental sculpture and the distinctive system of Maya hieroglyphic writing and calendrics whose ultimate origins may lie in Oaxaca to the north, the lowlands of southern Veracruz, or Tabasco, where they appeared among what was perhaps the earliest of Mesoamerican civilizations—the Olmec. Only later were monumental sculpture, writing, and the calendar introduced into the Maya lowlands by means not yet fully understood; it was there that they reached their highest development.

It is probable that the highlands and lowlands were competing economically throughout the Late Preclassic period, with the former seeming to hold the upper hand. Yet wherever this competition might ultimately have led, its outcome may well have been settled catastrophically toward the end of the period, when the Ilopango volcano in El Salvador suddenly erupted. Excavations have shown that this disaster not only caused extensive destruction in the area immediately surrounding the volcano, but that it wrought devastating environmental consequences in a much wider zone. A natural catastrophe of this magnitude could have greatly benefited the lowlands by effectively eliminating preexisting economic competition while, in addition, migrants from the highlands, seeking to escape the aftermath of Ilopango's eruption, may have moved to the lowlands, thereby helping to stimulate new cultural developments.

Moreover, some sites like Cerros, whose prosperity was closely tied to trading contacts with highland centers, also suffered a decline at the end of the Late Preclassic period. Yet such sites as Tikal, which were able to take economic advantage of the changed circumstances, began their rise to dominance. Obviously, the cultural stimulus initiated in the Late Preclassic period continued, and with growing lowland populations and new economic opportunities, it was rapidly intensified throughout this region as the Classic period began.

Classic Period (A.D. 250–800)

The Classic period unquestionably represented what might be termed the Golden Age of Maya civilization and marked the apex of intellectual and artistic achievement in the lowlands (see pp. 23–28). It also witnessed the rise of large populations, with relatively dense settlements, widely scattered over the area. It was a time of dynamic change (in con-

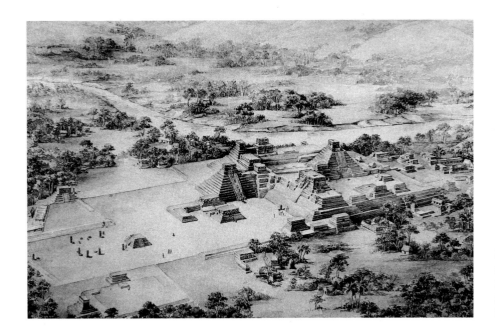

Fig. 9. Copán, Honduras, as it appeared about A.D. *700. Courtesy the Peabody Museum of Archaeology and Ethnology, Harvard University.* Restoration drawing by Tatiana Proskouriakoff

trast to earlier perceptions of the Classic period as being culturally static); and although there was a considerable degree of cultural uniformity throughout the lowlands, there were significant regional differences, especially in art, architecture, and city planning.

Until recently the Classic was viewed as a more or less homogeneous era. The inhabitants of its thriving cities—Tikal, Uaxactún, Yaxchilán, Piedras Negras, Seibal, Palenque, Copán, and dozens of other sites—were seen as existing in isolation in their jungle heartland, with each center ruled by a theocratic elite. The peasants were a peaceful people living on the outskirts of nonurban ceremonial centers filled with pyramid temples, palaces, courtyards, and religious monuments (*Fig. 9*). They practiced slash-and-burn agriculture centered on the cultivation of maize, while the elite classes devoted themselves to intellectual and ritual pursuits. Even their hieroglyphic inscriptions were believed to be esoteric in nature, with little historical content. In essence, the Classic Maya were envisioned as quite different from all other ancient civilizations. They were unique!

As is the case with so many aspects of Maya studies, however, this oversimplified view has collapsed in the light of new research. While there are obvious differences between the Maya and other civilizations, the similarities are generally more pronounced. Furthermore, the Classic period appears to have been quite heterogeneous and varied in many details from our previous conceptions.

A number of trends are evident during the Classic period. Among the most significant was a general increase in population throughout the lowlands. This demographic upsurge manifested itself in several ways, including the founding of many new sites and a steady increase in population at most of the existing centers—two factors that were almost surely related. As populations increased, with resultant pressures on the resource base, formerly uninhabited areas were occupied by peoples migrating from the larger settlements. In addition, there appears to have been a growing nucleation of the populace in and around the core of some of the larger sites, which may have been the result of many people

leaving full-time agricultural pursuits in favor of more specialized functions: arts, public works, administrative duties, commerce.

Most discussions of ancient Maya population figures are based on settlement-pattern studies—surveys designed to identify such evidence of human occupation as the mounds which mark the remains of ancient houses. Since the 1950s, settlement-pattern research conducted at Tikal, Copán, Dzibilchaltún, Altar de Sacrificios, Seibal, and at other locations has provided overwhelming evidence that these sites were not vacant ceremonial centers as previously theorized—with only small populations of resident priests and acolytes—but were actually sizable cities. Although scholars are in agreement as to the urban nature of Classic Maya centers, there is widespread disparity in their estimates of precisely how many residents occupied these sites at any given time. Are we talking about hundreds, thousands, or tens of thousands in the large cities? Unfortunately, archaeologists do not yet have the means to offer more than rough estimates. It is not always clear how many of the mounds uncovered in surveys actually were dwellings, how many were occupied at the same time, or what number of people lived in each house. Moreover, there is evidence that some ancient residences leave minimal or no surface remains. Nevertheless, despite these obstacles, archaeologists have been able to make what seem to be reasonable approximations of site populations at given periods in their history. It has been postulated, for instance, that around A.D. 700, Tikal—perhaps the largest lowland city—may have been inhabited by 40,000 to 50,000 people, while the entire lowlands could have sustained a total population at this time of 1 to 2 million, though some estimates go higher *(Fig. 10)*.

Unfortunately, the nature of the political, economic, and social connections among the growing number of Classic cities is not clear, although extensive contacts definitely existed at all levels, including movement of goods and people. Drawing upon analogies with the ancient Greeks, some scholars have viewed the major centers as more or

Fig. 10. The central core of Tikal, Guatemala, as seen from the air. Courtesy the University Museum, University of Pennsylvania.

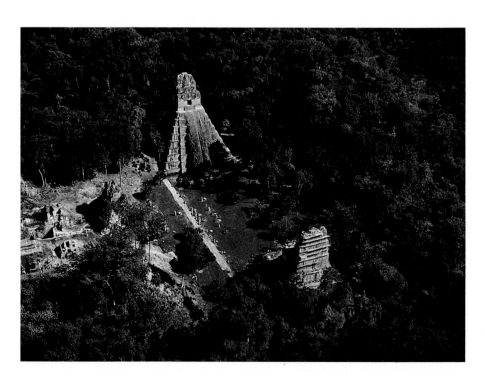

less autonomous city-states, while others argue strongly for the existence of regional capitals with extensive powers that were exerted over surrounding cities by means of political and economic alliances, military control, or intermarriage.

Regardless of these disputes, the sizable number of cultural similarities among the lowland sites cannot be denied. There is incontrovertible evidence for a significant amount of trade in goods which appear to have been used by the ruling classes, and many of the above-mentioned similarities undoubtedly resulted from this commerce. A segment of the populace who left the purely agricultural realm and contributed to the nucleation of large sites might well have been involved in manufacturing and transporting craft items. Other parallels—in city planning, architecture, implements, and locally made utilitarian pottery, as well as widespread similarities in hieroglyphic inscriptions, cosmology, and religious concepts—point to the movement of merchants, artisans, priests, and other specialists. And hieroglyphic texts indicate that there was a considerable amount of intermarriage among elite families from different sites, a fact which would also have contributed to the process of interchange.

Another major characteristic of the Classic period was the apparent increase in the power and wealth of the upper class. The growing bureaucratic functions of this group may also be indicated by an accelerated emphasis on the construction of "palaces" (if such buildings can conclusively be shown to have had some public functions) in the later part of the Classic period. In general, society appears to have become more stratified, with a corresponding decrease in social mobility, although emphasis on craft specialization probably gave rise to a "middle class" of artisans, or at least to growing social complexity, as would the emergence of merchants who transported craft goods from one site to another. An additional indication of a widening gulf between the elite and the rest of Maya society is evidenced by diminished public access to sacred areas like temples and shrines. As the Classic period progressed, contact between the elite and the public seems to have been increasingly restricted to administrative or bureaucratic levels. Esoteric concerns such as astronomy, calendrics, ritual, and divination seem to have remained almost entirely in the hands of the elite class, who probably came to be looked upon by the populace as something close to god-kings.

As settlement-pattern studies (especially at Tikal) demonstrated that the population of the Classic centers were much larger than previously thought, some scholars began to question the old assumption that the ancient Maya relied solely on slash-and-burn agriculture for their subsistence. A number of archaeologists felt that such primitive agricultural practices could not have provided for the population density revealed by the high concentration of house mounds. They began looking for evidence of other subsistence techniques, and from both aerial photographs and ground exploration they found traces of a variety of intensive agricultural features—terracing, ridging, and the reclamation of large areas of swamp lands (*bajos*) through the construction of raised fields *(Fig. 11)*. Although certain of these techniques had been introduced in Preclassic times, there are indications that they were increasingly utilized in the Late Classic period. Quite possibly the growth in population and the rising number of non-food producers during this time placed added pressures on the existing agricultural system, necessitating a reliance on more intensive forms of cultivation, the utilization of household gardens,

and the growing of breadnut trees. In fact, there is some evidence that malnutrition may even have become a problem toward the end of the Classic period.

Furthermore, rising populations could have caused a more intensive intersite competition for land and the control of natural resources and trade. Raiding and warfare, which certainly had occurred in the Preclassic era, appeared to have increased as the Classic period progressed, a fact verified by numerous depictions of battles and captive figures in sculpture and murals. Prisoners obtained in raids may have been used for labor forces involved in constructing intensive agricultural features, the erection of buildings, roads, and other public works, or they were put to death as sacrificial victims.

By the eighth century A.D., all these trends seem to have created accelerated strains on both Maya society and the environment, particularly in the southern lowlands. At the same time, the lowlands began to experience external pressures as well. Such outside influences and threats were not new to the Maya. Peoples from the Maya highlands, the southern frontier of Mesoamerica, and the Olmec region in Tabasco and Veracruz, all had significant impact on the development of the lowland Maya during the Preclassic period. And in the Early to Middle Classic period, the great central Mexican city of Teotihuacán and the highland site of Kaminaljuyú—which was conquered by Teotihuacán—clearly had close ties with various lowland sites. The exact nature of these influences at sites such as Tikal is currently under scrutiny, but it may well turn out that these contacts had profound effects on the development of Classic Maya civilization.

Terminal Classic to Early Postclassic Period (A.D. 800–1250)

In the late-eighth and early-ninth centuries A.D., most sites in the southern lowlands ceased construction of large-scale buildings and the carving of monumental sculpture. Their population declined drastically and many cities were totally abandoned. This phenomenon has been called the Classic Maya "collapse" and has attracted great interest in both the

archaeological community and among the general public. Numerous theories seeking to explain this event have been generated over the years (including natural disasters, epidemics, agricultural failure, and political upheavals), but none of these hypotheses has proved to be entirely satisfactory and the "mystery" surrounding the "collapse" has remained unresolved.

On the basis of new evidence, there are strong indications that the collapse itself was probably an extremely complex process and that the term collapse may not be entirely accurate. At the same time that activities at most southern lowland centers were diminishing, many sites in the northern lowlands—especially the huge city of Chichén Itzá and the great Puuc sites such as Uxmal, Kabáh, Sayil, and Labná (located in or near the Puuc Hills of the state of Yucatán)—were beginning a major florescence. In addition, sites along the east coast of the Yucatán Peninsula and in northern Belize began to flourish or continued prospering. Excavation has now shown that there were significant populations in the lake district of the southern lowlands (around Lake Petén Itzá) after the demise of the major centers. And a few sites along the western and southern borders of the lowlands, particularly Seibal and Altar de Sacrificios, which are situated on the Pasión and Usumacinta rivers, show strong evidence of having been occupied by invaders from Mexico or northern Yucatán in the ninth century.

While it is clear that the large centers in the southern lowlands (with the exception of northern Belize) had ceased to function by the end of the ninth century, other parts of the lowlands show quite different developments. What appears to have happened was not a massive collapse, but a partial one, with large-scale demographic, political, and economic rearrangements. The Classic tradition did not die out entirely, but its focus shifted from the southern to the northern lowlands.

The general causes of this "rearrangement" have become clearer in recent years, but the means by which it was triggered still remain elusive. The growth of population throughout the Classic period and the increase in the size of the non-food-producing sector of the populace at the expense of the food producers must have placed enormous pressure on the agricultural system which provided the foundation of Classic Maya civilization. Attempts to intensify agriculture may well have led to environmental degradation. Added to the internal and external strains discussed earlier, these problems could have caused the demise of the great southern cities.

This calamity may have been exacerbated by certain actions of the ruling elite. Just prior to the fall of the southern centers, the erection of temples, palaces, and religious monuments seemed to be at its height. It has been hypothesized that the elite were aware of some of the problems facing them at this time, and one of the actions they might have taken could have been to attempt to placate the gods by public construction in their honor. But such projects would have required a greater expenditure of labor, thus adding further burdens to the already strained farmers and the agricultural system. It is possible that these activities might have accelerated the process of collapse.

Whatever the proximate causes of this demise, why was there no recovery in the southern lowlands after the initial collapse? The answer might be an economic one. The Classic Maya were skilled artisans and the goods they produced were traded over a vast geographic area, but

they did not control many basic resources which were in constant demand. Salt, a highly prized commodity, was produced along sections of the coastline of the northern lowlands. Cacao, an ancient Mesoamerican currency, may have been grown at this time in northern Belize, which did not witness the fall of all its major centers at the end of the Classic period. It is possible that Chichén Itzá and the Puuc cities of northern Yucatán, which also had some of the best soils in the lowlands, were able to flourish at the expense of the southern sites through their control and marketing of agricultural products and salt. The northern cities may also have been allied with or controlled by aggressive mercantile groups—a Maya-speaking people known as the Chontal—from the Gulf Coast of Tabasco and Campeche who dominated the long-distance trade routes around the entire Yucatán Peninsula. In fact, these Chontal Maya, sometimes termed the Putún, were at least partly responsible for the takeover of Seibal and Altar de Sacrificios in the ninth century. And they may not only have played a role in precipitating the demise of the southern centers but have prevented a recovery there through their influence.

Along with Chichén Itzá, the Puuc sites reached their zenith from about A.D. 750 until 1000–1100, with Chichén Itzá probably maintaining its importance for approximately another century. In general, the architecture, arts, city planning, and artifacts of these sites show strong continuities with the Classic cities in the southern lowlands. Although there are differences, they appear to be more on the order of the regional variations that existed, for example, between Palenque and Copán to the south. Moreover, the similarities between Classic sites and those of the Puuc–Chichén Itzá area seem to far outweigh the differences. In contrast to older models that posited a temporal sequence for the Puuc sites which supposedly preceded the rise of Chichén Itzá, it now appears that there was a significant overlap between the two and they may have been competitors. Additionally, they overlapped the Terminal Classic occupation of Seibal, Altar de Sacrificios, and other centers in the southern lowlands.

It was also during this period that the Toltecs—a powerful nation in central Mexico—were traditionally thought to have conquered Chichén Itzá, bringing with them a number of "Mexicanized" innovations such as religious cults (especially the worship of Quetzalcóatl, the plumed serpent), an emphasis on militarism, and new concepts in art and architecture. Lately, however, this view has been challenged. As scholars first observed years ago, a great deal of Mexican influence was already evident in the northern lowlands prior to the supposed Toltec invasion. Based on present evidence, there is reason to suspect that these influences at Chichén Itzá were probably introduced by the Chontal Maya rather than by Toltec peoples who migrated directly from central Mexico to Yucatán, although this point is far from resolved (Fig. 12).

The reasons for the eventual fall of Chichén Itzá and the Puuc sites are also not clear. Quite possibly the former centers lost out to Chichén Itzá in a prolonged struggle for economic control of Yucatán; and it has been suggested that a well-preserved mural in the Temple of the Jaguars at Chichén Itzá may portray a battle between Chichén Itzá and one of its Puuc adversaries. In any case, Chichén Itzá, once the most dominant city in Yucatán, ultimately suffered a severe economic and political decline somewhere around A.D. 1200, at the end of the Early Postclassic. Even though it was not completely abandoned and became a major

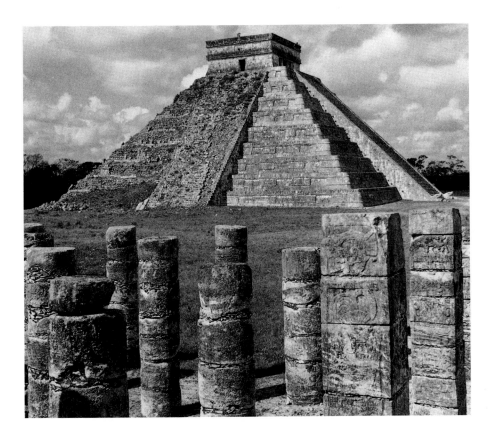

Fig. 12. The Temple of Kukulcán at Chichén Itzá, one of the best examples of Mexican influences in the Postclassic architecture of Yucatán.
Charles Gallenkamp

shrine for religious pilgrimages until the time of the Spanish Conquest, its downfall, along with the demise of the Puuc cities, brought the Classic tradition to a close.

LATE PHASE
Late Postclassic Period (A.D. 1250–the Spanish Conquest)

It was during this era that a city known as Mayapán rose to prominence. Located to the southwest of Chichén Itzá, Mayapán controlled much of the northern lowlands for about two hundred years (A.D. 1250–1450). In effect, Mayapán replaced Chichén Itzá as the political and economic center of Yucatán. In some cases its inhabitants even attempted to replicate the architecture of Chichén Itzá, although on a smaller and decidedly inferior scale. Yet despite this fact, Mayapán is vastly different from Chichén Itzá, and these differences exemplify the significant changes in Maya culture that characterize this period. It has been argued that if one draws a line between Classic and Postclassic traditions on the basis of current archaeological evidence, then A.D. 1250—the approximate date of Mayapán's rise—would most clearly mark this dividing line.

As the capital of a confederacy which spanned much of the northern lowlands, Mayapán had direct political control over a series of provinces, each with its own local government. Interestingly enough, however, the leaders of these provinces were required to live at Mayapán, thus assuring the ruling elite at the capital of the loyalty of the subject provinces.

The city itself was quite different in appearance from earlier Maya centers. Unlike the more spacious Classic sites, Mayapán was very compact, with approximately twelve- to thirteen-thousand inhabitants living in a 1.5-square-mile area surrounded by a wall. The latter may well be

indicative of heightened fears of raiding and warfare that characterized the times (although walled sites are known from earlier periods). The architecture of the period is not nearly as impressive as that of the Middle phase. Mayapán's buildings were roughly constructed and heavy coats of plaster were applied to give the visible surfaces a finished appearance. Most monumental sculpture was crude at best, and ceramics, with the exception of incense burners, were generally simple and minimally decorated. Features such as these have prompted some archaeologists to characterize this period as "decadent," and clearly, in terms of art and architecture, the label is appropriate. But there is disagreement among scholars as to whether or not it is accurate to extend this evaluation to Late Postclassic culture in general.

Both the political and economic systems, particularly the latter, appear to have remained complex and vigorous. On the east coast of the Yucatán Peninsula—at sites on the island of Cozumel, at Tulúm, Tancah, Xelhá, and Xcaret in Quintana Roo, and at Lamanai and Santa Rita in northern Belize—archaeologists have found that these centers were flourishing during the Late Postclassic period and had close ties with Mayapán. They also actively participated in extensive, long-distance trade, not only with Mayapán but with sites as far away as Naco in Honduras and Xicalango and Potonchón on or near the Gulf Coast of Mexico. Excavations on Cozumel and at Mayapán have shown that the general populace had access to a wide variety of trade goods, perhaps indicating that the overall standard of living had improved at this time and the cultural emphasis had shifted away from the esoteric pursuits of earlier centuries toward mercantilism.

Spanish Conquest (Sixteenth Century A.D.)

With the fall of Mayapán in the mid-fifteenth century, due in part to political intrigues and internecine warfare, no single dominant site emerged to take its place. Yucatán became divided into a series of autonomous provinces ruled by independent lords. It was with this decentralized, regionally oriented society in the Maya lowlands that Spanish explorers first made contact early in the sixteenth century. Hernández de Córdova (1517), Juan de Grijalva (1518), and the renowned conquistador Hernando Cortés (1519) led the first wave of European adventurers, with others soon following. Most notable was Francisco de Montejo, who launched a prolonged campaign that eventually led to the conquest of Yucatán in 1542. With their superior weapons, the Spaniards were able to overwhelm the Maya militarily and effectively bring about the destruction of their civilization, although the last Maya stronghold in the Petén region of Guatemala did not fall until 1697 and certain remote sections of the eastern Yucatán Peninsula were never fully "pacified" by the Spanish. Nevertheless, the combined effects of Spanish Colonial policy, religious conversion, and massive demographic losses resulting from the tragic introduction of European diseases (primarily smallpox and measles) were too much to overcome. Despite the fact that the Maya people, their languages, and numerous indigenous customs survived, and still flourish today, their once brilliant civilization, which had thrived for nearly two thousand years, came to an end, and for all practical purposes their immense archaeological legacy vanished from the outside world until the nineteenth century.

3 · MAYA ICONOGRAPHY

Clemency C. Coggins

Maya art is an idealized representation that reflects religious concepts, worldview, and languages in images that are unfamiliar rather than deliberately esoteric or obscure. One approach to understanding Maya imagery (discussed by Flora Clancy in the essay on sculpture that follows) derives meaning from the form of an object in conjunction with its context, or manifest function. Another approach concentrates on Maya iconography or symbolic representation.

Iconography, originally the study of icons, is now generally understood to refer to the system of symbolic imagery used by a culture. There are, of course, levels of meaning. Since we lack ancient Maya literature, sometimes we are unable to identify even the most accessible level. However, with stelae (standing carved stone monuments) we generally know, at least at the superficial level, that we are looking at the portrait of an important man, perhaps a warrior. At the next level we may know that this is Lord Flint Jaguar, ruler of a certain site, because an inscription so states, or other clues of costume and style may suggest it. At a third level we can infer that the figure is the incarnation of a royal lineage, that he may be viewed as a personification of elapsed time and an earthly representative of the sun and the god Itzamná. These last inferences are based on knowledge of Classic Maya culture as a whole; they are inherent in the symbolic system, not in the portrait of a man.

In the past century tremendous progress has been made in understanding Maya iconography. This first occurred through the discovery and excavation of archaeological sites which have provided a corpus of monuments and significant objects of known provenience from which a chronological framework and geographical interrelationships have been sketched. The second great source of information about the Classic period Maya has come from work on the decipherment of hieroglyphic writing. This research has provided extraordinary insight into dynastic sequences and ritual practices; it has also demonstrated a close relationship between hieroglyphic writing and the post-Conquest Maya languages, thus opening unimagined vistas into ancient Maya thought and speech.

The presence of a system of hieroglyphic writing is one of the criteria of Classic Maya civilization; when glyphs first appeared on monuments in the lowlands they recorded only historic events, dates, and titles, while the accompanying imagery is filled with symbolic forms that carry meaning which might, in later times, be understood. Hieroglyphic writing always retains a close relationship with the symbols of Maya imagery; the glyphs incorporated into writing serve as phonetic pointers, and as both sound-alike and look-alike puns—seen in the rebus writing later developed in central Mexico. Thus both iconography and writing are multivalent, with hidden meanings which will unfold only as we recover

the sounds of the Maya voice. Similarly, we must assume that these levels of meaning, so obscure to us, were clear to the literate Maya elite.

What we call Maya art is really only those tangible expressions which have survived. The masonry architecture, stone sculpture, and jade and clay portable objects are simply the least perishable parts of ancient Maya culture, like the writing system which was developed as the ultimate instrument of permanence: historic records. Worked objects made of imperishable materials were the prerogative and property of the ruling elite, an entitled minority of the population who defined the social and religious order, institutions, and commissioned works of art. Maya folk art was ephemeral—perishable, oral, and kinetic—and was probably reflected only slightly, if at all, in the static records and arrested imagery of the rulers.

The Maya iconography discussed in this essay is for the most part represented in the MAYA exhibition; however, a generalized conception of Maya worldview is essential to a broader understanding of the subject. We must depend on ancient images to give us the grand metaphors of the lowland Maya cosmos because post-Conquest Maya literature, upon which we would like to rely, comes from the southern highlands and the northern lowlands and betrays the cultural influences of outside groups who moved into the Maya regions in Postclassic times. These sources provide many valuable clues to ancient Maya culture—particularly in the regions they were written in—but have less relevance to southern lowland myths and cosmology, especially to the role of the ruling elite and their hieroglyphic records, which by Colonial times had not been in existence for five centuries or more.

Maya iconography changed through time, becoming more complex and varied as Classic culture spread and great centers developed their own painting and sculptural styles. Variations are also evident in omissions; for instance, the scarcity of polychrome ceramic painting in the north, or the absence of a stela cult in the west at Palenque and in the Guatemalan highlands (where the Classic Maya did not make stone sculpture or carve inscriptions). The omissions are symbolic statements which may reflect cultural affiliations, social structure, or geographic distance from the heartland where these features were the norm.

WORLDVIEW

A few concepts have withstood cultural dilution and the erosion of time. These are part of a Maya worldview which is found in the mountains of Chiapas today; it was also recorded in post-Conquest sources, repeatedly illustrated in Classic period art, and elaborated upon in Preclassic monuments at the site of Izapa in Chiapas (see p. 67).

This worldview, or cosmological order, puts humanity on the surface of the earth, at the center of a three-level vertical axis, and also at the center of a four-sided horizontal plane. These four sides—east, north, west, south—are determined by the path of the sun—the place where it rises, the place where it sets, and the two positions in between. However, in Classic period art the threefold vertical axis was the dominant one, and the horizontal plane was metaphorically tipped to the vertical so that, following the actual path of the sun in the sky, north (between east and west) was symbolically equated with up, or the zenith, the highest point, and south with down, or the nadir, when the sun was in the Un-

derworld. At Izapa the threefold vertical order is found on stelae that show World Trees growing from the watery Underworld, through the realm of humanity, and into a sky where a mythical bird perches. Remarkably, this Preclassic imagery is known to have been carved in stone at only one other site—Palenque (located directly north of Izapa)—where reliefs showing these motifs were represented in the purest Classic style about eight hundred years later.

Fourfold, or horizontal, imagery was symbolized at Izapa in the layout of the site, as was the case at many Classic cities. The eastern group at Izapa has stelae that depict rising bodies, like an anthropomorphic sun and possibly Venus, whereas the western group has descending ones. This Classic Maya worldview, so clearly present at Izapa in Preclassic times, made its way to Tikal in the southern lowlands during the first century B.C. because Tikal's ruling elite apparently migrated from there, or from a nearby Pacific coastal region which drew upon Izapa as the early promulgator of religious imagery and dogma.

Stela 11 from Kaminaljuyú (No. 19), carved in the Preclassic style of Izapa, sets the Classic pattern for formal elite portraiture by defining it within the threefold vertical axis. A heavily costumed figure with towering headdress stands upon the upper jaw of the Underworld monster, while in the sky a great-beaked celestial bird looks down upon him. Eventually, in the Classic period, perhaps in imitation of central Mexican traditions, such superior celestial imagery was dropped by the Maya and allusion to heavenly realms was found only in the emblems of rulership. At this early date the name and title of the figure on Stela 11 are entirely implicit in his headdress and costume, before monumental inscriptions were used.

A second Izapan-style monument (No. 18) expresses the fourfold imagery of the path of the sun. On this tetrapodal stone cylinder, which has a twin with reversed imagery, the large-beaked bird of the highest heaven is shown with saurian (lizard) legs and clawed feet set in the Underworld while its serpentine wings are outspread, with the right one marked by a *kin* sign signifying day and the east; the left wing is marked with *akbal*, denoting darkness and the west. The bird's body consists of a sun glyph in profile, and thus the bird embodies east, up (north), west, and down (south), as well as the sun itself—as did its mate on the matching cylinder. The two may have been ballcourt markers, placed at either end of the court, one facing north, the other facing south so that their east and west imagery would have been opposite.

Two Late Classic southern lowland examples of threefold vertical structures are found on a jade from Altun Ha and an incensario from Tikal (Nos. 82 and 86). On both pieces the basal element is a large Long Nose Head (an Underworld denizen discussed below). In each case the Maya lord, wearing a bird headdress, and seated upon this head, connotes the middle realm. On the censer the headdress bird is clearly the only indication of the upper realm, but the Altun Ha plaque retains the true sky imagery of Preclassic times and features a World Tree as well.

STRUCTURE OF THE UNIVERSE

As with the three- and fourfold worldviews, the structure of the Maya universe was often illustrated in monumental art and was first made explicit in a Preclassic sculpture at Izapa. This reptilian structure was prob-

ably called Itzamná (literally meaning Lizard House). It is the outer limit of the Maya cosmos—a cloudy, wet, eternal frame that transcends the sun and the other celestial cyclic bodies with which the culture closely identified. Itzamná was depicted in the sky by an overarching double-headed serpent with heads that hung down at either end. This serpent probably had four heads, one for each direction, but only two (usually east and west) could be represented at a time within the two-dimensional limitations of Maya monumental art.

Below the horizon Itzamná usually took the reptilian form of the more crocodilian inhabitants of the earth and waters of the Underworld—waters that were contiguous with those of the earth's surface, such as lakes and rivers. Among nonreptilian creatures only the celestial serpent-winged bird (No. 122), guardian of the zenith, shared the nature of both Itzamná and the sun and plied between the highest heaven and the infernal depths, displaying the traits of each place. Birds and reptiles share many important characteristics, but iridescent scales or feathers and birth from eggs were probably most significant in this connection.

TIME

The ruling elite viewed their lineage, themselves, and the episodes of their lives within the context of a history that began in 3114 B.C. Although they referred to mythical time before that date, most historic inscriptions were described in their relationship to this starting point, or "zero date," of the Maya calendar. Cycles of elapsed time—the Long Count—were enumerated in units of 400 years (*baktuns*), 20 years (*katuns*), years (*tuns*), months (*uinals*), and days (*kins*), until the day in the current combined ritual and solar years, the Calendar Round, was reached (see p. 26). It was also possible to compute longer cycles of time with the Long Count as shown below, though most inscriptions extend only as far back as *baktuns*:

20 *kins*	=	1 *uinal* (20 days)
18 *uinals*	=	1 *tun* (360 days)
20 *tuns*	=	1 *katun* (7,200 days)
20 *katuns*	=	1 *baktun* (144,000 days)
20 *baktuns*	=	1 *pictun* (2,880,000 days)
20 *pictuns*	=	1 *calabtun* (57,600,000 days)
20 *calabtuns*	=	1 *kinchiltun* (1,152,000,000 days)
20 *kinchiltuns*	=	1 *alautun* (23,040,000,000 days)

This apparently difficult system is actually analogous to our own, which records elapsed time before and after the birth of Christ in units of 1,000 years, 100 years (centuries), 10 years (decades), and years until we arrive at a current month and day: for instance, 1984, June 12. One important difference, however, is that the Long Count, like all Maya culture, was an ideal construct; it is based upon units of 20 (vigesimal, whereas ours is decimal). Long Count years were only 360 days long, composed of eighteen 20-day months, and thus only approximated the solar year. The solar year was, however, more accurately recorded in the functional, pan-Mesoamerican Calendar Round, which followed the divine Maya Long Count in an inscription *(Fig. 13)*.

The earliest contemporary recorded date on a monument in the south-

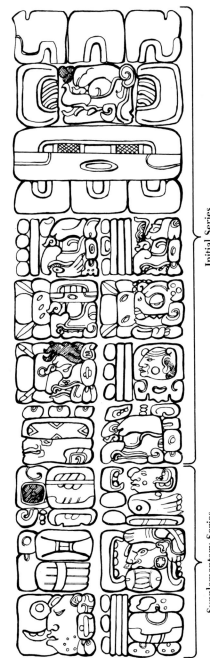

Initial Series Introducing Glyph

Grotesque head in center is the only variable element of this sign. This is the name glyph of the deity who is patron of the month (here Cumku) in which the Initial Series terminal date falls:

9 *baktuns* (9 × 144,000 days = 1,296,000 days)	17 *katuns* (17 × 7,200 days = 122,400 days)
0 *tuns* (0 × 360 days = 0 days)	0 *uinals* (0 × 20 days = 0 days)
0 *kins* (0 × 1 day = 0 days)	13 Ahau (day reached by counting forward above total of days from starting point of Maya Era)
Glyph G9 Name glyph of the deity who is patron of the Ninth Day in the nine-day series (The Nine Gods of the Lower World)	Glyph F Meaning unknown
Glyphs E and D Glyphs denoting the moon age of the Initial Series terminal date, here "new moon"	Glyph C Glyph denoting position of current lunar month in lunar half-year period, here the 2nd position
Glyph X3 Meaning unknown	Glyph B Meaning unknown
Glyph A9 Current lunar month, here 29 days in length. Last glyph of the Supplementary Series	18 Cumku (month reached by counting forward above total of days from starting point of Maya Era). Last glyph of the Initial Series

Fig. 13. How a Long Count, or Initial Series, date inscription is read. Redrawn by Dolona Roberts from The Ancient Maya *by Sylvanus G. Morley.*

ern lowlands is 8.12.14.8.15 13 *Men* 3 *Zip* (A.D. 292) on Stela 29 at Tikal. The practice of erecting stelae with Long Count dates is generally limited to the centuries between the middle of *baktun* 8 (like this one) and early in *baktun* 10, or during the period between A.D. 250 and 900. Monumental dates tend to record the completion of time cycles and to note births, deaths, accessions to office, and rituals related to each other and to major periodic celebrations. Placing rulers within the sacred Long Count was an important purpose of Maya monumental art; augural and individual matters were recorded by their position in the Calendar Round, which was composed of both the 365-day solar year and 260-day ritual almanac. The Calendar Round date—13 *Men* 3 *Zip* on Stela 29—included information of both numerological and astrological significance,

and it is unlikely these dates were more accurate or "naturalistic" than any of the other idealized constructs of Classic Maya culture.

The periods of the Long Count were personified, and perhaps deified, with the *baktun* (400 *tuns*), *katun* (20 *tuns*), and *tun* all portrayed as the celestial serpent-bird. The next unit of time, the 20-day month *(uinal)*, was a toad associated with the moon and woman, and this *uinal* toad may be seen personified together with the *tun* bird on an Early Classic jade plaque (No. 31). The basic unit, the day, was the anthropomorphic sun, so that the two shortest periods of time were the male solar day and the month, which had both female and lunar connotations.

GODS

If gods are defined as personified forces or activities that influence human beings, then there is no question that the Classic Maya had numerous gods depicted as heads, faces, and sometimes as bodies representing natural phenomena and human constructs like time and lineage. However, many of these personifications might better be described as patrons rather than gods, since they were supernatural but not transcendent. Before Postclassic times (when central Mexican practices were introduced in the lowlands) there is no evidence that the Maya made idols of these patrons or worshiped them, although there are numerous such images after about A.D. 1200. (No. 179). The Classic period ruling elite were primarily involved in the veneration of their ancestors and, while these ancestors may have assumed divine characteristics, truly transcendent Maya gods can probably be reduced to two complexes: one astronomical, including the sun and Venus; the other being Itzamná—both of which were completely integrated into Maya ancestor devotion.

Maya supernaturals—whether gods, patrons, or personifications—are identifiable by "god marks." These are half-visible cartouches placed on the curving dorsal surfaces of their anthropomorphic arms, legs, and backs (No. 110). The cartouches frequently have arching lines, or else *akbal* darkness signs within them, and thus may have the same significance as similar forms found on the foreheads of some of these figures (No. 40). Forehead cartouches are thought to be mirrors and the arching lines they exhibit may be reflected paths of heavenly bodies, suggesting that god marks, if they do represent reflective surfaces, may describe these supernaturals as sky watchers, like the Maya themselves.

"God-eyes" are another identifying characteristic. These are large, semirectangular, and often have partially outlining fillets. If celestial, such eyes have squared pupils that are "crossed" or focus on the nose (No. 82). If they pertain to the Underworld, these eyes have hooks in place of the pupils, although such "hook-eyes" are actually the inner outline of a scroll, so Underworld god-eyes are really scroll-eyes.

THE SUN AND VENUS

The sun deity, Kinich Ahau (Sun-eyed Lord), is made in the image of man, and the solar cycle is a metaphor for human life. When at its zenith in the sky, the sun is portrayed as cross-eyed, with an aquiline (eaglelike) nose, incisors filed into a T, a beard, and often a short "flaming" haircut. In the Underworld at night, the sun is an old man, and completely identified with the jaguar (No. 34). His eyes have scrolled eyebrows and are

partly encircled by a fillet that is twisted over the aquiline nose; his incisors may be filed to a point and his hair twisted into a hank above the forehead.

Because of its close identification with man, and with the four-directional path of the sun, solar iconography is prominently associated with the central axis and World Trees (discussed below in connection with the "quadripartite badge" and the symbolism of the middle realm). In Terminal Classic and Postclassic times, the sun and raptorial birds were prominent elements in a militaristic symbolism introduced from Mexico. The moon, which is female, has terrestrial connotations and, although nocturnal, belongs primarily to the solar grouping because of its cycling celestial character and consequent human associations.

There are few clear references to Venus in the Maya lowlands before Late Classic times, when a Venus cult may have been introduced from central Mexico. But the importance of Venus increased steadily thereafter, and in the Postclassic Maya highlands, the planet, with its Morning and Evening Star aspects, was personified by the Hero Twins—ballplayers who overcame the ordeals of the Underworld to achieve immortality. The Maya ballgame, played from Preclassic times, reenacted the movements of heavenly bodies, and may always have been as concerned with the cycles of Venus as with the sun, though evidence for this role of Venus appears only in Late Classic times at Copán and Yaxchilán on the southeastern and western edges of the lowlands.

Five complete Venus cycles equal eight solar cycles; like the sun, Venus was seen as rising strong and youthful in the east, and as old during its time as Evening Star in the west before its descent into the Underworld. In the Terminal Classic northern lowlands, Venus was associated with battles and warriors, and the most powerful warriors wore Venus emblems and took the title of the feathered serpent Kukulcán (No. 158). These feathered serpents were a Mexican concept—inversions of the Maya serpent-bird—but like the Maya sun, Kinich Ahau, the cycle of Venus as a heavenly body was compared to the cycle of human life.

ITZAMNA

As the reptilian structure of the universe, Itzamná encompasses phenomena that transcend and are antithetical to the sun. It does, however, have distinct celestial and Underworld components like the sun. In the sky, Itzamná is mostly serpentine, with one or more heads that grow naturally from its body. These heads have elongated snouts, nostrils with jade bars, long eyes, scrolled "eyebrows," fanged jaws, and a lolling tongue and scroll at the corner of the mouth. Sometimes the tail "head" of the serpent is anthropomorphic, skeletal, and placed at right angles to the body, in contrast to the front head. Supernatural beings often emerge from the open jaws of the celestial serpent and its body may consist of a Sky Band, a sequence of celestial signs. This serpent is also commonly represented as the "serpent bar" carried by many Maya lords in their official portraiture, showing that the lord and his lineage worship and may descend from Itzamná.

Beneath the human realm, Itzamná symbolized the structure of the earth, and in the waters of the earth and Underworld, where death reigns, it takes the skeletal forms of such aquatic reptiles as crocodiles. These are usually portrayed as Long Nose Heads, either skeletal or with

no lower jaw (which means the same thing). Such Long Nose Heads—often without bodies—are sometimes referred to as "long-lipped," but it is their nose or snout that is actually elongated and flexible (No. 180).

Long Nose Heads take many forms, but two are most important in the Underworld. The first is the Cauac Monster, a Long Nose Head that is usually marked with Cauac signs (No. 82). The Cauac glyph refers to rainy skies, and also to the *tun* as a period of time. *Tun* also means stone, so that, in a typical Maya play on words, the stony structure of the earth and moist celestial character of Itzamná are combined in this Underworld Long Nose Head.

The second Underworld Long Nose Head is sometimes called the Imix Crocodile. It is shown with water lilies *(imix)* in the streams of the Underworld (No. 120), and often represents that lower realm in monumental art. Both of these subterranean Long Nose Heads partake of the generally damp, cold, and dark reptilian nature of Itzamná, the great Lizard House.

IMAGERY OF THE THREE REALMS

The Sky In Preclassic times celestial imagery was an important part of monumental art (No. 19), but by the middle of the fifth century A.D., in the Early Classic, it was seldom included, perhaps due to intrusive central Mexican practices. Instead, the solar, planetary, and serpentine symbolism of the sky was incorporated into the regalia of Maya rulers in their official portraiture. Yet in Terminal Classic times, when Classic culture was under external pressure and disintegrating, there was a religious revival in which the archaic celestial imagery of the upper realm was again portrayed.

The World The middle realm, as seen in Maya art, consists mostly of official portraiture that was located in the plazas; it depicted Maya lords standing upon pedestals symbolic of the lower realm. The upright stone monuments, or stelae, which often carried Long Count dates and a record of events in the ruler's life, associated the man portrayed with time itself by virtue of his personification of the stone. The Yucatec word for both stone and year is *tun*, thus these monuments were probably called *tuns*.

Public stelae were supplemented by less formal pictorial records of dynastic and prisoner-taking ceremonies that were located inside the rooms of temples and palaces. The few remaining frescoes, also on interior walls, tend to deal with battles, captives, and associated rituals; they do show, however, more of the Maya world, including platforms, complete buildings, and the locations of battles. And like stelae, they portray prisoners, who stripped of their regalia, represent a naked humanity outside the formal construct of elite culture. At the same time sacrificial victims display a rigidly prescribed role within this construct, personifying an ideal of degradation. Landscapes, plants, children, and animals are seldom shown, even though they are part of the visible world. When a painting includes one of these categories, its stylized, rationalized, and iconic nature is usually evident; World Trees—essentially the only type of tree ever depicted—are a good example (No. 121).

The principal image of the middle realm is the portrait of the ruler who, heavily laden with jade, wears his own characteristic and realisti-

cally portrayed regalia. This attention to detail is necessary because these emblems and clothing are among the most meaningful elements in the artificial construct of elite Maya culture—their treatment is descriptive but not naturalistic. The Maya ruler depicted on a stela may wear a belt with crossed bands to symbolize the sky, carry a serpent bar to signify the celestial serpent, wear a loincloth apron to show a sun mask, a backdress with a skull, and a headdress composed of a Long Nose Head with both celestial and Underworld attributes. All of these serve to associate the ruler and his lineage with the sun and with Itzamná. Foremost among these emblemata of power and divinity, however, is the Manikin Scepter, a small Long Nose Head creature, sometimes called God K, who has "god marks," scaly ventral surfaces, a serpentine leg, and a mirror with an ax or a smoking tube inserted in its forehead (see *Fig. 14*). Maya rulers are shown holding this Manikin Scepter by its serpentine leg. It is the personification of lightning, the weapon of Itzamná, who is associated with rain and storms, and it is analogous to the hafted Maya ax, just as the Mexican storm god, Tlaloc, had his weapon—the characteristic Mexican spear thrower—for the same purpose.

The concept of the supreme weapon-bearing storm deity is found in many cultures, but among the Maya this divine weapon was overtly serpentine and specifically emblematic of lineage. Like all of the major and minor Long Nose Head creatures (aspects of the reptilian Itzamná), the Manikin Scepter is symbolically phallic in both its serpent leg and its flexible snout. The Maya have been considered a puritanical people who suppressed all reference to sexuality. This may, however, be a misconception that derives from our ignorance of ancient Maya languages. Maya art is filled with phallic imagery which was probably perfectly obvious to the Maya, whose words for such forms doubtless included several meanings. Multiple serpentine aspects of Itzamná still exist among the modern Chorti Maya, who call them Chiccháns; they personify most earth and sky phenomena, especially rain and thunderstorms. There were apparently fewer such Classic Maya Long Nose Chiccháns because only those relating to elite lineages were portrayed in the art.

An example of the linguistic and symbolic complexity of Maya iconography is found in the "quadripartite badge." This four-part emblem, worn on a headdress, sums up the threefold worldview. It features an upright feather set between a shell on one side (symbolic of the Underworld) and crossed bands (symbolic of the sky) on the other. The three are mounted on a sun sign (*kin*), which unifies the badge as it unifies the three levels. The central feather, sometimes shown as a stingray spine, is a bloodletter—the sharp object used to draw blood from the penis in the dynastic ritual that involved dropping blood on sacred paper which was burned so the smoke could reach to the sky. This element connotes man in the middle realm, as well as his reproductive organ, which both in this ceremony and through the continuity of lineage maintained generational contact with the divine ancestors above. In confirmation of this interpretation, George Kubler has pointed out* that the Yucatec Maya word for quill (*chun k'uk'um*), also has connotations of *origin*, *root*, and *trunk*.

In formal portraiture there are rules of composition which have symbolic meaning. These quite simply derive from the three- and fourfold worldviews. A man is usually treated as if he were facing north so that his

*In a personal communication.

position and his body take on the values of the directions. His right hand is east, and his head (up) is north—both positive, honorable directions; whereas west and south, his left hand and back (down) are negative and less honorable. Stela 17 from Dos Pilas (No. 66) follows these rules exactly. This Maya ruler faces his right and wears a solar loincloth in front, connoting the sky. He holds the most important royal symbol, a Manikin Scepter, in his right hand, and in the left his shield, which has the Western imagery of a complete solar cycle. His backdress is a tiered Underworld construction: a bird is above a jaguar in a niche, which surmounts a Long Nose Head. All of this is above a skeletal mask with a solar fret below—very much like the backdresses shown on the polychrome cylinder from Holmul (No. 88). The ruler's body, position, and paraphernalia are thus properly displayed in their relation to the four-part solar cycle. Interior scenes with enthroned Maya lords are among the commonest subjects painted on ceramic vessels and carved on relief panels. When these are found on funerary vessels it is difficult to know whether the scenes are taking place in the dead lord's own palace during his lifetime, in a palace somewhere else, or in the Underworld.

The Underworld Fears, fantasies, and night terrors were personified in the cold and gloomy hell that was the Maya Underworld—an often grotesque caricature of life on earth. This infernal imagery is common on funerary vessels, but there is also evidence for more than one conception of this Underworld, or at least of more than one way to experience it. These variations seem to represent regional practices and beliefs, but a unifying element is found in a hieroglyphic text that is written on such vessels from many locations.

The two Underworld segments of Itzamná, the Cauac and Imix Long Nose Heads, are important structural features of the Underworld. Most of the infernal inhabitants are either distorted versions of men and life on earth or aspects of the solar and Venus cycles. In some accounts, two lords rule this hell. They are old men with solar features. One may have the black-spotted pelt and round ears of the jaguar, while the other may wear the black-spotted feathers of the Moan bird (a mythological screech owl), both nocturnal animals. In certain areas, especially in Postclassic times, the important lord of the Underworld is the old man who wears, and emerges from, a gastropod (conch) shell or its equivalents: a turtle carapace, crocodile jaws, or from some other aquatic monster (No. 205).

Throughout lowland Maya history the Jaguar Sun, symbolic of night in the Underworld, was the most consistent personification of death and the nether regions (No. 25). Similarly, long-beaked water birds, which dove beneath the terrestrial waters to fish, were symbols of resurrection (No. 45), as were all infernal forms of the circling sun and Venus. In the Late Classic the Moan bird, emblematic of death and bloodletting ceremonies, was depicted whole or by its stylized feathers on ceramic plates and bowls.

As described in the Late Postclassic highland Maya epic, the *Popol Vuh*, the Hero Twins, who were Venus as Morning and Evening stars, went down into the Underworld to play ball. There they survived many ordeals, including death, and ended by killing the ruling lords. This myth is found illustrated in the Late Classic southern Maya regions (No. 114), and northward along the Caribbean coast, but is not found elsewhere in the Maya lowlands.

The adventures of the Hero Twins, and many other stories of the ordeals of hell, are suggested by the grotesque inhabitants of the Underworld depicted on grave goods and on ceramic vessels (particularly on a large number of unknown provenience which are not included in the MAYA exhibition). These scenes prominently include skeletons, the water-lily jaguar, monkeys, and deer, as well as peccaries, rabbits, dogs, foxes, toads, vultures, bats, and insects.

The official middle-realm imagery of the Underworld, scarcely acknowledged in the bizarre cast of characters painted on Late Classic vessels, was reserved for incensarios, which were used in the ancestral veneration ritual performed at burial temples (No. 109). These incense burners represented the Jaguar Sun in the Underworld, alluding by their function to the Old Fire God, the most ancient Mesoamerican deity (No. 34), and also by symbols of self-mutilation to the dynastic ritual in which burning blood-spattered paper was carried as smoke to the celestial ancestors, thus uniting the three realms. Maya iconography, as we understand it today, is the visual language of the ruling families, who perpetuated their legitimacy and identified themselves securely within a divinely ordered and cycling cosmos.

4 · MAYA SCULPTURE

Flora S. Clancy

In its power and imagery, Maya sculpture is strongly evocative of half-hidden mysteries and truths. So often we are certain that we could recover some of the essential meaning of these creations if we could only understand the visual language of their icons and translate their hieroglyphic inscriptions. Although this essay is based on the hope of finding essential meanings, it deals with neither glyphs nor iconography. Its concerns are the forms of Maya sculpture—the material components and structure, shape, color, line, and mass—and how the manipulation and combination of such forms yield answers about original function and thematic intent. While this essay will focus on the most important periods in the history of Maya sculpture, encompassing the Early Classic (A.D. 250–550) and the Late and Terminal Classic (A.D. 550–1000), occasional references will also be made to the Preclassic and Postclassic periods. As there are many cultural similarities between Early and Late Classic, the term Classic is used by itself when appropriate.

CONTEXT

There has been some resistance among students of Pre-Columbian art to the traditional aesthetic structure that distinguishes between the major and minor arts. Still, most summary descriptions of sculpture divide it into categories determined by medium, and monumental stone sculpture is given primary treatment. Metal and jade objects are considered jewelry, and clay pieces—no matter how brilliantly executed—are relegated to a minor position relative to stone sculpture.

Maya sculpture is organized, here, into a contextual structure determined by the locations of particular types. Three major sculpture types can be defined: plaza, architectural, and buried. These groups can also be recognized by a specific set of forms, functions, and styles; a piece of sculpture without a known provenience can be placed into one of the three groups on the basis of its formal and stylistic characteristics. Of course, this structure is general, not exact enough to reflect subtle exceptions which might exist in diagnostic criteria. Its value lies in the fact that it does not impose an aesthetic judgment derived from a European tradition of sculpture. It is interesting, however, that plaza and architectural sculpture is usually carved from stone, and buried sculpture is often made of clay, wood, and semiprecious stones. We may not know whether the Maya held ideas about major or minor arts similar to our own, but this relationship between material and usage does suggest that they made some kind of distinction.

Plaza Sculpture These massive pieces are available for everyone to see, as they are found in the great plazas or on the terraces that face the

plazas. Art created for open viewing is seldom artistically exciting; its public (and political) functions are too important to risk using evocative, unknown, or expressive images. Maya plaza sculpture, therefore, is conservative in form and theme. Invariably, it is a relief sculpture carved on stone, usually the limestone which constitutes the vast geologic shelf known as the Yucatán Peninsula. When limestone was not readily available, as in the highlands or the southeastern region, the monuments were carved from equally soft stones, such as sandstone and trachyte. The choice of easily worked materials was apparently important, since it allowed for greater aesthetic latitude. Another major consideration in the selection of soft stone was that the Maya had no metal tools. Instead, sculptors worked with stone chisels or celts, flint blades (for detailed carving), and hammerstones, though they may have also used wooden mallets.

Plaza sculpture assumed three different shapes: the stela, the pedestal, and, rarely, the boulder. The Maya stela bears a resemblance to ancient Greek stelae. It is a rectangular, upright slab of stone taller than its width and wider than its thickness (*Fig. 14*). Often the top was rounded off, creating the appearance of a large gravestone. The earliest Maya stelae tended to be used in a freshly quarried, rough state. There was little concern for smoothing the stone into flat surfaces; it was left in a more natural state with the protrusions, cavities, and pits typical of limestone. The relief-carved images were forced to follow the irregularities of the stone, and the images often seem of secondary concern—perhaps the sculptor intended to indicate by this roughness that the images were buried within the stone itself and revealed only in the quarrying. The sculptor's job would have been to "see" and then enhance what was already there.

In the Early Classic period, the desire to make the stela and its image appear natural gave way to a greater concern for the potential of the image itself as a means of carrying public and political information. The monument's form became secondary, almost unnoticeable. Using polishing stones to abrade the surface, a sculptor would smooth the stela and straighten its edges until it became a rectangular shaft, or prism, and the relief carving virtually covered the surface of the monument. In addition, most stelae were brightly painted with red, blue, and yellow being the most commonly used colors.

Quite often stelae and pedestals were placed in such a way as to suggest a direct relationship (*Fig. 15*). Although such a pairing was clearly the intent of the Late Classic Maya, archaeological evidence does not allow us to assume that these monuments were originally intended to be erected together. For instance, at many sites, including Copán in Honduras, relief-carved pedestals dating from the Early Classic were situated in plazas, indicating a definite public function, yet they were not associated with stelae.

Pedestals are both cylindrical and rectangular in shape. They are positioned on the ground so that the major carved surface is parallel to the plaza floor. While one looks *at* a stela, one looks *down* on a pedestal. Pedestals have previously been termed altars, but such nomenclature assumes a religious function that has little or no archaeological evidence to justify its use. There is some evidence, however, that these pedestals were used as seats or stands. The relief on many of them shows wear in the center of the top, and images found on stelae, lintels, and wall panels depict people standing or sitting on pedestals.

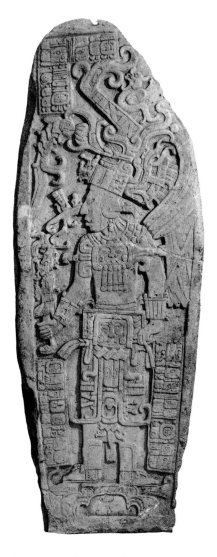

Fig. 14. Stela 7, Machaquilá, Guatemala. Stuart Rome

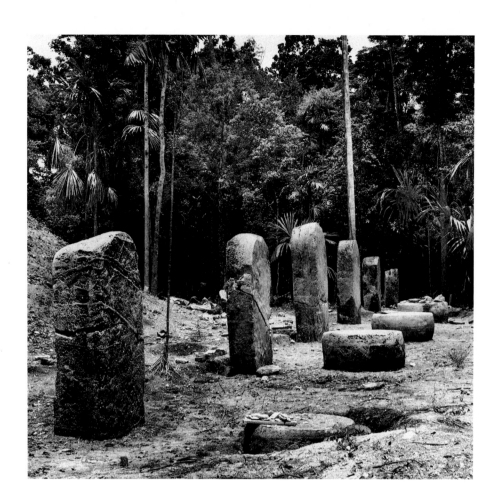

Fig. 15. Stelae and pedestals, Tikal, Guatemala. Charles Gallenkamp

There are numerous examples of the "plain stela" and the "plain pedestal." These sculptures have been shaped—often elegantly so—into the recognizable forms of the plaza monuments, but they bear no relief carving. One might infer from this that the plaza monument, whether or not carved imagery was added, must have had a special meaning in itself. In fact, it is a particularly significant feature of plaza sculpture that the basic form is recognizable as a monument with or without carved information. Such a statement, however, throws into some question the famous sculptures from Quiriguá known as boulder sculptures, or zoomorphs *(Fig. 16)*. These sculptures use natural boulders as a field for the relief carving. Without the reliefs they would not be easily recognizable as monuments; they would look like ordinary boulders. However, their context within the main plaza—a place where boulders are not found naturally—suggests that any boulder in a major plaza space, carved or plain, would have to be recognized as an intentional monument. Furthermore, the undressed or unshaped boulder sculptures are reminiscent of the earliest stelae, and the theme of naturalness is again evident.

There are a few—very few—plaza sculptures which were carved in the round. As far as is known, their occurrence is limited to the sites of Copán and Quiriguá in the southeastern part of the Classic Maya area, and to Toniná and Palenque, both situated in the modern state of Chiapas in the western Maya area. Like much Egyptian sculpture, the forms of these pieces were composed to reflect the original shape of the stone block from which they were carved (glyptic relief). Again, one is remind-

ed of the respect shown for the stone used for most plaza sculptural works.

Architectural Sculpture This type is generally carved on the stone and wood used in structures. During the Late Preclassic and Early Classic, relief work built up by the application of stucco was common, and stuccowork reliefs continued into the Late Classic at Palenque.

Sculpture that functions within an architectural context is partly defined by the restricted space in which it was placed—the small rooms of temples and palaces. Viewing these artworks must have been a fairly private affair. Seldom could more than two or three people have fit into the interior spaces that hold them, and in many instances there would have been limited light by which to see. In order to understand the images, the viewer would have to spend time with them. Architectural art is for contemplation; this contrasts sharply with the face-to-face confrontation experienced by those viewing the large public stelae.

During the Terminal Classic period the occurrence and emphasis of architectural sculpture became much greater, especially in the northern lowlands. This change is definitive for the Postclassic, while plaza sculpture, so characteristic of Classic sites, is almost nonexistent. We do not yet understand the structural and functional changes that must have occurred when plazas ceased to be a major setting for public monuments, but the importance of sculpture in an architectural context is strikingly evident throughout the northern Yucatán Peninsula from about the middle of the tenth century until the Spanish Conquest. Added to the usual decoration on buildings, the cornices and walls of structures were also embellished—most commonly with inset mosaic stonework of geometric designs, enormous masks, deities, human figures, and animals. In addition, a number of new motifs appeared at this time which reflect strong Mexican influences that infiltrated Yucatán during the Postclassic period (see pp. 42–46).

Major examples of architectural sculpture are named for their particular functions: lintel, wall panel, pier, and jamb. Unlike plaza sculpture,

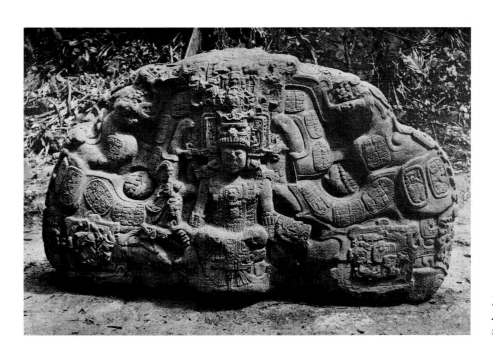

Fig. 16. Altar P, Quiriguá, Guatemala. A zoomorph *in the form of a two-headed monster.* Alfred P. Maudslay

these works do not utilize an abstract monument form by which they can be recognized; they can only be identified because of their relief work.

Architecture provides a totally man-made cultural context for sculptured monuments. Plaza sculpture, although certainly having a cultural context, nonetheless has vistas of the sky, natural light, and openness to the weather, and therefore a strong relationship to the natural world. Architectural sculpture, in contrast, is situated with no other reference to nature than that which may be alluded to within the relief-carved images. Furthermore, it was apparently not necessary to mimic a natural scale, and the images found in architectural contexts are usually reduced one-third to one-half from the life-size to larger-than-life-size scale of plaza art. This reduced scale can be explained in part by the limited space of the interiors themselves, though not entirely. At Yaxchilán, the images and scenes carved on lintels seldom use all the space available to them. The smaller scale, in these cases, must have been a matter of choice. The basic thematic background for architectural sculpture refers to images within the culture and to man-made systems and structures. There are few, if any, architectural sculptures in a natural context, as we see it.

Buried Sculpture Here the contexts are either burials or caches dedicated to the construction of a building or the erection of a stela. Whether these artworks ever had uses prior to their burial which might approximate the functions of architectural and plaza sculpture, or whether they were made specifically for funereal use and caching rituals, are open to question. The pristine condition of some pieces found in burial contexts tells us that they were made specifically for this purpose, although the archaeological records may be unclear.

There are two obvious points that set buried sculptures apart from those identified with architectural and plaza functions: material and scale. Buried sculptures are modeled or molded in clay or carved from such semiprecious stones as jade, or in bone, shell, and wood (rarely found because of its rapid decay in humid climates). Seldom is limestone a medium for funereal art. The scale of the burial pieces is miniature, and though one would not expect to find objects of monumental size in burials because of the physical restrictions of most Maya tombs, there are a few interesting exceptions. A famous example is the extraordinary Ruz Tomb found in the Temple of the Inscriptions at Palenque—the burial place of a prestigious and elite ruler. The tomb is a vaulted chamber with nine human figures modeled in stucco along the walls. The sarcophagus was covered by a five-ton limestone slab beautifully carved in low relief *(Fig. 17)*. This piece has all the narrative and formal characteristics of the architectural works of art found at Palenque and the nearby sites of Yaxchilán, Jonuta, and Bonampak. In this case, it would be easy to imagine that it was conceived to serve two successive functions. That is, it was carved before the burial and was first placed in an architectural context of limited access for a few people to contemplate; its second context, the burial ritual itself, and the carving—like all buried works of art—became accessible only to worms and spirits!

The monumental scale and extraordinary refinement of the sarcophagus lid set it apart and, paradoxically, by this we can introduce the idea of burial sculpture as works of personal art. Art found in funereal contexts certainly had such functions, but it can be argued that whether these

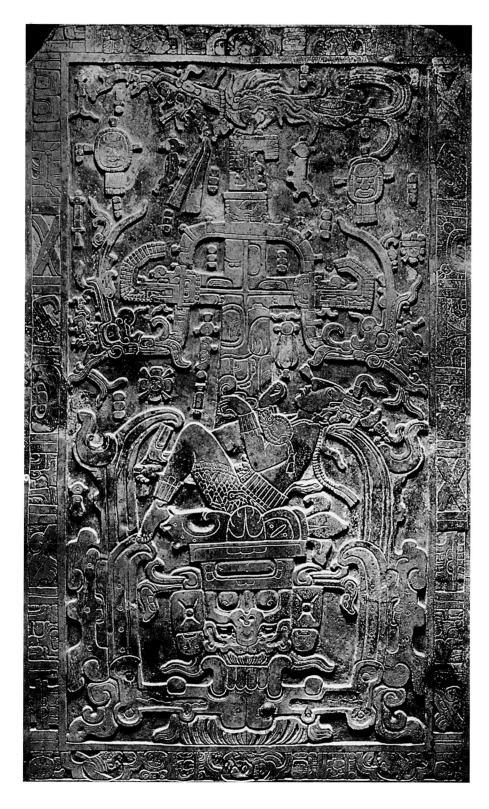

Fig. 17. The sarcophagus lid from an
elite tomb in the Temple of the Inscrip-
tions at Palenque, Chiapas.
Merle Greene Robertson

works served another purpose within the private or public spheres, or
whether they were made specifically for burial, they nonetheless were
indicators of a unique individuality and of personal activities. These ap-
pear in items from nonelite burials where it is common to find objects of
everyday and personal use. These things tend to be tools such as spindle
whorls, corn grinders, or weapons, and would identify the activities and

status of the individual. Nor is it unusual to find offerings of food and drink placed in ceramic vessels accompanying the body. It is likely that structural and metaphoric similarities exist between these burials and the tombs of elite persons, where the sculptured works of art are found. Those items we deem art would make reference (although often indirectly) to the nonelite practices of including identifying objects of personal use.

Obviously, the professional and social status of an individual affect the items found in the burial. Objects of elite personal use and identification were closer in kind to the architectural and plaza works of art. One reason for this is that the items of personal use for the elite were, most likely, made by the same artists he or she had patronized for the plaza and architectural works (Fig. 18).

During the Classic, the contents of elite burials seem to have been determined by some conventional tradition because the items are predictable and can be described as "meaningful" sets of objects. At Tikal, most elite burials had at least one bowl, one cylinder vase, and one plate. Of these ceramic pieces one ideally would be of imported manufacture. The burials that make up the necropolis on the island of Jaina off the northwest coast of Campeche usually included modeled or molded figurines. Such objects are not common to the Classic burials found in sites of the central Petén region, but like specific sets of pottery vessels at Tikal, figurines can express the idea of a meaningful group of objects.

Many, but certainly not all, clay figurines functioned as musical instruments: rattles, whistles, and flutes. Whether the buried instruments were used by the living, which seems likely, or were considered necessary items to accompany the spirit is, as usual, difficult to determine. Nonetheless, they can be understood as objects of personal use or need—before or after death—which make reference to the individual's profession and status.

The modeled figurines have been called experimental because their exuberant expressiveness contrasts with the more controlled and conservative appearance of plaza and architectural sculpture. And it is true that the artist's close observation of an everyday, unofficial humanity has been poignantly synthesized into simple pulled-clay forms for arms and legs, an expressive angle for the tilt of the head, the furrow of a frown, or a lopsided smile (No. 90). The greater stylistic and iconographic freedom that often characterizes works of art found in burials is part of their function as objects of personal use and the fact that they were not bound by the demands placed upon public and architectural arts—demands that would require conventional and more easily understood forms and meanings.

Almost all Classic examples of sculpture in the round are in fact the miniature-scaled clay figurines found in burials and caches. The method of modeling these figures was relatively simple. The body and limbs, whether constructed as hollow or solid tubes of clay, were pieced together and the head added by inserting the neck into the top part of the torso. The joints would be smoothed over and the figure would then be "dressed" by adding thin slabs of shaped clay for the clothing. Facial features and the textile designs of the costume were created by applying pellets of clay and by cutting and shaping them until the desired details were achieved.

The molded pieces were usually made from two molds, one for the

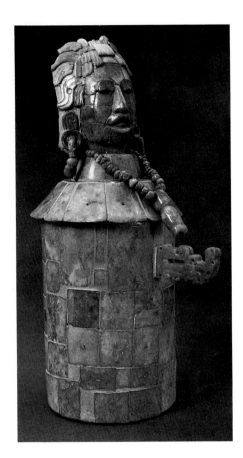

Fig. 18. Jade mosaic cylinder with a "portrait" head lid from a Late Classic tomb (Burial 196) at Tikal, Guatemala. Stuart Rome

front and another for the back of the figure (No. 102). It is thought that the use of molds was in response to a greater demand for figurines by a growing military aristocracy that became the governing class during the Late Classic. Because of the importance we place on uniqueness and originality as attributes of great art, the molded pieces seem to lack the vitality and clarity of form our modern eyes can see in the hand-modeled pieces.

Like many other peoples, the Maya had a myth that in one of the creations of the world (they believed there had been three previous creations and that we are now living in the fourth), man was created from clay. The hand-manipulated additive process of clay sculpture has often been likened to an act of creation: soft formless mud can be given form by artistry and life by the fires of the kiln.

MAYA STYLE

It is helpful to draw a distinction between the features that characterize Maya art in general and the variations that can be detected within this basic style. Such variations may represent differences in locality or time of production, and they may reflect the individuality of an artist or the hallmarks of an artistic school. For Maya art, the identity of individuals or schools is difficult to assess, but it is possible to chart local and temporal styles.

Maya style is linear, with a distinctive and peculiar quality of line. It is a graceful, curving, highly controlled line that has a "pulled" quality—a tensile strength to it. Despite its expressiveness, however, it is seldom used for purposes of abstraction; the Maya artist used line to portray objects as we might actually see them. A close look shows that the artist was interested in depicting a high degree of naturalism and reality. He paid close attention to details. He showed us how anklets were tied around the ankles and how the necklace curved around the shoulders (No. 66). Grotesque creatures emerge from combinations of skeletal, plant, serpent, human, and animal forms. Nonetheless, even in the monsters one observes a naturalism in the depictions of the various parts. In these unearthly combinations one cannot see reality as we know it, but Maya artists never departed from a natural basis for their representations.

Densely packed, compressed compositions are another important aspect of Maya style. Line, not mass or color, controls the formal elements in compositions. To the Western eye they often appear to be a confusing array of serpentine forms. Complex images overlap each other, and forms seem to grow into and out of one another. This is unusual in other Pre-Columbian art, where images, although complex and highly symbolic, are often placed next to one another like building blocks, and the full depiction of a motif or image was never obscured. By contrast, the Maya were willing to leave *implied* that which was hidden in the overlapping.

In general, then, Maya style can be described as predominantly linear, expressive, and descriptive, based in naturalism, and using overlapping forms in densely packed compositions.

The Narrative Style This is best represented within the western boundaries of the Maya area at the sites of Yaxchilán, Bonampak, Piedras Negras, Palenque, and Jaina. It is usually found in architectural contexts—executed in relief on lintels and wall panels—and in burial con-

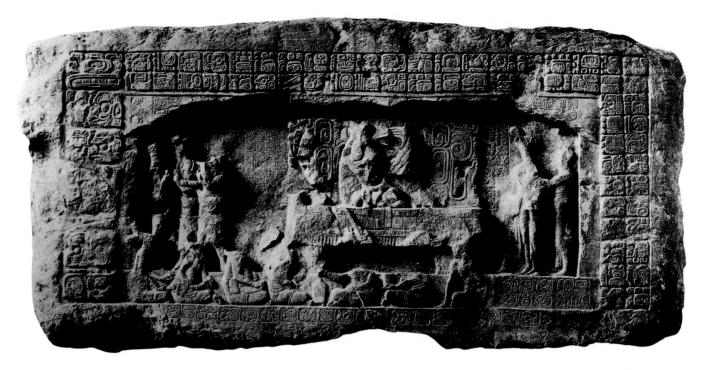

*Fig. 19. Lintel 3, Piedras Negras, Guate-
mala.* Sylvanus G. Morley

texts as sculptured figurines or objects carved of bone and semiprecious stones. Invariably the narrative style depicts the human figure in active and asymmetrical poses—poses that represent activities common to mundane human action (No. 89). People sit, stand, kneel, hold things, gesture, and in doing so appear to be participating in some kind of narrative. Even if the "actors" are definitely not human, as in a famous boating scene carved on a bone from Tikal, the actions are recognizable and mundane in that they represent commonly experienced activities. This impression is heightened by the fact that usually two or more active and asymmetrical figures are depicted as interacting. It has never been seriously questioned that such depictions of action and interaction represent a story, whether it be a historical event, as is generally assumed for Lintel 3 at Piedras Negras *(Fig. 19)*, or a mythical event, as is surely the case for Lintel 15 from Yaxchilán *(Fig. 20)*.

The interaction between two or more figures, however, is not a necessary feature of the narrative style. There are several representations that depict only one individual and still belong to the narrative style. Males identified as ballgame players are often portrayed alone. Kneeling figures carved on tablets at Palenque, also belonging to the narrative style, show the hand placed to the mouth, but not quite touching it. Implicit in this chosen moment is the previous action that drew the hand upward and the future action when the hand descends. The image must represent one moment from a series of related actions—a moment carefully chosen to evoke the entire story.

Single figures, like the scenes with multiple figures, are portrayed in a recognizable action by a predominance of unstable diagonal and organically curved lines. The use of strong asymmetries in the represented action is understood as one moment in a longer series of actions. It is likely, then, that for a story to be portrayed, it is necessary to use pronounced dynamic asymmetry and diagonal and curved lines. These lines repre-

sent action, and the asymmetry represents the direction of the movement in time and space.

In relief sculpture the use of the narrative style is a Late Classic phenomenon. Yet during the Late Preclassic period this style was very much in evidence on relief sculpture referred to as Izapan, after the Mexican site of Izapa on the Pacific coast of Chiapas. Izapan sculpture is thought by many scholars to be a proto-Maya manifestation. The narrative style is also evident in Late Preclassic clay figurines—active, bold, but miniature portrayals of women. There is a hiatus of almost seven hundred years between the Izapan use of a narrative style and the Late Classic examples, and a difference in its functional context. The Izapan narrative pieces were commonly stelae placed in public plazas, quite different from the Late Classic context within buildings or burials. Narrative-styled stelae placed in public contexts do exist at the Classic western sites where the narrative style is extensively used, but these are the exceptions, not the rule. The use of this style outside the western area occurs in the northern Yucatán Peninsula during Postclassic times. It is almost always in architectural contexts and is seldom used with the same dynamic and realistic power.

Hieratic Style The best examples are found in the southeastern portion of the Maya area at the sites of Copán and Quiriguá. Beautifully carved, the plaza sculptures at these sites are nonetheless organized by the explicit bilateral symmetry of the frontal human figure they present *(Fig. 21)*. The personage is shown in a static and apparently formal pose. The arms, the only possible source of asymmetry in a full-frontal pose, usually mirror one another and so maintain the bilateral structure of the body. Even in the most ornately carved pieces at Copán, strong vertical and horizontal lines are visible: the regalia (the double-headed ceremonial bar), the belt, the kilt, the knee ornaments, and the anklets are clear horizontals. The central axis, visibly marked by the loincloth apron, is the strongest vertical. A pair of vertical lines can also be seen running through the earplugs; they frame the edges of the headdress and face and are continued downward by the edges of the ceremonial bar, the belt lappets, and the leg ornaments. At Copán, the relief cut is deep and sculptural, and the motifs of the costume and regalia are intricately detailed with curving, rhythmic, taut lines. At Quiriguá, the relief is often deep, but the cut is angular and the motifs are presented in varied-level planes.

Not all Maya scholars would agree with the use of "hieratic" to describe the prescribed and formalistic style of these monuments. But the iconographic interpretation of a full-frontal figure is frequently that of a god or a high-status individual, attesting to the conventional and formal qualities of this style. It is the very beauty of the detailing on these monuments that may be the cause for disagreement. Within the foliated motifs on Stela H of Copán, little figures are depicted in dynamic poses. Although the use of a narrative style within the details of this stela indicates a complexity of meaning and intent, it does not control the overall representation, which is styled by hieratic principles.

Molded (not modeled) figurines are commonly hieratic in style. These figurines are Late Classic to Postclassic in date and are found concentrated in sites along the Campeche coast and down into the states of Tabasco and Chiapas on the Usumacinta River. They are organized by the same

Fig. 20. Lintel 15, Yaxchilán, Chiapas, Mexico. Drawing by Ian Graham. Courtesy the Peabody Museum of Archaeology and Ethnology, Harvard University.

67

bilateral symmetry of the frontal figure as the stone reliefs from Copán and Quiriguá. Unlike the modeled figurines, they are closer to relief work than sculpture in the round. The backs of the molded pieces are often plain and smoothed; all the imagery is on the front.

Another hieratic ceramic tradition is represented by the great incensarios thought to be produced at or near Palenque. Large hollow tubes are embellished with frontal "portrait" faces resplendent with ornate earplugs and headdresses (No. 109). Although the original context for many of these sculptures is unknown, their very preservation indicates the protection of the burial site.

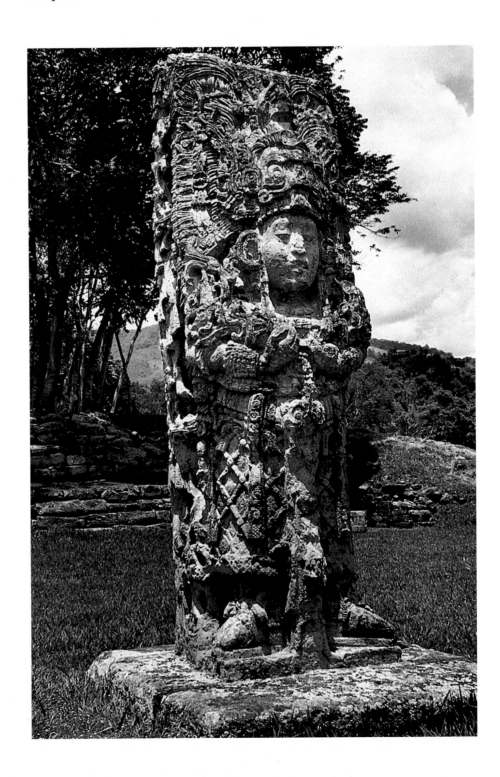

Fig. 21. Stela H, Copán, Honduras.
Charles Gallenkamp

The hieratic style was concentrated in the southeastern and north-western areas during the Late Classic. Early Classic examples are few; in fact only three are known—one from Quiriguá (Stela 26), and two from Uaxactún (Stelae 26 and 20). Located in the Petén district of northern Guatemala, Uaxactún is in the central Maya area, a region generally devoted to the iconic style. However, Piedras Negras, a Late Classic western site on the Usumacinta River, has several stelae which embody hieratic principles; they display either a seated full-frontal figure in a niche (thought to represent a ruler's accession to the throne) or a full-frontal standing figure dressed in a ceremonial warrior's costume.

Full-frontal symmetrically composed figures carved in relief are known from the Late Preclassic, but they are very rare. Hence, the best historical source for the Classic Maya use of the hieratic style, whether it be in clay or stone, comes from sculpture in the round, a medium used with much greater frequency during the Preclassic than the Classic. We can properly think of the Maya hieratic style as a translation of fully sculptured forms into relief carving, and it is no coincidence that the Classic hieratic reliefs are deep and more sculptural in look than either the narrative or the iconic styles.

The Iconic Style This is the most common in Classic Maya sculpture. While it is found in all areas and in all functional contexts, it is concentrated in the central Maya area and predominantly employed for plaza sculpture. The iconic style is used to depict one image: "portraits" of rulers whose identity is given in costume and regalia rather than in their individualized facial features or active narrative poses (No. 66). In the Early Classic, this iconic image is in a quasiprofile or three-quarter pose. During the Late Classic, they are represented with their faces and head-dresses in profile while their bodies are frontal with their arms asymmetrically positioned. Less commonly, they are shown in complete profile.

The iconic style uses asymmetry, but unlike the narrative style, the asymmetry is balanced and stable. The image of the upright, usually frontal body is by itself symmetrical, but its apparent immobility is countered by the profiled head and active asymmetrical arms. Thus the iconic style is a synthesis of the godlike full-frontal symmetry and the representations of mundane human actions in a dynamic narrative style. The iconic style represents a formalized, impressive image whose qualities are surely derived from artistic conventions learned in the workshop, conventions that deal with the ritualized significance of costumes and types of gestures, all of which had an iconographic meaning.

Historical precedent for the iconic style is hard to find. Relief carvings of single figures are rare in Late Preclassic sculptural traditions, which are mainly devoted to multifigured scenes and the narrative style. The advent of single-figure compositions in the iconic style occurs so close to the end of Late Preclassic times that it suggests that this style should be considered a Classic innovation.

Some sculptures found in buried contexts may have served dual functions: one before burial and one directly associated with burial and the attendant rituals. Nonetheless, those pieces actually found in buried contexts were determined by traditional, innate ideas about what constituted a "proper" burial. These funerary objects—especially sculptured ones—fall into predictable groups.

Made from clay, bone, and semiprecious stones, sculpture found in buried contexts (caches and graves) is miniature in scale. Both the narrative and hieratic styles were used to refer to and define the individual characteristics of either the person or event honored in the burial. The thematic background of the burial is uniqueness. Sculpture in the narrative style should be understood as descriptive of unique events or characteristics (and this might explain the enormous variety of narrative themes shown on the painted polychrome pottery found in burials). Hieratic sculpture should be understood as more talismanic, not so unusual in itself, but by its associative references, capable of defining the individual's habits and perhaps ideological inclinations.

Stelae and pedestals were the monumental sculptural forms associated with plaza sculpture, and were carved, for the most part, in an iconic style. The iconic style, as a synthesis of narrative and hieratic styles, is considered an innovation of Classic Maya sculptors for public and, probably, political functions of the plaza context. The underlying thematic background for plaza sculpture contains many references to nature, and to illusions that man-made events are the same as natural events.

The predominance of the iconic style in plaza contexts throughout the Maya area makes the hieratic plaza sculptures of Copán and Quiriguá quite distinctive. Clearly these pieces represent a significant departure of some kind from the iconic sculptures, but the significance is difficult to establish. A different public function is the most likely explanation, and the frontal, symmetrical figures suggest an emphasis on ritual and ceremonial uses.

Sculpture within architectural contexts presents a contrast to plaza sculpture. Found on lintels, piers, and as wall panels, architectural sculpture has no recognizable monumental associations other than its context. Architectural contexts place the sculpture in spaces where viewing is restricted in terms of available light and space. In comparison to plaza sculpture, its function is for private or perhaps ritual use, and it establishes a thematic background that makes references to cultural events rather than natural ones.

Architectural sculpture is usually carved in a narrative style that allows for the depiction of action. Unexpectedly, from our point of view, the Maya chose a dynamic and narrative style for private, often recondite contexts. One might easily assume that these reliefs were representations of an oral literary tradition of common knowledge. If so, their function would not have been to teach (like European religious art), but to be a focus for contemplation—an interesting difference from our own visual traditions.

5 · MAYA CERAMICS

T. Patrick Culbert

For ordinary people, pottery is a convenience. One can use it for storage, cooking, eating, as a status item, or to please the gods with offerings. But for those who use it, pottery is not one of life's major priorities. It would be hard to imagine a tale of a kingdom lost for lack of a pot, and dozens of prehistoric cultures survived contentedly for millennia using gourds and baskets instead of pottery.

Yet for archaeologists, pots are paradise. When cultures use ceramics they are present in quantity in every household; they are easily broken, and potsherds—the result of pots' fatal accidents—are almost imperishable. Accumulating in decaying rubbish, buried beneath the earth through frosts, storms, earthquakes, and sun, potsherds wait patiently to be rescued and cherished.

No other class of artifact has been more studied and written about than pottery, and there are sound reasons for this archaeological obsession: ceramics have amply demonstrated their usefulness in revealing otherwise unobtainable data about ancient cultures. Because pottery changes through time in all its characteristics—color, vessel shape, and decoration—a sequence of pottery types can be identified for a site or area that serves as an important chronological device for dating newly discovered material. Pottery can also tell us something about the way people lived. Social differences between classes are reflected in material objects such as ceramics. Studies of manufacturing centers for pottery often help us reconstruct long-vanished economic systems. And since pottery is utilized in ceremonials and deposited as offerings in burials and caches, it yields a wealth of information about religious life. In effect, then, ceramics provide scholars with a singularly useful tool, and nowhere is this fact more evident than in our attempts to understand the complexities of Maya civilization.

Based primarily upon surface treatment and decoration, archaeologists have classified Maya pottery into hundreds of named types, all of which are associated with specific sites, geographical areas, and chronological periods. Using finer variations as criteria, these types have in turn been subdivided into an even larger number of varieties. Fortunately, details of the classification, analysis, and complicated statistical techniques employed in the study of Maya pottery are not essential for the nonspecialist to appreciate the marvels of this extraordinary ceramic tradition. Although this essay discusses some of the more important named types of Maya pottery, lay readers can be spared most of the minutiae in which archaeologists luxuriate.

It is also impossible here to deal equally with all varieties of Maya pottery. Obviously, the emphasis of an essay arising from a museum exhibi-

tion designed to bring masterpieces of Maya art before the public must be those ceramics on which the Maya lavished their greatest skills and that they themselves must have prized most highly. By and large, these are ceramics of an exuberantly decorated style, most of which fall within a class of wares called serving vessels—vases, bowls, dishes, and plates—that were usually of relatively small size. As the name implies, these vessels were used to serve food, a conclusion supported by considerable evidence from Maya painting (for instance, a vase from a tomb at Tikal decorated with a scene showing a plate filled with fruit resting beside the throne of a ruler, while a cylindrical vase, easily imagined to contain some exotic tropical drink, sits near his hand). Vessels of this type were also commonly placed among the burial furnishings of all social classes and they were widely used in ceremonial offerings or deposited in caches on special occasions such as the dedication of buildings. It is, in fact, because of the existence of these ritualistic offerings that we have obtained the finest examples of Maya ceramics, for the debris of ordinary Maya households almost never yields whole, or even reconstructible, vessels.

Less attention will be given in this essay to such utilitarian wares as cooking pots, water jars, and large storage vessels. Since pottery of this kind was rarely decorated, one suspects that the Maya were more interested in how well it worked than in its appearance. Although utilitarian vessels provide the bulk of potsherd collections from excavations and supply useful information on chronology and household activities, they are not an exciting medium for tracing the skill of Maya master craftsmen. Also, while the use of Early, Middle, and Late phases in the new chronology suggested by Jeremy Sabloff (see *Fig. 7*) has utility for understanding Maya cultural development in general, the study of ceramics has so long been wedded to the traditional divisions of Preclassic, Classic, Terminal Classic, and Postclassic, that this chronology will be used in the following discussion.

TECHNOLOGY

Throughout their history the Maya utilized the same techniques for producing pottery. Vessels were shaped by a coiling method in which long rolls of clay were added one by one to build up the walls, and the joints between coils were then obliterated by pressing them together and smoothing the outer and inner surfaces. After the vessel was partially dry, its surface was carefully scraped and polished before firing. Since the principle of the wheel was never put to practical use in ancient America, wheel-thrown pottery and its resultant shapes were unknown. The only alternative to the coiling method used by the Maya was the occasional manufacture of certain types of vessels that were shaped by pressing the clay into molds.

In the case of some vessels—mainly large jars for domestic use—there was no further surface treatment after scraping and polishing, and because they were left unslipped, the color remained that of the clay from which the vessel was formed. Usually, however, the surface was covered with a slip consisting of a thin coating of pigment applied before the vessel was fired. Of the available pigments, the most common were iron compounds which fired to a red or orange color if the fire's oxygen supply was adequate. A black color could be produced either by firing iron pig-

ments in a smoky reducing atmosphere or by using manganese pigments which turn black in an oxidizing fire. White or cream slips made from lime or clay pigments were the third most frequently used colors. In applying slips, Maya potters could vary their tone and colors by altering the thickness of the pigment or by controlling the firing conditions. Unfortunately, the fires themselves—large stacks of wood under which the vessels were piled—were difficult to control, and smudged black spots and unintentional variations in tone are common features of Maya pottery. Without the use of a kiln, the high temperatures necessary to achieve a glazed surface and the wide variety of colors available in glazed pigments were impossible to achieve.

Three predominant decorative techniques appear. The most popular was the use of painted designs or figures produced by using two or more pigments (or varying thicknesses of the same pigment). A second method involved modifying the surface of the clay by grooving, incising, or fluting. Finally, vessels were sometimes modeled to produce sculptural effects, often effigies of humans, animals, or mythological creatures. The most elaborate of the sculptured vessels were used to burn incense.

PRECLASSIC PERIOD
(2000 B.C.–A.D. 250)

The earliest known Maya pottery was discovered by Norman Hammond at the site of Cuello in Belize. Excavations in 1975 in the deepest levels of this site revealed new types of pottery that comprise what is called the Swasey Complex. The radiocarbon dates assigned to Swasey pottery came as a great surprise; some of them suggested that the material dated back as far as 2500 B.C.—more than a thousand years earlier than any previously known ceramics in the Maya lowlands. Although these dates are still the subject of some debate, there seems to be no doubt that Swasey pottery is the oldest unearthed so far in the area and that it can hardly have been introduced later than 2000 B.C. (No. 1).

Swasey potters were not given to exuberant decoration. Unslipped vessels, along with red and orange slipped wares, predominate, and a few pieces are incised with simple geometric patterns or painted with red-on-cream decorations. Figurines and an occasional modeled whistle are the only ceramic objects other than purely functional vessels. Swasey pottery is remarkably well made and even the earliest examples give no hint of anything resembling primitive first efforts. The pots were skillfully shaped, the application of slips was well controlled, and the overall impression is that of a fully mature ceramic craft.

The source from which Swasey pottery arose cannot be determined. There are earlier ceramics from northern South America, but they are not similar enough to Swasey pots to suggest South America as a likely point of origin. Nor is the question of origin particularly bothersome. Pottery making was a simple enough invention that it might well have been discovered independently in a number of places. Once the basic techniques had been worked out, it is quite feasible that sophisticated ceramics could have been produced within a few generations, a short enough time so that no archaeologist would be likely to stumble across the actual site of invention or the first crude efforts of the earliest potters. So until there is evidence to the contrary, it is reasonable to assume that ceramics were invented locally somewhere in the eastern part of the

Maya lowlands. To date, Swasey pottery has been recovered from only a few sites in Belize, and it is still too soon to predict whether it was a local phenomenon or will eventually be found in other areas.

By the beginning of the Middle Preclassic (around 900 B.C.) pottery had become more common and widespread. A slightly changed variant of Swasey pottery continued to be produced in Belize, but it had now been joined by a type of ceramics called Xe from sites along the Río Pasión in the southern lowlands, by Eb pottery in the central lowlands, and by Dzibilchaltún 1 pottery in northern Yucatán. Each of these regional traditions features wares that are technically excellent but stylistically quite simple. As there is not much resemblance between these pottery types, it is likely that the lowland population was still too small and scattered for there to have been much interregional communication or trade.

By 600 B.C. the number of sites had increased significantly and contact between regions was far more extensive. Although there was still a considerable variation in ceramics from one area to the next, enough similarity exists for these wares to be grouped under the common name Mamom. Chaste simplicity was the hallmark of Mamom pottery. Painted decoration was minimal and confined to simple designs executed in two colors. Incised decoration was relatively common but consisted of nothing more than a line or two encircling the lips of plates or, more rarely, a row of triangles or a checkerboard motif. Flat-bottomed plates were produced in great abundance. Round-sided bowls and open-mouthed jars—inelegantly called cuspidors by archaeologists—are among the most pleasing pieces, and the best examples, which are thin and polished to a bright luster, are fine specimens of the potter's art (*Fig. 22*).

The Mamom ceramic horizon was succeeded by another known as Chicanel, which lasted from 300 B.C. to A.D. 250. In contrast to earlier wares, Chicanel pottery is characterized by an astonishing uniformity throughout the lowland area. From whatever part of this region Chicanel pieces come, they are unmistakable in their technical attributes, colors, and shapes. At no other time in Maya history was there such widespread contact and conformity to a single uniform tradition in the manufacture of pottery. The shapes of Chicanel vessels shook off some of the conservatism of their Mamom precursors. Bowls and plates with shelflike flanges are common in both household refuse and offerings. Tall urns, resembling elaborate vases for flowers, occur in burials (No. 13). Small jars, sometimes with spouts and occasionally fashioned in the form of animal effigies, were popular items in offertory caches.

Chicanel ceramics were a logical outgrowth of the Mamom wares that preceded them. Unslipped and monochrome vessels continued to dominate, but the soberness of decoration so typical of Mamom pottery began to diminish, especially in the number and complexity of painted vessels. The most frequently used style of decoration was called Usulután, after its homeland in El Salvador to the southeast of the Maya lowlands. On Usulután pottery two or three colors—red, orange, and black—were used to create wavy or zigzag patterns of parallel lines. Each line follows exactly the twists and turns of those next to it, suggesting that the decoration must have been applied with a multiple-pronged tool or brush. In El Salvador the Usulután style utilized a resist technique: a design was painted over a first slip with a material such as wax that would prevent

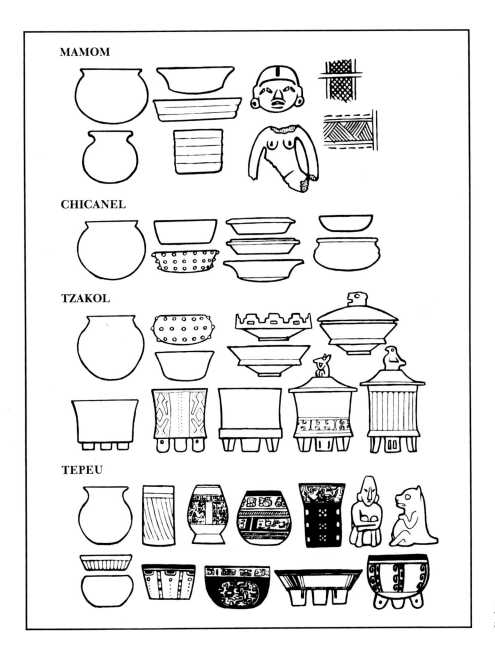

MAMOM

CHICANEL

TZAKOL

TEPEU

Fig. 22. Typical shapes associated with the periods of Maya ceramics.

the adherence of a second or third slip. When the vessel was fired, the resist agent burned away, revealing the design in the color of the initial slip. When Maya potters adopted the Usulután style, they retained the multiple-brush effect of parallel lines, but discarded the difficult resist process in favor of simply wiping off parts of the second and third slips to produce patterns (No. 11). Usulután wares were largely confined to the southern half of the lowlands, and the rare examples found in the northern and western sectors were probably trade items.

Near the beginning of the Christian era, a new ceramic tradition, Floral Park, replaced Chicanel in parts of Belize and along the Río Pasión in the southern lowlands. With the introduction of the Floral Park style came an influx of orange domestic pottery that replaced the Chicanel redwares. Floral Park included a strong Usulután decorative element, associated primarily with open bowls resting on four bulging appendages known as mammiform feet because of their breastlike appearance (No.

20). Most important, Floral Park vessels included the first true polychrome decoration in which three colors were used as integral elements in painted designs. Despite the strong Usulután roots of the Floral Park tradition, polychrome painting seems to have originated in the Maya lowlands, since nowhere in El Salvador did the Usulután style give rise to early polychrome vessels.

A number of scholars believe that Floral Park ceramics were brought to the Maya lowlands by emigrants from El Salvador who may have been displaced by the eruption of the Ilopango volcano (see p. 38). Indeed, the possibility that new populations entered the lowlands around this time is supported by the distribution of ceramics in Belize and eastern Guatemala. Some sites in those areas, such as Holmul, have yielded spectacular early polychromes from tombs, showing strong Floral Park connections, while other contemporaneous centers continued to produce pottery within the Chicanel tradition, especially those in the central and northern lowlands where Chicanel ceramics persisted until the beginning of the Classic.

EARLY CLASSIC PERIOD
(A.D. 250–550)

Since the earliest days of Maya archaeology, ceramic change has been considered one of the hallmarks that signaled the rise of Classic civilization in the lowlands. As archaeological control of data and dating has become more precise over the years, the characteristics of Classic ceramic traditions have been clarified, but the fact that the beginnings of the Early Classic mark a ceramic watershed has not changed. These changes can be described as a recrystallization of ceramic traditions. It would be hard to specify any trait of Classic ceramics—be it slip color, vessel shape, or finishing method—that did not occur in occasional examples well back into Late Preclassic times. Yet the way in which these individual traits were combined, and the frequency with which they occurred, provide a Classic tradition that was profoundly different from that of Preclassic ceramic complexes; thus, the term recrystallization. The Classic was not marked by a sudden influx of new ideas but by a new emphasis in the way existing traits were combined.

Although this section concentrates on highly decorated Early Classic ceramics, the great majority of the vessels used during this era, especially in household activities, continued to be unslipped or monochrome. But even the utilitarian wares changed substantially at this point. Most Late Preclassic ceramics had displayed a tendency toward heaviness; thick walls and bulging lips ornamented with deep grooves were typical of the period.

With the advent of Early Classic pottery—known to archaeologists as Tzakol—vessel walls thinned, the necks of jars became taller and more delicate, and small bowls and dishes were increasingly common. There were accompanying changes in the colors and techniques of surface finish. The most common slip color of the Late Preclassic period, a dark red, gave way in the Early Classic to bright orange, and production techniques that had previously resulted in slipped surfaces with a waxy feel yielded to those that produced a glossy surface.

Two shapes deserve special mention for their roles as Early Classic diagnostics. The first is the basal flange bowl in which a short, nearly

vertical upper wall is separated from the rounded base by a broad, down-sloping flange that encircles the exterior wall. The portion of the exterior wall above the flange served as the major field of decoration. Bands of scallops or lines of alternating colors at the lip and on the flange delimited a long, narrow design space. The interior of the vessel was usually left undecorated except for bands of colors at the lip. Basal flange bowls found in offerings were frequently provided with splendid dome-shaped covers that swept upward to effigy-head handles (No. 44). The covers offered a larger and more versatile space for design and were sometimes used for magnificent compositions of complex cosmological symbols or bodies of animals whose heads formed the handle.

The second characteristic Early Classic shape was the cylindrical tripod. The inspiration for this shape originally came from Teotihuacán, the vast Mexican city that lay to the north in the Valley of Mexico and whose influence was strongly felt in various parts of the Maya area. But after the Maya borrowed the idea, they transformed the shape to suit their own tastes, producing a far more graceful vessel than the Mexican original. At Teotihuacán, the cylindrical tripod tended to be a squat, prosaic vessel which stood on slab feet that seemed to be too big for the upper portion. In Maya hands, this vessel became taller and had a slight curve to the sides that gave a hint of an hourglass shape. Although the slab feet remained, they were brought into better proportion with the rest of the vessel (No. 28).

Beginning with the Early Classic, the decoration of pottery took on an importance that it had previously lacked. This is not to say that decorated pottery is abundant in ordinary household refuse, for less than 10 percent of the pottery from such collections is decorated. Yet both the variety and technical skill involved in the best of the decorated pieces were such that for the first time the word "artist" comes to mind when referring to the creators.

One of the decorative styles that marked the Early Classic was polychrome painting. Red, orange, black, white, and buff—colors that can be easily achieved from clays and earth pigments and will withstand the heat of firing—were commonly used. Frequently the designs were repetitive bands in which steps, scrolls, and other elements followed each other around the walls of basal flange bowls. Even these simple configurations, however, were drawn from the repertoire of elements that had iconographic significance. When more detailed motifs were involved, it was characteristic to use medallion-like spaces to create fuller representations of such creatures as the Celestial Serpent. A few naturalistic designs occur in Early Classic polychromes, especially from the central lowland site of Uaxactún, where elongated birds or reclining human figures were squeezed into the design space on basal flange bowls.

The second major decorative style involved surface manipulation—incising, gouging, and scraping. Usually done on vessels that were slipped black and mostly confined to cylindrical tripods, the best compositions belong to the type that archaeologists have christened Urita Gouged-Incised. These vessels made frequent use of several medallions on cylindrical tripod walls, often matched by half-medallions on the vessel cover. The medallions were filled with complex curvilinear representations of mythical beings. Occasionally, the compositions became very convoluted, as seen in a cylindrical tripod vase from Becán (No. 33)

which was used as a receptacle for a figurine collection imported from Teotihuacán. Some overall designs were more geometric and less explicitly iconographic, with repeated elements such as scrolls, sometimes in pleasing diagonal bands, and there are a few vessels that show specific scenes of individuals or deities.

LATE CLASSIC PERIOD
(A.D. 550–800)

The dawn of the Late Classic period marked another drastic change in lowland Maya pottery. There was a marked acceleration in the rate of stylistic change. Whereas Early Classic ceramic styles had remained stable over a period of 300 years—so stable that it is possible to discuss the entire period within a single section of this essay—any consideration of Late Classic ceramics demands two separate sections for a period of roughly two and a half centuries.

As was true at the start of the Early Classic, there were changes in utilitarian vessels that are of importance to the specialist in sorting out ceramics of different periods. Although the same range of basic shapes persisted, differences in such features as neck height, lip treatment, and wall thickness provide keys to period designations. The most noticeable changes, however, were in decorated wares, especially in polychrome painting, which reached its height in both quantity and artistic skill during Late Classic times. There is little doubt that decorated vessels were made in specialized manufacturing centers. The fact that such wares were readily available even in nonelite households, where as many as a third of all vessels were of polychrome types, says something about the economic structure and standard of living during the Late Classic period. Finer temporal subdivisions than have previously been used are necessary for a discussion of Late Classic ceramics. The period between A.D. 550 and 700 is designated as the Tepeu 1 horizon, a name first applied in an archaeological sequence derived by Robert Smith in 1955 at Uaxactún and later extended to other sites that could be linked by the presence of the same ceramic criteria. The succeeding period is defined as Tepeu 2.

Tepeu 1 (A.D. 550–700) The dominant painted ware was Saxché Orange Polychrome, characterized by black and red decorations over an orange to yellowish base. Two distinctive shapes comprise the majority of Saxché ceramics. One was a shape that ranged from a round-sided bowl with a restricted orifice (No. 122) to a barrel-shaped vessel that was broadest at a point below the center and tapered gracefully toward the top. Designs frequently consisted of a single band of decoration on the exterior slightly below the rim. This band almost always contained either Maya glyphs or pseudoglyphs—elements having a generally glyphic shape but without meaning. Other barrels had a more central design consisting of either a decorative band near the vessel's midpoint or elements at opposite sides of the vessel connected to each other by ribbon-like streamers. Only a few painted figures occur on barrel-shaped vessels, but those that do include some of the most outstanding compositions of Maya ceramic painters.

The second major shape associated with Saxché Orange Polychrome was the lateral-ridge tripod plate, a large but shallow form in which the walls sweep widely outward from a broad, slightly rounded base. The

exterior, almost unnoticed beneath the broad flare of the walls, has a ridge or flange marking the juncture between walls and base, and the plate rests on three small round feet. The interior of the vessel offers two concentric fields for decoration: the wall and the base itself. On the bandlike shape of the wall is a row of glyphs or pseudoglyphs, delimited at the top and bottom by contrasting lines of color. The large circular space at the base is used for a single central motif such as a human or demon head, a flower, or an animal (No. 107). Most often, however, there are compositions in which a standing or dancing human or mythological figure graces the plate's center, providing some of the most spectacular examples of Maya art (No. 106).

Tepeu 2 (A.D. 700–800) At the beginning of the eighth century, when the Tepeu 2 ceramic horizon began, Saxché Orange Polychrome was replaced by two new polychrome types, Zacatel Cream Polychrome and Palmar Orange Polychrome. The Tepeu 2 polychromes use brighter colors and busier designs than those of the relatively clean and restrained Saxché Orange Polychrome. Overall patterns or repeated motifs include checkerboards, diamonds, dots within circles, sausage-like semicircular brackets, and such glyphic elements as the *kan* cross or *kin* sign. Although many of the motifs were borrowed from the glyphic and iconographic vocabulary of the Maya, it seems likely that they had lost any intended meaning and been reduced to the status of pure decoration.

Three vessel shapes are strongly associated with the Tepeu 2 polychrome types. Tall cylinders with relatively small diameters and vertical sides offered design space on the exterior wall (No. 156). This space is defined at the top and the base with several bands of color or a secondary banded decoration. The broad design band between these limits is filled with the various motifs described above.

Small, flaring-sided bowls are also typical of this period. Although the diameter is large enough to make the interior a usable decorative space, the most common practice was to leave the interior a solid color except for a stripe or two of a different color just below the rim. The exterior wall was used in much the same way as the exterior of cylinders, with a central design area delimited at the top (and frequently the bottom as well) by several bands of alternating colors.

Finally, a large number of flaring-sided tripod plates are found in Tepeu 2 horizons. Since the walls of these plates stand relatively straight, both the exterior and interior can be seen; consequently, both sides are used for bands of decoration drawn from the standard motifs of the Tepeu 2 repertoire. The interior base of plates is far less popular as a design space in Tepeu 2 than in Tepeu 1. Occasionally, central base decorations occur, not unlike those on Saxché Orange Polychrome, but more often bases are either left undecorated or devoted to numerous repetitions of the same configurations. A favorite design for burial vessels was the "dress shirt," a column of dots or circles, each smaller than the one above it, descending from a semicircular motif. Actually, the dress-shirt design represents the plumage of the mythical Moan bird, a denizen of the Maya Underworld (No. 151).

Polychromes of the varieties just described were common property of all classes. They occur in abundance in the refuse from both house mounds and palaces, and were standard burial furniture for the poor as well as the mightiest of rulers. But there also appeared during the Late

Classic era a far more elite style of polychrome decoration—the figure-painted polychrome. Figure-painted polychromes show scenes of mythological or historical beings, often accompanied by glyphic inscriptions (No. 79). Fragments of these vessels rarely occur in refuse and the majority of examples come from tombs of the highest ranking members of Maya society. Some may have been created specifically for burial offerings, but others were probably made for nobles to treasure during their lifetimes and only eventually went with them to the grave.

The earliest figure-painted polychromes appeared in Tepeu 1, but their apogee clearly lay within the time span of Tepeu 2. They may have been produced by a group of artists separate from those who made everyday polychromes. Obviously, the best examples, which rank among the masterpieces of Maya art, were the work of talented experts. Yet not all of the figure-painted polychromes were the products of great masters. As an example, a set of figure-painted polychromes found in the tomb of Ruler A—also known as Ah Cacau—at Tikal are of very mixed quality. Some of them (No. 70) are superbly made, while others are of dreadful workmanship. (I have always wondered whether such bad pieces might not have been painted personally by lords of other sites to show their respect for a colleague while inadvertently demonstrating their lack of talent.)

Figural polychromes were almost invariably painted on cylindrical vessels. The top and base are very simply delineated—sometimes a single band, sometimes multiple bands of contrasting colors. If the vessel had a glyphic inscription, all or part of the inscription occurs as a band around the top. The remaining space is devoted to the scene that is portrayed.

Figure-painted polychromes show a staggering variety of decorative scenes. Some of them are clearly religious and mythological. Michael Coe, who has done extensive research on figure-painted polychromes, believes that many of the scenes depict incidents in the saga of the Hero Twins, a pair of mythological characters whose exploits are chronicled in the *Popol Vuh*, a collection of Maya myths recovered in a sixteenth-century copy from the Guatemalan highlands but probably based upon prehispanic sources. Francis Robicsek is of the opinion that whole series of painted cylinders functioned as codices, but since the vessels with which he deals come from private collections and undocumented sources, it is not possible to verify his argument in the light of the necessary archaeological context.

Other scenes seem more likely to deal with reality rather than the world of myth and spirit. Many figure-painted scenes show actual rulers in what may be called "formal throne scenes" which depict a ruler seated upon a throne, dressed in the symbolic trappings of his office, and frequently interacting with a kneeling supplicant. A somewhat more enigmatic throne scene is that from Burial 196 at Tikal (No. 96), in which a ruler converses with a corpulent Maya wearing a gigantic headdress of a bird bearing a snake in its beak while a jaunty individual smoking a cigarette seems to dance behind the pair.

Probably the most famous of all figure-painted polychromes, the Altar Vase (*Fig. 23*), seems to depict an actual burial ceremony. Discovered at the site of Altar de Sacrificios, the vessel was in a secondary grave associated with the burial of an important woman. Richard Adams has concluded that the scene represents the woman's funeral ceremonies. On the

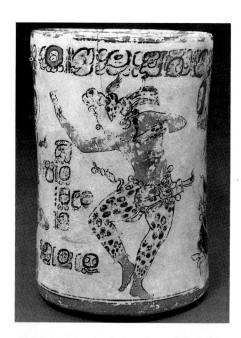

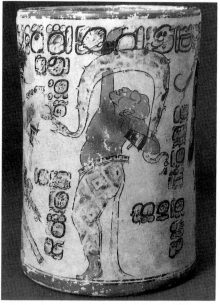

Fig. 23. Two views of the Altar Vase, one of the masterpieces of Late Classic Maya polychrome ceramics found at Altar de Sacrificios, Guatemala.
Stuart Rome

vase, three dignitaries are identified by glyphs. The dancing figure wearing a jaguar costume is Bird Jaguar, the ruler of the important site of Yaxchilán. A seated figure, holding a pot, has the glyph of Tikal in his inscription, while a bald dancer grasping a snake is from a site whose name glyph cannot be identified. In the woman's grave there were three sets of imported pots, one set probably coming from Yaxchilán, one from Tikal, and the third resembling ceramics known from the Guatemalan highlands. They may well be offerings brought to the funeral by visitors from other sites.

Thus, the Altar Vase not only tells us something about Maya history, but also demonstrates the elaborate nature of funerary rites and the far-flung connections between the Maya elite class. It provides a striking example of the importance of archaeological context. If the vase had appeared in a collection devoid of information about its place of origin and associated artifacts, it would retain its beauty and the glyphs would still identify the actors, but we would never know the story it tells of an actual burial ceremony, nor of the offerings sent from distant places to honor the woman from Altar. There are undoubtedly dozens of Maya rulers whose stories will never be known because the contents of their tombs have been looted to satisfy the demands of the antiquities market.

TERMINAL CLASSIC PERIOD
(A.D. 800–1000)

The Late Classic was succeeded by a period that archaeologists now call the Terminal Classic. It was during this era that Maya civilization collapsed in the southern lowlands, and the remnants of the populations that occupied the centers in this region were reduced to living in poverty amid the decaying splendors of their past. Oddly enough, however, these inhabitants continued the previous ceramic traditions. Their pottery was technically well done, so that the domestic vessels, which can be distinguished from earlier ones by minor changes in shape, showed no decline in the potters' skill. Nevertheless, earlier traditions of painting visibly decayed, and polychromes became far less common. Of those that were produced, a few still show the old care in craftsmanship and are the equal of earlier examples. But most Terminal Classic polychromes were of inferior workmanship: colors were faded and poorly controlled, line work had become sloppy, and of the multitude of motifs that had existed in Tepeu 2 only a few were still produced—the most notable being the dress-shirt design previously discussed. .

It was during this period that the Maya lowlands were penetrated by the first of several trade wares that were to play an important role in Postclassic ceramics. Foremost among these was Fine Orange ware, named for its color and the extremely fine, untempered paste from which it was produced (No. 171). Neutron activation analysis has traced the source of the material to the silty clays of Tabasco at the northwestern edge of the Maya lowlands, an area that was later identified as a center of commerce and the home of the Putún, who were famed as long-distance traders (see pp. 42–45).

Fine Orange pottery included a number of types that continued to be made for several centuries. The most important of these were Altar Fine Orange, a relatively simple variety that only occasionally showed the addition of black paint as a form of decoration, and Pabellon Modeled-

carved, a type in which elaborate scenes were produced by molding the vessels in a carved template.

Technically, Altar Fine Orange was superb pottery: hard fired, thin walled, and with a variety of simple elegant shapes. William Rathje has argued that some of these shapes were specifically designed to nest one inside another to reduce breakage and make shipping over long distances less expensive. Pabellon Modeled-carved also made concessions to economy of production, since its molded designs could be completed far more rapidly than if each piece had been individually carved. Their decorations give hints of the militarism of these disruptive times, for spears and shields are commonplace, and scenes showing conferences between individuals can well be imagined as meetings of traders who may also have been war lords. The appeal of Pabellon Modeled-carved was such that it spurred a local imitation—Sahcaba Modeled-carved—which used the same molded techniques and similar scenes but was made of different clays, probably somewhere in northern Guatemala.

EARLY POSTCLASSIC PERIOD
(A.D. 1000–1250)

By this time strong regional differences had developed between the northern and southern sections of the Maya lowlands. In the south, small populations continued to exist and produce ceramics in Belize and along a string of lakes that crosses the center of the lowlands. The north, however, was the site of vigorous regional growth in which local Maya culture was eventually taken over by a group of Mexican-influenced peoples who ruled the northern part of the Yucatán Peninsula from the site of Chichén Itzá.

In the production of Postclassic ceramics pragmatism triumphed over aesthetics. The common wares of the north are simple red and unslipped vessels, along with a number of types of what are called Slate Wares, distinguished by drab brown and gray colors and a soft waxy slip. About the only decorated pottery made locally were black-on-slate and black-on-cream wares in which the black paint was trickled on in vertical lines or applied in simple designs.

Well-made trade wares continued to thrive in the Early Postclassic period. Later types of Fine Orange were distributed from their Gulf Coast production centers, the most attractive of which is Balancán Fine Orange, in which a white slip was applied and then removed by carving and incising to show the underlying orange clay color. Designs are usually simple geometric elements of fairly restricted varieties, although a few human figures appear. By far the most spectacular pottery made for trade during the Early Postclassic is Plumbate ware (No. 161). Plumbate was produced along the Pacific coast of Guatemala, and was traded not only to the Maya lowlands but as far away as the Toltec capital of Tula north of Mexico City, and south into Central America. Plumbate is the only Mesoamerican pottery that achieved the appearance of a glaze. Black to grayish in color, the glazelike characteristics were due to peculiarities of the clay in the area of the pottery's production. Human and animal effigies were the most common Plumbate forms.

(A.D. 1250–1519)

The Late Postclassic was a period in which Maya artistic impulses were clearly directed to fields other than ceramics. The standard pottery was redware, which was quite similar throughout northern Yucatán, where Mayapán served as capital during much of the Late Postclassic (see pp. 45–46); it also extended down along the eastern coast of the peninsula to thriving centers such as Tulúm, Santa Rita, and Lamanai. Plumbate ware had disappeared by this time, but certain types of Fine Orange continued to circulate in what appears to have been a vigorous trade network that utilized large seagoing canoes rounding the peninsula. At Mayapán in particular there was a strong emphasis upon modeled incensarios for household worship (No. 179), and brightly painted effigy vessels of relatively poor workmanship.

By the time of the Spanish Conquest, the Maya ceramic tradition, having lasted for more than three and a half millennia, had come full circle and returned to the almost exclusively utilitarian craft that it had been at the outset. Millions of vessels must have been produced during this long history, only a tiny fraction of which have survived and been recovered by archaeologists. Yet even these few surviving vessels amply demonstrate the skill of the nameless potters and painters whose creations rank among the finest ceramics ever produced.

6 · ANCIENT MAYA ARCHITECTURE

Peter D. Harrison

Architecture arose from a basic human need for shelter. It came into existence with the construction of simple freestanding dwellings that replaced the use of caves and rock shelters by early hunting-and-gathering societies. While such houses served the primary function of protection from the elements and utilized building materials readily available in the immediate environment, their design was determined at least partly by human factors involving the perception of specialized needs and aesthetics.

Aside from the fundamental need for shelter, changes in the size, shape, and decoration of these houses were manifestations of the wealth, prestige, and other secondary considerations which emerged as cultures became progressively more complex. Where once a simple, perishable hut was perceived as all that was required, a wealthy or politically powerful individual—participating in a more advanced stage of the same society—gradually found that he "needed" a multiroomed palace. Such structures contained considerable elements of grandeur and a wide range of functional capacities, including the secondary needs of comfort, defense, religion, and administrative uses, though not necessarily in any particular order of preference other than that dictated by the society itself.

Throughout the history of civilization it often happens that the most elaborate and aesthetically pleasing examples of architecture are buildings which do serve some secondary need—buildings designed to accommodate government, religion, science, or education. In the Western world the benefactors of such public buildings lavished similar effort and expense on their own dwellings, as was true, for example, in the Italian city-states of the Renaissance. Whether this connection of patronage between public and private buildings also existed among the ancient Maya is a question still couched in speculation. For that matter, in attempting to analyze many other aspects of Maya architecture we are confronted with equally difficult problems arising from the fact that it is so far removed from the Indo-European traditions with which we are familiar. We can appreciate the subtleties of Egyptian, Greek, Roman, or Medieval architecture precisely because they are an integral part of our Western cultural heritage. Even the secondary needs they served—though quite different from those of modern architectural modes—are readily comprehensible to us.

In a medieval castle, for instance, we recognize the component elements of its design and the reasons for their existence. We can even

identify the secondary functions in order of their importance as the building was planned. First, it is obvious that defense took precedence over comfort as evidenced by the moats, walls, battlements, and towers; and since a self-contained, structured community lay within its walls, it had to include provisions for religious needs, public and private chambers for the ruling family, dwellings for the serfs and craftsmen who depended upon familial protection, and rooms for the pursuit of affairs of state. In other words, a single, large, complex structure contained a microcosm of the entire society, and although this type of structure may seem curious, even primitive, to us in many respects, it is still within the scope of our understanding.

By contrast, when we look at an equally complex example of Maya architecture, such as the Great Palace at Palenque (Fig. 24), we lack the reassuring base of traditional criteria to judge its functions or to evaluate its success or failure in serving them. Moreover, we have practically no historic information to use for comparisons except for a few descriptions of similar buildings written by Spanish chroniclers during the Colonial period. Obviously, these descriptions relate almost exclusively to Late Postclassic Maya architecture, though some useful information has also been gleaned from post-Conquest accounts of other Mesoamerican cultures, especially the Aztec. But the time span separating the Conquest-period structures observed by the Spaniards from those erected during the Classic and Preclassic epochs represents a quantum leap in interpretation and considerable stretch of the imagination.

Nowhere is the enigma of ancient Maya civilization more evident than in its architecture. Why were certain structures built along specific lines, some in complex arrangements while others are simple and stand alone? To have an answer to this and other questions would enable us to move closer to understanding the thought processes of the people who constructed and used these buildings. If we could only see through it, architecture could serve as a window in the wall of obscurity standing between their culture and ours.

Yet we are not totally at a loss; the window is not completely opaque. By observation and the collection of enormous amounts of data from the lowland regions, certain recurring features can be noted. It has become possible to begin the process of analysis, and to define a few principles which seem to have been intrinsic features of Maya culture.

One of the most fundamental principles underlying the development of Maya architecture was the translation of the structural form of the simplest and earliest thatched-roof perishable hut into a stone building. The basic hut had several elements which persisted through time and retained their essential features, even when transformed into the most elaborate palaces and temples. These elements were the preparation of ground, walls, and roof—each of which had ranges of complexity of form that are still visible in the houses used in the Maya lowlands today.

In order to erect these huts, the ground was cleared and leveled; then a layer of crushed limestone (cal) was spread over the intended floor area to provide a smooth, flat surface. The next step was to dig holes for posts that supported the roof and walls. Before the walls were constructed, flat stones were laid around the perimeter of the house, outlining the floor. Vertical walls made of sticks were then placed on these stones, which served both as a foundation for the walls and to retard rot by keeping the base of the walls clear of water in the rainy season. The simplest walls

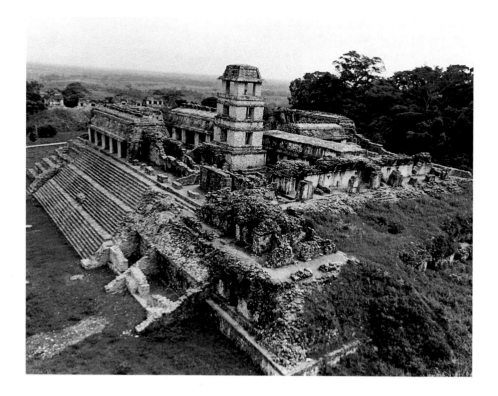

Fig. 24. The Palace complex at Palenque, Chiapas. Peter D. Harrison

consisted of upright sticks—all of approximately the same diameter—held together by intertwined vines woven horizontally between the sticks. The roof structure was the most complicated element, requiring crossbeams and trusses designed to form the framework of a single gable. Each beam, truss, and crosspiece was held together by hand-knotted vines. In the final stage, the gable superstructure was covered with rows of overlapping thatch, usually made from the fan, or *guano*, palm—a material that is waterproof, cool in summer, and provides warmth during the cold, rainy season. The gable ran parallel to the long axis of the structure, with the doorway in the center of one of the long walls *(Fig. 25)*. In the lowlands it is common for the kitchen to be in a separate structure behind the living quarters, so that in case of fire the house is not lost.

Viewed from the "front," the three basic elements of this hut are readily visible: the prepared floor with its stone perimeter, the walls (visibly divided by vines), and the roof with its component layers of thatch. From this simple beginning, increases in structural complexity and design followed a progression of logical developments related to specialized needs such as wealth, social status, family growth, and public or ritualistic functions. By elaboration the prepared floor became a raised platform, possibly hewn from exposed bedrock or constructed as a single-step platform of masonry. Ultimately it evolved into a multistaged series of platforms ascended by a stairway. Elaborations of the wall form included a covering of mud and plaster to provide improved insulation and strength, but although this covering sealed the walls, it did not obscure the horizontal lines of the intertwined vines that supported the stick framework. In fact, these vines formed bulges in the walls which may have been considered a decorative as well as functional device.

A further development was to thicken the mud and plaster until the horizontal lines disappeared, leaving an undivided (and possibly undeco-

rated) facade. The roof was capable of little elaboration other than increases in size and pitch, which in turn increased the complexity of the interior trusswork but had almost no visible effect on the exterior.

We have no idea how far back in time this basic design extends, but present evidence suggests that it was very likely in existence by 2000 B.C. What variations were already extant at that date is unknown, though it began to be translated into stone at least as early as the Late Preclassic period (beginning around 300 B.C.) and had probably been in use since Middle Preclassic times. It is certain, however, that the earliest stone buildings in the Maya lowlands incorporated the same three elements as did their perishable prototypes: a single-stepped platform (representing the ground preparation), a lower zone of masonry and plaster walls, and a projecting upper zone—either vertical or slanted—which evolved from the thatched roof. Inside the buildings, the parallel to the thatched roof is even clearer. Since the Maya did not invent the true arch, they devised a less sophisticated arch of overhanging, horizontal stones, the corbeled arch (Fig. 26), which creates an interior visual effect almost identical to the slope of a thatched roof. Crossbeams were utilized in the construction of the corbeled arch, and their effect is strongly reminiscent of the crossbeams of their more primitive predecessor. On the exterior was an overhang which recreated in stone the projecting edges of thatched roofs and served the same function of protecting the walls from dampness in the wet season.

Once rendered in stone and masonry, this basic structure was modified and elaborated in a number of ways. By raising the structure on a series of diminishing platforms, Maya builders achieved the effect of a terraced pyramid, thereby producing the most commonly recognized "temple" form. If the structure was elongated, and contained numerous rooms and doorways elevated only minimally above ground level, the result was a "palace" (Fig. 27). The actual uses of such structures is the subject of controversy, and the distinction between temples and palaces—along with their functions—still requires clarification. Hence the foregoing description is a deliberate oversimplification intended to con-

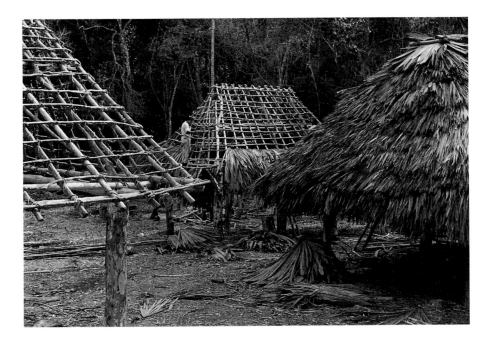

Fig. 25. The construction of typical Maya thatched-roof houses showing the superstructure of poles lashed together with vines. Peter D. Harrison

vey the process of structural evolution leading from the simplest thatched hut to a basic stone version, and from there to a variety of more complex forms.

While the temple was created by the addition of supplementary platforms, another element was added to the roof which, so far as we know, was not present on the thatched prototype—a roof comb, a decorative device that adds height as well as embellishment to the building. Throughout the central Petén, the roof comb consisted of a series of hollow, inaccessible chambers which provided a facade covered with decorative sculpture in monumental and heroic scale. Executed in stone or stucco, this sculpture—usually painted in several colors—frequently depicted the visage or full figure of a human being, presumably an actual personage connected with the construction of the building.

Elsewhere in the lowlands, especially to the north and west of the central Petén, the roof decoration was a much thinner, fragile-appearing open fretwork, stuccoed and probably painted. Investigations in Quintana Roo have yielded evidence that this style of roof comb may date back to the beginning of the Early Classic, although the best known examples are found on Late Classic structures. The finest fretwork roof combs occur along the Usumacinta River drainage and in the northern lowlands. The sites of Palenque and Yaxchilán in the west contain prime examples, along with several sites in the Chenes, Río Bec, and Puuc zones to the north—areas to be described in more detail *(Fig. 28)*.

As pointed out by Jeremy Sabloff (pp. 37–44), it was formerly thought · that monumental architecture was a feature of the Classic period. However, recent excavations in Belize and the Petén have unearthed structures dating from Late Preclassic times that were among the largest ever built in ancient America. In addition, many of the conventions of Maya architectural decoration were already established by this era (300 B.C.– A.D. 250). Such conventions included the use of masks to embellish supplementary platforms, and elaborate decoration on the upper zone of buildings (the thatched roof in the prototype). This upper zone is frequently inset and enclosed with a bordering frame, thus creating a panel filled with decorative devices such as stone or stucco masks over doorways, figures of deities, religious symbols, and panels of hieroglyphs. In some instances the iconography of this sculpture can be at least partially interpreted, but the vast majority of such decorations are a matter for future research.

For example, at Tikal some of the upper-zone palace decoration is highly suggestive of symbols associated with the sun god, Kinich Ahau, and the rain deity, Chac. These ostensibly religious emblems are strongly parallel in their usage to totemic decorations found on houses in the Pacific Northwest cultures of the United States and Canada, and it could well be that family clan associations are represented by the Kinich Ahau and Chac symbols. The subject remains open to further investigation based on a careful analysis of similar decorations found on hundreds of structures at numerous sites. Recent research has suggested that there are indeed familial ties between such distant sites as El Mirador in the northern Petén and Tikal in the central zone. Iconographic studies of monumental architecture, as well as the contents of tombs and caches, will very likely provide significant new insights into our understanding of sociopolitical interaction and cross-ties throughout the lowlands.

There are a number of architectural features which appeared quite

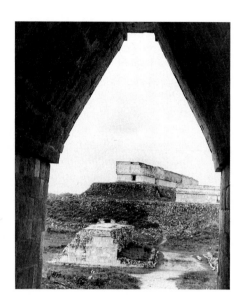

Fig. 26. A corbeled vault in a passageway of the Nunnery Quadrangle at Uxmal, Yucatán. Peter D. Harrison

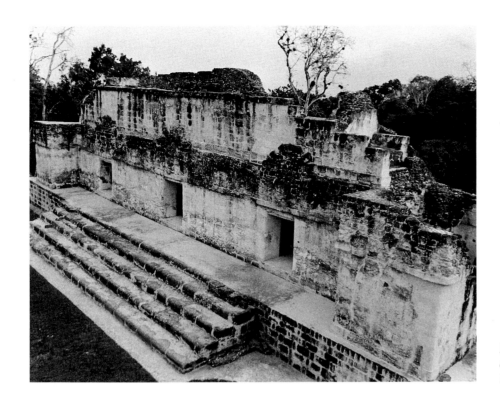

*Fig. 27. A three-doorwayed "palace" on
a low platform at Tikal.*
Peter D. Harrison

early and are curious for their wide distribution and persistence over a
long period of time. For instance, the earliest and most common type of
structure with the apparent function of a temple had three doorways on
the facade instead of one. These doorways originally opened into a single
front room. The overall configuration, particularly the width of the
facade, caused the building to appear lower in height than if only one
doorway were present. In Late Preclassic times, and well into the Early
Classic, this three-doorwayed temple was prevalent throughout the low-
lands; it continued to be constructed in Late Classic times on the periph-
ery of the central Petén.

In general, the Late Classic may be considered a period of diversifica-
tion, a time during which the greatest variety in architectural style oc-
curred—despite the ubiquitousness of the three-doorwayed temple. At
the present time, it is only during the Late Classic that we can speak
with confidence of a trend toward architectural variation and the emer-
gence of regional styles. In many respects our knowledge of these styles
is undeniably sketchy, and one region is often distinguished from an-
other on the basis of rather gross differences. Nor have their exact geo-
graphical limits been well researched to date. Some styles seem to have
been restricted to clearly defined areas, while others appear to cover
sizable portions of the lowlands. This uncertainty is due to two factors:
the amount of intensive investigation which has been conducted in spe-
cific areas (a consideration largely determined by ease or difficulty of ex-
ploration resulting from the terrain and vegetation), and the state of
preservation of architectural ruins, which varies from one region to the
next.

The question of preservation is particularly important and is deter-
mined by differing circumstances. Reuse and reoccupation of buildings
during ancient times often resulted in the destruction of Late Classic

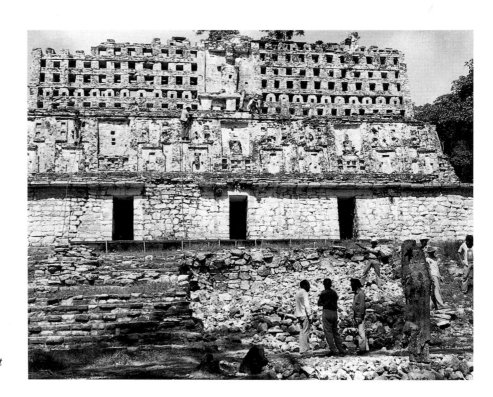

Fig. 28. Detail of a fretwork roof comb at Yaxchilán, Chiapas. Peter D. Harrison

stylistic details. Significant portions of many structures in southern Quintana Roo and Campeche were so altered by Postclassic occupations that remnants of Late Classic styles have been widely obliterated. And there are the depredations of time and environment—primarily moisture and dense vegetation—which have seriously damaged or destroyed countless buildings and monuments. This is especially true where a site was largely abandoned prior to the Late Classic period. Architectural styles can be studied only by surface observations or by what archaeologists have chosen to excavate. The discovery of well-preserved buildings on the surface is invariably a matter of luck, and by comparison with the number of buried structures in any given site, the number of excavated examples is microscopic. Thus, our basis for a comparative stylistic analysis of Maya architecture is anything but ideal.

Today, however, archaeology in Mesoamerica is experiencing a new awareness of the importance of cultural detail, including previously overlooked or ignored architectural data. This has resulted from the accumulation of an enormous amount of field work conducted during the 1960s and 1970s, much of which has not yet been synthesized in published form. Once all this information can be assimilated, new perceptions of architectural regions in the lowlands will surely emerge. We also hope to have more penetrating insights into the evolution of Maya architecture based on comprehensive surveys of specific regions and styles rather than antiquated studies of individual sites. While the site-equals-style approach is patently outdated, it has not yet been supplanted by a more modern synthesis, and as a result the concept of Maya architectural style is tenuous at best.

Nevertheless, it is possible to offer some generalizations on the subject of regional styles. The basic structural elements outlined earlier were nearly always present throughout Maya history. The treatment of

these elements—the basal platform, walls (lower zone), and roof (upper zone)—differs dramatically, and it is these variations that identify individual styles. From an artistic viewpoint, this idea is simple enough, although the classifications are complicated by the cardinal orientation of certain buildings, uses of land modification, and decorative symbolism. An interesting example of such variables is seen in land modification, which the Maya often relied upon to conserve labor and express their penchant for spectacle and illusion. At the site of Yaxchilán on the Usumacinta River, they constructed a series of low, palace-like buildings on top of a high, rocky ridge, using the slope of the ridge itself to construct stairways which, from the level of the river, causes the "temples" to take on an extraordinary loftiness and grandeur.

By contrast, if these same structures were found at Tikal without the elevated ridge, they would easily be classified as palaces rather than temples. It is the artifice of land use that creates the illusion of function in the mind of the modern observer. At Tikal one easily recognizes temples, since they are elevated on truncated pyramids and great temples always have only one doorway. No such structure occurs at Yaxchilán.

The regional style known as the Central Petén is typified by the huge city of Tikal. Considered by many to be the major focal point of lowland Maya civilization, all other styles have been considered to revolve around it. Temple I at Tikal is the "pinup" of Maya architecture, one of the glories of Late Classic culture as it is popularly envisioned (Fig. 29). The reasons why this view is likely to be completely "reversed" have to do with a particular perspective of the evolution of architecture in the lowlands. Although the Central Petén Style epitomizes the high, vertical, one-doorway temple, structures of this type are anomalous in the lowlands as a whole. It is a development which sets Tikal (and the entire zone represented by the site) apart. Its tall, vertical temples were not trendsetters, but rather a specialized outgrowth of the more common lowland styles. In no way does this viewpoint denigrate the importance of the Central Petén Style; instead, it epitomizes Tikal's relationship to the rest of the lowlands. Temple architecture at Tikal may not be normal for the Maya, but it underscores the unique role that this site enjoyed in the overall scheme of Late Classic culture. The boundaries encompassing the Central Petén Style are actually rather restricted; they extend southward to Lake Petén Itzá, eastward to the Belizean border, northward probably to the site of Calakmul, with an unknown western boundary, though it stops well short of the Usumacinta River drainage.

Another distinctive style is that of the Usumacinta River district, although it is still impossible to define exact boundaries for this region. It included the site of Palenque—about which volumes have been written—and is firmly represented at Yaxchilán. How far south of Yaxchilán it extended is not certain, though it may have included (or at least influenced) Seibal and Altar de Sacrificios; and the art and architecture of various sites in the Lacandón district of eastern Chiapas suggest strong affinities with the Usumacinta style. As yet no one has tested for architectural differences or similarities among riverine sites such as Yaxchilán, Piedras Negras, Altar de Sacrificios, and Seibal, or compared their features with those of other major centers located away from rivers.

In the extreme southeastern sector of the lowlands, the famous sites of Copán and Quiriguá appear to constitute a distinct Southern style. It has been argued that Lubaantun and Nimli Punit in southern Belize also re-

late to this style. The degree to which this area interacted with the rest of the lowlands bears further investigation, since the two largest centers are separated in a rather dramatic fashion by an intimidating barrier—the Sierra de las Minas—which made communication with the lowlands proper a roundabout affair, either via Belize to the northeast or up the Río Motagua through the highlands. Some scholars consider this region an outpost, although Copán and Quiriguá were obviously important Maya cities and their monuments and buildings exhibit an exceptional style of sculptural art.

Northern Belize constitutes still another architectural zone, though one that presents numerous problems for further research. Here one encounters a high level of architectural achievement at an early date. Large, impressive, and elaborately decorated structures occurred at the

Fig. 29. Temple I at Tikal, Guatemala.
Peter D. Harrison

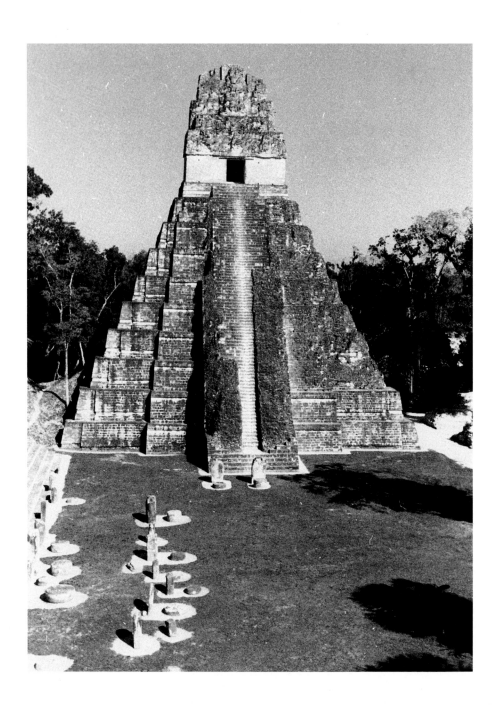

sites of Cuello, Lamanai, and Cerros at least as far back as the Late Pre-classic period (see pp. 37–38). Yet during Late Classic times there seems to have been no distinctive style, but rather a melting pot of elements borrowed from the central Petén to the west and from various northern districts. A noteworthy feature in Belizean architecture was the continuation into the Late Classic of an early type of structure found elsewhere in the lowlands—a temple with three doorways instead of one. It is interesting, too, that northern Belize experienced some of the earliest and latest occupations known in the lowlands, demonstrating a longevity and endurance which the more specialized central Petén never achieved.

The bulk of the Yucatán Peninsula—the northern Maya lowlands—is characterized by three distinct Late Classic styles: Chenes, Río Bec, and Puuc. The Chenes Style acquired its name from a section of Campeche noted for its artificial wells (*chen* in Yucatec). It is readily identified by buildings embellished with ornate facades, including both the upper and lower zones. These structures are low, multiroomed buildings of the palace type, and the open mouth of the Maya earth monster often forms a frame for the central doorway.

The Río Bec Style occurs in a relatively restricted area in southern Campeche and Quintana Roo. It is typified by the use of false-temple facades that imitate the elevated pyramid-temples of the central Petén, a kind of structure that does not occur in the Río Bec region *(Fig. 30)*. These facades are a purely decorative, nonfunctional device, at least from our point of view, which were added to palaces. In this zone the distinction between temples and palaces is once again problematic. It was originally thought that these styles were mutually exclusive in terms of their relative geographic distribution, but recent work at Becán and Chicanna proved that both building types can occur within the same plaza, with one style facing the other. Since then these two types of structures have been combined under the rubric of Central Yucatecan Style.

Of all the regional styles in the northern lowlands, the Puuc is perhaps the most fascinating and complex, and is thought by many archaeologists to represent the aesthetic apogee of Maya architecture. Named after a range of low hills in the state of Yucatán (*puuc* means hill in Yucatec), this style is concentrated in Yucatán but extends into northern Campeche and parts of Quintana Roo. Some of the most famous Maya sites belong to the Puuc tradition: Uxmal, Kabáh, Sayil, and Labná. Even Chichén Itzá, the most frequently visited of all Maya ruins, contains outstanding examples of Puuc structures dating from its pre-Mexican occupancy (see pp. 43–46). The diagnostic traits of Puuc buildings are unmistakable: the lower zones are undecorated and faced with finely cut masonry, while the facades of the upper zones are covered with a maze of cut-stone decorations featuring geometric elements, serpents, human figures, animals, and deities—especially huge, complex masks of the rain god, Chac, with fangs, a curled nose, and peglike eyes *(Fig. 31)*.

If the Late Classic period was the cutoff point for our consideration of Maya architecture, the highlights would end here. What followed during the Postclassic was an interesting mixture of older Maya traditions with powerful influences derived from Mexico, resulting in such structures as the Temple of Kukulcán (see *Fig. 12*), the Ballcourt, and the Temple of the Warriors at Chichén Itzá, and similar "Mexicanized" buildings at Mayapán, Dzibilchaltún, Izamal, and elsewhere in Yucatán. Along the coast of Quintana Roo, these Mexican influences were particu-

Fig. 30. A temple known as Río Bec "B," a prime example of the Río Bec regional style, Campeche. Peter D. Harrison

larly strong at Tulúm, Xelhá, Xcaret, and several other locations. In fact, they were so pronounced as to give rise to a separate Coastal Style during the Late Postclassic period.

As mentioned earlier, the recognition of regional architectural styles as a study is still in its infancy. Moreover, the significance of regional variation is uncertain; nor do we know what constituted a "difference" to the ancient Maya. Our classification system responds to Western traditions, an awareness that may or may not coincide with the Maya mentality, and thus any overview of regional styles must remain tentative.

There is, however, one principle of Maya architecture which cannot go unmentioned, since it was vital to the creation and evolution of individual buildings and entire cities: the destruction and burial of structures. Archaeological evidence leaves no doubt that the Maya did not hesitate to destroy, either partially or totally, any architectural creations that had outlived their purpose. Adding one structure on top of another, or modifying existing structures, was a way of life, the manner by which settlements grew. Sometimes the older building survived entirely or in part. Even the defacing and destruction of decorative facades was carried out in a fashion that suggests the ritual "killing" of images to make way for newer and larger edifices. In the Late Classic this practice resulted in a number of remarkably complex building groups, and excavations have demonstrated the manner in which these complexes grew from small plaza groups into enormous, multibuilding acropolises.

A perfect example of this growth is seen in the Central Acropolis at Tikal. The final version, with six courtyards and forty-six buildings visible on the surface, represents only the end result of a centuries-long ef-

fort. Human touches are detectable in the details. The addition of a second story was accompanied by a private stair with a lead-in baffle. The urge for privacy clearly accelerated at the peak of the Late Classic. Doorways were often closed off to protect the view into palace interiors, and portions of the same structure were enclosed to form a secluded patio. The passages between courtyards were protected by baffle walls, and the desire to enclose living space, add fabric coverings to doorways and otherwise seal off the interiors of buildings is evident everywhere.

We can only speculate on the causes of this apparently sudden obsession with closure and privacy. Was it population growth, fear of attack, drastic changes in the function of buildings? The stones offer no clues. At Tikal this drive toward privacy was the last visible indication of architectural activity. The next event on the record is the slow onset of the collapse of Maya culture in the southern lowlands during the ninth century, the beginning of the end!

Apart from temples and palaces (allowing for the controversy surrounding the use of these terms, since we cannot always be sure what specific functions these buildings served), Maya cities contained a variety of other architectural features, including causeways, ballcourts, sweat baths, drainage systems, artificial reservoirs, platforms, and shrines. Although the vast majority of peasants lived in simple thatched-roof houses in outlying areas, some sites also contained a number of residential-type structures that may have been dwellings for the elite classes, priests, minor administrators, or individuals involved in special trades or crafts.

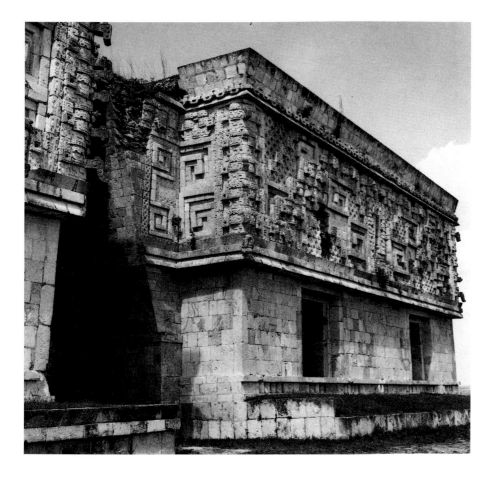

Fig. 31. A section of the Palace of the Governors at Uxmal showing typical Puuc architectural traits: an undecorated lower zone, the upper facade ornately embellished with cut stone, and long-nosed Chac masks (upper left corner).
Charles Gallenkamp

The cities show a great deal of variation in the arrangement of buildings, though the grouping of important public structures (temples and palaces) around open courtyards or plazas was a characteristic feature of lowland sites. A concern with the visible surface texture of these edifices evolved in conjunction with the quality of construction technique. Earlier buildings were raised with an emphasis on solidity and less consideration for the appearance of surface texture. From the Late Preclassic to Late Classic times these concerns were reversed. By the time the Puuc style was achieved in the northern Yucatán Peninsula, the major focus of interest was on the extreme fineness of the surface appearance, although the smoothly polished stones are not well tenoned to the core of the wall behind them and fall off relatively easily with the passage of time.

The cardinal orientation of buildings was also of great importance. In a few isolated cases, it can be demonstrated that certain structures were carefully erected to form alignments with each other in configurations of astronomical significance. These occur at Uaxactún in the central Petén and at Copán in the south. However, the actual orientation of all buildings also has some significance not yet thoroughly explored. There seems to be an evolving orientation which changes during the Classic, moving from roughly 15 degrees east of north at the beginning of the period to a point close to magnetic north by the end. Such a trend is highly suggestive of the use of a magnetic device, but the evidence for this possibility remains circumstantial.

While there were some regional differences in methods of construction, types of masonry, and materials, certain basic techniques were widespread throughout the lowlands. Limestone, which was readily available and easily worked, was the predominant building material, but in the southeastern and western lowlands sandstone, rhyolite, and trachyte were occasionally used, and one site in Tabasco, Comalcalco, was constructed with fired bricks. Mortar and plaster were made by burning limestone, reducing it to powder, then mixing it with sand and water.

The supporting platforms on which most structures rested were built of rubble and earth covered with cut-stone masonry. The buildings themselves were constructed in a similar fashion, using an inner core of tightly cemented rubble faced with masonry. Due to the amount of rubble needed to support the heavy, overlapping stones of the corbeled arch, Maya buildings had thick walls and appeared to be "top heavy."

In most cases, the masonry surfaces of both the exterior walls and interior rooms were covered with a layer of smooth plaster, and they were sometimes painted with solid colors (primarily red), horizontal bands of color, or murals, the finest examples of which were found at Bonampak in Chiapas.

The complexities of the architecture created by the Maya are an eloquent testament to the extraordinary level of their civilization. They also demonstrate the differences between Maya and Western society. We cannot always expect to understand how or why certain building types came into existence, or to know precisely how they functioned. Nor can we ever hope to equate these structures—from either a practical or aesthetic viewpoint—with our own architectural standards. It is this difficulty in interpreting them that contributes to the aura of mystery that continues to surround ancient Maya civilization.

CATALOGUE

Flora S. Clancy, Clemency C. Coggins, and T. Patrick Culbert

All photographs in the catalogue are by Stuart Rome except for the following:

Hillel Burger, The Peabody Museum of Archaeology and Ethnology, Harvard University, Cambridge: Nos. 20, 21, 22, 25, 52, 53, 78, 88, 114, 115, 128, 133, 165, 197, 198, 199, 200, 201, 202.

Diego Molina, Guatemala City: Nos. 44, 45, 46, 47, 71, 95.

The Art Institute of Chicago: Nos. 141, 145.

Ursula Parifer, Dumbarton Oaks, Washington, D.C.: Nos. 30, 31, 32, 67, 110, 118, 136, 142.

Throughout this section, short references to authors cited in the full Bibliography (pp. 232–36) may appear at the end of the descriptive material. When more than one work was published in a given year, the references occur, for example, as: 1981*a* or 1981*b*.

PRECLASSIC

1 Grooved jar
Santa Rita, Belize; Structure 134
Ceramic; slipped orange
H. 10.7 cm.
Early to Middle Preclassic (c. 1000 B.C.)
Belize Department of Archaeology, Belmopan 35/203-5:95

This jar is a late example of the oldest known pottery excavated to date in the Maya area. It belongs to a ceramic tradition designated as the Swasey phase, which was first discovered at the site of Cuello in Belize. The earliest Swasey pottery dates back at least to 2000 B.C.—it may actually be several centuries older—yet it was remarkably well made and often decorated with simple incised, grooved, or painted designs. Swasey ware has been found at several sites in Belize, and this jar from Santa Rita is embellished with horizontal grooves around the neck and shoulder. It was covered with a reddish-orange slip, traces of which are still visible. TPC

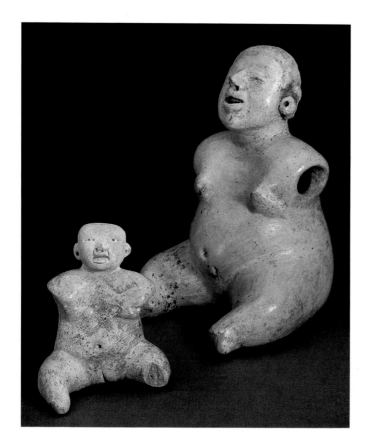

2 Seated figurine
Kaminaljuyú, Guatemala
Ceramic; slipped ivory white and orange
H. 12.5 cm.
Middle Preclassic (600–300 B.C.)
Museo Nacional de Arqueología y Etnología, Guatemala C4

The solid seated female figure on the left, modeled of a fine white clay, once had movable arms. They were attached by strings threaded through the holes in the deep sockets at the shoulders and leading out to the back, where they could have been manipulated. This plump, ivory-slipped baby figurine is like others known from Kaminaljuyú, especially the much larger "Muneca Kidder" shown here with it (not included in the exhibition), and recalls earlier Olmec-style figurines from central Mexico. CCC

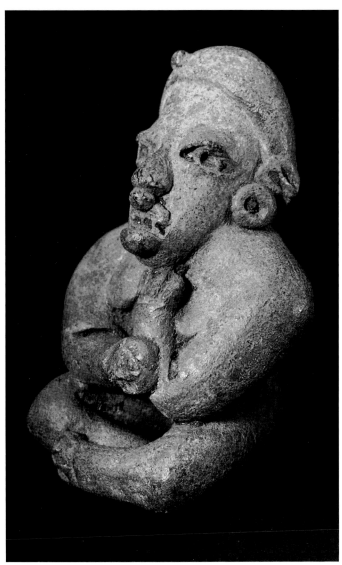

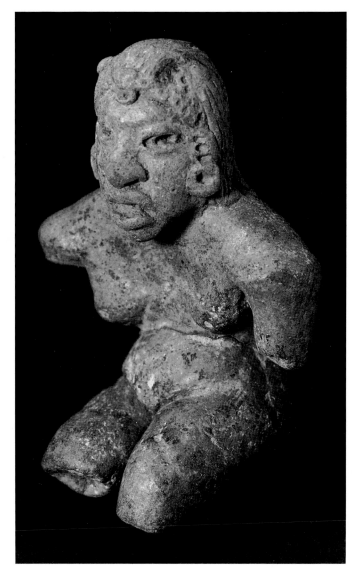

3 Seated female figurine
San Agustin Acasaguastlán, El Progreso, Guatemala
Ceramic; slipped brown
H. 9.7 cm.
Middle Preclassic (600–300 B.C.)
Museo Nacional de Arqueología y Etnología, Guatemala 9702

Seated with legs crossed, this pensive female figure rests her chin on her left hand, holding up a large head hunched between broad, rounded shoulders as is characteristic of this period. Her face is elongated and somewhat narrow, with an open mouth made of two strips of clay and three punctures that indicate teeth. She wears a nose bead, earflares, and what may be a turban, but little attention was given to the hair. Fingers and toes (which are usually broken off) were also summarily indicated on this unusually well-preserved Preclassic figurine. ccc

4 Seated female figurine
San Agustin Acasaguastlán, El Progreso, Guatemala
Ceramic; slipped red-orange
H. 10.5 cm.
Middle Preclassic (600–300 B.C.)
Museo Nacional de Arqueología y Etnología, Guatemala 9701

Usually the heads are broken from the bodies of solid Preclassic figurines like this, and a complete one is rare. In typical fashion this female's head is set directly upon her broad shoulders, with a large mouth and nose and elongated punctate eyes in her rather flat face. She wears only earflares. The greatest attention was given to depicting the hair, which may have been cut very short on the sides, with a few long locks, while at the center the hair was left long and hung down the back. It is also possible that the figure might have been wearing a tight, patterned cap through which her hair was drawn to hang down at either side and at the back. Such elaborate hair treatment is common on figurines of this period. ccc

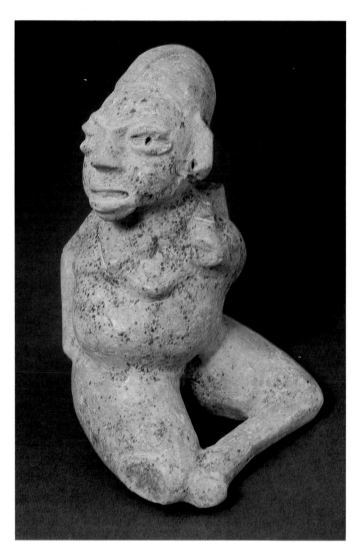

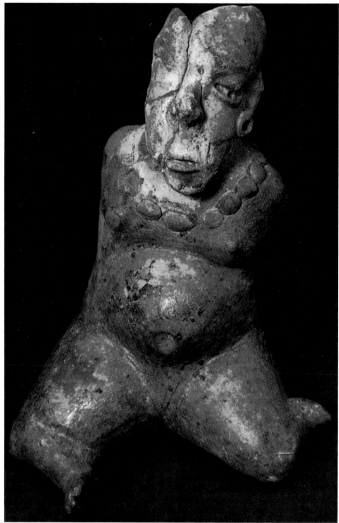

5 Female effigy vessel
Alta Verapaz, Guatemala
Ceramic; slipped orange
H. 15.5 cm.
Late Preclassic (300 B.C.–A.D. 100)
Museo Nacional de Arqueología y Etnología, Guatemala 5828
* (Dieseldorff Collection)*

Once spouted, this seated female effigy vessel may represent a woman who is both pregnant and deformed, but her twisted body makes this difficult to determine. This turning position, in which the left arm once held a burden (the spout) upon her back, lends a liveliness to this effigy, and the woman's large features, direct gaze, and artificially elongated head almost suggest individual character. A hole in the side of her hollow head was the mouth of the spouted vessel. CCC

6 Female effigy vessel
Alta Verapaz, Guatemala
Ceramic; slipped red-orange
H. 20 cm.
Late Preclassic (300 B.C.–A.D. 100)
Museo Nacional de Arqueología y Etnología, Guatemala 5880
* (Dieseldorff Collection)*

The torso of a seated pregnant woman forms this effigy vessel. With distorted features that include a sightless eye, the woman's head serves as the mouth of the vessel; she has large thighs with tiny lower legs. Her arms are bound and she is clearly a hunchback. In her pathetic condition, she presents such an image of helplessness that one wonders what could have been the purpose of the vessel. CCC

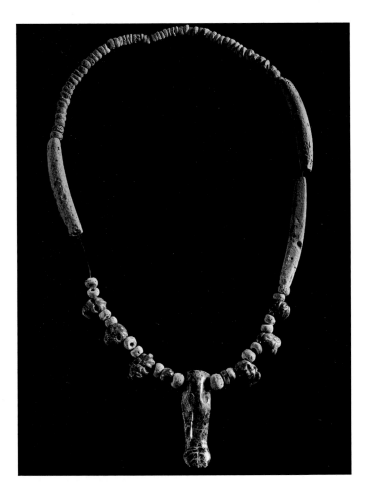

7 Jade and shell necklace
Altun Ha, Belize; Structure F-8, Tomb F-8/1
Jade, shell; red pigment
L. 29 cm.
Late Preclassic (A.D. 100–300)
Royal Ontario Museum, Toronto 967.25.18 RP 297/1

A jade crocodilian head serves as the central pendant element in this assemblage which includes six tiny jade beads in the shapes of monkey and human heads. These are stylistically related to jade "bib-helmet" heads that have been excavated from several Late Preclassic caches in northern Belize. Tomb F-8/1 is of particular archaeological interest because of an offering that was made immediately after the burial, composed of objects like those found in caches at the distant central Mexican site of Teotihuacán. CCC

Pendergast, 1971

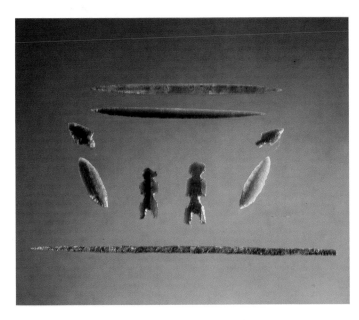

8 Nine miniature "eccentrics"
Altun Ha, Belize; Structure F-8, Cache F-8/1
Green obsidian
L. 8.5 cm. (spine)
Late Preclassic (A.D. 100–300)
Royal Ontario Museum, Toronto RP 297/14,20,26,27,28

After Tomb F-8/1 was roofed over, a large and unusual offering was made; though this included a great many shell artifacts and jade beads which were not uncommon in offerings, the 22 non-Maya ceramic vessels, 245 tiny "eccentrics," and 13 larger stemmed bifaces made of green obsidian were extraordinary. This was not only because they were imported from central Mexico, where green obsidian was mined, but because the association of these objects replicated caches made at the great Mexican site of Teotihuacán in the second century A.D. In Maya archaeology, "eccentric" traditionally refers to odd shapes and nonfunctional forms chipped from obsidian and flint, presumably for ceremonial purposes. Five forms representative of the delicately flaked miniature eccentrics in this offering are included here: human figures, double-ended points, projectile points, prismatic blades, and the one very long "spine," which had been worked in the round. This cache is clear evidence of unusually early contact between Teotihuacán and the Maya lowlands, although the most puzzling aspect of the cache is not its early date but its excellent condition. Could such a foreign offering have been made and assembled so far from home? If not, how were so many fragile objects transported such a great distance, and why? CCC

Pendergast, 1971, fig. 3

101

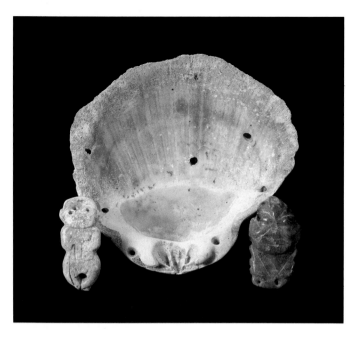

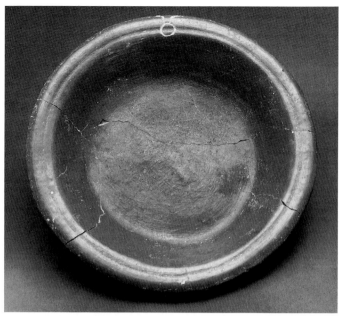

9 Three cache objects
Lamanai, Belize; Cache N10-43/6
Spondylus shell; jade
W. 11.7 cm.; H. 4.7 cm.; H. 4.7 cm.
Late Preclassic (100 B.C.–A.D. 100)
Lamanai, spondylus shell LA 385/2; shell figurine pendant
 LA 385/4; jade pendant LA 385/5

These objects were cached together on the axis of the largest
securely dated Preclassic structures in the Maya area, known as
Lamanai Structure N10-43. This may also be the earliest known
caching of "jewels" inside a spondylus shell, which had been
ground away to reveal its orange inner wall. The bowlegged
shell figurine, of a type dubbed Charlie Chaplins in their Clas-
sic period form, has a downturned mouth and infantile propor-
tions suggestive of the much earlier Olmec style. Jade head
pendants like this are called bib-helmet because many seem to
be wearing helmets and to have short bibs below the chin; ex-
amples have been excavated from Late Preclassic caches else-
where in northern Belize, but here the bib is unusually long,
and it has been perforated for additional danglers. CCC

Pendergast, 1981a, pp. 41–42

10 Everted rim bowl
Tikal, Petén, Guatemala
Ceramic; slipped red
D. 29.5 cm.
Late Preclassic (300–150 B.C.)
Museo Sylvanus G. Morley, Tikal 12P-598

This bowl was found in a pit cut into the bedrock underneath
more than forty feet of construction in the North Acropolis at
Tikal. The vessel was probably not an intentional offering, but
simply a part of the extensive refuse deposit excavated at the
same location. Both the position of the find in the North
Acropolis and its shape indicate a fairly early date within the
Chuen phase (300–150 B.C.). The deeply carved design of un-
known significance may be a protoglyphic symbol. TPC

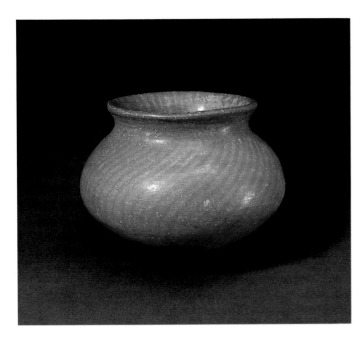

11 Short-necked jar
Tikal, Petén, Guatemala; Structure 5D-Sub-11, Burial 166
Ceramic; slipped red on orange
H. 11 cm.
Late Preclassic (c. 50 B.C.)
Museo Nacional de Arqueología y Etnología, Guatemala 9962

This jar was discovered in Burial 166 at Tikal, an important Cauac phase (100 B.C.–A.D. 150) tomb in the North Acropolis. Its body and the interior of the neck are decorated with multiple parallel lines that swirl around the vessel in the characteristic design known as Usulután style. The red lines were painted individually over an underlying orange slip, a method that departs from the usual technique of applying the second color over the entire surface and then wiping off parts of it with a multipronged instrument. Burial 166 contained the bodies of two adult women whose skulls provide the earliest known examples of cranial deformation produced by binding the head during infancy. Such deformation was considered a mark of beauty by the aristocracy of Late Classic times. TPC

W. R. Coe, 1965*a*, pp. 11, 12, fig. 2d

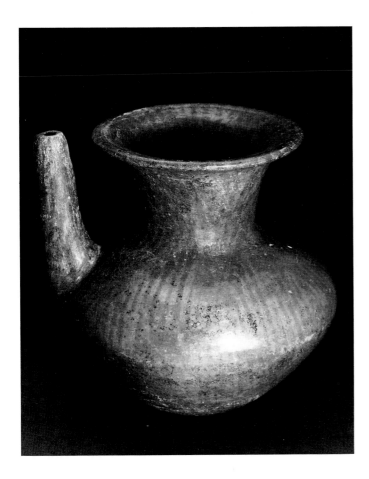

12 Jar with spout
Tikal, Petén, Guatemala; Structure 5D-Sub-11, Burial 166
Ceramic; slipped red on orange
H. 21.2 cm.
Late Preclassic (c. 50 B.C.)
Museo Nacional de Arqueología y Etnología, Guatemala 9963

This spouted jar is a companion piece to the previously described vessel (No. 11) from Burial 166. It was also decorated in the Usulután style by painting red lines one by one over an orange slip. Its shape is a rather unusual one that occurs occasionally in burials but rarely in everyday refuse. TPC

13 Offertory urn
Tikal, Petén, Guatemala; Structure 5D-Sub-1-1st, Burial 85
Ceramic; slipped red and fluted
H. 42 cm.
Late Preclassic (c. A.D. 1)
Museo Nacional de Arqueología y Etnología, Guatemala 9964

This large vessel was one of many offerings in Burial 85 in the North Acropolis at Tikal. Its bizarre shape, affectionately known to archaeologists as a "fire hydrant," is frequently encountered in burials but it seldom appears in household remains. The sides of these vessels are often fluted—as here—and the dark red slip is characteristic of Late Preclassic ceramics. TPC

W. R. Coe, 1965*b*, fig. 2j

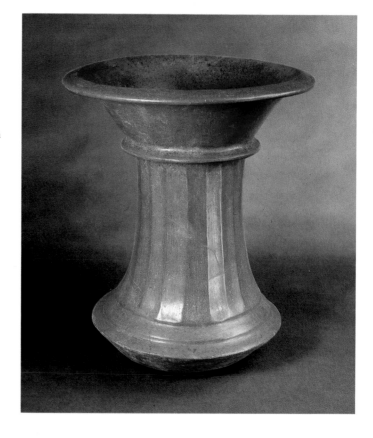

14 Turbaned male head effigy vessel
San Agustin Acasaguastlán, El Progreso, Guatemala
Ceramic; slipped orange on cream
H. 17 cm.
Late Preclassic (200 B.C.–A.D. 250)
Museo Nacional de Arqueología y Etnología, Guatemala 4955

The striking linear orange-and-cream pattern which covers this vessel was painted with a four-tip multiple brush in the resist technique called Usulután after its presumed region of origin in El Salvador. The vessel is modeled as the head of a turbaned old man with a thin, beaked nose and deep lines around his mouth which, with a protruding lower jaw, is held open to reveal his tonsils. This is one of the old earth deities, inhabitants of the Underworld, who continued to be represented on Maya ceramics until the sixteenth century. CCC

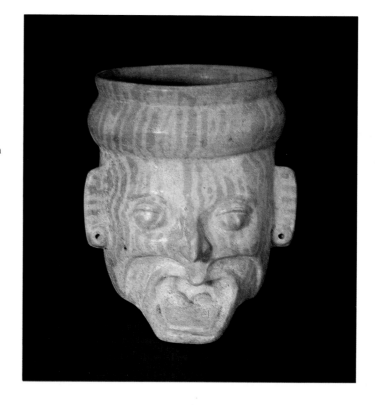

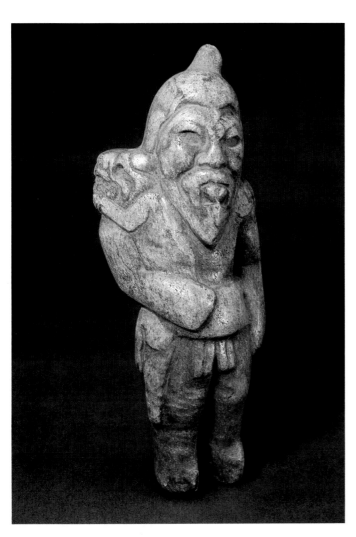

15 Stone figurine pendant
Tamahu, Alta Verapaz, Guatemala
Fuchsite
H. 20 cm.
Late Preclassic (200 B.C.–A.D. 100)
Museo Nacional de Arqueología y Etnología, Guatemala 5095
 (Dieseldorff Collection)

A jaguar cub is held like a baby over the right shoulder of this bearded and mustached man wearing a close-fitting cap with what may be a shaman's horn at the top of his head. The man's large head, with its heavy features, resembles those of other Late Preclassic Guatemalan sculptures, as does the presence of flanges rather than earflares. This man's close relationship with the jaguar may signify his role as chief of a highland group or lineage for whom the jaguar, king of tropical American beasts, was the supernatural associate and protector. This standing figure, though large and heavy, is drilled at the back so as to be worn as a pendant. ccc

Kidder, 1954, p. 13, fig. 9b

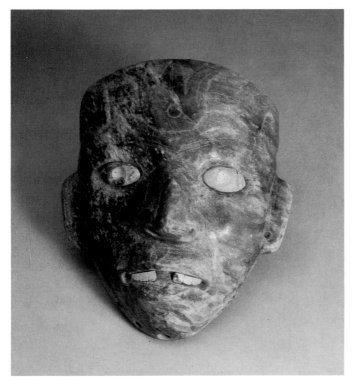

16 Stone mask
Tikal, Petén, Guatemala; Structure 5D-Sub-1-1st, Burial 85
Fuchsite; shell
H. 12.3 cm.
Late Preclassic (25 B.C.–A.D. 25)
Museo Sylvanus G. Morley, Tikal 12P-98/78

This mask probably took the place of the missing skull of an important Preclassic ruler at Tikal who was buried on the axis of the North Acropolis. In its original form, with all of its teeth, inlaid pupils, and objects dangling from the mouth, chin, and ears, this mask must have been striking. It may have even been a likeness in view of its large nose and a mustache incised on the upper lip. Like other Preclassic sculptures, this mask has ear flanges; and like the figure from Uaxactún (No. 17), it is made of fuchsite and incised with symbolic designs, including split elements similar to those on the temples of the seated figure. Here on a headband they flank a trefoil badge which may have served as a title. ccc

W. R. Coe and McGinn, 1963, pp. 29, 31

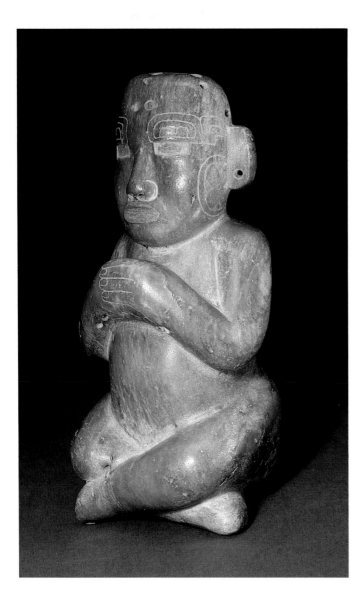

17 Stone seated figure
Uaxactún, Petén, Guatemala; Structure A18, Cache A31
Fuchsite; red pigment
H. 25.3 cm.
Late Preclassic (200 B.C.–A.D. *100)*
Museo Nacional de Arqueología y Etnología, Guatemala 924

The softly rounded body of this seated infant suggests the much earlier Olmec sculpture of the Gulf Coast, but the figure is proto-Maya. It was found with obsidian and flint "eccentrics" cached within an Early Classic vessel. The incised U elements over the eyes and *kin* signs on the cheeks are, however, typical Late Preclassic symbols. The eyes were once inlaid, and flanges serve as combined ears and earflares. Thirteen pairs of holes are biconically drilled on the head, legs, and feet and around the realistically detailed hands clasped over a plump abdomen. This monumental baby figure suggests Classic anthropomorphic baby jaguar images and may have originally signified the reborn Sun; hence, this heirloom might have been a sacred ancestral image suitable for a dedicatory cache in Structure A18, the highest at Uaxactún. CCC

Kidder, 1947, pp. 47–48

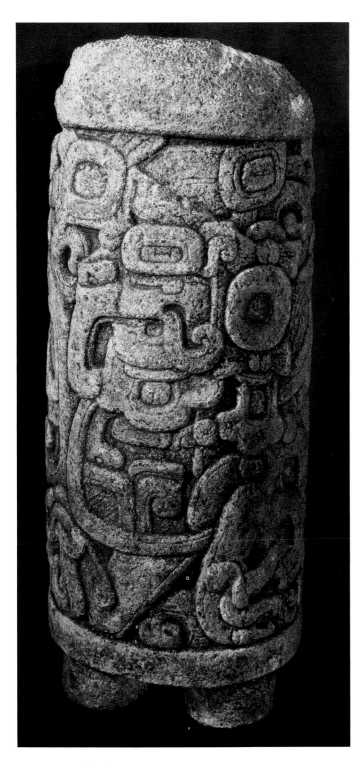

18 Tetrapod, Altar 10
Kaminaljuyú, Guatemala
Light green volcanic stone
H. 65.5 cm.
Late Preclassic (200–1 B.C.)
Museo Nacional de Arqueología y Etnología, Guatemala 63685

The great site of Kaminaljuyú is now overlain by the modern suburbs of Guatemala City. Altar 10, along with Altar 9 (a matching tetrapod), was found in 1961 during the construction of a municipal housing project. The large missing piece of Altar 10 was sheared off by a bulldozer. When Altar 10 was thus found, it still had traces of red and blue pigment. Each altar is a tall stone cylinder and stands on four small feet—hence tetrapod. At the top and bottom of Altar 10's drumlike cylinder are two plain bands that frame the relief-carved image as it wraps around the entire body of the altar. Wraparound compositions were common in contemporary ceramic traditions and on small carved objects like bones and shells, but were rarely used for stone monuments. Altars 9 and 10, then, represent the interesting and early phenomenon of monumentalizing a compositional theme used for miniature representations.

The intensity of the design is not varied, and there are few clues for the untrained eye to follow in order to find the main areas of focus and meaning. Given the clarity of design and image on the contemporary Stela 11 from Kaminaljuyú (No. 19), the obscurity of this piece must have been a conscious choice on the part of the designers. Furthermore, unlike its best prototypes—ceramic pots—one could not easily turn this piece in one's hands to contemplate the design. The wraparound image is a mythical bird of complex design. The bird is created as a composite of other mythical beings. The head, wings, and body are each made of different monster heads. The bird's head is a long-lipped beast thought to be derived from a serpent. The head wears a three-part earplug with a plain doughnut-shaped disk as the large central element. It also wears a headdress with two glyphic cartouches believed to be signs for Maya day names: the one above the beast's nose is the day *Akbal*, and the one above the earplug, *Muluc*. The body of the bird is outlined by a cartouche-like curve containing another head facing in the same direction as the main head. The mouth is squared and open, revealing a diagonal bar, and the eye is partly overlapped by the bird's trefoil neck ornament. The outspread wings on either side of the head and body are probably another type of serpent head whose upper jaw replaces the long bones of the wings. The right wing is the most visible since the left wing is partially covered by the earplug assemblage. The curved line that describes the upper edge of the wing is the upper jaw, the serpent nose is the squared knob atop it—just missed by the bulldozer's blade. Hanging from the wing-jaw is a cartouched glyph (visible on both wings) and stylized feathers.

The legs of the mythical bird are snake bodies ending in heads with scrolls issuing from their mouths. The tail appears to be actual feathers bound with beads and composed into a large scroll. Behind the tail, and on the opposite side of the cylinder from the bird's head, is another serpent head in a vertical position. It lacks a lower jaw but has skeletal, human-like front teeth. Great scrolls issue from its jawless mouth and merge with the forms of the bird's right wing. The vertical serpent head was pendent from a large cartouched glyph, now missing on Altar 10, but on Altar 9 this glyph is almost identical to the cartouched head that is the bird's body. This particular bird-monster has been variously named the serpent-bird, the principal bird deity, and the serpent-winged monster. It is a celestial icon, and can be seen in the supernal image on Stela 11 (No. 19). During the Classic period, it became associated with rituals of rulership, and the serpent wing, abstracted from the whole figure, serves as a major element in the Classic headdress. FC

Parsons, 1983, pp. 145–56; Bardawil, 1976, pp. 195–209

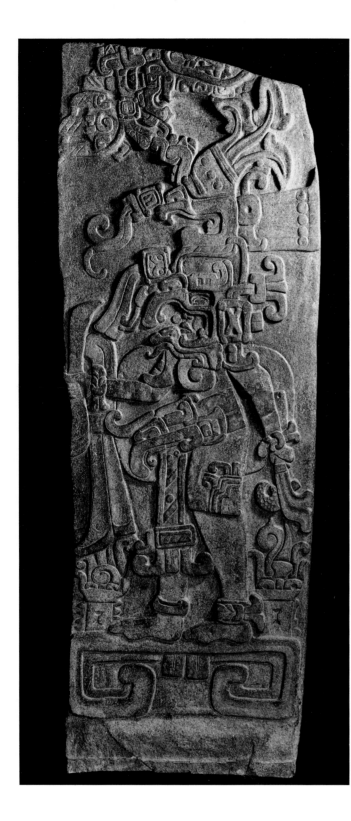

19 Stela 11

Kaminaljuyú, Guatemala
Granite
H. 189 cm.
Late Preclassic (350–100 B.C.)
Museo Nacional de Arqueología y Etnología, Guatemala 3093

The pristine condition of Stela 11 is remarkable enough, but the image itself—its lucid carving style and clarity of detail—is even more extraordinary. Although this piece dates from the Preclassic, it fully anticipates the single-figure compositions typical of Classic stelae. The design field is horizontally divided into three major areas: the *supernal* image above the main *figural* image, which stands upon the *basal* image. The down-gazing head of the supernal image is the long-lipped monster, a mythical or allegorical bird whose wings are asymmetrically posed. One wing rests below the bird-monster's chin, its shape outlined by a half-oval frame. The other wing extends from the front of the forehead to the left edge of the stela.

The head of the supernal image is very similar to the mask worn by the figural image, even to the cartouched glyph over its nose. The rendering of the mask is remarkable; it graphically illustrates the underlying content of humanism—or at least a human basis for the meaning of this image, as the human face can be seen within its outward mask. Above the mask, the headdress proper consists of stiff beaded feathers extending straight out of a fantastic head whose upper face has been replaced by a conch shell sprouting three leaves. The headdress and mask fully occupy one half the height of the stela. The main figure, even while bearing the weight of these complex motifs, leans forward in the direction he is facing, his feet and legs placed apart as if the sculptor intended to present a striding gait. Nonetheless, the figure is depicted with two right feet carved in almost comic outline, and he stands rather firmly upon the basal image that supports two incensarios with flames or smoke rising from them. The figure holds a weapon in each hand: a club (?) and a knife. The fancy knife, carried in the figure's left hand, has vegetal or feather scrolls which cover half the sharply curved blade. The blade itself is realistically given the texture of knapped flint. (The same knife, with scrolls and knapped blade, can be seen on Stela 10, also from Kaminaljuyú, and found in the same pit with this stela.) The masked man may carry weapons, but within the illustrated contexts of the supernal and basal images and the costuming, the role of warrior is allegorical—the *role* is allegorical—but we see the actor. FC

Miles, 1965, pp. 237–75

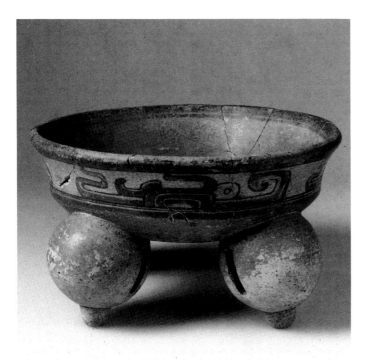

20 Tetrapod bowl
Holmul, Petén, Guatemala; Group II, Structure B, Room 9
Ceramic; slipped black and red on orange
D. 23.9 cm.
Late Preclassic (A.D. 150–250)
Peabody Museum of Archaeology and Ethnology,
 Harvard University 11-6-20/C5657

At Holmul, in northeastern Petén, Structure B was found to have served for several centuries as a burial temple. This polychrome bowl was one of seven vessels in the earliest known interment in the building; it was placed in a pit beneath the floor of a vaulted room which was later incorporated into the pyramidal substructure. Five of the seven vessels were tetrapodal with long vents in their globular mammiform rattle feet. This one is the most graceful. A serpent head, painted with calligraphic elegance and economy, and repeated four times around the wall of the vessel, alludes to the much more complex reptilian head that was often depicted a century later on basal flange bowls. The serpent head faces right; its elongated snout is fretlike, its eye has a hook, and a sinuous tail-like scroll trails behind. CCC

Merwin and Vaillant, 1932, pp. 38–39, pl. 18e

CLASSIC

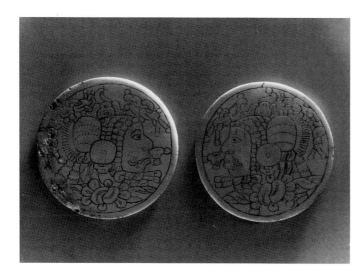

21 Pair of incised shell disks
Holmul, Petén, Guatemala; Group II, Structure B, Room 2
Shell; red pigment, resin traces
D. 4.7 cm.
*Early Classic (*A.D. *300–400)*
Peabody Museum of Archaeology and Ethnology,
Harvard University 11-6-20/C5619, C5620

When the pyramidal Structure B at Holmul in northeastern Petén was finally completely converted for burial purposes, a large collection of shell objects, including these incised disks, was scattered on a temporary floor in Room 2. The disks may have been part of an earflare assemblage, or inlaid in the shell mosaic mask also found in the deposit, since traces of a resinous adhesive suggest they were glued to a backing or were part of a copal incense offering. The head incised on both disks wears a tight-fitting, beaded hoodlike covering that is tied at the chin. Abbreviated fish-reptile (?) forms flank *Ahau* (lord) symbols at the top of the head. There are large twisted bows at the neck and an unidentified oval form with streamers at the back of the head. An inverted *Ahau* bead at the nose probably connotes divine, or at least royal, breath. This trilobe nose bead is typical of Early Classic imagery; similarly, this man's heavy, blunt features and low forehead are also characteristically Early Classic, contrasting markedly with the Late Classic aristocratic ideal. CCC

Merwin and Vaillant, 1932, p. 29, fig. 29; pl. 36d, f

22 Two jade earflares
Holmul, Petén, Guatemala; Group II, Structure B, Room 2
Jade; red pigment
D. 9.3 cm. (maximum)
*Early Classic (*A.D. *350–450)*
Peabody Museum of Archaeology and Ethnology,
Harvard University 11-6-20/C5454, C5556

These jade earflares may have been part of different burials in the Holmul temple room that had been converted to a mausoleum (as discussed in No. 21), but they were deposited near each other at about the same time, and they are certainly a pair. The cylindrical throats of these flares would have passed through holes in the earlobes, and a counterweight attached to a perforated disk filling the opening probably hung down behind to keep the heavy jade in place against the ear. Jade was the most valuable Mesoamerican stone. Available only in the mountainous southern highlands, it was worked with great economy, and any excess jade cut away while making flares like these would have been made into beads. CCC

Merwin and Vaillant, 1932, pl. 33aa, cc

23 Basal flange tripod bowl
Uaxactún, Petén, Guatemala; Structure A5, Burial A20
Ceramic; slipped black, red, orange, and gray on buff
H. 12.7 cm.
Early Classic (A.D. 400–450)
Museo Nacional de Arqueología y Etnología, Guatemala 91

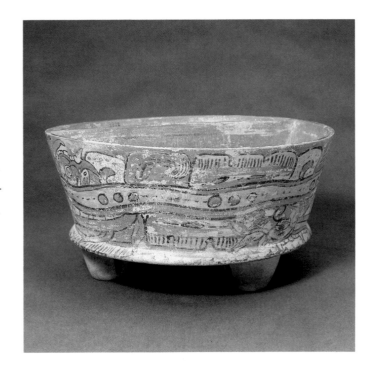

The Underworld water frieze that decorates the wall of this
polychrome vessel is an early example of this motif. It consists
of a medial band with alternating circles and dashes, and with
dotted scrolls and trilobed elements along the upper and lower
edges. Serpentine and fishlike creatures swim around the band.
The same motif was painted on the walls of an Early Classic
tomb at Río Azul in the Petén, but otherwise it was found only
on funerary vessels until Late Classic times, when it was used
as an architectural decoration. This is the only known vessel
that is divided in half by a partition. CCC

R. E. Smith, 1955, p. 85, figs. 11f, h

24 Cylinder tripod with lid
Petén, Guatemala
Ceramic; slipped red and black on orange
H. 15.7 cm.
Early Classic (A.D. 350–450)
Museo Nacional de Arqueología y Etnología, Guatemala 8459a, b

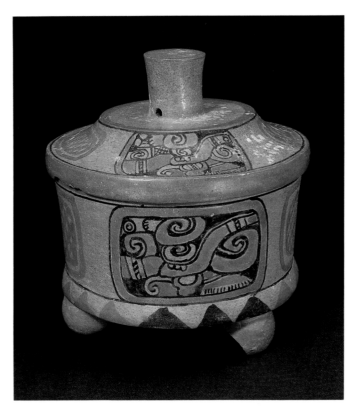

Lidded cylinder tripods are a hallmark of the Early Classic.
However, they are usually monochrome and often carved and
incised, probably in emulation of a Mexican form. This exuber-
ant variation on the sober cylinder tripod scarcely acknowledges
its foreign origins. It combines an indigenous ceramic poly-
chrome tradition and serpent imagery with the adopted form.
In the decorative medallions the upper jaw and long snout of a
serpentine head faces right. The central scroll, or hook, with
three circles below, forms the eye, and the scroll above it con-
stitutes the eyebrow. The vessel's modified basal flange has
nine red and nine black triangles like those found on some con-
temporary basal flange bowls, and the medallions are similarly
filled with serpent heads and scrolls. Such emblems were also
incised on monochrome vessels, where they become abstrac-
tions, losing their visual vivacity and sense of three-dimensional
form. CCC

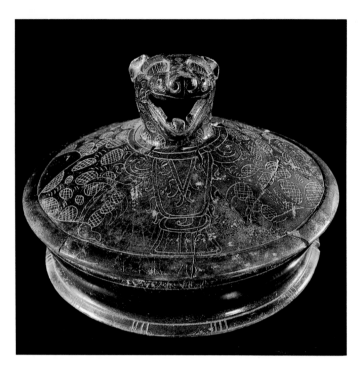

25 Basal flange bowl with effigy lid
Holmul, Petén, Guatemala; Group II, Structure B, Room 2
Ceramic; slipped black with red pigment
D. 29 cm. (lid)
Early Classic (A.D. 300–400)
Peabody Museum of Archaeology and Ethnology,
 Harvard University 11-6-20/C5577a, b

Two black jaguar effigy lid bowls accompanied the burials that followed the conversion of Room 2 in Structure B at Holmul into a mausoleum. Both this and a larger lidded vessel from the same room have plain bowls with sets of four incised vertical lines encircling their basal flanges, while the lids are modeled and incised with jaguars that are spread across them, their open-jawed heads serving as knobs. Crosshatched spots denote the black marking of a jaguar pelt, and the beast wears devices that identify it as the Underworld jaguar associated with the sun in the Underworld. It wears chevron bracelets and a bib collar with flamelike and hook elements that is knotted at the back. Behind the left leg, the tail terminates in a serpent head. Four vertical lines, like the ones on the flange, fill the eyes, unlike the matching jaguar effigy, which has the usual three cross-hatched spots of the Underworld jaguar's *ix* sign in its eyes. The roaring head of this striking effigy may originally have seemed more ferocious, since bone or shell teeth were once inserted in holes at either side of the tongue and in the upper jaw, and whiskers may have filled holes in the animal's snout. CCC

Merwin and Vaillant, 1932, p. 35, pl. 22

26 Tetrapod bowl with effigy lid
Tabasco (?)
Ceramic; slipped black-brown, red pigment
D. 27.5 cm. (lid)
Early Classic (A.D. 300–400)
The Brooklyn Museum, New York 64.217 a, b

Modeled in unusually high relief, this crested water bird, with a fish in its long, hooked beak, is a mythological creature with serpent-bird wings which have solar eyes incised on them. The bird also has several other identifying devices—a crosslike form on its beak, badges at the temples, and a doubled triangular design on its back—but their meaning is not yet known. This may be because the bowl and other black vessels reported to have accompanied it came from Tabasco, outside the Maya area. Early Classic lidded vessels of this type usually have straight walls and basal flanges. This rounded bowl stands upon four trunklike legs covered with modeled and incised feathered and scrolled elements and beads, including eyes that suggest these forms are reptilian. The legs are extraordinary for this animated decoration which extends upward onto the bowl itself; in the Petén such ceramic supports may be mammiform, but they are otherwise plain. CCC

Brooklyn Museum Annual, VI, 1964–1965, p. 27

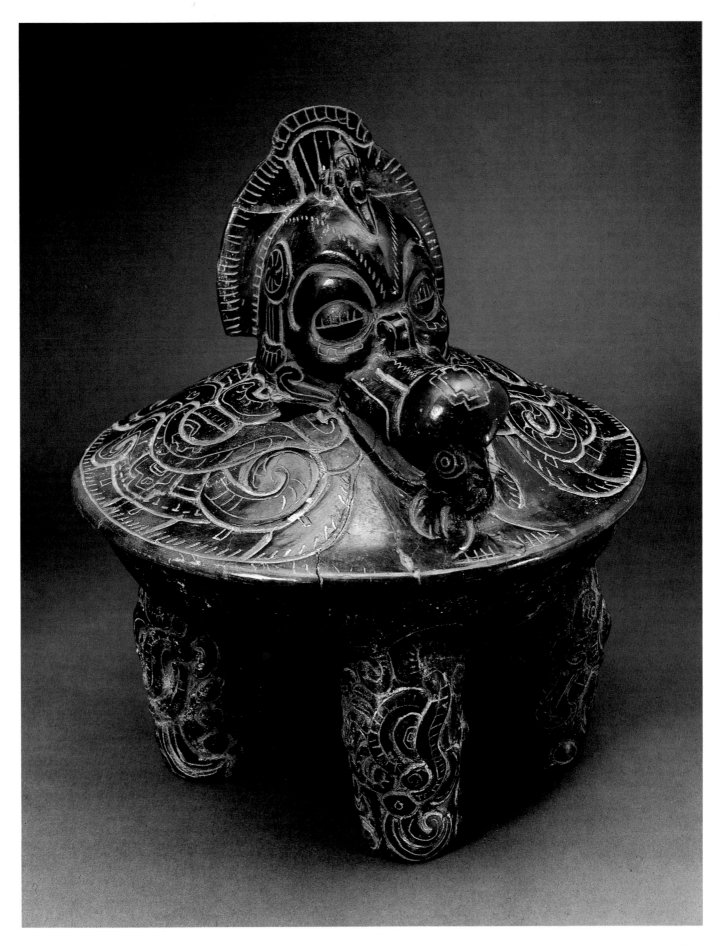

27 Carved cache bowl lid
Tikal, Petén, Guatemala; Structure 7F-30, Burial 132
Ceramic; red pigment
D. 48.3 cm.
Early Classic (c. A.D. 550)
Museo Sylvanus G. Morley, Tikal 3B-4/4

The young man in Burial 132 was probably the direct descen-
dant of an important man found in a nearby tomb, since he was
interred axially above him. His burial contained many anoma-
lous elements which, like this cache vessel lid, probably came
from an earlier disturbed cache. Worked after firing, this crisply
carved quatrefoil medallion contains an emblematic skeletal
Long Nose Head that is identified with the Underworld by the
small circles meaning "bone," by the three-part earflare, by the
crosshatched spots and pupil, and finally, by the bar and two
circles that identify the head with the patron god of number 7,
who is the Underworld jaguar. The five surrounding glyphic
cartouches may amplify this concept, and possibly refer to the
caching ritual itself, which in this case may have involved the
depositing of marine materials, flint and obsidian "eccentrics,"
raw jade, and a jade and shell mosaic—although it is not known
if the lid was carved for the original cache or for the later
burial. CCC

W. R. Coe, 1965*b*, cover

28 Fluted tripod vessel with lid
Tayasal, Petén, Guatemala; Burial T12B-1
Ceramic; slipped brown-black
H. 16 cm.
Early Classic (A.D. 450–550)
Museo Nacional de Arqueología y Etnología,
* Guatemala 9993 a, b*

On the lid of this elegant black vessel a spiraling fluted design
contrasts with a circular incised pattern of intertwined, lobed
scrolls with interior hooks—the latter worked with less assur-
ance than the subtle modeled grooves. The knob handle and
each of the tripod feet have spiral vents and a ball inside caus-
ing the vessel to rattle with two different sounds when it is
picked up. CCC

A. F. Chase, 1984*b*

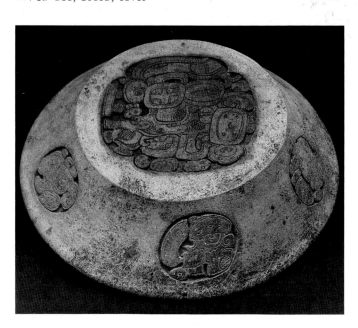

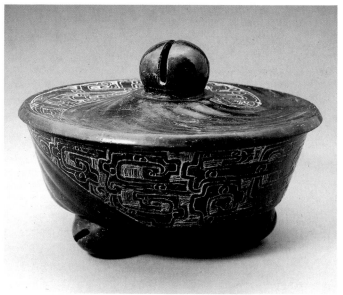

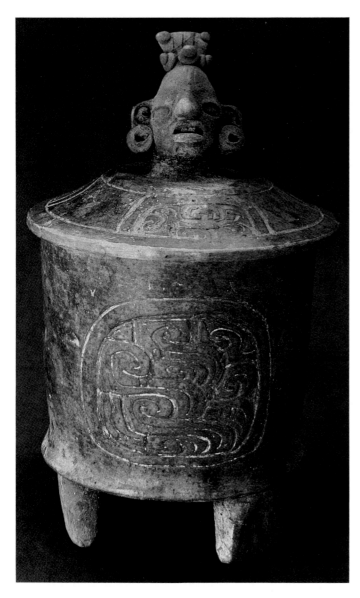

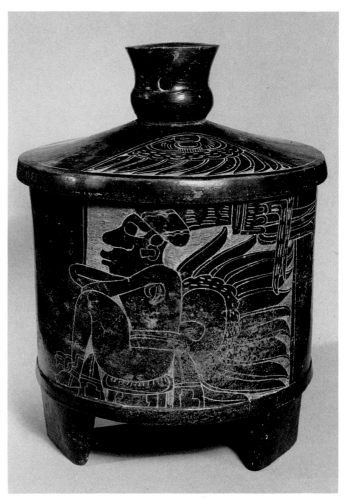

29 Cylinder tripod with head knob lid
Tikal, Petén, Guatemala; Structure 5D-34, Burial 10
Ceramic; slipped orange, postfire white, red, and
 yellow pigments
H. 22 cm.
Early Classic (A.D. 400–450)
Museo Sylvanus G. Morley, Tikal 12C-477a, b/34

Lidded cylinder tripods were among the most important funer-
ary vessels early in the fifth century at Tikal, and there were
seven among the thirty-two vessels in the tomb of this ruler,
Curl Nose. Two were imported from outside the area, and
three of the locally made examples had been stuccoed and
painted, whereas two—including this one—were carved with
serpentine medallions below a human head that served as a
knob for the lid. The composition of scrolls and hooks which
fills these five medallions derives from local polychrome serpent
imagery, but on the fashionable monochromatic pottery these
designs lost much of their meaning. CCC

30 Cylinder tripod with lid
Northern Petén (?), Guatemala
Ceramic; slipped brown-black
H. 23.2 cm.
Early Classic (A.D. 450–550)
Dumbarton Oaks, Washington, D.C. B-590.70.MAP

Incised in a strikingly un-Maya style, this cylinder tripod is re-
ported to have been one of many from a single tomb. The two
figures wearing feather backdresses are too large for their fram-
ing panels; they are seated on two different kinds of stools, with
their feet planted on the ground and their arms, folded in sub-
mission, resting on their knees. Since elite figures are never
shown sitting this way in lowland Maya art, these two may be
high-ranking captives depicted as foreign by their thick, pro-
truding lips, large noses, and feathered turbans. CCC

M. D. Coe, 1975, no. 1

31 Jade plaque with inscription
Campeche (?)
Jade; red pigment
H. 10.2 cm.
*Early Classic (*A.D. *400–500)*
Dumbarton Oaks, Washington, D.C. B-157.MAJ

This beautifully incised jade plaque was reworked without regard for its initial carving, and it may have once been worn as a pendant on the ceremonial belt of a Maya ruler. The two glyphs in the cartouche are detailed with engraved crosshatching and faint depressions in a late Early Classic style, and they are allegorical rather than historical since they are head glyphs for the *tun* and for the *uinal*, the 360-day year and 20-day month. Possibly the most interesting aspect of this piece was its reshaping, during which it was turned upside down and shallow pits were drilled for eyes, notches made for shoulders, grooves for fingers, and legs were indicated by a perforation and a string-sawed groove. This could only have taken place in Costa Rica, where such simple figural forms were worked, and where a number of inscribed Early Classic Maya jades like this example appeared in the fifth century A.D. CCC

Lothrop, Foshag, and Mahler, 1957, no. 117, p. 252, pl. 68, top

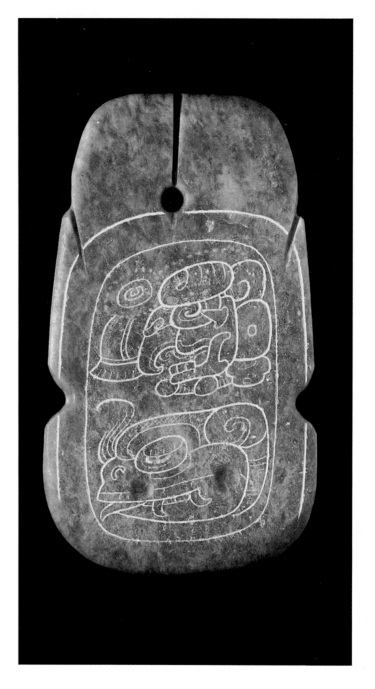

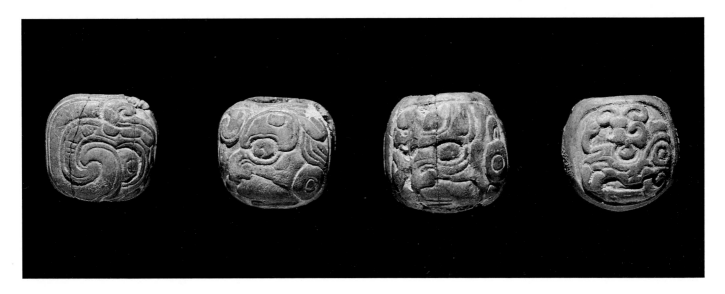

32 Four carved beads
Yucatán (?)
Bone
H. 2.6 cm. (maximum)
Early Classic (c. A.D. 550)
Dumbarton Oaks, Washington, D.C. B-192.MAL

Each of these four bone beads has a glyph carved on one side.
They are hollow, made by gluing together two carved pieces,
possibly from small mammal skulls. Since such carved beads are
otherwise unknown, it is very likely that these came from a sin-
gle archaeological context, and that others may not have been
salvageable. Nevertheless, it is surprising that two, possibly
three, different carving and glyphic styles should be represent-
ed. The two "human" head glyphs (left to right) are very similar
in their softly rounded relief and in having prefixes; whereas
the "bird" medallion, with its skeletal lower jaw and decorated
scroll eyebrow, is in a different scale, has a higher, more pol-
ished relief, and is more heraldic than glyphic. The fourth, a
coiled serpentine form with an eye, is stylistically similar to the
two large heads. These might have been part of a personified
Initial Series sequence. CCC

Handbook, Bliss Collection, no. 71

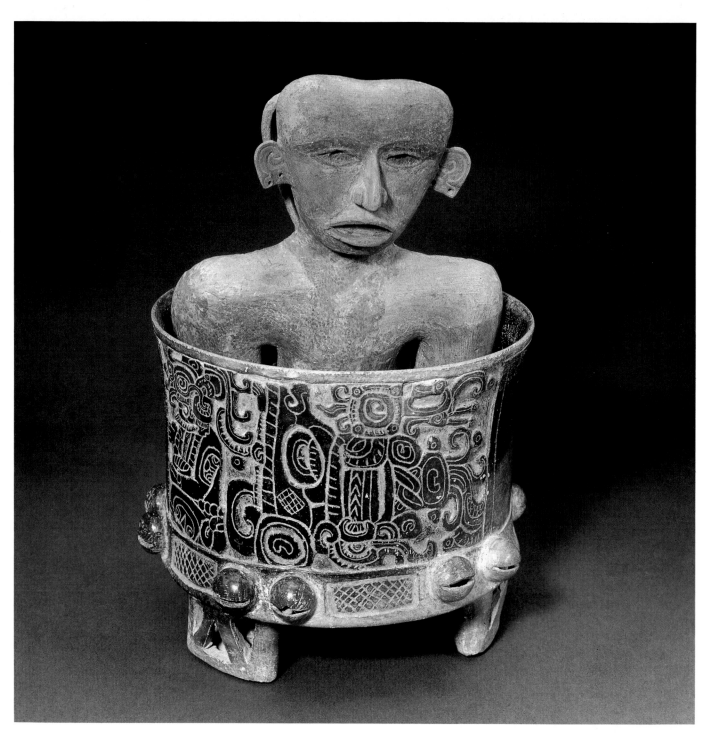

33 Tripod vase with figurine and cache
Becán, Campeche; Structure XIV
Ceramic; buff figurine, dark gray bowl
H. 27.5 cm. (overall)
Early Classic (A.D. 500–600)
Museo Regional de Antropología, Mérida X-196-1-42

This unusual ceramic assemblage from Becán was probably cre-
ated and cached in Structure XIV between A.D. 500 and 600 to
dedicate an ancient rebuilding project. Originally the hollow fig-
urine encased ten solid and smaller figurines and many pieces
of ceramic appliqué, jade, and shell. When the cache was found,
the front half of the large hollow figure was broken (now re-

paired), and much of its contents had fallen into the vase and
surrounding rubble.

This cache brings together two major Pre-Columbian styles.
The vase is a beautiful and typical example of Early Classic
Maya ceramics; the figurine is created according to stylistic
principles prevalent at the Mexican site of Teotihuacán, more
than 1,000 kilometers west of Becán. It is important to realize
that this assemblage reveals clear intentions on the part of its
makers to represent two distinctive styles—one local and one
foreign. There is little question that the Maya had close ties
with the highland peoples of central Mexico since there are
many artifacts—including this Becán cache—that make it clear.
Although the Becán figurine is stylistically different from its

Maya vase, the solid figures encased within it present an interplay between Mexican and Maya iconography. If one were to expand the idea of "Mexican" to include neighboring cultures beside that of Teotihuacán, the cache could be understood as a statement of "internationalism."

In addition to the obvious contrast represented by the hollow figure and the pot, the emblems and costumes of the solid figurines found inside the figure evoke several different cultural affiliations. A whimsical owl with a star shield on its breast and a goggle-eyed frontal figure with its large plumed headdress unmistakably refer to the iconography of Teotihuacán. Joseph Ball identifies this piece as a "Tiger Knight," calling the beaded and feathered headdress a jaguar's head. One could as easily see it as a bird or serpent and also compare it to the headdress worn by the figure on Stela 7 from Piedras Negras (No. 85). Four of the other Becán figurines, shown in profile, wear costumes—helmets, belts with large knots and back pendants, and knee ruffs—associated with warriors. Such depictions can be found throughout Mesoamerica and are difficult to associate with any one culture. Two profiled warriors with turban-like headdresses appear to be Maya by their iconography, and Ball considers the two other profiled figures with sectioned headdresses to be Maya as well. Three frontally posed figures, holding round shields, can be compared iconographically to the cultures of Oaxaca and Veracruz. Both the rectangular forms of the headdresses worn by the two smaller figures, and the asymmetrically shaped bird headdress of the larger one are, provocatively, worn not only by warriors but by women. At El Zapotal, Veracruz, depictions of women wearing this rectangular type of headdress are also shown with their eyes closed, like these pieces.

The small solid figures within the Becán cache should be understood as representing groups or organizations whose membership reached beyond local and cultural borders. Still, these figurines were placed within a figure whose stylistic and iconographic precedents are from central Mexico. In turn, the hollow figure was placed inside a vessel that is Maya in style and iconography.

This assemblage depicts in microcosm what archaeology has suggested to be true for the macrocosm: within the two major cultures extant during the Early Classic—the Maya and Teotihuacano—there existed several cultures of more regional and diversified character. Nonetheless, there was some sort of Mesoamerican hegemony. Whether this was based on military might, the economics of trading, or religious ideals is not clear. FC

Ball, 1974

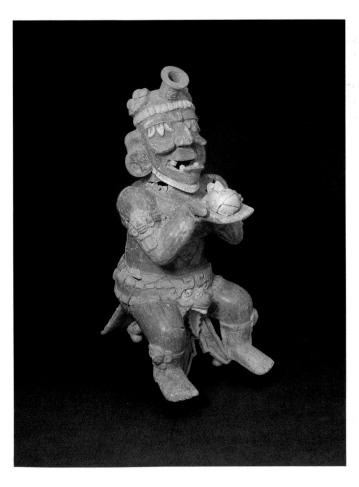

34 Old God effigy censer
Tikal, Petén, Guatemala; Structure 5D-34, Burial 10
Ceramic; slipped orange and black on white
H. 36 cm.
Early Classic (A.D. 400–450)
Museo Sylvanus G. Morley, Tikal 12C-508a, b

This Old Fire God censer presided over the North Acropolis tomb of a ruler at Tikal who was also accompanied in death by nine other individuals, a headless crocodile, and a variety of birds. The Old Fire God is probably the most ancient Mesoamerican deity, and he was particularly important to the southern and highland Maya, whose tastes and practices were clearly evident in this lowland tomb. He lived beneath the earth and personified the sun in the Underworld. The Tikal effigy censer emphasizes these associations by the sun (*kin*) emblems on his head, his solar beard, aquiline nose, trident eyelids over sightless eyes, and by the three night jaguar (*ix*) spots on his earflares. There is also a skull carved on the smoke spout, and the tripod legs of the stool are femur-shaped.

As lord of the Underworld, this macabre figure, while chortling over a head held in his upraised hands, wears jewelry that includes masks at his calves and upper arms and a loincloth apron that hangs from the head of an Underworld bird with a blood-letter tongue. The tail feathers of the bird hang below a back shield, or mirror, with a U upon it. CCC

W. R. Coe, 1967, p. 60

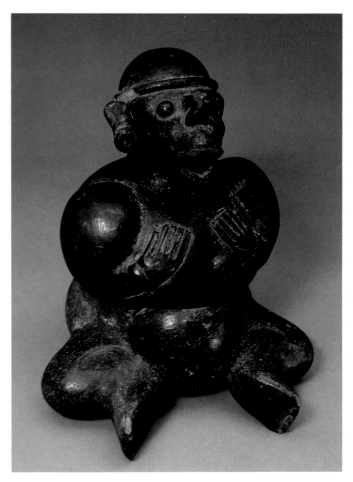

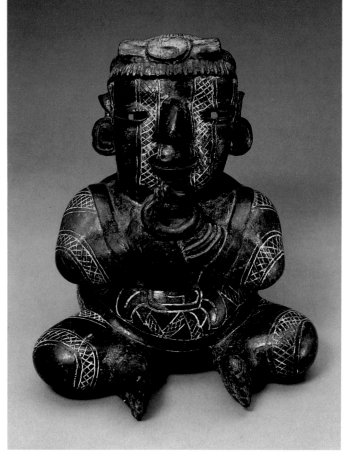

35 Monkey effigy censer
Uaxactún, Petén, Guatemala; Structure A5, Burial A20
Ceramic; slipped brown-black
H. 21.6 cm.
Early Classic (A.D. 400–450)
Museo Nacional de Arqueología y Etnología,
 Guatemala 200a, b

Like the effigy censer in a tomb placed symmetrically with this one in Structure A5 at Uaxactún (No. 36), this monkey vessel was once filled with copal. Smoke from the burning incense would have poured from the protuberant mouth and from a hole at the top of its head. The two-part effigy appears to be female and is probably pregnant, a condition that may symbolize the impending period which the dead Maya lord must spend in the Underworld before his rebirth and apotheosis in the sky in emulation of the sun. CCC

R. E. Smith, 1955, pp. 85, 86, fig. 11k

36 Human effigy censer
Uaxactún, Petén, Guatemala; Structure A5, Burial A22
Ceramic; slipped black with white pigment
H. 22.9 cm.
Early Classic (A.D. 400–450)
Museo Nacional de Arqueología y Etnología,
 Guatemala 214a, b

This enigmatic figure, and another like it from the same tomb, seem to represent pregnant women, although it is usually men who have knots at the waist where their loincloths are tied. The gesture made by this figure—a circle formed by the left thumb and index finger while the right hand grasps the left wrist—is of unknown significance. However, in view of her apparent pregnancy, the knots at the waist and forehead, and the circularity of gesture, it is possible that this rotund figure symbolizes the life cycle of the man in the tomb, while the pregnancy implies both the beginning and the end of cycles and predicts the rebirth of the dead man. There are crosshatched vertical stripes on the faces of both human effigies from this tomb. Such stripes are also found on the face of the later Mexican deity Xipe Totec, a god associated with agricultural regeneration, and such stripes may have a similar meaning here. This modeled and incised two-part vessel has thin walls, and the eyes, nose, and mouth are pierced, with openings made at the back of the head as well. These perforations emitted light and smoke from the burning copal incense which once filled the lower vessel and darkened the interior of the lid with soot. CCC

R. E. Smith, 1955, pp. 85–86, fig. 5e, i

37 Tubular bead
Altun Ha, Belize; Tomb A-1/1
Jade
L. 13.2 cm.
Early Classic (A.D. 450–550)
Royal Ontario Museum, Toronto RP 200/125

A rough-hewn chert container in the southwest corner of Tomb A-1/1 held about one hundred worked jade, pearl, and crystalline hematite objects, including this unusually large tubular jade bead that has an unexplained groove along one side. CCC

Pendergast, 1979, p. 63, fig. 21f

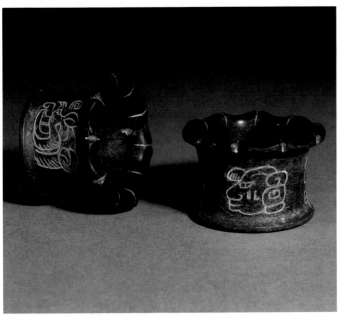

38 Incised earflares
Altun Ha, Belize; Tomb A-1/1
Obsidian
D. 4.4 cm.
Early Classic (A.D. 400–500)
Royal Ontario Museum, Toronto RP 200/1a, b

The middle-aged man who possessed these fluted and incised earflares also had the remains of a stuccoed and painted codex, ceremonial flints, and nearly three hundred jade objects in his richly furnished tomb. The cinnabar-filled inscription on the spools apparently states that these were the earflares of a Maya lord whose names and titles included a bat head, but it is unlikely that this refers to the entombed person since the style of the inscription suggests it was carved a century before his interment. One of these exquisitely thin, ground, fluted obsidian flares was broken and mended in ancient times. The Maya did not ordinarily utilize obsidian for such ornaments; in fact, it was almost a millennium later before such workmanship became common, and then it was found in central Mexico. CCC

Pendergast, 1979, pp. 61, 79, 80, fig. 18d, e

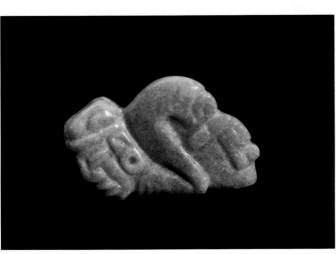

39 Hunchback pendant
Altun Ha, Belize; Tomb A-1/1
Jade; red pigment
W. 4.4 cm.
Early Classic (A.D. 450–550)
Royal Ontario Museum, Toronto RP 200/12

Carvings that depict hunchbacks have been found in caches at Copán, Quiriguá, and in central Honduras; this one comes from a rich tomb at Altun Ha. The deformed figures with oversized heads wear only a loincloth and, as here, often have a cap with a curled peak. They may represent an earlier manifestation of the unexplained but significant role of dwarfs, which during Late Classic times are represented on monuments and painted ceramics. CCC

Pendergast, 1979, p. 62, fig. 19k

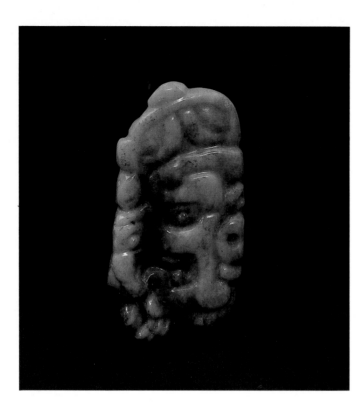

40 Long Nose Head pendant
Altun Ha, Belize; Tomb A-1/1
Jade; red pigment
H. 6.4 cm.
Early Classic (A.D. 500–550)
Royal Ontario Museum, Toronto RP 200/33

Like the obsidian earflares (No. 38), this jade pendant comes
from a mid-sixth-century tomb at the center of Altun Ha. The
nearly three hundred jade objects found in this tomb attest to
the great wealth of Altun Ha at the time, and this piece exem-
plifies the characteristic low-rounded relief of the local jade-
carving style. A profile of a bearded Long Nose Head is
represented with a hook in its eye signifying Underworld affili-
ation, as does the *Akbal*, or darkness, emblem on its forehead—
an element that may denote an obsidian mirror. The back of the
Long Nose Head was hollowed out and, for burial purposes, the
cavity had been packed with cinnabar, which coated most of the
brilliant green jade in this sumptuous funerary
assemblage. CCC

Pendergast, 1979, p. 63, fig. 19m

41 Two jade earflare assemblages
Lamanai, Belize; Caches N9-56/5, N9-56/6
Jade
D. 2.7 cm. (earflare maximum)
Early Classic (c. A.D. 500)
Lamanai, jade earflares LA 446/13, LA 447/8; flanged tubes
 LA 447/7 a, b; perforated beads LA 447/9, 10

One of these speckled jade earflares came from a cache that was
placed on the axis of the great Lamanai pyramid with flanking
masks, Structure N9-56. The matching flare and the flanged
tubes and perforated bead danglers, which were probably part
of two ear-ornament assemblages, came from a nearby related
cache. There they had been stained by iron pyrite from disinte-
grated mosaics that originally also included jade and shell ele-
ments. Tiny, matched perforations at the plain ends of the thin
ground tubes were for the attachment of counterweights—possi-
bly the irregular perforated beads. Such weights would have
held the opposite, flanged end of the tube securely against the
face of the earflare and held the flare against the earlobe,
through which the shank of the tube passed. CCC

Pendergast, 1981a, p. 40

42 Dancer pendant
Altun Ha, Belize; Cache B-4/13
Jade
H. 10.5 cm.
Early Classic (A.D. 500–550)
Royal Ontario Museum, Toronto RP 371/5

Dancing movement is suggested by the twist in this figure's
body as he turns his head backward, raises his right knee in
front, and holds up an object in his left hand. The pendant is an
excellent example of a jade-carving style at Altun Ha which em-
ployed a low, rounded relief with sinuous, ambiguous, possibly
vegetal forms—shown here in the elongated object he holds, a
leaflike skirt, and in his ill-defined headdress. The carved jade
pendant was the most striking component of this particular
cache, and it may have been the earliest ritual deposit in the
famous Structure B-4, which contained the "Sun God's
Tomb." CCC

Pendergast, 1982*b*, p. 47, fig. 31a

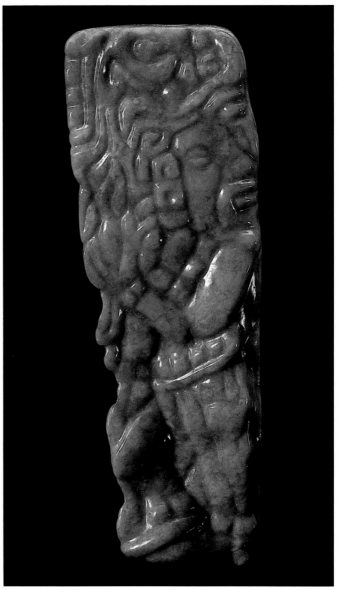

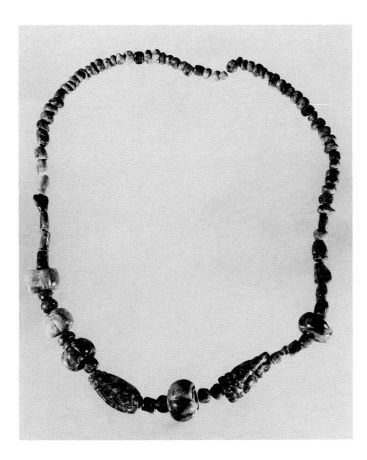

43 Bead necklace
Lamanai, Belize; Tomb N9-56/1
Jade
L. 4.9 cm. (bird-head bead); 45.8 cm. (overall)
Early Classic (c. A.D. 500)
Belize Department of Archaeology, Belmopan 32/196-1:83

Mostly brilliant green, these jade beads belonged to a man
whose entombed body, painted red and coated with clay, had
been seated in a red cloth-shrouded enclosure. His tomb was
built near the base of the mask-flanked stairway of Structure
N9-56. The beads vary in form and finish; they include three
lobed and one square in addition to three that were carved into
animal and shell shapes. The longest of these has a large-beaked
bird head carved on one side and perhaps a crocodile on the
other. The second is an *oliva* shell shape, and the third resem-
bles a small gastropod. CCC

Pendergast, 1981*a*, p. 39

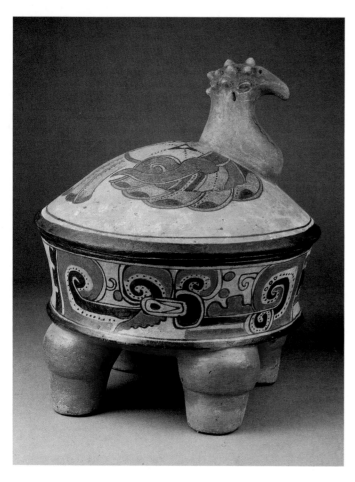

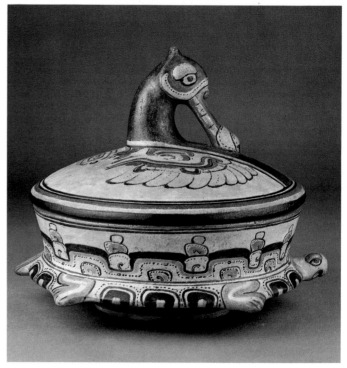

45 Turtle flange bowl with water-bird lid
Tikal, Petén, Guatemala; Structure 5D-88, Tomb 1
Ceramic; slipped black, red, and orange on buff
D. 16.5 cm. (lid)
Early Classic (A.D. *350–400*)
Museo Nacional de Arqueología y Etnología, Guatemala
* MPA-173a, b*

Smaller than most basal flange bowls with lids, this polychrome effigy vessel is extraordinary for its modeled flange which, in portraying a turtle, denotes the lower realm in the three-part Maya worldview. The turtle swims in water that is represented by the dotted serpentine forms painted on the wall of the vessel. Above, the lid is presented as a modeled, crested water bird with painted serpent-bird wings; water birds, masters of the sky and of terrestrial waters, are frequently depicted on burial offerings. CCC

44 Tetrapod bowl with turkey lid
Tikal, Petén, Guatemala; Structure 5D-88; Tomb 1
Ceramic; slipped black, red, and orange on buff
D. 22.5 cm. (lid)
Early Classic (A.D. *350–400*)
Museo Nacional de Arqueología y Etnología, Guatemala
* MPA-175a, b*

The knobby head and neck of an oscillated turkey serve as the handle for this sturdy four-legged vessel. The turkey's variegated feathers with "eyes" at the tips are painted on the domed lid, and an Underworld "hook-eye" on each wing further identifies this as a serpent-bird. Panels painted on the body of the vessel have dotted serpentine scrolls that suggest Underworld water symbolism. This polychrome tetrapodal, effigy-lidded bowl may be older than the other two from Tomb 1 (Nos. 45 and 46), which was located in a temple on the east side of the "Lost World" group at Tikal. CCC

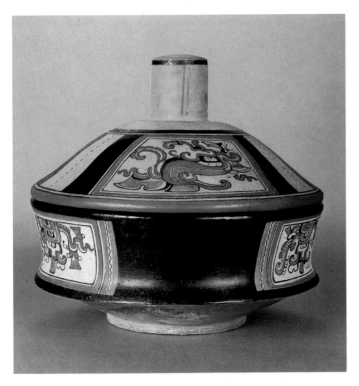

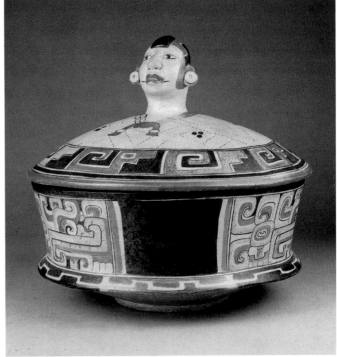

46 Bowl with lid
Tikal, Petén, Guatemala; Structure 5D-88, Tomb 1
Ceramic; slipped black, red, and orange on buff
D. 23.5 cm. (lid)
Early Classic (A.D. *350–400*)
Museo Nacional de Arqueología y Etnología, Guatemala
 MPA-174a, b

During the fourth century A.D., large, heavy polychrome bowls
with lids were the most important funerary vessels. The three
included in this exhibition from a single tomb in the "Lost
World" group at Tikal are all early variations on the form. This
beautifully preserved bowl lacks the prominent basal flange that
was typical of later examples. Instead, the panels painted on the
curving wall of the vessel continue on to the basal projection. A
serpentine head is painted on each panel of the lid. These face
right, with a "hook-eye" and a magnificently scrolled "eye-
brow," an "egg tooth" at the front of the recurved upper jaw,
and a scroll at the inner corner. The panels on the wall of the
vessel have abbreviated, symmetrical Long Nose Head em-
blems. These allegorical compositions are painted in clear,
strong reds on the pale buff of the body of the vessel, and con-
trast strikingly with the lustrous black that was one of the great
achievements of Petén potters. CCC

47 Basal flange bowl with head knob lid
Tikal, Petén, Guatemala; Structure 5D-84, Tomb 2
Ceramic; slipped black, gray, red, and orange on cream
D. 25.8 cm. (lid)
Early Classic (A.D. *350–400*)
Museo Nacional de Arqueología y Etnología, Guatemala
 MPA-086a, b

Elegant and aristocratic, the modeled head of a Maya woman
rises above this domed lid, which in itself forms her ample
body, clothed in a patterned *huipil* bordered by a wide step-fret
band. She also wears a knotted necklace. The bowl is a typical
Tikal basal flange vessel with brilliant serpent-head polychrome
panels that alternate with black, and with an angular, undulat-
ing design on the basal flange which probably refers to the wa-
ters of the Underworld. This vessel and its tomb may be of
later date than Tomb 1, which was located directly south of it,
in the eastern range of the "Lost World" group. CCC

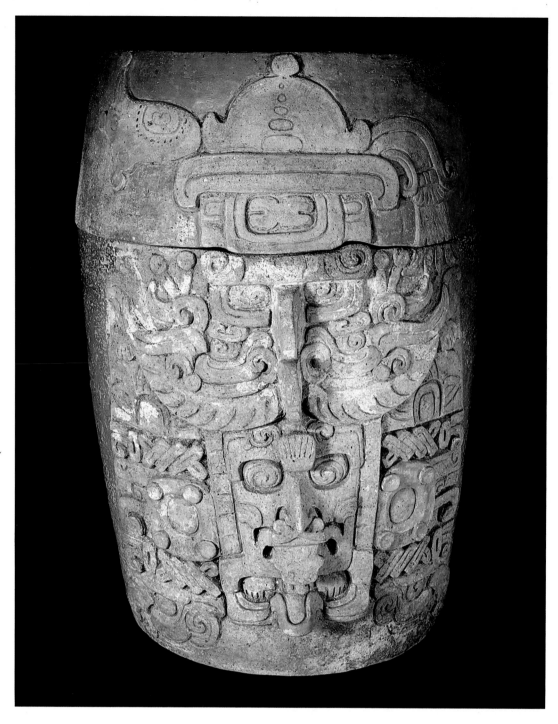

48 and 49 Lidded urns
Site unknown
Ceramic
H. 47.5 cm.; 49 cm.
Early Classic (A.D. 250–550)
Recinto Prehispanico, Fundación Cultural Televisa A.C.
 R-21 P.J. 180; 181

These urns formed a pair and may bear some comparison with the paired tetrapod altars 9 and 10 (see No. 18, Altar 10) from Kaminaljuyú. It was suggested that the stone altars were composed and carved to follow the tenets of the miniature-scaled sculptures of ceramic and bone. For these urns, a similar trans- ference has taken place, but here the ceramic forms bear a monumental image associated with the architectural stucco sculpture found on Early Classic structures—that is, symmetri- cally composed masks or heads bearing intricately detailed ear- plugs and headdresses. Furthermore, the designs have been applied to the body and lidded tops of the urns in a way that is visually suggestive of applied stuccowork. Unlike the tetrapod altars' wraparound designs, the images on the urns occupy only that portion of their perimeters that can be seen without having to turn the pieces. The barrel-shaped urns were constructed and the designs were applied when the clay was leather-hard. It was not until *after* the appliqué work was done that the lids were cut from the barrel bodies.

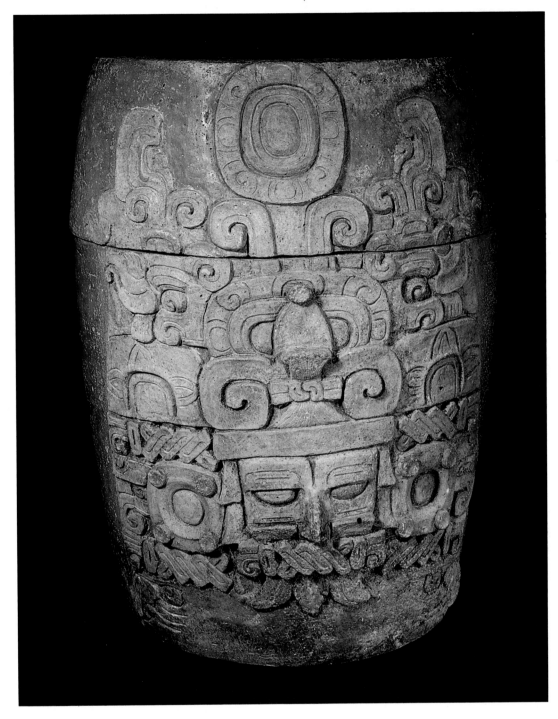

For both urns the iconography appears to be remarkably complex. The image of No. 48 is made up with head-upon-head and face-within-face. The main face is a grotesque with sharp, deep incisions that outline the large eyes and nostrils and mark the cheek creases framing the distended mouth. This was probably a convention for showing age. The brow frets and spiraled pupils suggest that this is a celestial deity (possibly the sun or Venus) in his aged, western, nighttime, and Underworld aspect. Appliquéd to the lid, the uppermost motif is the graphemic "quadripartite badge" that supposedly refers to the earth (the shell), the sky (the pendent crossed bands), and man (the central element, which here looks more mammiform than its usual phallic shape). The supporting base for these elements is the

kin sign, meaning day or sun. Although the style and composition are the same on both urns, the earplug assemblages are the only matching motifs. On No. 49 the main rectangular face, or mask, is more schematic. The eyes and aquiline nose are realistically modeled, but the forehead is cleft, the eyebrows and cheeks lightly engraved, and a graphemic motif of a mat and three-part blunt scroll substitute for the mouth and chin. Compared to No. 48, this face seems youthful, and since it is paired to the old celestial deity, it is reasonable to assume that this is the same celestial deity, but depicted in his youthful, eastern, and daytime aspect. FC

127

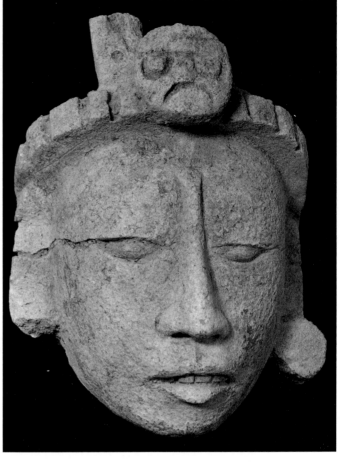

50 Profile head
Palenque, Chiapas
Polychrome stucco
H. 14 cm.
Late Classic (A.D. 550–800)
Museo Nacional de Antropología, Mexico 5-1048

In their representations of humans, the sculptors of Palenque achieved a level of mimetic reality even while conjuring an ideal; and in the aesthetic ideals of the "classic" Maya profile represented in this piece, one can still sense the uniqueness of an individual. In this profile of a human male head, one can see beneath the cosmetic addition to the bridge of the nose the actual physiognomy of the person portrayed. Cranial deformation was another sign of beauty and class. FC

Soustelle, 1967, fig. 86

51 Stucco head
Origin unknown
Stucco; traces of red pigment
H. 27.5 cm.
Classic (A.D. 250–800)
Museo Nacional de Antropología, Mexico 5-3688

This subtly modeled sculpture displays a remarkable knowledge of the internal forms of the head. The eyes gaze downward and the mouth is slightly open, exposing the front teeth. The slack lower lip is a characteristic of the Maya profile. The aquiline nose has been extended up between the brows. Apparently, the elongated nose was considered a sign of beauty and nobility, as most portrayals of Maya elite have this feature. Because some sculptures show the natural profile along with an artificial nose extension, it is likely the latter was an actual cosmetic practice and not a sculptor's convention. Wood, clay, or beeswax have been suggested as materials for the false noses. Here, the youthful face, once painted a deep red, wears a headband of square beads with a central medallion of a schematic (perhaps glyphlike) face with a downturned mouth. The top and back of the head have been mutilated, probably when it fell or was pulled from its original setting. FC

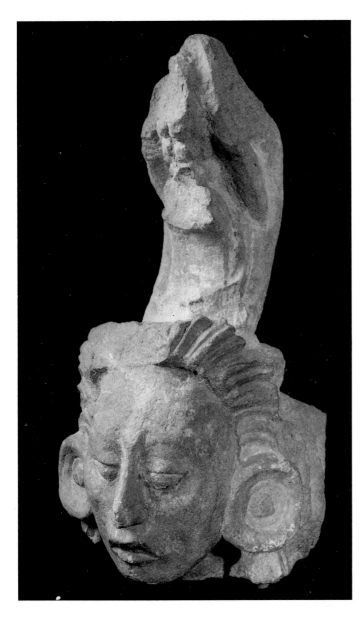

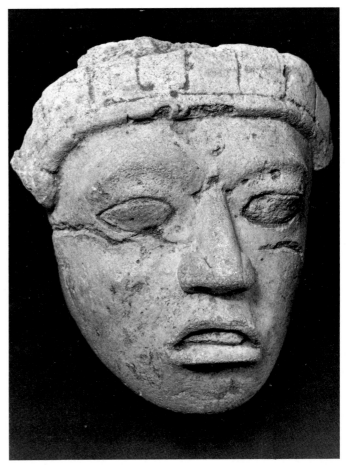

53 Stucco head
Palenque, Chiapas (?)
Stucco; traces of red pigment and blue paint
H. 31.6 cm.
Late Classic (A.D. 550–800)
Museo Nacional de Antropología, Mexico 5-1121

Wearing a square-beaded headband, this larger-than-life stucco head is quite similar to No. 51, even to the way it was broken from its original mounting. It appears, however, to have been more hastily done, with little attention to the underlying forms. The eyes are outlined by incisions, and the pellets applied to form the nostrils are not carefully integrated into the nose—the pellet outlines still show. The front teeth revealed within the slightly opened mouth have no separations between them. Whatever formal defects we may now see, however, were probably covered over and diminished by paint. There is evidence of red pigment overall, and traces of blue paint around the chin. FC

52 Tenoned head with corn headdress
Copán, Honduras
Green stone
H. 60 cm.
Late Classic (A.D. 550–800)
Peabody Museum of Archaeology and Ethnology,
 Harvard University 95-42-20/C728

This youthful head is carved with a subtlety of form that reflects a clear understanding of the anatomical structure of the cranium. The sculpture belongs to a large group of similar heads which generally functioned in the context of architecture. Designated as youthful maize gods (more because of tradition than scholarship), these heads are characterized by the extended Maya nose and receding chin. Very likely they represent an ideal beauty. Most display large round earplugs, swept back bangs or a headband, and often the scrolling form of a corn plant. On this head, the plant has been broken and repaired. Pal Keleman illustrates it without this detail. FC

Keleman, 1969, pl. 88d

54 Two incised spangles
Altun Ha, Belize; Structure E-1, Tomb E-1/1
Crystalline hematite
H. 2.4 cm.; 2.5 cm.
Late Classic (A.D. 700–800)
Royal Ontario Museum, Toronto RP 30/14, RP 30/18

An ideal of Classic Maya beauty is found on these incised la-
minae of reflective crystalline hematite. In these profiles the tip
of the nose is most prominent, with a browridge and forehead
that recede toward the crown of the head, an effect achieved in
infancy by cranial deformation. Below the nose the open lips
and chin also recede, and the eye—with a marked epicanthic
fold—is indicated by the two curving lines of the lids. Located
in a group of structures south of the center of Altun Ha, this
tomb was particularly rich in spondylus shells, and included 286
tiny items made of jade, shell, pearl, mother of pearl, and crys-
talline hematite. Perhaps they were part of mosaic-covered
wooden objects, or some might have been spangles originally
attached to a backing by perforations like the ones through the
cheeks of these heads. CCC

Pendergast, 1965, fig. 6

55 Three hands
Copán, Honduras; Structures 21 and 22
Stone
H. 23 cm.; 22 cm.; 13 cm.
Late Classic (A.D. 550–800)
Peabody Museum of Archaeology and Ethnology, Harvard
* University 92-49-20/C68; 92-49-20/C69; 92-49-20/C40*

The life-sized hands (a and b) are freely and skillfully carved.
Both were found in the debris of Structure 21. Because they
are both right hands wearing different wristlets, they must have
belonged to two separate figures. Still, they were surely carved
by the same sculptor. The hand gestures seem to be relaxed
and informal, particularly so when compared to the more for-
mally posed hand (c) from Structure 22. This hand, held palm
forward, is turned at right angles from the wrist, a position
similar to the gesture of the "youthful maize god" illustrated by
Pal Keleman, where both wrists are held at waist level and the
right hand of the figure rises sharply from the wrist while his
left hand turns down. FC

Keleman, 1969, pl. 89a

a

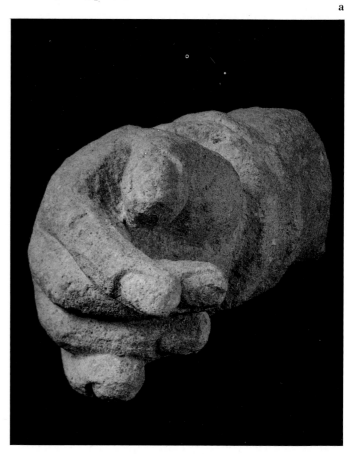

b

c

131

This regal female wears a neck ruff and very large earplugs. Her hair is pulled back and styled to emphasize her ideal profile. It may be that the scarification on her chin was an indication of high status, but it seems certain that hair cut in squared sections along the temple, such as this woman's, was a sign of high or royal status. FC

56 Seated female
Jaina, Campeche
Ceramic; traces of blue and rose paint
H. 15.5 cm.
Late Classic (A.D. 550–800)
Museo Nacional de Antropología, Mexico 5-3919

This piece is modeled and hollow. Some blue paint still remains on the woman's blouse *(huipil)*, and traces of a rose pigment are on her face. It is a representation of an elite personage but with few identifying attributes. The left rear side of her hair and extended foot have been recently replaced. FC

57 Seated female
Jaina, Campeche
Ceramic
H. 14.9 cm.
Late Classic (A.D. 550–800)
Museo Nacional de Antropología, Mexico 5-3543

58 Standing female whistle
Jaina, Campeche
Ceramic; blue pigment
H. 24.5 cm.
Late Classic (A.D. 550–800)
Kurt Stavenhagen Collection, Mexico (INAH) 1612

This female could be considered typical of Jaina mold-cast figurines in presenting the corpulent ideal of feminine beauty. Like many representations of elite persons, this woman's face has been scarified with scroll patterns around her mouth. Her unusual headdress and the flower-like pendant on her forehead may be clues to her identity; otherwise this piece seems to be more of a generalized portrayal of an elite personage rather than a specific individual. FC

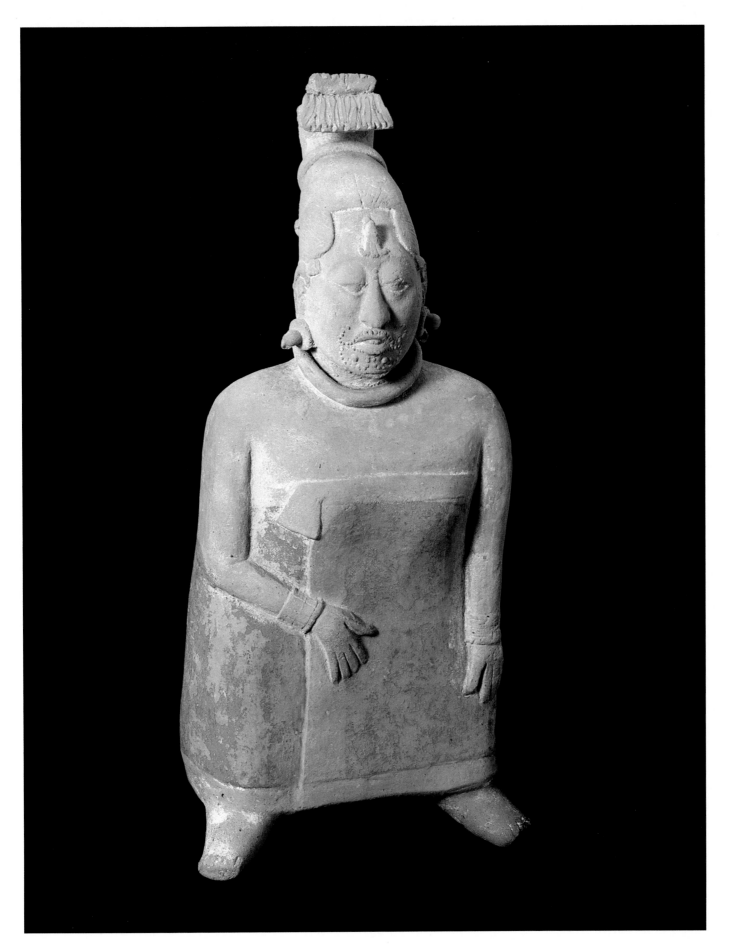

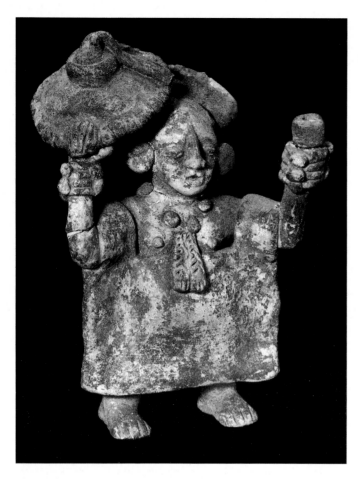

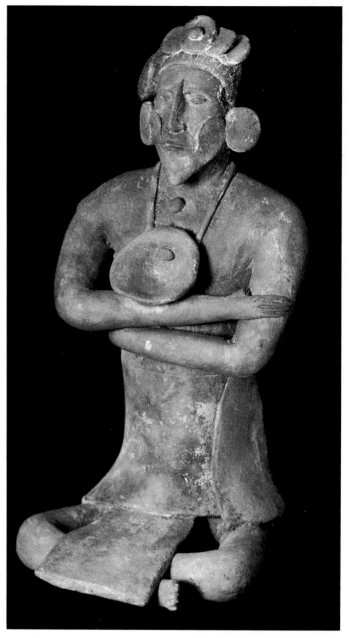

59 Female with hat and cup
Jaina style, Campeche (?)
Ceramic
H. 17 cm.
Late Classic (A.D. *550–800*)
Barbachano Ponce Collection, Mexico (INAH) 304

This female figure has been broken and repaired. She is holding a conical hat in her right hand and a cup in the left. Although some details of this piece show fine craftsmanship, the shift with the large square neckline that reveals the breasts has been rendered to appear ragged and disheveled. As the result of a recent restoration, the hands on this figure have been reversed since this photograph was taken. FC

Fondo Editorial, fig. 269

60 Seated male whistle
Jaina, Campeche
Ceramic
H. 17.9 cm.
Late Classic (A.D. *550–800*)
Museo Nacional de Antropología, Mexico 5-3851

In the corpus of Jaina-style figurines, there are several examples of seated males wearing a large disk necklace hung on a narrow band. The disk has been identified as a concave obsidian mirror useful to seers, but Christopher Corson is probably correct in calling it a large bivalve shell. Other repeated features found in figures of this group are the overlapping disks of the headband and the plain, wraparound kilt with loincloth. Although this figurine has an imposing mien, he is probably not of the highest status and may have been a court attendant. The pose and simple costume may mean that this image-type is repeated often enough to suggest the portrayal of a genre rather than an individual. Within this group the greatest variations lie in the treatment of facial decoration—either different patterns of scarification, or, as here, a stylized (false?) beard. As noted by Corson, such figurines are characterized by a discrepancy between the careful modeling of the head, imparting an expressive power, and the summary treatment of the rest of the body, especially the legs. FC

Corson, 1976, p. 12

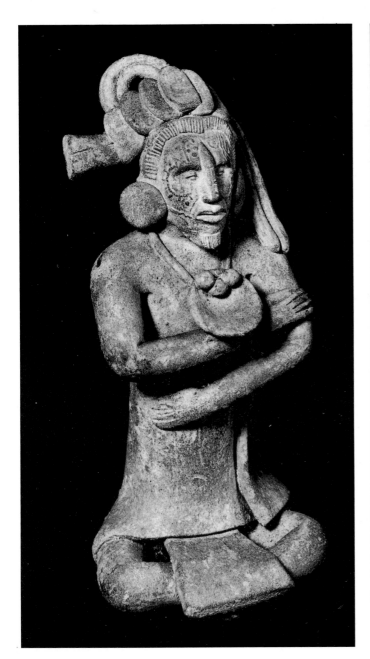

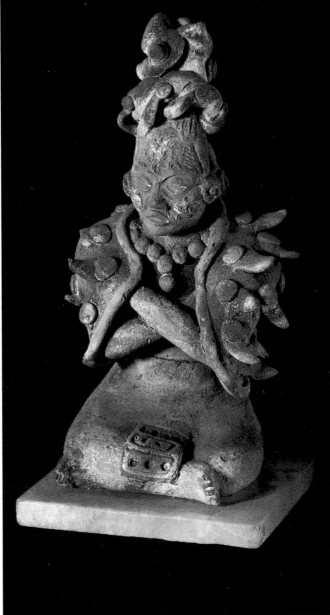

61 Seated male whistle
Jaina, Campeche
Ceramic; blue paint
H. 18.5 cm.
Late Classic (A.D. *550–800*)
Kurt Stavenhagen Collection, Mexico (INAH) 1903

This piece is iconographically the same as No. 60, but is in bet-
ter condition. The asymmetrical headdress is intact, and the
blue paint is well preserved. What distinguishes this particular
male figure are the complex and unique patterns of scarification
all over his face, his neat beard, and the flamelike bangs that
frame his upper face. FC

62 Seated caped figure
Jaina style, Campeche (?)
Ceramic; traces of white and blue pigment
H. 16.5 cm.
Late Classic (A.D. *550–800*)
Barbachano Ponce Collection, Mexico (INAH) 305

This modeled figure of a male resembles an incomplete example
illustrated by Christopher Corson. The cape is decorated with
lappets, and the loincloth that falls over the legs abruptly disap-
pears into the kilt. The facial scarification is unusually rich, cov-
ering the man's forehead and cheeks. Traces of white and blue
pigment are still visible. FC

Corson, 1973

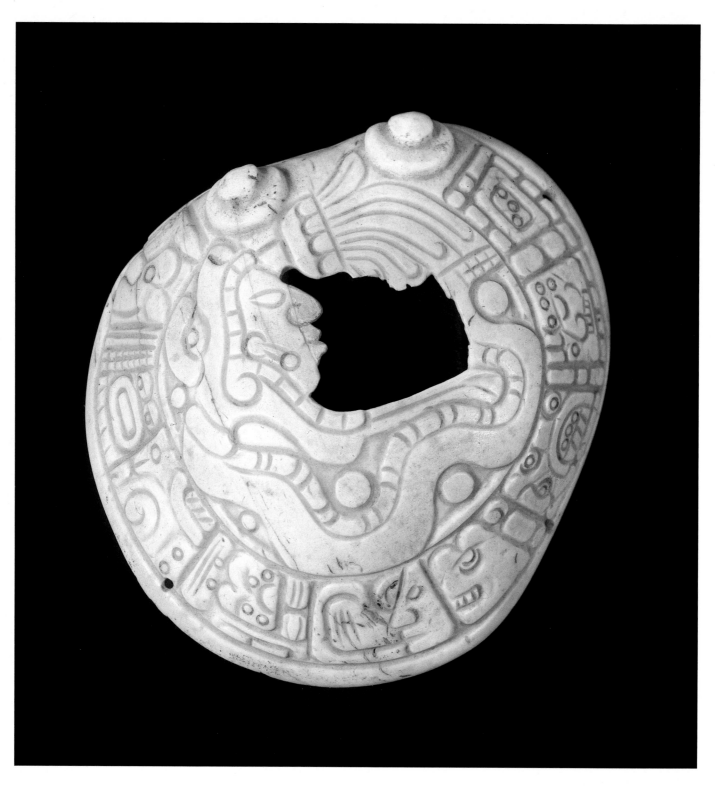

63 Shell pectoral
Site unknown
Bivalve seashell
D. 14.5 cm.
Late Classic (A.D. 550–800)
Kurt Stavenhagen Collection, Mexico (INAH) 2048

This pectoral (probably worn as a necklace against the chest) displays an important icon: a human head within the open jaws of a serpent. The serpent's body undulates along the inner perimeter of the surrounding glyphs, ending in a rattle. The carving was done by cutting, abrasion, and the use of a bone drill for detailing. The glyphs are schematically rendered and therefore difficult to identify with assurance. As there is no clear calendrical information, this inscription may be a ritual phrase or prayer. FC

64 Moon goddess rattle
Jaina, Campeche
Ceramic
H. 21.1 cm.
Late Classic (A.D. 550–800)
Museo Nacional de Antropología, Mexico 5-1449

Holding a circular object in front of her at waist level, this standing female belongs to a large group of similar figurines that are identified by Christopher Corson as the moon goddess. Like this piece, all of the examples Corson chooses to illustrate are mold-made rattles. It seems likely, however, that this woman's elaborate headdress was modeled and added after the molding process. The holes in her armpits and under her headdress are functional fire holes. FC

Corson, 1973

65 Female effigy whistle
Alta Verapaz, Guatemala
Ceramic; unslipped postfire blue paint
H. 14.8 cm.
Late Classic (A.D. 700–800)
Museo Nacional de Arqueología y Etnología, Guatemala 5895
 (Dieseldorff Collection)

The front of this whistle is molded in the shape of a woman who represents a broad-faced ideal of Maya beauty. She has a bow-shaped upper lip, thin nose, and close-set eyes with full lids and high brows on a receding forehead that suggests cranial deformation. Her hair is parted in the middle and falls over her shoulders, which are encircled by a shawl. She is bare-breasted, wears a long wrapped skirt like the Guatemalan highland women of today, and carries a jar in her right hand. This molded whistle suggests the Classic feminine ideal may have involved more than the child-bearing preoccupations evident in Preclassic figurines. CCC

R. E. Smith, 1952, fig. 23g

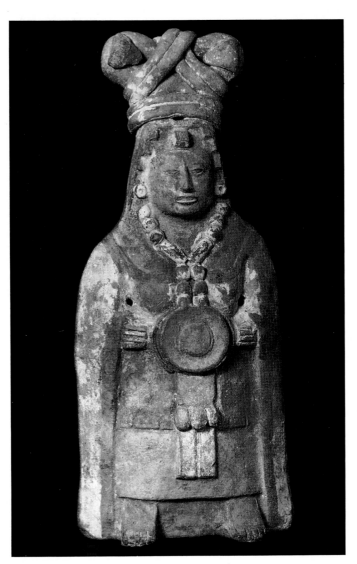

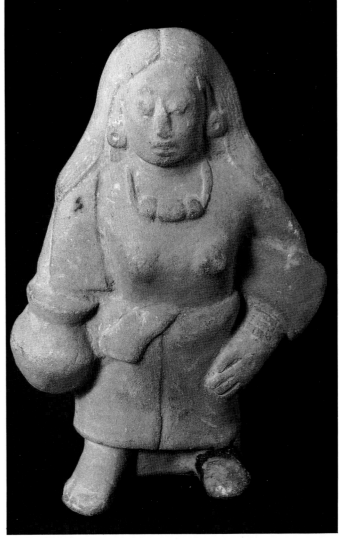

66 Stela 17

Dos Pilas, Guatemala
Limestone
H. 265 cm. (original); 249 cm. (fragment)
Late Classic (c. A.D. 810)
Museo Nacional de Arqueología y Etnología, Guatemala 10374

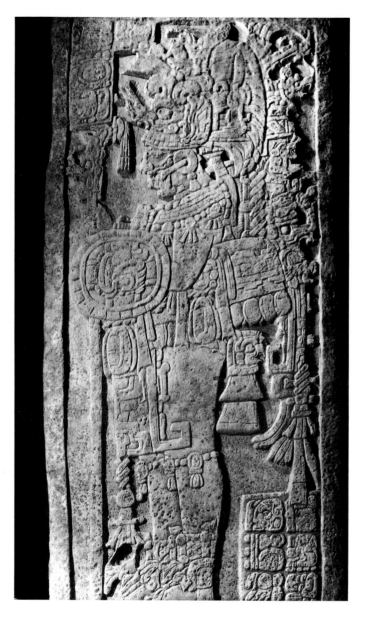

Looters took this stela from Dos Pilas in July of 1971. All but the basal portion was recovered, and, except for this missing section, the relief work on the stela remains in fine condition. A rubbing of the entire stela made before the theft by Merle Greene Robertson shows the basal section to be a pedestal upon which the main figure stood. Carved on the pedestal's side is a small human being depicted as a crouching jaguar.

The main human figure of Stela 17, dressed in a complex and ornate costume, carries a round ceremonial shield in his left hand. In his right hand he has a long staff topped by the grotesque head of God **K** (identifiable by the scrolled protrusion at the front of his forehead). Like the shield, this may be considered a ceremonial weapon. The costume is in many ways typical of Late Classic portrayals of the Maya elite. Three major components are the beaded collar, the headdress with its grotesque mask and panache, and the large, thick belt that supports a complex back ornament.

Hanging from the belt, in the front and the rear, are the loincloth aprons. The front apron is framed by a rigid fret—referred to as a serpent fret—while the rear apron is doubled, one behind the other. The inner part has wide cloth lappets suspended from a bird's head; the outer part, also framed by serpent frets, is attached to the back ornament. The back ornament displays a marvelous collection of fantastic animals. The repeated bird head of the rear apron's inner part is most likely the mythical Moan bird. On the back of the belt rests a long-nosed saurian head with a lily pad and water lily as his forehead or hat. Rising from this plant is a fat little feline with mouth fiercely opened in a roar. A rectangular canopy, probably a structural component of the back ornament, separates the cat from another small beast whose grotesque head emerges from a serpentine mouth; the upper jaw can be seen rising toward the upper right-hand corner of the stela.

The main figure wears beaded garters just below his knees and fancy sandals with heel guards. The artist has been careful to show exactly how the sandals are tied and fastened between the toes. This awareness of detail, and the desire to depict it, can be seen throughout the image. The day 9 *Ahau* is carved in the upper left-hand glyph panel. This is a very brief calendrical statement, but it is possible that this stela dates to 9.19.0.0.0 or A.D. 810. FC

Robertson, 1972, pl. 93

138

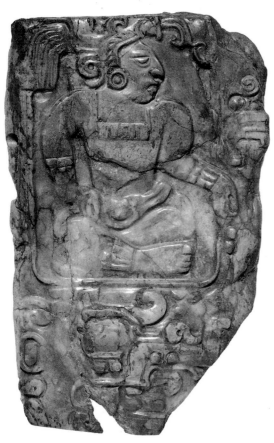

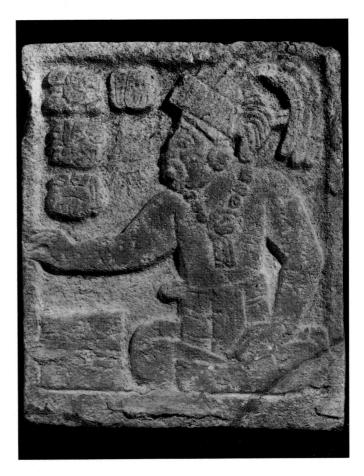

67 Jade plaque
Nebaj style, southwest Maya region
Jade; iron pyrite stain, resin
H. 14.1 cm.
Late or Terminal Classic (A.D. 750–850)
Dumbarton Oaks, Washington, D.C. B-155.MAJ

Jade carvings with this pictorial theme are called Nebaj style after a famous plaque excavated from a tomb at Nebaj in the western highlands of Guatemala. Although it depicts a frontally seated lord who faces left instead of right (as on its namesake), this plaque is made of the same unusual light-blue mottled jade and it has been similarly stained yellow by iron pyrite decomposing from other objects buried nearby. The figure, his right hand firmly set on his knee with elbow out so as to emphasize heavy, rounded shoulders, drops or "scatters" two beadlike objects with his left hand. The crowded feathered headdress has a bell-shaped central element with hair (?) pulled forward through it.

The frame of the niche in which he sits is breached by this gesture just below an outward-facing allegorical profile head, while below the niche there is a large Long Nose Head. The lower head has a three-part earflare and a large eye with two beads at the bottom and a scroll at the top. The snout projects to the right and turns up at the tip, with fangs and the lower jaw just below it. CCC

Lothrop, Foshag, and Mahler, 1957, no. 118, pp. 252, 253, pl. 68, bottom

68 Relief panel
Northern Yucatán Peninsula
Limestone
H. 66.5 cm.
Late Classic (A.D. 550–800)
Barbachano Ponce Collection, Mexico (INAH) 511

The panel depicts an elite male seated cross-legged with his left hand on his left leg and the other hand extended to the panel frame over a box or altar. The minimally clad but definitely regal figure is reminiscent of royal portraiture at sites along the Usumacinta River, especially at Palenque. The carving style of this panel, however, is similar to that of the architectural reliefs from Structure 3C7 of Oxkintok, a site in northern Yucatán. Similarities can be seen in the handling of the facial details—the protruding eyes and thick mouth—and in the almost delicate treatment of the hands. The reliefs from Structure 3C7 also display the same contrast between the plain tubular torso and the more carefully observed outlines of the arms and legs. Gentle curves describe the shoulders, upper arms, and the fullness of the calves as they are drawn into the cross-legged position. This panel may be the capstone reported by Henry Mercer in 1896, and mentioned by H. E. D. Pollock as now missing from Structure 3C7. FC

Mercer, 1896, p. 63; Pollock, 1980, p. 304

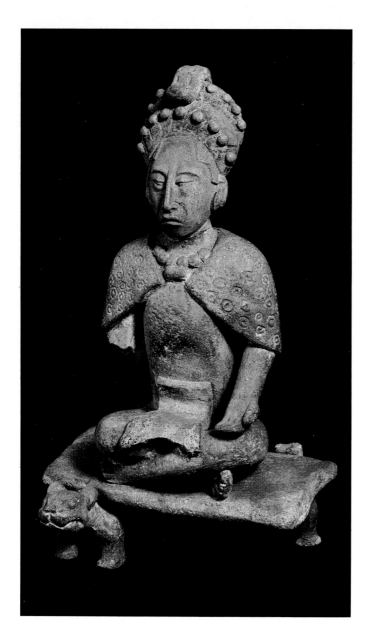

69 Figure seated on a jaguar throne
Jaina, Campeche
Ceramic; red and blue pigments
H. 26 cm.
Late Classic (A.D. 550–800)
Kurt Stavenhagen Collection, Mexico (INAH) 2086

The jaguar throne consists of a slab laid over the backs of two felines whose tails arch together to form the backrest. Actual jaguar thrones of various designs have been found at sites in the northern Yucatán Peninsula, and are depicted in many Classic relief carvings (a famous example is the Oval Tablet from Palenque). Their association with royalty is undisputed. The enthroned figure is impressive: the male's body is modeled out of simple, tubular forms, while his face and headdress are carefully detailed; his haughty expression, his upright back, and simple, open-handed gesture create a portrait of a royal personage sure of his status and position. The most elaborate features of this lord's costume are the studded bonnet-like headdress and the short cape textured by concentric circles. Traces of a deep, almost navy blue, pigment remain in the headdress. The figure itself was dark red. FC

70 Cylinder with four figures
Tikal, Petén, Guatemala; Burial 116
Ceramic; slipped black, red, and orange on cream
H. 30.5 cm.
Late Classic (A.D. 700–750)
Museo Sylvanus G. Morley, Tikal 4P-106/37

Temple I at Tikal was built as a funerary monument to the Late Classic ruler Ah Cacau, formerly referred to as Ruler A. Almost eighty when he died, after a reign of more than fifty years, his tomb was resplendently furnished and his body accompanied by more than sixteen pounds of worked jade, including a jade mosaic head-knob cylinder similar to one found in the later Burial 196 (*Fig. 18*). Among the twenty-two ceramic vessels in the tomb, there were ten unusually large cylinders like this one, nine of which had scenes of enthroned lords on either side. Each vessel apparently depicts a specific lord seated on his characteristic throne, with an inscription on the rim above; the scenes are divided by vertical bands that may represent the columns or doorjambs of a palace.

This polychrome cylinder—the most elegant of the nine vessels—is painted with a flowing calligraphic line which varies in weight. The barefoot lord, seated on a table throne beneath a canopy, wears only the skirt, jewelry, and headdress suitable for an interior event, unlike the more elaborate regalia of stela portraiture. His wrapped conical headdress has water-lily elements and long feathers. A fish feeds on the water lily, and there is a single black-and-white spotted feather of the Moan bird. The feathers of this nocturnal and ill-omened mythological bird form the circular headdress of one of the two old gods of the Underworld, and Late Classic plates and bowls decorated with this feather design often reproduce the headdress.

The lord shown on this vessel, whose ideal facial beauty and

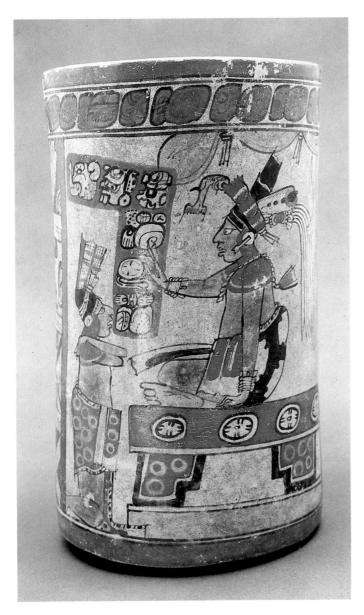

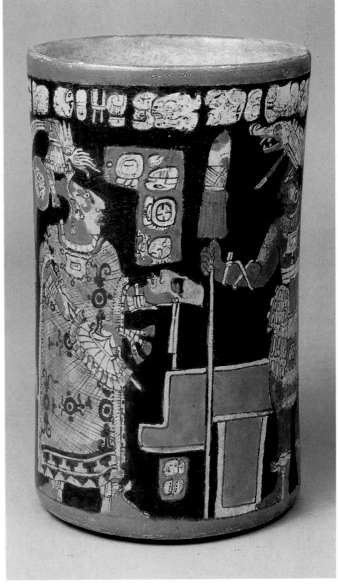

physical refinement are emphasized, gestures toward a coarsely featured attendant—possibly a captive—who kneels in submission with arms crossed on his chest. On one side of the vessel the Maya lord is identified by glyphs; on the other the lesser figure is referred to in relation to his superior. Whether the lord is actually Ah Cacau, who was buried in the tomb, or another elite personage who may have presented the vessel as a gift, is still an unanswered question. CCC

Trik, 1963, p. 9

71 Cylinder with lord and lady
Tikal, Petén, Guatemala; Structure 5D-46, Tomb B, No. 1
Ceramic; slipped black, pink, red, and orange on cream
H. 15.8 cm.
Late Classic (A.D. 750–800)
Museo Nacional de Arqueología y Etnología, Guatemala
 MPA-001

Magnificently clothed in a long pink *huipil* with black embroidery, a courtly Maya lady on this painted cylinder shows a human head, like Salome, to her lord. He stands before his throne, holding a spear and rattle (?) so that a servant behind may reflect his image in a large mirror. The lady's head is aristocratically deformed into the ideal Maya shape—like the offered head and that of her attendant, who wears a hat like hers, balanced atop an exaggerated coiffure, and carries a similar fan. This attendant also bears a large, shieldlike object with a mask (?) draped over it, perhaps part of the military regalia of the lord.

Unlike many such scenes, this apparent narrative has no symbols suggestive of an Underworld setting except for the black ground. However, the sixteen glyphs in the rim band include elements of a text often found on funerary vessels, as does the vertical divider panel. A short panel in front of the lord may give his name and titles. Glyphs and other details were reserved in the black background of this vessel, and lavish use was made of the specular pink hematite pigment. These technical traits, and the costume and objects portrayed, are otherwise unknown at Tikal, and it is likely this vessel was taken there near the end of the eighth century. CCC

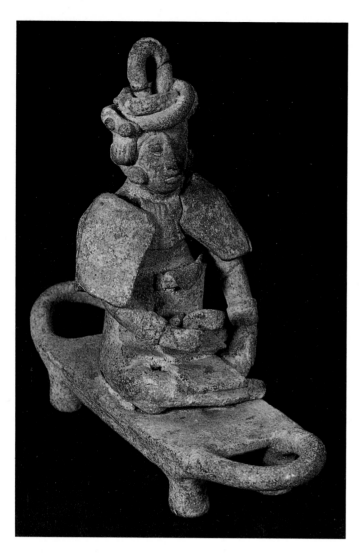

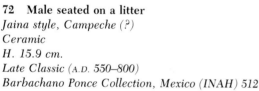

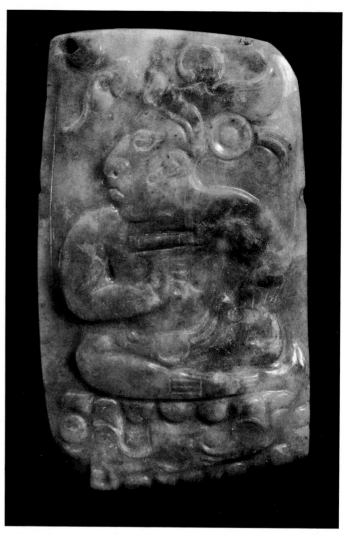

72 Male seated on a litter
Jaina style, Campeche (?)
Ceramic
H. 15.9 cm.
Late Classic (A.D. 550–800)
Barbachano Ponce Collection, Mexico (INAH) 512

The litter on which this figure sits is reminiscent of the large ceremonial grinding stones (*metates*) found in Costa Rica and Nicaragua and thought to have been used as thrones or benches. The costuming and pose of the figure, however, are fairly common within the Jaina figurine tradition. The object held in the man's right hand may be a knife or a small club, but in fact it has a soft appearance and is difficult to identify. This piece has been much repaired, having been broken in several places. The head was broken off at the neck, and the body from the litter. The face is mold-made, while the body and costume are modeled. Colored pigments, if they ever existed, are no longer visible. FC

73 Jade plaque
Toniná, Chiapas
Jade
H. 11.4 cm.
Late Classic (A.D. 750–800)
American Museum of Natural History, New York 30.1/1444

One of eleven jades in an ash-filled ceramic vessel, this plaque was excavated in a tomb at Toniná, Chiapas, by Ephraim G. Squier in 1852. The frontally seated lord with head in profile is the principal Late Classic jade carving convention, but this one differs from the better known Nebaj-style jades in lacking a frame, and in the figure being seated upon a frontal instead of a profile Long Nose Head. The figure's rounded shoulders and his pose, with curled right hand at the chest and left hand on the knee, are common, as is the bell-shaped forehead element. However, his large, heavy-featured head differs from the idealized portraits of the Nebaj style, even though the costumes are quite similar. A horizontal perforation suggests this plaque was suspended, but eleven diagonal holes along the rear edges were probably used to attach it to a backing. Such figural plaques are never shown as part of the costume of Maya lords, and it is possible they were hung within the palaces as emblems of rulership and wealth. CCC

Easby, 1964, pp. 72–74, fig. 2c

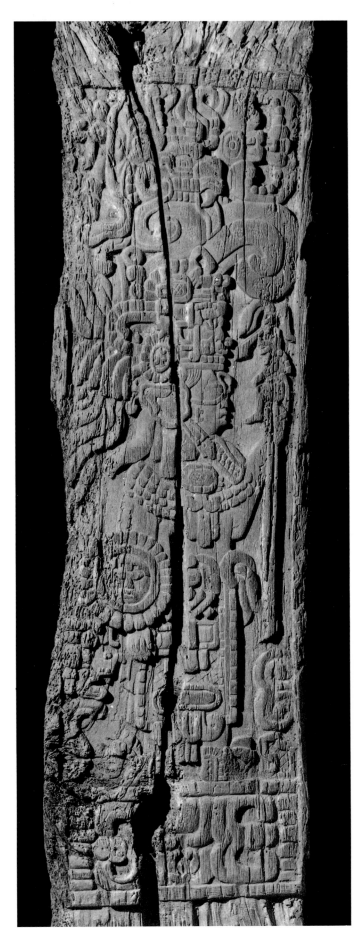

74 Wooden lintel
Southern Campeche (?)
Wood
H. 216 cm.; W. 43 cm.
Late Classic (A.D. 550–800)
Barbachano Ponce Collection, Mexico (INAH) 513

This lintel presents a composition and theme usually associated with stelae as plaza monuments: the iconic depiction of an elite person in ceremonial stance and costume. Carrying a small round shield and a manikin scepter, the figure stands upon a pedestal-like basal image and beneath the grotesque head of the supernal image. Thus, he is in the middle of the three-part cosmos. One motif, a symmetrically doubled scroll, is found in all three levels and perhaps joins the three vertical parts into some kind of rational unity. The doubled scroll emerges in front of the grotesque supernal face; it is rendered as a small background motif in the middle realm, placed at knee level to the figure and attached to the frame of the lintel; it appears again as a repeated motif in the basal pedestal.

The rendering of the body, the pose (with the arms close to the torso), and the manner in which the feathers are carved suggest stylistic affiliations with sites in Campeche and Yucatán, especially Oxkintok and Xcalumkin. Another diagnostic feature—first noticed by Clemency Coggins—is that this person holds his shield in his right hand. Almost invariably, the ceremonial shield is held in the left hand, and only nine other examples of right-handed shield bearers have been found. It may be significant that well over half of these examples are from sites in the northern regions of the Yucatán Peninsula. What this reversal of the norm might signify is difficult to say. Right-hand shield bearers are represented in scenes of paired figures where the other figure properly holds his shield in the left hand, as dancers or winged figures, or as masked figures. For the figure on this lintel, the face masking consists of a fillet under the eyes that crosses in a loop over the nose (usually referred to as a "cruller"), and prominent jaguar ears. It is similar to that worn by the so-called Jaguar God of the Underworld. There is a row of badly damaged glyphs on the left edge—the lintel edge that would have been flush with the exterior wall of the structure and visible to those standing outside the building. The glyphic statement starts with the number 4 (four dots), but this does not seem to be a calendrical statement. FC

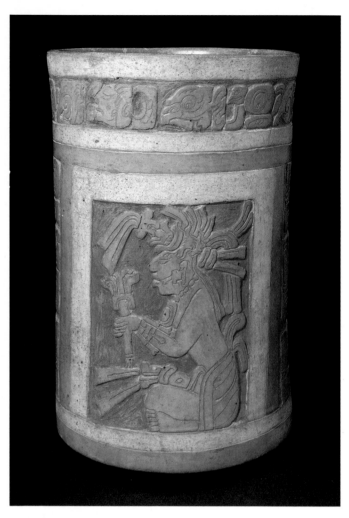

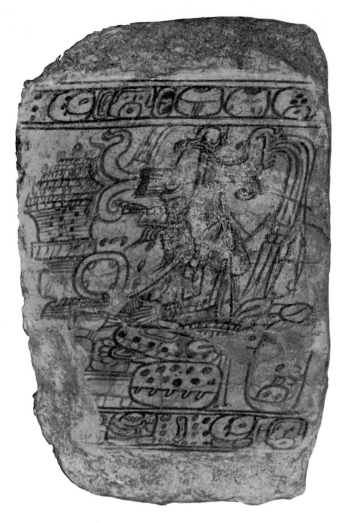

75 Carved cylinder vase
Motagua Valley (?), Guatemala
Ceramic; slipped buff on cream, red pigment
H. 23.2 cm.
Late Classic (A.D. 750–800)
Museo Nacional de Arqueología y Etnología, Guatemala 8456

Carved and incised monochromatic styles tend to dominate
Late Classic elite ceramics of the southeastern region. This
large vessel, with its subtle interplay of cream and buff slips, is
a carved southern interpretation of a motif regularly painted in
polychrome in the north. This decorative formula calls for
slightly differentiated Maya lords seated in profile, one on each
side of the vessel, separated by panels with large emblematic
glyphs and with a glyph band around the top. The details of
these figures are incised in a somewhat angular style and the
excised backgrounds are emphasized by red pigment added
after firing. Both of the lords depicted here carry ceremonial
staffs and wear feathered, water-lily headdresses, but they differ
in details of dress. The same three glyphs—a female head, a
vulture, and a hook-eyed beast—are in both panels, but in dif-
ferent order, and appear more than once in the twelve-glyph
rim inscription. CCC

76 Painted capstone
Dzibilnocac, Campeche, Structure 1
Limestone with stucco; painted red on buff
H. 56.5 cm.
Terminal Classic (A.D. 800–1000)
Museo Regional de Antropología, Merida MM 1984-6:8

Capstones of this type were placed at the top of the corbeled
arch used in Maya buildings (see *Fig. 26*). Two other painted
examples were excavated in Structure 1 at Dzibilnocac. All of
them, including this piece, are closely related stylistically and
may have been painted by the same artist. On each example
God K is the subject. He is easily identified by the striated and
scrolled form emerging from his forehead and the repeating
lines of small rectangles on the back of his arm and along the
underside of his thigh. These designs are thought to be scale-
like, denoting the god's reptilian aspect. In front of him is a pile
of baskets filled with offerings. The glyphic statement, in
framed rows at the top and bottom of the image, differentiates
this piece from the other two examples at Dzibilnocac since
their images do not include such glyphic information. In this
case, there is a similarity with augural statements found in the
Dresden Codex (p. 28), and the glyph accompanied by the nu-
meral 3 (the first glyph in the upper row which is repeated in
the lower band) was considered to be of good omen. FC

Jones, 1975, pp. 83–110; Pollock, 1970.

144

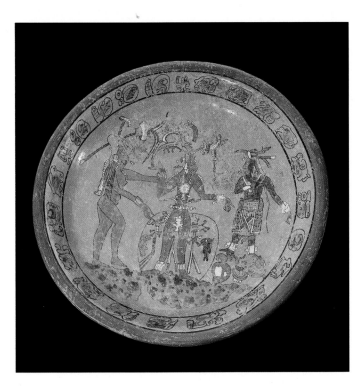

77 Tripod plate
Northern Petén area (?)
Ceramic; black, yellow, red on orange
D. 31.6 cm.
Late Classic (A.D. 550–800)
Kurt Stavenhagen Collection, Mexico

Delicate detailing and flowing calligraphic lines describe this unusual scene within a frame of glyphs. A short, dark-skinned man dressed in a jaguar kilt stands upon an oddly configured pedestal. He faces two other figures with whom he is having a lively discussion. The tall central male, dressed mostly in jewelry, is gesturing to the small male and a nude female with large flowers in her hair. She is depicted in the middle of taking a step with her arms held out. It is difficult not to interpret this as a scene of temptation, though a woman's alluring sexuality is an uncommon motif in Classic Maya narratives. The three feet supporting this large plate are realistically modeled snake heads. Along with the tripods, eight clay beadlike projections encircle the underside of the plate. FC

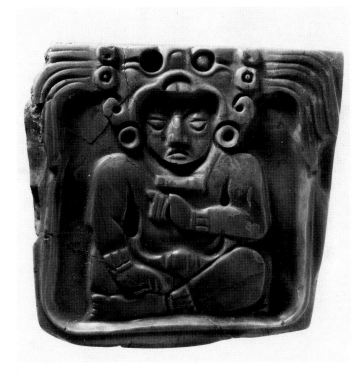

78 Carved plaque
Southwest Maya region
Jade
H. 8.3 cm.
Late or Terminal Classic (A.D. 750–850)
Peabody Museum of Archaeology and Ethnology,
 Harvard University 28-1-20/C10107

Wearing a "jaguar" headdress, this lord is seated frontally within a niche with a simple raised border that is partially covered by headdress feathers. His bodily forms and facial features are outlined by arcs which are evidence of the use of tubular drills held at an angle—a Terminal Classic technique which became increasingly mechanical. This thick, mottled blue-gray jade plaque, with a single horizontal perforation, has a surface layer of bright blue-green stone; this was exploited for crisp relief by a craftsman whose workmanship is also found on a very similar plaque excavated at Nebaj in western highland Guatemala. CCC

Proskouriakoff, 1974, p. 176, pl. 74:6

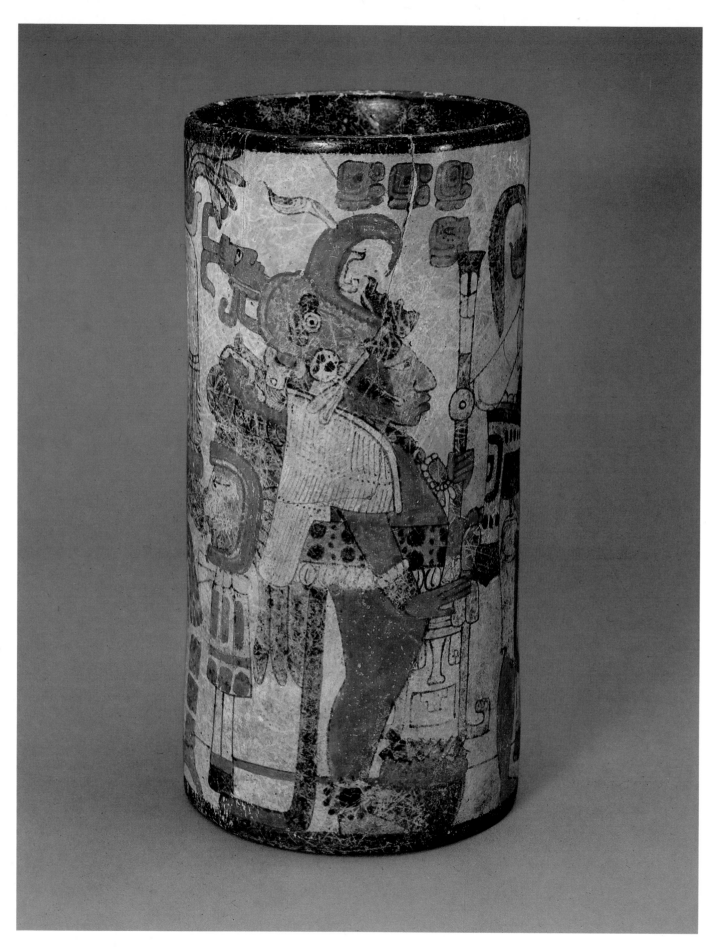

79 Polychrome vase
Site unknown
Ceramic; black, red on buff
H. 22 cm.
Late Classic (A.D. 550–800)
Recinto Prehispanico, Fundación Cultural Televisa A.C.,
 Mexico R21 P.J. 182

This extraordinary vase represents a courtly scene of confrontation among three standing figures of unequal height. All three males are richly attired, wearing animal headdresses. The central figure (shown here) is the smallest. He appears to be presenting a shield to the tallest and most extravagantly costumed man. The two taller figures wear enormous shieldlike back ornaments made from human heads surrounded by red frames. The two shield-heads gaze at each other over a small, profiled, kneeling man. In this view, they create a mythical "scene" that contrasts with the more mundane appearance of the courtly encounter on the other side of the vase. FC

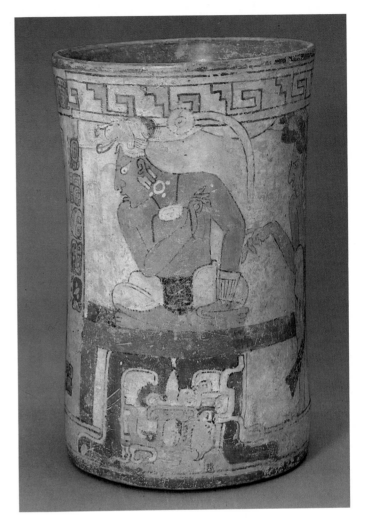

80 Cylindrical vase
Northern Petén (?), Guatemala
Ceramic; orange, red, black, and white on buff
H. 22.5 cm.
Late Classic (A.D. 550–800)
Recinto Prehispanico, Fundación Cultural Televisa A.C.,
 Mexico R21 P.J. 183

The composition of this court scene is divided into equal but distinctly different areas. In one an enthroned figure and his standing attendant (shown here) are in front of a white wall; above them is a curtain furled in swags to a cornice-like feature with six stepped frets. On the reverse side the frets are replaced by six glyphs that, along with the frets, make up a horizontal frame above the entire scene.

The narrative depicted on the reverse side of this beautifully executed vessel shows three figures, two of which are dark-skinned and ungainly, with non-Maya profiles. Their general appearance and subordinate poses suggest they may be foreign visitors to the court. Standing between them is a lighter-skinned male, probably an attendant for the enthroned lord. All of the figures are portrayed with an easy, assured line. What event this courtly scene portrays is uncertain, although there is reason to believe it may represent the accession of the enthroned ruler to power. Perhaps homage to the new ruler by the dark-skinned foreigners was considered important enough to be recorded. FC

147

81 Necklace with figural pendant
Altun Ha, Belize; Tomb B-4/7
Jade, serpentine, quartz
H. 4.6 cm. (pendant); 42 cm. (overall)
Late Classic (A.D. 550–600)
Royal Ontario Museum, Toronto RP 364/36

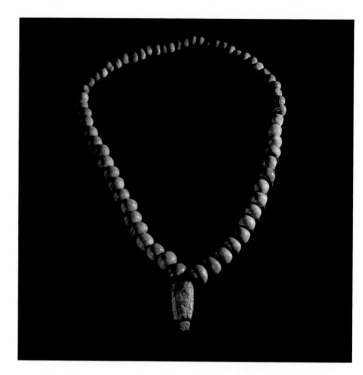

This necklace was worn by the elderly man in Tomb B-4/7 with whom an enormous jade head of the sun god, Kinich Ahau, was buried. However, neither the figure carved on the pendant nor the two poorly formed glyphs on the back have any apparent association with solar symbolism. Flanked by vertical "mat" (plaited cord) signs, this male figure holds his open left hand across his chest and his eyes are closed, possibly connoting death. Most of the sixty-six pieces in this necklace are made of a whitish-green albite-jade, but (although hard to detect) there are eight pure jade beads and one each of serpentine and quartz. CCC

Pendergast, 1982*b*, p. 62, pl. 23, fig. 35b

82 Plaque with enthroned figure
Altun Ha, Belize; Tomb B-4/6
Jade
H. 20.3 cm.
Late Classic (A.D. 600–650)
Royal Ontario Museum, Toronto RP 256/3

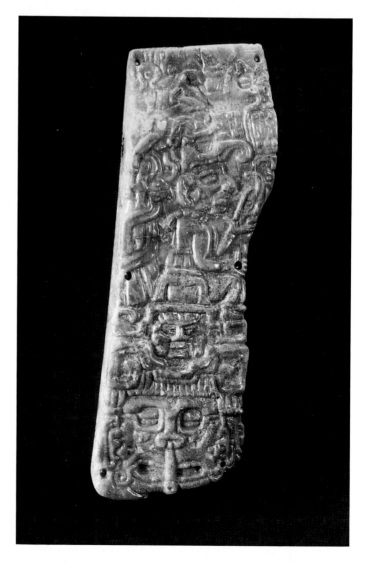

This vertically perforated jade, the largest carved plaque known, came from Tomb B-4/6. Altun Ha was richer in carved jade than any other known Maya site. Although few inscriptions were found there, this plaque has two dates and at least three personal names in the twenty-glyph inscription on its back.

The enthroned figure on the front faces toward his left and holds an unidentified object (possibly a "Jester God") in his left hand. He has a Long Nose Head or bird headdress and may be wearing a ballgame belt. There is a large frontal head at the base of the throne. Known as the Cauac Monster, this cleft head signifies the cavernous, stony Underworld into which the sun disappears at night and from which it emerges. Here the head of the Sun God is shown above the cleft and forms the seat of the throne. As suggested by the presence of the famous jade head in Tomb B-4/7, Altun Ha may have possessed the "Sun God throne," which the individual depicted on this plaque may have occupied.

Behind the figure a vine-entwined cacao tree, probably also a World Tree, reaches up to the sky. In the heavens above there is a jumble of rounded nebulous elements that seem to include two faces looking in opposite directions, and possibly two bodies in another scale—as ambiguous as clouds. An event noted in the inscription occurs in A.D. 584, but the tomb, with its young male occupant, is thought to have been constructed more than fifty years later. Perhaps the plaque belonged to his father, Lord Akbal, whose parentage is detailed on the back of the plaque. CCC

Pendergast, 1982*b*, pp. 84, 85, fig. 55a, b

83 Shell necklace
Altun Ha, Belize; Tomb B-4/7
Spondylus shell; jade
L. 72 cm. (overall)
Late Classic (A.D. 550–600)
Royal Ontario Museum, Toronto RP 364/14

Like the shorter jade necklace (No. 81), this shell necklace was also worn by the possessor of the jade head of the sun god, Kinich Ahau. The 121 graduated shell beads vary in color from creamy yellow to orange to wine red. They were cut from the hinges of the shell of the thorny oyster, spondylus, a material which was used conspicuously in a ceremonial role at Altun Ha, which is located near the sea. CCC

Pendergast, 1982*b*, p. 60, pl. 20

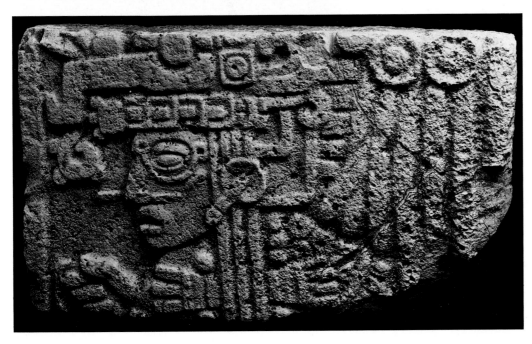

84 Fragment of a doorjamb
Halal, Campeche
Limestone
H. 39.5 cm. (fragment); 197 cm. (original)
Late Classic (A.D. 550–800)
Barbachano Ponce Collection, Mexico (INAH) 514

This fragment of a human wearing a headdress belonged to a doorjamb depicting a man in ceremonial costume. It was found on the western terrace of the Acropolis at Halal, Campeche. When published by Tatiana Proskouriakoff in 1950, this jamb was already broken into three parts: this piece is the middle section.

The patterned use of verticals and horizontals so apparent in this fragment (Proskouriakoff calls it "geometrical arrangements") is typical of some Late Classic architectural sculpture found in the northern Yucatán Peninsula. The profiled face with its obvious browridge above the nose is not a Classic Maya profile; nor is the straight-bar noseplug extending on either side of the nose typically Maya. These features may indicate foreign influences from Mexico that became increasingly evident in the Terminal Classic period. Nonetheless, the "cruller" (the looping form under the eye), the headdress, and the carved motifs on the rest of the jamb (not seen in this fragment) are Maya motifs best explained by iconographic elements usually associated with warriors or militant priests in ceremonial costumes.

The headdress consists of a large saurian head lacking its lower jaw. In the fragment, the long, down-curved snout is visible as well as the round eye and the squared concentric circles of the creature's earplug. The feathers of the panache are to the right of the human head, hanging from beads of concentric circles. All the visible motifs are described by straight lines or as circles—except for the profile of the man's face and one stray feather that juts through the rigid panache behind his head. FC

Pollock, 1980, fig. 925; Proskouriakoff, 1950, fig. 104a

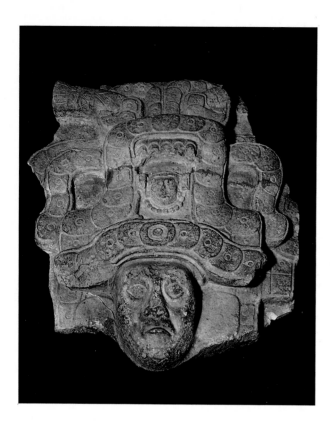

85 Fragment of Stela 7
Piedras Negras, Guatemala
Limestone
H. 82 cm.
Late Classic (c. A.D. 712)
Museo Nacional de Arqueología y Etnología, Guatemala 10623

Cut from Stela 7 at Piedras Negras by looters, this fragment displays part of the headdress and face of what was once the representation of a proud warrior in full ceremonial costume. At Piedras Negras, rulers portrayed themselves in various kingly roles, and that of a warrior with captive was quite common.

On Stela 7 the ruler was shown wearing a great feathered cape and holding a long-tasseled bag and a ceremonial spear and shield. Kneeling at his feet was a small figure whose upper arms were bound by ropes. A section of the ruler's magnificent headdress can still be seen in the fragment. He wears a diadem of circular beads, and above this a mythical serpent appears to have opened wide his mouth to reveal the ruler's head within. Its upper jaw rises over the diadem, displaying the serpent's inner mouth. One can see the teeth and, just below them, a small human effigy head. On either side of the mouth, the eyes are framed by arching bead-scales. The beast's nostrils, pierced by intricately wrought long beads, are on the top of the upper jaw. Originally, great plumes of feathers issued from the long nostril beads and joined the larger panache of the headdress. The squared beads to the right of the face continue to form the open lower jaw that frames the human face. Perhaps the most remarkable aspect of this fragment is the portrayal of the ruler's face: he is not a young man; the lower lids of his eyes sag, as do his cheek muscles, and he seems to have the permanent frown of care and age. FC

Proskouriakoff, 1950, fig. 53c

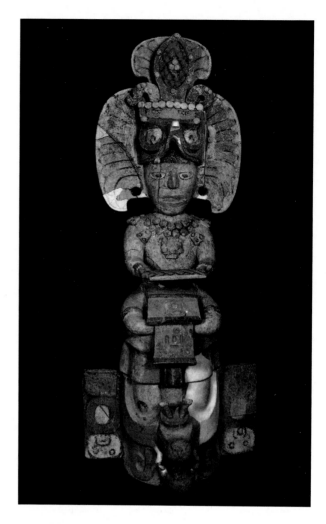

86 Effigy censer
Tikal, Petén, Guatemala; Structure 5D-32, Problematical
 Deposit 180
Ceramic; postfire black, blue, orange, brown, and white
 pigments
H. 62.6 cm.
Late Classic (A.D. 650–700)
Museo Sylvanus G. Morley, Tikal 12U-82/16

The lid of this two-piece censer represents a seated Maya lord. He wears a loincloth apron and a jade collar with bone *Ahau* pendants and a shell-shaped pendant in the center. In his hands he holds a board with a mat or *Pop* sign painted on it, denoting royal authority. His symmetrically feathered headdress represents a bird with hook-eyes and Cauac markings, and at the top a foliated pod, perhaps of cacao.

The base of the censer, with ear flanges that served as handles for lifting the assemblage, is the head of the Underworld Cauac Long Nose Head. Aromatic smoke from burning copal incense would have escaped through holes in the unpainted back of the censer. Deposited in a North Acropolis temple, this censer may have figured in the elaborate accession ceremonies of a ruler later entombed in Temple I. It may even be an early image of that individual who led Tikal to its Late Classic florescence and whose name was Ah Cacau or Lord Cacao—perhaps the name modeled in this headdress. CCC

W. R. Coe, 1967, p. 18

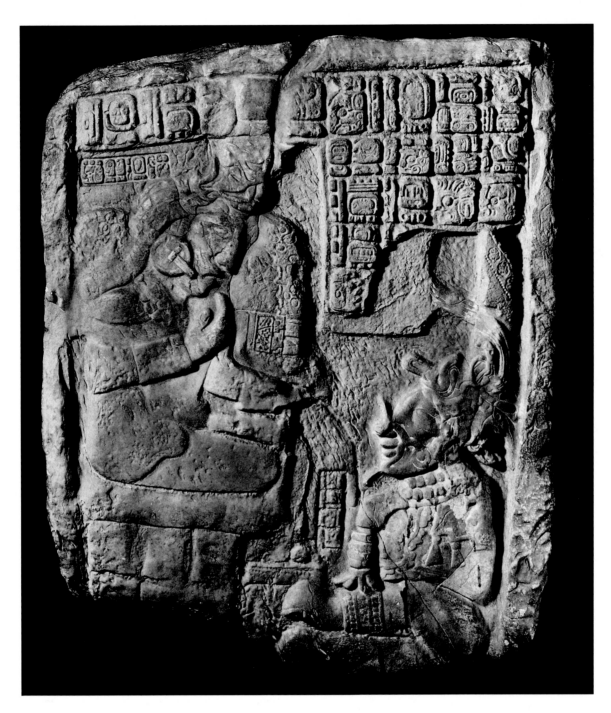

87 Relief panel
Usumacinta area (?)
Limestone
H. 87 cm.; W. 66 cm.
Late Classic (A.D. *550–800*)
Kurt Stavenhagen Collection, Mexico

This panel pictures a female (?) attending a male seated upon a throne: they may be mother and son or man and wife. The rendering and proportioning of the figures are unusual, but thematically they can be related to monuments from the western Maya area. It could be that this panel was originally part of a carved stairway, like the one that fronts Structure 44 at Yaxchi-

lán, as the panel shows different states of wear. Except where the panel has been damaged from cracking and flaking, the glyphs are clear. The images, however, appear worn and weathered, but small areas of design detail remain on the throne and in the attendant figure's headdress.

The glyphic statement begins with a Calendar Round date, 12 *Ahau* 13 (perhaps *Zac*), but the following glyphs are obscured. Another Calendar Round date (perhaps 4 *Ahau* 13 *Yax*, 9.15.0.0.0 or A.D. 731) follows a distance number—the count of days from one date to another—but it is also difficult to identify. The uncertain date and rendering of the figures in this piece may be the products of a provincial artist not practiced in the courtly conventions of relief carving. FC

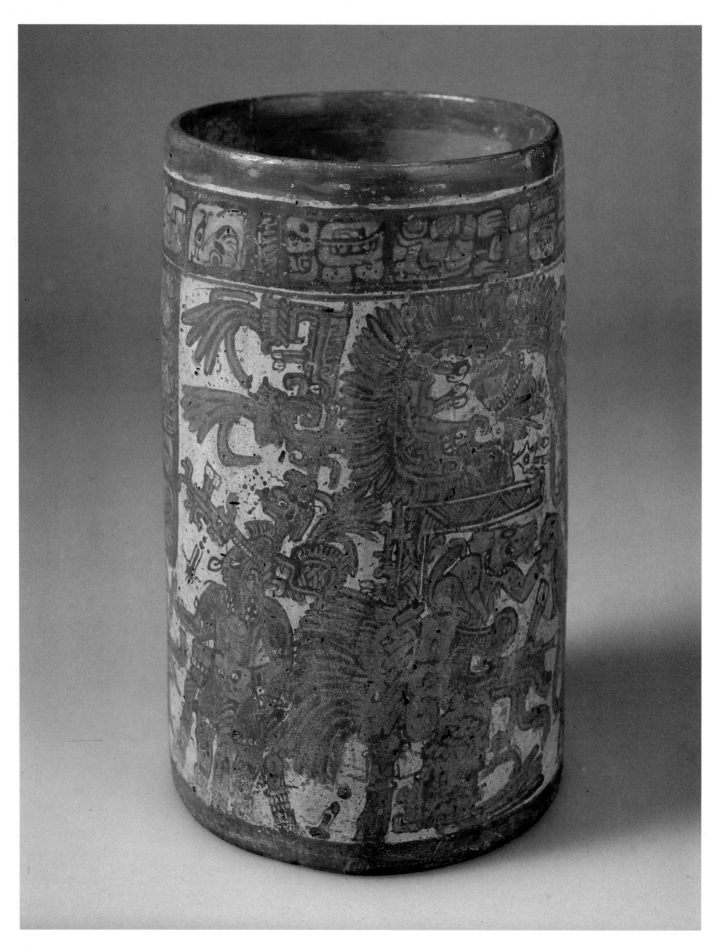

88 Polychrome cylinder

Holmul, Petén, Guatemala; Group I, Building F
Ceramic; slipped red and orange on cream
H. 22.1 cm.
Late Classic (A.D. 750–800)
Peabody Museum of Archaeology and Ethnology,
* Harvard University 11-6-20/C5668*

This distinctive painting style, which has red and orange-on-cream slips without dark outlining, was found on three vessels excavated in two Late Classic burials at Holmul. A tripod plate in the same style accompanied this cylinder in the interment of an individual for whom a large burial platform was built. The plate had a central scene depicting a lordly figure wearing a backdress, facing a dwarf, and identified by two glyphs that apparently refer to Tikal.

On one side, at the beginning of the rim inscription, a frontally portrayed man, with three plaited streamers flying around his slightly bent legs, gestures toward a hunchback figure; this small person fits below a vertical glyph panel which, like the rim inscription, refers to a standard ceramic text. The principal figure is elaborately attired like rulers shown in profile on stelae wearing fantastic backdresses, so it must be assumed he is actually wearing this tiered construction, even though it is shown next to him. In emulation of the three-level worldview, the backdress consists of a Long Nose Head at the bottom, a jaguar (?) in a basketry niche at the middle level, and a serpent-bird at the top. The figure also wears serpentine headdress elements that are cantilevered off his artificially elongated head, while an animal head above this has jade and feather constructions. The man's apron, worn over a kilt, is a large bivalve shell of the type usually worn as an apron by noble women.

On the opposite side of the vessel the composition is the same, but the figures and details of costume are slightly different. Outstanding variations are a long-beaked bird above and a Cauac Long Nose Head below in the backdress, and a true dwarf as the secondary figure. Hence, the two sides seem to have contrasting significance. CCC

Merwin and Vaillant, 1932, p. 15, pls. 2b, 30a, c

89 Stela 7 fragment

Itzimte-Bolonchen, Yucatán
Limestone
H. 94 cm. (fragment)
Late Classic (A.D. 550–800)
Barbachano Ponce Collection, Mexico (INAH) 515

This fragment is the topmost portion of Stela 7. The triangular shape is unusual but not unique. The main portion of the stela depicted a richly dressed figure in the iconic style who stood upon an enlarged day sign, perhaps 2 *Ahau*. The configuration is directly comparable to a contempory stela from Machaquilá, Guatemala, far to the south on the Pasión River. Hieroglyphic inscriptions suggest that the date of Stela 7 is 9.19.5.0.0 2 *Ahau* 13 *Yaxkin* or 10.2.10.0.0 2 *Ahau* 13 *Ch'en*—either A.D. 820 or 880. This fragment, the supernal image of Stela 7, depicts a narrative scene of two figures in violent combat. One figure has fallen and is threatened by a masked warrior who grabs his hair and places a spear to his throat. The masked figure looks away from his victim as if seeking permission from a superior to kill. The moment *before* the thrust of the spear is shown, but the outcome is clear. The victor wears as a headdress a human head with the same drooping lower lip and strange ear ornament as the victim's. The only difference between the still living head and the headdress is the absence of hair. The sculptor has managed, in a single scene, to expand the time and events of the story: we are shown the moment before the killing and, by means of duplicating the heads, the results of the victory. Furthermore, as the victor seems to look away for permission, the artist alludes to other events or actors not included in the scene. FC

Von Euw, 1977

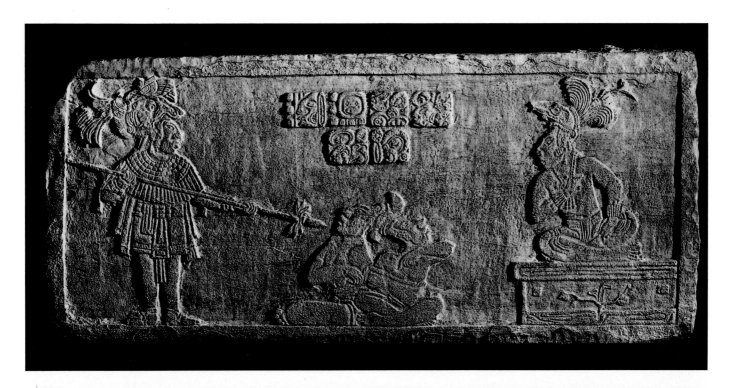

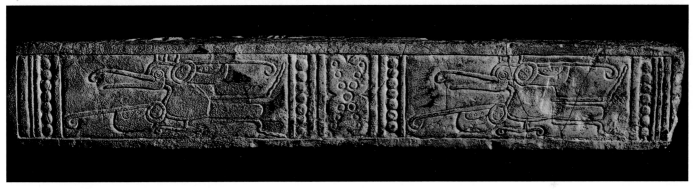

90 Standing warrior
Jaina, Campeche
Ceramic
H. 14.8 cm.
Late Classic (A.D. 550–800)
Museo Nacional de Antropología, Mexico 5-1228

Thick slabs and fillets of clay have been used to dress this male
figure in protective but still regal clothing. In his left hand he
holds a round shield with a lightly engraved grotesque head fac-
ing toward the figure. The turn of his head, the frown, and the
asymmetrical placement of his tightly closed mouth give the
warrior a poignantly introspective expression. It seems likely,
however, that this figure once possessed a removable mask or
headdress. He does not wear the expected earplugs, and the
smoothed-down areas on the rolled collar near his ears probably
were a base to support such a feature. Perhaps the mask or
headdress was a reptilian creature to match the scaly boots.
Since the "boots" have human-like toes, one wonders exactly
how human this warrior was meant to be. FC

91 Sculptured panel
Site unknown
Limestone
H. 23 cm.; L. 51.8 cm.
Late Classic (A.D. 550–800)
Barbachano Ponce Collection, Mexico (INAH) 256

This unusual sculpture, which was probably a wall panel, de-
picts two bound captives guarded by a richly dressed warrior
holding a spear. The prisoner on the left faces the guardian,
while his companion offers a gesture of submission to a lord
seated on a throne embellished with a curious plantlike motif.
Along the bottom edge of this piece are two water birds sepa-
rated by decorative panels. In general, this sculpture relates
stylistically to monuments from the western Maya area—par-
ticularly those found in sites along the Usumacinta River. Yet
there are inconsistencies in its sculptural style and overall com-
position, and the water birds appear unrelated to the scene
carved on the face of the panel. It has therefore been suggested
that this piece may have been reworked, either by Maya sculp-
tors or modern forgers. FC

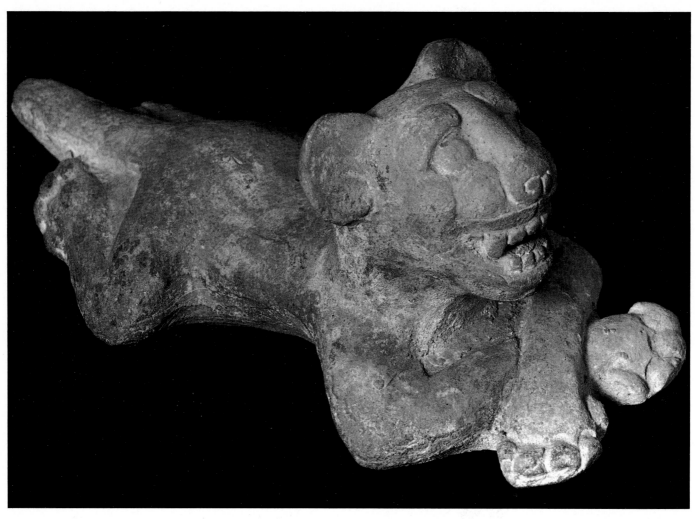

92 Resting feline whistle
Jaina, Campeche
Ceramic; traces of yellow ocher
L. 20.2 cm.
Late Classic (A.D. *550–800)*
Museo Nacional de Antropología, Mexico 5-1023

With the hind legs splayed rather than tucked, there is a marvelous casualness and domesticity about this feline. Even with its mouth open and teeth bared, one still has the impression that the cat is smiling. Stylistically, this creature could come from the Classic cultures of Oaxaca or Veracruz, as sculptures of playful, slightly comic cats were seemingly common to all Mesoamerican peoples. This whistle is made from a mold, and the blowhole is in the feline's left hind knee. Traces of yellow ocher paint are still visible on the body. FC

Corson, 1976, fig. 34c

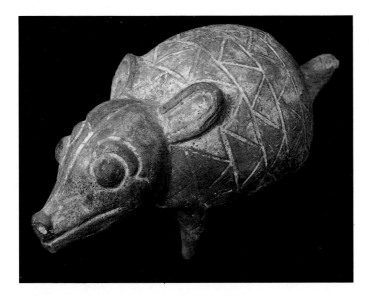

93 Armadillo whistle
Jaina, Campeche
Ceramic
H. 8.3 cm.
Late Classic (A.D. 550–800)
Museo Nacional de Antropología, Mexico 5-1413

The blowhole for whistling is on the creature's left side, just as the belly turns inward. Made from a mold, this armadillo has a youthful and comic quality. The large round eyes, the slightly exaggerated ears, and the chubby body create an appealing image—like Piglet from A. A. Milne's *Winnie-the-Pooh*. Nonetheless, the anatomical details, despite their roundness, are carefully observed. FC

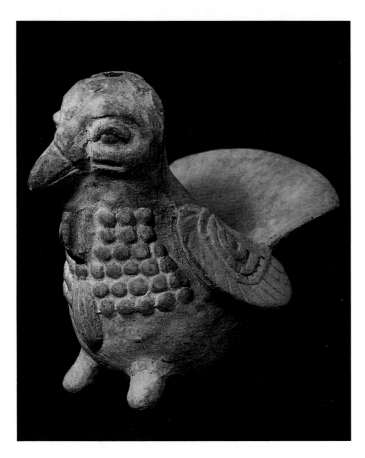

94 Turkey whistle
Jaina, Campeche
Ceramic
H. 11.5 cm.
Late Classic (A.D. 550–800)
Museo Nacional de Antropología, Mexico 5-1438

Like the armadillo (No. 93), this turkey was mold-made; its body and head are appealing rotund forms. The beaded and tasseled collar and the emblematic "serpent" wings are anthropomorphic conventions. (Just above the collar tassel, however, realistic wattles have been included.) Turkeys were domesticated by the ancient Maya for their meat, feathers, and eggs. They are commonly used by the modern Maya for sacrifice and ritual purposes, but there is little archaeological evidence for such a practice in ancient times. Nonetheless, the "serpent" wings suggest a celestial or cosmic meaning, and recall the passage in *The Chilam Balam of the Chumayel* that describes the attributes of the four cardinal directions as each possessing a different type of corn, color, tree, stone, and turkey. Broken and repaired, this piece has a reconstructed tail. FC

Roys, 1967, p. 64

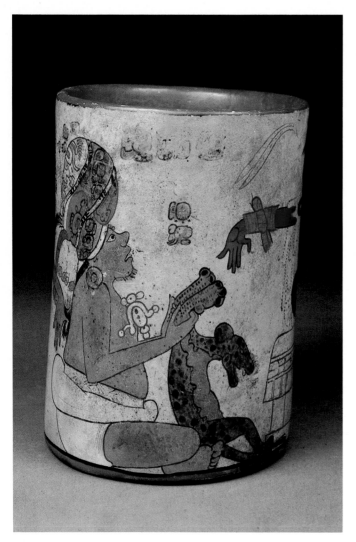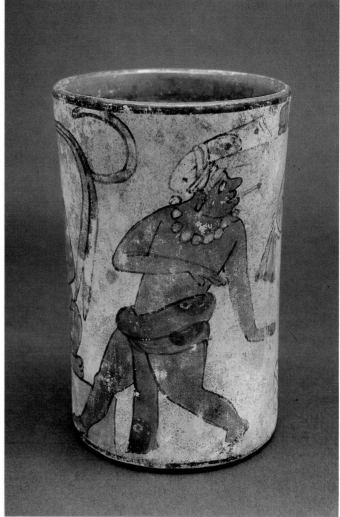

95 Cylinder with three figures
Tikal, Petén, Guatemala; Structure 5C-49
Ceramic; slipped black, brown, gray, pink, red, and
* orange on cream*
H. 13.2 cm.
Late Classic (A.D. 750–800)
Museo Nacional de Arqueología y Etnología, Guatemala
* MAP-004*

Rescued in fragments from a looter's trench, this sensitively and humorously painted vessel is related to another from a tomb at Tikal (No. 96), with which it has striking compositional, thematic, and polychrome similarities. Both vessels portray three figures in a continuous scene; there is an enthroned lord on the right, a plump figure seated on the ground to his right, with a third, somewhat antic, figure of low status framing the scene behind the other two. In each case the central figure has an enormous headdress and there are conspicuous animal forms. Here he holds a limp young jaguar which may be a gift for the imperious enthroned lord, who wears an extravagant cape and is probably identified by the glyphs immediately to his rear. These two vessels may represent a school of painting, or even the early and late work of a single artist. CCC

96 Cylinder with smoking figure
Tikal, Petén, Guatemala; Structure 5D-73, Burial 196
Ceramic; slipped black, brown, orange, white, and
* pink on cream*
H. 17.4 cm.
Late Classic (A.D. 700–800)
Museo Sylvanus G. Morley, Tikal 117A-2/36

This vessel is best known for the mincing figure with a glowing cigarette in his mouth who seems to tiptoe away from an audience between two more important figures. On the right a Maya lord, seated frontally upon a platform and wearing a water-lily-and-skull headdress, leans toward a paunchy figure who has a striking vulture-and-serpent headdress. The three figures are identified by glyphs, but the nature of this explicitly detailed event is unknown. There were three polychrome cylinders with figural scenes included in this important tomb, which had forty-five other ceramic vessels. These three are completely different from each other, and none was painted in a common Tikal style. They may have been gifts made for the funeral of the man in the tomb. CCC

W. R. Coe, 1967, p. 52

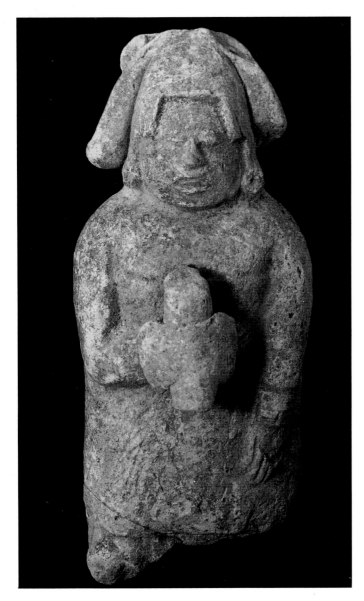

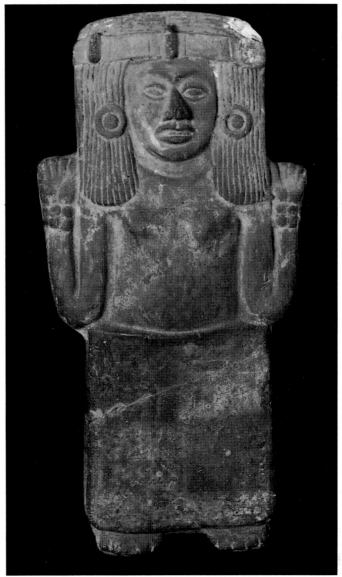

97 Female effigy whistle
Tikal, Petén, Guatemala; 66X-38a/20, Problematical Deposit 116
Ceramic; unslipped postfire red and blue paints
H. 13.5 cm.
Late Classic (A.D. 700–800)
Museo Nacional de Arqueología y Etnología, Guatemala 9982

A Maya woman of beauty and dignity is shown with her hair cut square around her face which emphasizes, with her modeled headdress, a high, receding forehead. This woman who lived in the warm lowlands is covered by a sarong-like dress. She has a woven textile cuff in place of a bracelet and wears no necklace, although she has earflares. Mostly mold-made, this whistle-woman holds a modeled, blue-painted bird to her breast. CCC

98 Woman with upraised hands rattle
Campeche (?)
Ceramic
H. 27.2 cm.
Late to Terminal Classic (A.D. 550–1000)
Museo Nacional de Antropología, Mexico 5-135

There are a large number of female figurines made in molds that stand in the position of an *orant*—arms raised and hands palms forward, a gesture of awe and wonder. This female wears a large checkered skirt of light blue. She is quite flat, almost two-dimensional in conception, except for her face, which by contrast stands out as almost fully three-dimensional. Rattles of this type were made by placing clay pellets, pebbles, or possibly beans inside the figurines. They were used as musical instruments to accompany chants and other ritual purposes. FC

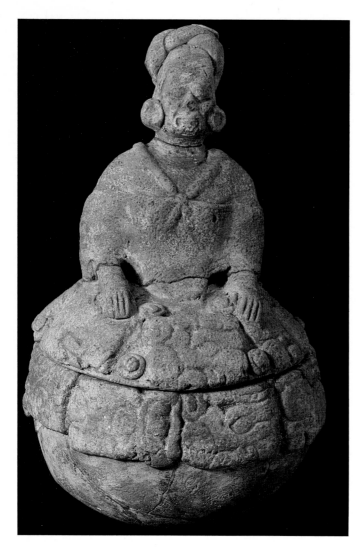

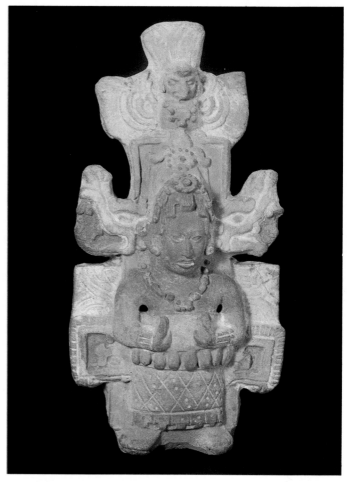

100 Standing goddess or priestess
Jaina, Campeche
Ceramic; traces of blue pigment
H. 22.5 cm.
Late Classic (A.D. *550–800*)
Museo Nacional de Antropología, Mexico 5-634

99 Bowl with female effigy lid
Site unknown
Ceramic
H. 21.5 cm.
Late Classic (A.D. *550–800*)
Barbachano Ponce Collection, Mexico (INAH) 516

The lady's hands rest lightly on the flaring lid with appliquéd glyphs on the rim. These are matched by the glyphs that circle the body of the bowl. The glyphs are worn and lack definition, but it can be seen that the two front glyphs—on bowl and lid—match each other. The main glyph is a saurian head, perhaps T793b in J. Eric S. Thompson's catalogue, but it also resembles one of the emblem glyphs for the site of Palenque. The coarseness of the clay paste and the hasty treatment of the female effigy suggest a date toward the end of the Late Classic. In its composition, this piece recalls Early Classic effigy lidded vessels, and this archaistic statement may have been part of the original intent in making this piece. FC

Thompson, 1950

The richly dressed female stands in front of a cross-shaped object usually considered to be a throne or altar. The small bird wearing a necklace that rests at the top with outspread "serpent" wings suggests that the woman may be standing in front of a conventional cross-tree like that portrayed on the sarcophagus lid from the Ruz Tomb at Palenque *(Fig. 17)*. The serpent heads with little faces in their open jaws reinforce the comparison, as do the serpent heads with fretted and beaded jaws that extend out from her waist. The pose, gesture, and cross-tree are the repeated attributes of a small group of figurine rattles, one of which is illustrated by Román Piña Chán. This figurine rattle is mold-made, and clay pellets still remain inside it. Quite a bit of blue pigment can be seen on the woman's skirt, beads, and headdress. The beaded serpents and the brow plates of the upper serpent heads were blue as well. The bird's tail and wings, the rest of the upper serpent heads, and the feathered rectangular slab behind the lady are now covered with white, but originally these details may have been light green or yellow. FC

Piña Chán, 1968*b*, fig. 69; *Fondo Editorial*, 1964, ill. 384

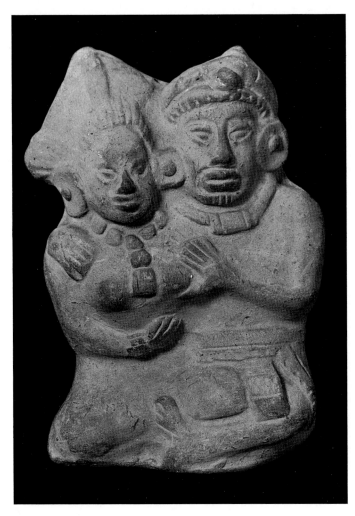

101 Embracing couple whistle
Jaina, Campeche
Ceramic
H. 11.9 cm.
Late Classic (A.D. 550–800)
Museo Nacional de Antropología, Mexico 5-239

The Maya, for whom modesty was a great virtue, seldom depicted any kind of overt sexuality. There is, however, one such theme that recurs within Jaina-style figurines: an embrace between a young woman and an old man. Although the old man is often depicted as touching the lady's breast, she never resists and seems to be at least fond of her partner. George Kubler compares this figurine theme to full-figure calendrical glyphs (composed by depictions of entire human or grotesque figures), and suggests that the woman represents a number and the old man the period of time. One of Kubler's examples is the full-figure Baktun 9 glyph on the west side of Stela D of Quiriguá; the female number 9 and the elderly Baktun are ardently embracing. In a larger perspective, this theme presents the conjunction of opposites—male-female, young-old. In this piece, the male does not appear to be very elderly, unless we are to understand the thickened lips and the beard as signs of age. FC

Kubler, 1969, p. 32

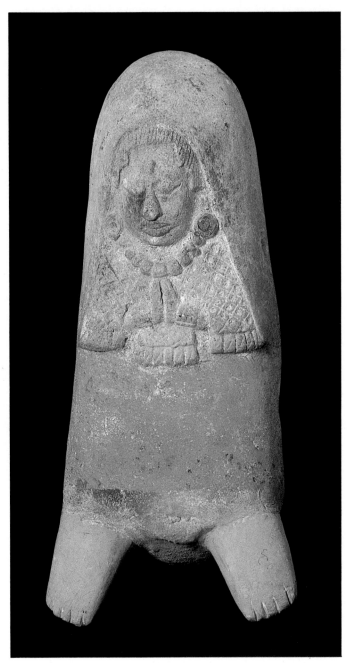

102 Hooded female
Jaina, Campeche
Ceramic; traces of red paint and blue pigment
H. 16.3 cm.
Late Classic (A.D. 550–800)
Museo Nacional de Antropología, Mexico 5-3544

This mold-made rattle and whistle was found at Jaina in 1973. It is matched in gesture and costume by a piece from Emiliano Zapata, Tabasco, and illustrated by Rands and Rands. Traces of red paint cover the face, hair, and hood. The netted and fringed top was white, while much of the original blue pigment remains on the long skirt. The feet are recent restorations. FC

Rands and Rands, 1965, fig. 49

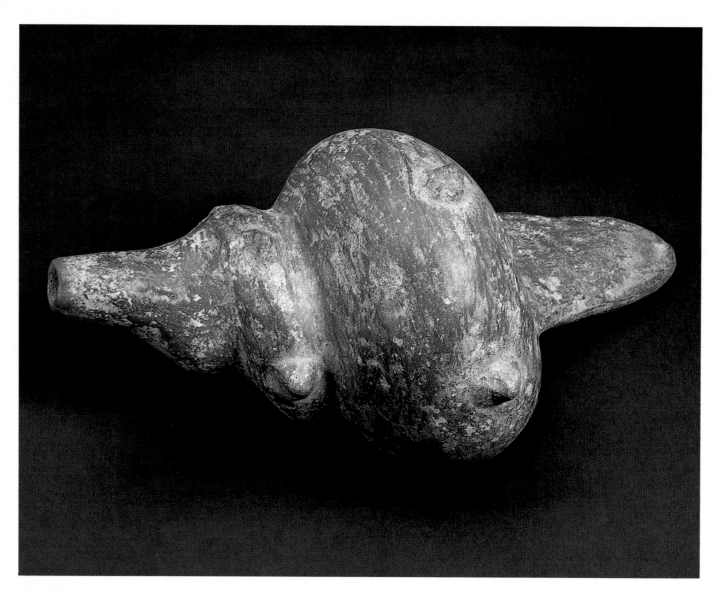

103 Conch-shell whistle
Site unknown
Ceramic
L. 39.2 cm.
Classic (A.D. 250–800)
Museo Nacional de Antropología, Mexico 5-82

The sculptor constructed this whistle from the inside out, and thus this beautifully simple representation maintains its spiral form on the interior as well as exterior. Actual conch-shell trumpets were commonly used by the Maya. FC

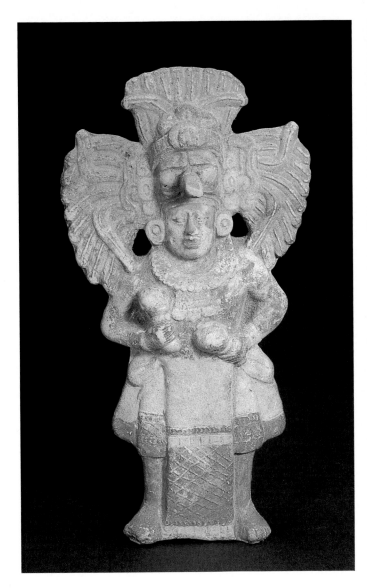

104 Musician effigy ocarina
Nebaj, Quiché, Guatemala; Structure 3, Tomb 2
Ceramic; unslipped postfire red and blue paints
H. 21.1 cm.
Late Classic (A.D. 700–800)
Museo Nacional de Arqueología y Etnología, Guatemala 4728

With a plain back and molded front, this large four-hole ocarina
represents a Maya lord who holds rattles in either hand; per-
haps such a dignitary would have supplied the rhythm for a
melody blown upon such an instrument. The man is dressed as
elaborately as the lords shown on jades and ceramics, and, like
them, he is barefoot. He wears an intricately woven cloth apron
that falls in front of another panel covering his kilt. Like the
luxuriant feathers decorating the headdress, his collar, pendant,
and bracelets are painted blue. The Long Nose Head head-
dress, flanked by vertically oriented serpent heads, has a head
band with a central circular motif similar to those found on jades
from this region. CCC

Smith and Kidder, 1951, p. 76, fig. 87e

105 Carved jade bead
Tikal, Petén, Guatemala; Structure 5D-73, Burial 196
Jade; red pigment
L. 9 cm.
Late Classic (A.D. 550–800)
Museo Nacional de Arqueología y Etnología, Guatemala
 117A-62/36

Worked on all four faces, this rectangular bead may have been
worn vertically as a pendant. Four acrobats are carved in alter-
nating positions so that the heads of two doing handstands are
next to the feet of two balancing on their crossed arms. These
figures wear jewelry and are more elaborately dressed than
might be expected of performers, but since the elite personage
buried in the tomb where this bead was found died during Ti-
kal's greatest period of wealth, this piece may represent the ex-
travagance of royal entertainment at that time. CCC

W. R. Coe, 1967, p. 51

106 Tripod dancer plate
Petén, Guatemala
Ceramic; slipped black, red, orange, and gray on orange
D. 33.8 cm.
Late Classic (A.D. *600–650*)
Museo Nacional de Arqueología y Etnología, Guatemala 8458

Dancer plates of this type were the most important decorated
ritual vessels in northeastern Petén during the seventh century.
Used examples are found in burials, and broken ones around
temples and shrines. This early dancer plate probably comes
from the vicinity of Tikal, where fragments of such plates were
found in fill of the North Acropolis. The dancer, his feet plant-
ed off center on the base line, holds one arm in front and one
behind while his headdress fillets, feathers, and loincloth fly
away from his turning body. The dynamic form fills the center
of the plate with an animated design that is encircled by a con-
stricting emblematic band. CCC

107 Tripod plate with feathered figure
Uaxactún, Petén, Guatemala; Structure A5, Burial A23
Ceramic; slipped black, red, and gray on orange
D. 24.8 cm.
Late Classic (A.D. *600–650*)
Museo Nacional de Arqueología y Etnología, Guatemala 302

Polychrome tripod plates with central motifs and encircling in-
scriptions are often coupled in seventh-century burials with
round-sided bowls. Burial A23 at Uaxactún was unusual in hav-
ing three round-sided bowls—all symbolically decorated—in
addition to this extraordinary plate. The man in the burial also
had jade earflares and a stingray spine (used for blood-letting
rituals) at his pelvis. The feathered image in the center of the
plate is enigmatic, and it has never been found elsewhere; it
may be read in two directions, as occasionally occurs in such
circular designs. The primary view is probably with the central
bulbous, feathered element projecting upward, since the in-
scription begins with the glyph that is just above it and to the
left. If this is correct, then the figure may represent an early,
unconventional, and incomplete example of the "quadripartite
badge" (see p. 55), a headdress ornament that most often has a
central feather flanked by a crossed-bands element and by a
shell. Conversely, if the large feather is pendent, then this may
be a personified bloodletter, an interpretation that would ex-
plain the "eyes." CCC

R. E. Smith, 1955, fig. 7i

108 Old warrior whistle
Jaina, Campeche
Ceramic; blue paint
H. 14.8 cm.
Late Classic (A.D. 550–800)
Museo Nacional de Antropología, Mexico 5-1013

Aged fat figures wearing striated costumes—thought to represent the quilted cotton dress of the military caste—are found as often in the Veracruz area of Mexico as in the Maya region. Large pectorals and loincloths are also part of these representations. On this piece, blue paint embellishes the collar and square pectoral, the belt and loincloth, and the tassel of the fan held in the right hand. The blowhole for this mold-made whistle is in the back. The earplugs, probably added after the molding process, are now missing, and the left foot is newly replaced.

Román Piña Chán points out that fans are usually considered attributes of women; perhaps the androgyny of old age is alluded to here. Clearly, the drooping jowls, sagging eyelids, and wrinkled, balding forehead are characteristics of old age—as is the paunch. Still, the similarity of these physical traits to dwarfs elicits a more mythical content than just an old warrior (No. 124). Tatiana Proskouriakoff illustrates two carved columns from the central door of Structure 3C7 at Oxkintok. While one column shows a carved human of normal proportions and physiognomy, the other depicts a dwarfish figure almost identical to this figurine. The pair presents an obvious contrast—one is tempted to say between the normal and abnormal or supernormal. A duality composed of opposite states of being—life-death, male-female, young-old—is a common Mesoamerican theme. FC

Piña Chán, 1972, p. 207; Proskouriakoff, 1950, fig. 97

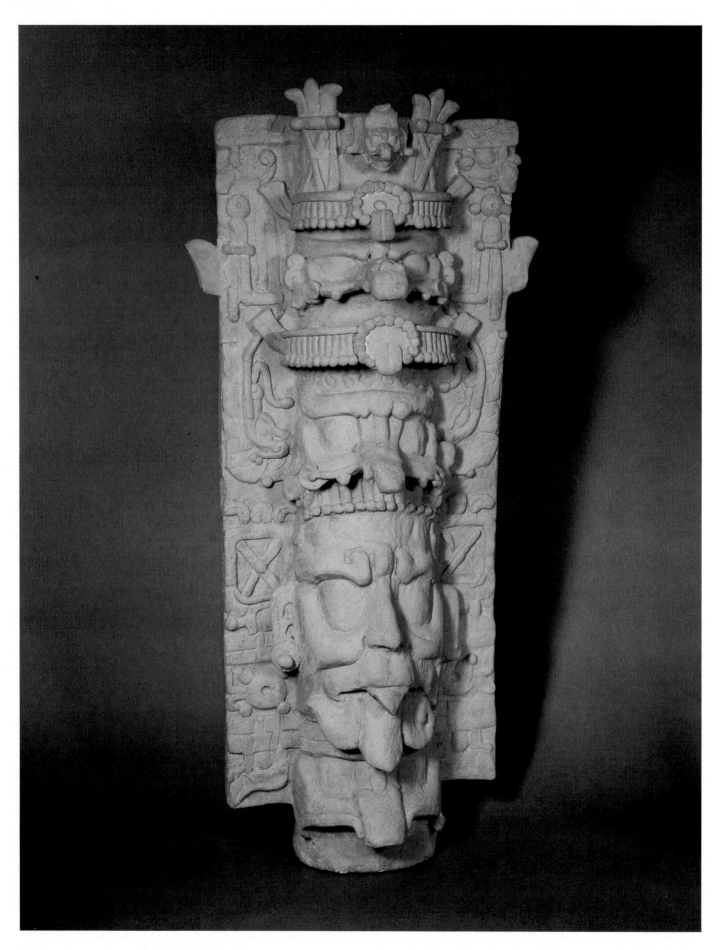

109 Incensario stand

Vicinity of Palenque, Chiapas
Ceramic; traces of blue pigment
H. 91 cm.
Late Classic (A.D. 550–800)
Museo Nacional de Antropología, Mexico 5-2784

Incensario stands of this type are thought to have been made at or near Palenque. They were holders for the incensario itself, which would have fit into the open top of the cylinder form. Given its size and delicacy, this piece is in excellent condition. The few restorations that have been made are intended only to reconstruct the visual integrity of the piece. Its composition and iconography relate to the Early Classic lidded vessels in the Televisa Collection (Nos. 48 and 49). Four stacked heads with flanged headdresses rise up the column of the narrow, tubular vessel. The largest head, second from the bottom, bears the characteristics of a celestial deity in its aged and nighttime aspect.

On Palenque-style incensario stands, the main head is usually the Jaguar God of the Underworld—otherwise known as the night sun or God III of Palenque. In this case, the jaguar attributes are lacking, as well as the important fillet that underlines the eyes and crosses over the nose. Paint may once have provided identifying clues, but now only traces of blue pigment can be seen on the upper two headbands. The three-part scrolling forms emerging from his mouth, however, may be an allusion to the smoking jaguar icon represented on a tablet in the Temple of the Sun at Palenque. The other heads are long-nosed grotesques that lack a lower jaw. At the very top, a small but full-faced grotesque is situated between two upright bars with crossed bands. The side flanges bear the expected motifs of crossed bands in a cartouched frame, flower-like pendants, and profiled, grotesque heads. The "serpent" wings that belong to the third head from the bottom are also common motifs. That this piece played an important ritual function is an inescapable assumption. The use of the hieratic principle of symmetry strengthens this perception. It is interesting, and possibly important, that a symmetrical organization is strictly observed throughout, except for the identifying three-part scroll issuing from the mouth of the main face. FC

Rands, Bishop, and Harbottle, 1979

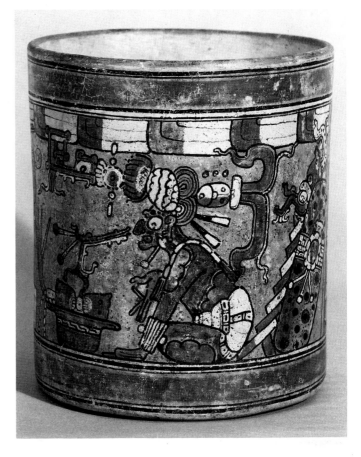

110 Cylinder with Old God

Alta Verapaz (?), Guatemala
Ceramic; slipped black, red, orange, and brown on cream
H. 18.5 cm.
Late Classic (A.D. 700–800)
Dumbarton Oaks, Washington, D.C. B-560.67.MAP

On this vessel an Old God, clearly a lord of the Underworld, confers animatedly with a fox-man with "god marks" who wears a netted headdress and an *Akbal* forehead emblem. The Old God's headdress includes a fret-nosed serpent head, a water lily, and a 3 *Ahau* glyph, while behind him there is a jaguar-skin-wrapped bundle decorated with an *Ahau* emblem and a tiered device composed of a mat sign below a Long Nose Head with a spondylus-shell headdress. This is probably a bundle of power like those possessed by Postclassic highland rulers. Two more scraped spondylus shells placed with beads and feathers in a bowl seem to be the topic of discussion between the two principals, although a third figure, who sits with his back to them, apparently listening, is also clearly involved. An ordinary man (perhaps on his journey into the Underworld), he sits with his bundles and another shell as if awaiting the verdict on his offering to these infernal lords. A glyph panel probably intended to identify the figures was never filled in, but in the single dividing panel six head glyphs are arranged vertically in emulation of an Initial Series date. CCC

M. D. Coe, 1975, no. 9

111 Stucco head
Palenque, Chiapas
Stucco; traces of red, blue pigment
H. 21.1 cm.
Classic (A.D. 250–800)
Museo Nacional de Antropología, Mexico 5-1091

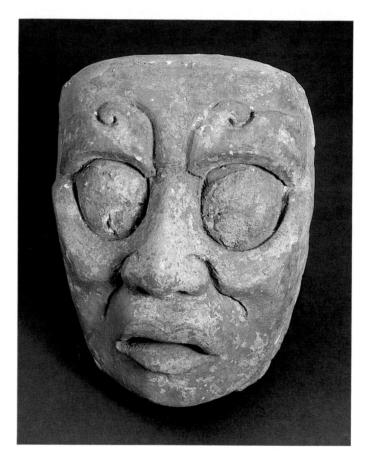

This powerful face is painted a deep blood-red while the eyes
and eyebrows are dark blue. Traces of a lighter blue pigment
can be seen on the lower face. The piece has been broken off
its mount, but the regular edge at the top of the forehead indi-
cates that it was originally conceived as a mask applied to a
larger stucco design. Jacques Soustelle believes this life-size
face is from Palenque, and identifies it as the image of the sun
god, Kinich Ahau. The large, squared eyes with volutes for eye-
brows and the exaggerated cheekbones are attributes of the Sun
God, but as the eyes are now plain, there is no reference to any
particular aspect of the Sun God's persona. Usually, this is indi-
cated by the shape of his pupils, either squared, spiraled, or
cross-shaped.

A high degree of modeling, with dramatic changes in the fa-
cial planes, is emphasized by deep scoring to outline the
strange eyes and brows and to emphasize the frown and cheek
creases. A notable feature of this sculpture is the asymmetrical
composition of the lower face. While the large eyes and brows
are symmetrical, the cheek creases, the nostrils, and the mouth
are rendered asymmetrically. This occurs in actual human faces
and imparts a portrait-like quality of uniqueness to the visage of
this god. FC

Soustelle, 1967, p. 272

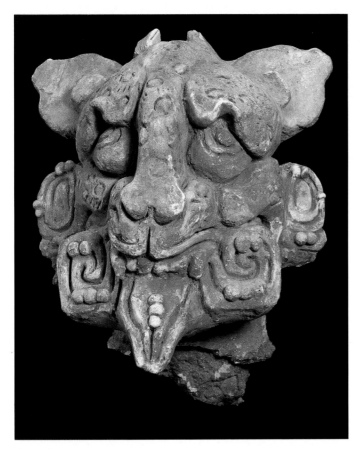

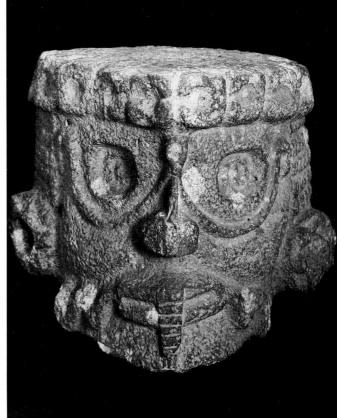

112 Smoking jaguar head
Toniná, Chiapas
Stucco; traces of red pigment
H. 34.3 cm.
Late Classic (A.D. 550–800)
Museo Nacional de Antropología, Mexico 5-4100

Represented here as larger than life, the "smoking jaguar" is a
creature without a lower jaw but with scrolls of smoke issuing
from his mouth. The central scroll element could either be
smoke or the beast's tongue. Like the Sun God, the deified jag-
uar had many different aspects, but he is usually associated with
the Underworld and the night sun traveling beneath the earth.
Linda Schele has noted that smoking jaguars are often associat-
ed with barlike forms which she considers to be thrones. At
Toniná, Structure E5-5 has the remains of a stucco design that
is suggestive of the bar motif, and the style of stuccowork is
similar—freely modeled, expressive forms using dramatic un-
dercutting and a series of small circles for emphasis. This piece
has been cracked and mended and the left earplug is new.
There is evidence of red pigment over all the face. The hole at
the top of the head once held an ornament, probably a scrolled
graphemic element that matched in composition the smoke
scrolls and tongue. FC

Schele, 1976, pp. 9–34

113 Grotesque head
Uxmal (?), Yucatán
Limestone
H. 27.5 cm.
Late Classic (A.D. 550–800)
Museo Nacional de Antropología, Mexico 5-1750

This small block of stone is almost square, and the relief-carved
head has been so arranged that one corner of the square is the
center line of the face while the ears are situated on the oppos-
ing corners. A break at the back of the head suggests that this
sculpture was originally tenoned into an architectural wall. The
spiral eyes and the sinuous line that runs under the eyes and
loops over the bridge of the nose, along with curls from the cor-
ners of the mouth, are important motifs in the iconography of
the Jaguar God of the Underworld. The iconic attributes of this
entity are depicted in many contexts, all of which, however,
have suggested to iconographers the dire aspects of darkness
and the Underworld. This particular head is thought to be from
Uxmal. H. E. D. Pollock notes that it is "published without
comment" as Figure 27 by Alberto Ruz; Pollock designates it as
"Miscellaneous Sculpture #44." In 1913, however, Herbert
Spinden published a drawing of this piece, assigning it to the
nearby site of Labná. FC

Pollock, 1980, pp. 200-201; Ruz, 1959; Spinden, 1913, p. 17,
fig. 1

114 Peccary skull
Copán, Honduras; Tomb 1
Bone with red pigment
L. 21.5 cm.
Late Classic (A.D. 600–700)
Peabody Museum of Archaeology and Ethnology,
* Harvard University 92-49-20/C201*

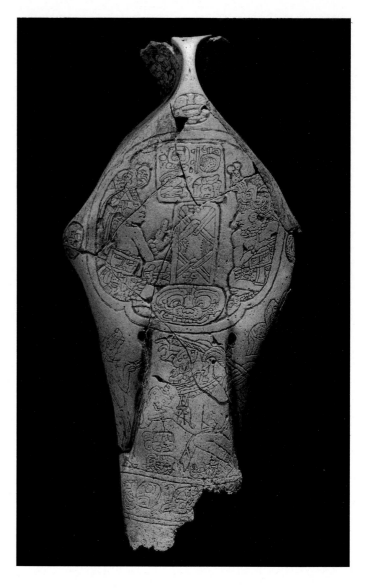

Like the dog effigy head (No. 115), this incised bone was exca-
vated from Tomb 1 at Copán. Within the four-lobed frame that
fills the top of the skull, two seated Maya lords flank a small
stela with a zoomorphic altar before it. At the top of the scene
four glyphs record the period-ending date 1 *Ahau* 8 *Che'en*,
which probably refers to the mythical past, as does the same
date—perhaps with the same heroic individuals—on the later
Stela N at Copán. This scene, with two figures wearing fringed
jaguar-skin kilts and ballgame belts, may refer to a mytho-his-
torical cyclic-completion ceremony, perhaps the beginning of
the Venus cycle on 1 *Ahau*. It may also refer to an epic of the
ballgame-playing, Venus Hero Twins, who overcame ordeals
while in the Underworld. The medallion with its miniature stela
also illustrates both the four-part horizontal and the three-part
vertical Maya worldviews (see pp. 48-49). The two figures are
differentiated in that the more important one (on the right) is
seated frontally on a raised jaguar-skin-covered seat and wears a
long-snouted animal headdress; the secondary figure, shown in
profile, wears a macaw headdress.

 Below this scene, in an Underworld position, is a crouching
skeletal-headed figure blowing on a conch shell. He wears a
"death-eye" collar and a deer antler projects from his forehead
just below a tumpline that supports a large bundle on his back.
The most animated parts of this composition are the other Un-
derworld creatures incised along the sides of the skull. A mon-
key-tailed deer on the left, and a flying, long-beaked bird on
the right, face the skeletal figure. Above the historical medal-
lion, on the right, a headband-wearing monkey shakes a rattle
in one direction while a jaguar faces in the opposite direction
behind him; on the left, three bristling peccaries stampede to-
ward a glyphic cartouche that may refer to the Maya lord en-
throned on the jaguar seat. The other glyphic cartouches and
inscriptions on the peccary bone are not readily
identifiable. ccc

Longyear, 1952, p. 111, fig. 107o

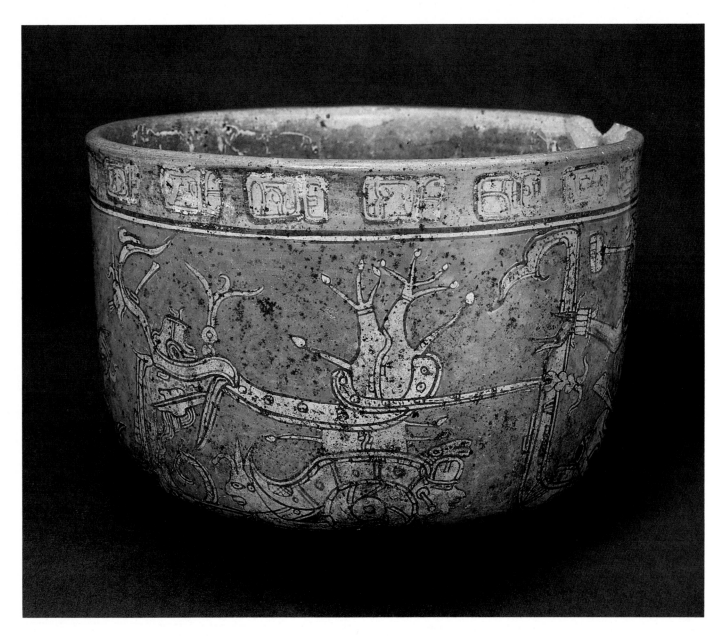

121 Bowl with Underworld figures
San Agustin Acasaguastlán, Guatemala
Ceramic; slipped black, red, and orange on white
H. 13.7 cm.
Late Classic (A.D. 700–750)
Museo Nacional de Arqueología y Etnología, Guatemala 1735

The three figures on this bowl are engaged in an activity that unfolds against a red subterranean background. On the right, two figures are seated on serpentine forms; they have black-painted faces and are covered with large black spots that probably indicate they are the dead Hero Twins who have been resurrected from an Underworld river. And, as fish men (symbolized by their headdresses), they take their revenge on the lords of Xibalbá. They brandish hafted axes and are perhaps about to kill the Old God on the left. This theme is found painted on vessels from Chamá, in the highlands, north of where this bowl was found. Like the Chamá vessels, this one was painted with a resist technique that left the white, unslipped body of the vessel visible in detail. Unlike the Chamá vessels, however, this scene features a serpent-entwined tree, perhaps a World Tree, growing from a double-headed snail at the center of the scene. Circles and dashes line the serpent's body, indicating its subterranean, watery significance. Red- and black-spotted liquids pour from its bearded head and overflow a dish into which a snail head seems to gaze. The nineteen glyphs, which are stylistically related to certain polychrome ceramics from Copán, are probably meaningless. CCC

A. L. Smith and Kidder, 1943, fig. 43b

119 Water-lily jaguar head pendant
Altun Ha, Belize; Tomb B-4/6
Jade
H. 3.7 cm.
Late Classic (A.D. 550–650)
Royal Ontario Museum, Toronto 966.159 RP 256/27

This small pendant, from the same tomb as the inscribed plaque (No. 82), represents the head of the water-lily jaguar. The nocturnal jaguar is the form taken by the sun at night when it is in the Underworld, its black-spotted golden skin the inverse of a star-spotted sky. The Underworld identity of this jaguar is evident from the hooks in its eyes and in the forehead water lily, which alludes to watery realms beneath the earth that the animal inhabits. This carving is unusual for its formal symmetry, which was achieved by the bilateral balancing of scrolls and hooks at the forehead, eyes, and nostrils, and by two circular pits drilled to frame the jaguar's prominent canines. CCC

Pendergast, 1982*b*, p. 90, fig. 56g

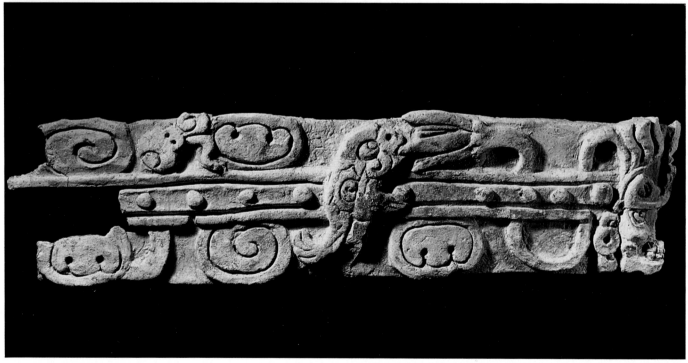

120 Architectural frieze
Altun Ha, Belize; Plaza A, Structure A-2
Stucco; red paint
H. 25.5 cm.
Late Classic (A.D. 600–700)
Royal Ontario Museum, Toronto 967.71.151

Located at the southwest corner of Plaza A at Altun Ha, the terraced platform known as Structure A-2 had an architectural decoration which consisted of an Underworld water frieze. This section of the frieze includes its most diagnostic elements: a horizontal band with tri-lobe elements and rows of dots (balls) bordered above and below with two scroll devices that denote waves. Fish feed upon a sinuous, long-stemmed water lily that intertwines with the straight surface-of-the-water band and which grows from foliate forms in the headdress of a skeletal head that would have been located at the corner of the platform. Such basal water friezes represent the waters of the earth and Underworld below the realm of human action (as on the basal panels of stelae), and would therefore designate Structure A-2 as the locus for lineage ceremony, perhaps in association with the tombs in the contiguous Structure A-1. CCC

Pendergast, 1979, pp. 96–99, pl. 17

117 Crouching jaguar
Tikal, Petén, Guatemala; Structure 5D-73, Burial 196
Jade; red pigment
L. 16.2 cm.
Late Classic (A.D. 700–750)
Museo Sylvanus G. Morley, Tikal 117A-50/36

This crouching jade jaguar inhabited the Underworld just as its mythological counterpart, the Jaguar Sun, journeyed nightly into the nether regions. The animal is identified by its round ears, by the three spots of the *ix* glyph in its eyes, and by the characteristic water lily on its forehead, which the nocturnal jaguar picked up in subterranean rivers. This is the largest piece of jade excavated to date at Tikal. CCC

W. R. Coe, 1967, p. 65

118 Jaguar head pendant
Highland Guatemala (?)
Jade
L. 3 cm.
Late Classic (A.D. 650–750)
Dumbarton Oaks, Washington, D.C. B-541.MAJ

Drilled both horizontally and vertically, this brilliant green jade jaguar head might have hung at the center of a necklace with another object attached to its bared teeth. It is smaller, probably later, and more naturalistic than the jade head from Altun Ha (No. 119), which has symbolic detail that suggests an explicitly religious significance. CCC

Handbook, Bliss Collection, no. 434

115 Dog head effigy vessel

Copán, Honduras; Tomb 1
Ceramic; slipped fire-blackened buff with red pigment
H. 21 cm.
Late Classic (A.D. 650–750)
Peabody Museum of Archaeology and Ethnology,
 Harvard University 92-49-20/C183

The highland Maya believed a canine guide and guardian led
the dead through the perils of the Underworld, and this dog
with gaping jaws and red throat—brilliant with cinnabar—may
have symbolized that companion. The incised peccary skull
from this same tomb (No. 114) apparently alluded to the adven-
tures of the Hero Twins in the Underworld, another southern
Maya belief. The finest Late Classic art produced at Copán
was sculptural, and this modeled tripod effigy belongs to that
local tradition. CCC

Longyear, 1952, p. 40, fig. 107d

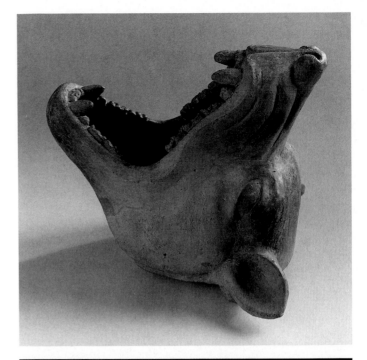

116 Dog effigy whistle

Alta Verapaz (?), Guatemala
Ceramic; postfire red and blue paints
H. 13.4 cm.
Late Classic (A.D. 700–800)
Museo Nacional de Arqueología y Etnología, Guatemala 5892
 (Dieseldorff Collection)

This male dog, with its wrinkled skin, resembles a young
xoloitzcuintli, a hairless Mexican dog known to have been raised
and eaten in ancient Mesoamerica. Yet this animal's conspicu-
ous ribs and vertebrae suggest it may have had some funerary
significance, since skeletal creatures inhabited the Underworld
and it was believed that these dogs protected and guided their
dead masters through that infernal region. The rope around the
dog's neck was once painted blue, a color thought in some con-
texts to connote sacrifice; indeed, *xoloitzcuintlis* would have
been sacrificed in order to perform their posthumous role in the
Underworld. This whistle may have been used in a Late Classic
highland funerary ritual. CCC

Villacorta, 1938, p. 294

122 Round bowl with painted birds
Tikal, Petén, Guatemala; Structure 5G-8, Burial 72
Ceramic; slipped black, brown, and red on orange
H. 12.5 cm.
Late Classic (A.D. 650–700)
Museo Sylvanus G. Morley, Tikal 27A-46/18

The subtlety and ingenuity of Maya ceramic painting may be appreciated in the mythological birds painted on this vessel. They display formal complexity through a tonal variation achieved with a single orange slip, which ranges from a near black through brown and red to the diluted orange of the background. This exceptional bowl was the sole vessel in the grave of a woman who was buried in the only vaulted tomb found away from the center of Tikal. The two birds have skeletal heads, jewelry, and headdresses that may have smoking mirrors at the front. Each has a single visible wing which, at the upper edge, is transformed into the upper jaw of a serpent; and each has a beaded and feathered tail ornament, with a single large claw below. These serpent-birds are the denizens of the highest heaven. The rim inscription was apparently painted later by a different hand, with little regard for the spacing envisioned by the original artist. The thirteen glyphs are unusual for Tikal in that they conform to the order of ceramic texts from northern Petén. CCC

W. R. Coe, 1967, p. 103

123 Old man with a pot on his back
Jaina style, Campeche (?)
Ceramic
H. 16 cm.
Late Classic (A.D. 550–800)
Barbachano Ponce Collection, Mexico (INAH) 517

Old age is poignantly portrayed here in the bulging belly and sunken chest that leaves the ribs and sternum visible through thin skin. But the artist's greatest attention, as with most modeled figurines, was spent on the old man's face. One can sense the sculptor's deftness as he pushed down the clay under the eyes to make drooping bags. Age seems to establish the dignity of this person of high status (indicated by the deformation of his skull). Old men bearing *brazeros* on their backs are often representations of the Old Fire God. However, this deity usually bears a few more attributes than age alone. It is possible that this old man originally had a removable headdress, particularly since the earplugs are pierced and may have received bindings from a headdress. FC

124 Articulated dwarf figurine
Jaina, Campeche
Ceramic; white paint
H. 25.1 cm.
Late Classic (A.D. 550–800)
Museo Nacional de Antropología, Mexico 5-1425

Made from a mold, this figure belongs to a popular group of puffy-faced beings with dwarfish proportions. The ratio of head to body is 1:3. Like the warrior whistle (No. 108), this figure appears to be representative of spirits rather than humans. The costuming is minimal, and only white paint is used to color the headband, face and upper chest, hands, loincloth, and feet. The earplugs of wide pendent cloth (?) forms are usually worn by bound figures and are associated with captives and sacrificial victims. Dwarfs are often portrayed with the features of old men mixed with those of children and were considered to have many supernatural powers deriving from their chthonic origins; they were also associated (or synonymous) with the four *bacabs* who supported the sky at the four corners of the world. J. Eric S. Thompson points out that Spanish Colonial chronicles refer to the *bacabs* as actors or mummers, and it is this attribute that best explains this puppet-like figure. The movable arms are molded in such a way that at whatever the level they are placed, the palms are forward in a gesture of supplication or discourse. The open mouth, the sunken, puffy eyes, and the frown suggest the appropriate exaggeration of tragic oration. FC

Thompson, 1970, p. 277

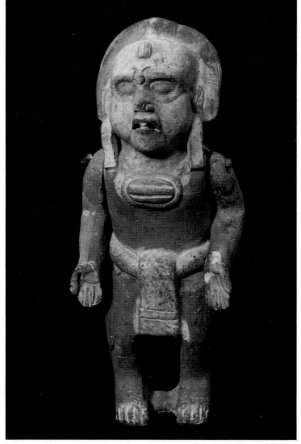

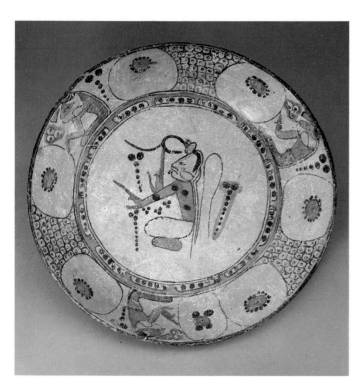

125 Plate with sacrificial figure
Site unknown
Ceramic; orange and black paint
D. 37.5 cm.
Late Classic (A.D. 550–800)
Recinto Prehispanico, Fundación Cultural Televisa A.C.,
Mexico R 21 P.J. 211

The central seated figure on the plate appears to have been performing self-penance: piercing his skin and drawing blood. The black spots on his orange body are the bloody wounds, and perhaps the black spots patterned in front of the figure are drops of blood. At his back is a shape outlined like a hairpin (perhaps a throne back), and behind that a phallic form outlined in red-orange and filled with the same pattern of black spots. This form is shaped like a perforator, a tool used to pierce the skin (actual examples are known archaeologically). Three seated figures wearing gray kilts are evenly spaced around the rim, and all three are framed with large, outlined mammiforms. The field between the figures is filled with small, scalelike shapes that give texture and color in contrast to the plain central field. The outlines were quickly applied by the sure hand of a skilled painter, in an expressive calligraphic line. FC

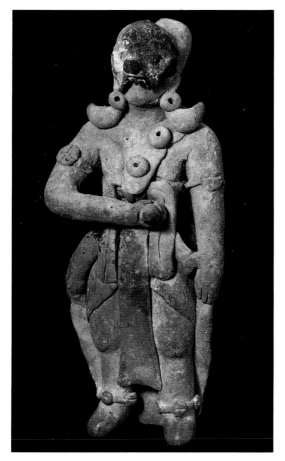

126 Masked-man ocarina
Jaina, Campeche (?)
Ceramic; black paint
H. 20.5 cm.
Classic (A.D. 250–800)
Museo Nacional de Antropología, Mexico 5-1135

Jon Freshour* has suggested this richly dressed figure is committing suicide. In his right hand he holds what seems to be a knife, and he appears to have just stabbed himself. If so, this is a rare representation. However, self-penance is well known as an ancient practice and generally is associated with bloodletting. The polychrome plate (No. 125) depicts a seated male dripping blood from many self-inflicted wounds. None, however, is in such a mortally vital area as shown in this ceramic piece. The most interesting costume motif is the removable black mask with large eyes and the upper jaw of a feline (?). Black is a color associated with death and war. The two holes on either side of the forehead were designed to accept the ties of the mask. Although the mask and the body of the figurine are modeled, the head and the cleft headdress or hairdo appear to have been mold-made. Both feet are modern replacements. The blowhole is on the back of the figure's right shoulder, but since three stops are placed down the back, this piece is more aptly called an ocarina than a whistle. FC

*Personal communication. Jon Freshour is the special registrar for the MAYA exhibition.

177

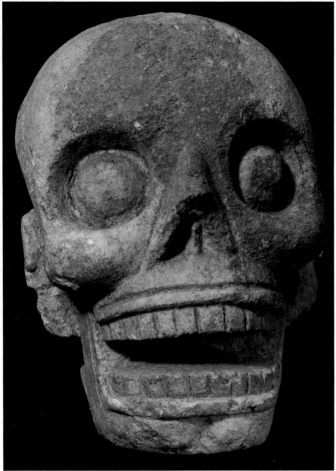

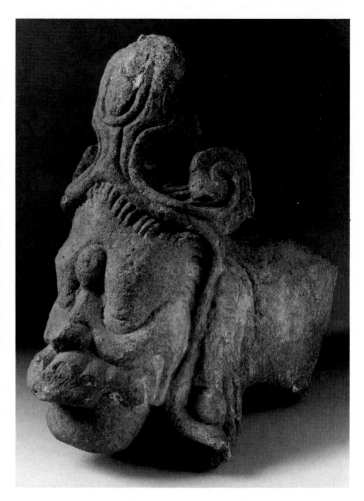

127 Skull
Uxmal, Yucatán
Limestone; traces of red pigment
H. 22 cm.
Late to Terminal Classic (A.D. 550–1000)
Museo Regional de Antropología, Mérida INAH-75/CRY-316

This piece is from the east side of the Great Pyramid of Uxmal. The tenon at the back of the skull indicates it was once part of the wall decoration. The Maya seldom depicted entire skeletons, and skulls by themselves were used to suggest death, violence, and sacrifice (the most common interpretation of skulls). Much of the original red pigment that once covered the face is lost; nonetheless, this realistically carved, life-sized skull is still powerful and eerie: undesiccated, the eyeballs stare from the socket holes, and the grimacing mouth has a full set of rectangular teeth. FC

128 Tenoned monster head
Copán, Honduras; Structure 22
Stone
H. 41 cm.
Late Classic (A.D. 550–800)
Peabody Museum of Archaeology and Ethnology,
* Harvard University C 92-49-20/C35*

By its exaggeration and distortion, this face is the opposite of the Maya ideal of beauty: the eyes are drooping crescents, the nose is short and concave, and the chin is large and bulbous. Yet even with the protruding, monkey-like jaw and teeth, a graceful coherence and rhythm is achieved by the interrelationship of the curving forms that make up the image. This piece was once covered with stucco and painted red. It comes from the southeast corner of Structure 22, a building with a clear ritual function. FC

178

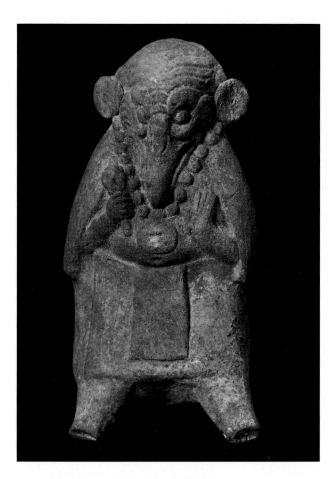

129 Anthropomorphic vulture whistle
Jaina, Campeche
Ceramic; traces of blue and white paint
H. 13.1 cm.
Late Classic (A.D. 550–800)
Museo Nacional de Antropología, Mexico 5-3481

The front of this whistle is mold-made and the round earplugs were attached later. The blowholes are at the rear of the figure. Anthropomorphs in the Jaina figurine style are common enough to have been given their own category by Román Piña Chán (his type III). The wrinkled forehead and elongated raptorial beak with a knob set between the eyes denotes a vulture; otherwise the figure is human. The fat belly, together with the wrinkled brow, may be signs of age. Thus, the Old Man Vulture holds a rattle in its right hand and displays the palm of its left hand in a gesture typical—interestingly enough—of molded Jaina figurines of women. So perhaps this is Old Lady Vulture. She (or he) wears a blue cape and a white wraparound skirt with a loincloth apron. The triangular composition of the earplugs and necklace nicely frames, indeed, emphasizes the vulture head. Vultures were associated with celestial and solar iconography and were considered portentious. The omens of the vulture, a carrion bird, were most likely dire. In the *Book of Chilam Balam of Chumayel* the expression, "rains from a vulture sky," may mean an overcast sky—portending much-needed rain—but as the vulture sky, it disappoints; it is cloudy but withholds its water. FC

Piña Chán, 1968*b*; Roys, 1967, p. 154

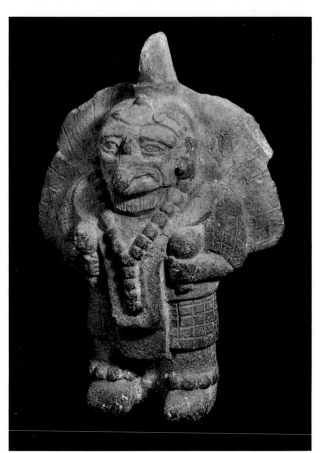

130 Anthropomorphic bird rattle
Jaina, Campeche
Ceramic
H. 17.7 cm.
Late Classic (A.D. 550–800)
The Brooklyn Museum, New York 37.2785

The front of this hollow figurine was made from a mold; its back is plain. This old man vulture or turkey is bearded and has wings on its upper arms and a flared-feather backdress. He carries gourd-shaped rattles in both hands and wears a beaded or quilted shift held at the waist by a plain, wide belt. Around his neck, the thick, crosshatched collar is reminiscent of warriors' attire from Yaxchilán. This ceramic piece was found at Jaina by B. M. Norman and published by him in 1843. Norman states that it was a household god and that the clay-pellet rattles were supposed to be "formed of the ashes of the victims that had been sacrificed to the particular god in which they were deposited." FC

B. M. Norman, 1843, p. 215, pl. 2

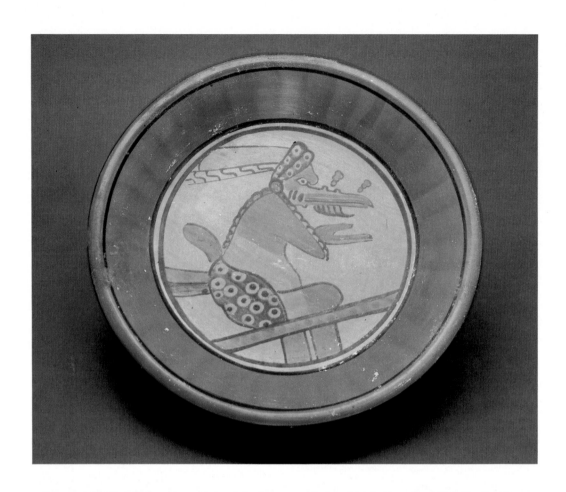

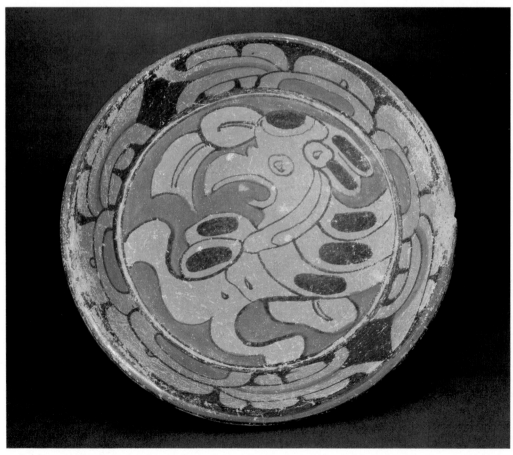

131 Anthropomorphic water bird tripod plate
North of Tikal (?), Petén, Guatemala
Ceramic; slipped black, red, and orange
D. 25 cm.
Late Classic (A.D. 750–800)
Museo Sylvanus G. Morley, Tikal 394-83

An anthropomorphic bearded water bird seated upon a table
throne fills the center of this tripod plate. Although the vessel
was seized from looters, and thus of unknown provenience, it is
likely that it was made somewhere near Tikal. The "red bar"
design, created by overlapping layers of orange slip, was com-
mon at Tikal, as was the Moan-bird-feather pattern, which was
adapted on the exterior wall of this plate by using a reserved-
circle technique, seen on the bird-man's kilt and headdress,
where it may indicate a batik dyeing process. CCC

133 Shell jewel box
Copán, Honduras; Mound 9
Spondylus shell, jade bead, cinnabar, specular hematite (?);
 pigments
W. 12.5 cm.
Classic (A.D. 400–800)
Peabody Museum of Archaeology and Ethnology,
 Harvard University 95-42-20/C686, C687

Spondylus or "thorny oyster" shells were of extraordinary sym-
bolic importance to the Maya elite, who included them in their
burials and caches. They were used whole, scraped to show
their orange inner layer, and cut in pieces to add color to jewel-
ry and mosaics. Spondylus shells, with long "thorns" still intact,
were obtainable only by diving below ten fathoms, whereas
wave-tumbled specimens, prized for their orange color, might
be found on beaches. Spondylus shells are shown as offerings
and possessions in the palace of the lord of the Underworld
and, like conch shells, some of their Underworld importance
must have derived from their submarine origins. Found cached
in the west range of the ballcourt at Copán, this complete shell
was a jewel box which held its jade bead nestled in brilliant red
pigment that once entirely filled the shell. It is a symbolic para-
digm of death, resurrection, and the three Maya realms: the
shell denoted the Underworld, the red pigment signified blood
and the realm of man; while jade—the most precious Maya sub-
stance—stood for the transcendent. CCC

Gordon, 1896, p. 21

132 Anthropomorphic bird plate
Edzná, Campeche
Cui-orange polychrome with black paint
D. 29.2 cm.
Late Classic (A.D. 550–800)
Museo Regional de Antropología, Mérida EZ 1670; 11/82

There are many examples of polychrome plates displaying this
particular bird, and a debate exists concerning its precise iden-
tification. Joseph Ball has specified the ceramic type of this
plate as *Cui*-orange polychrome. He names it after the owl—*cui*
in the Yucatec language—because of its iconographic associ-
ations with death. He sees the owl as an appropriate icon for
such ceramic plates, which were most certainly used in burial
rituals. What one *sees* when looking at this plate are not clues
to the underlying reality of the bird (whether it be a vulture or
an owl), but its mythical attributes. The painted line is calligra-
phic and expressive, and the relationship of the images to their
circular field is graceful and sophisticated. The bird is anthropo-
morphized by the human costume of a headdress and necklace.
It is also highly conventionalized; the wing is reduced to three
curving bars with black interior ovals. (One could suppose,
then, that all the outlined forms containing black ovals are
feathers.) The body and feet are rendered rather like a fish's
tail. Since the bird does have a downward-curving beak, one
might go so far as to suggest that the carnivorous nature of a
raptorial bird was an important part of this icon. FC

Ball, 1975, pp. 32–39

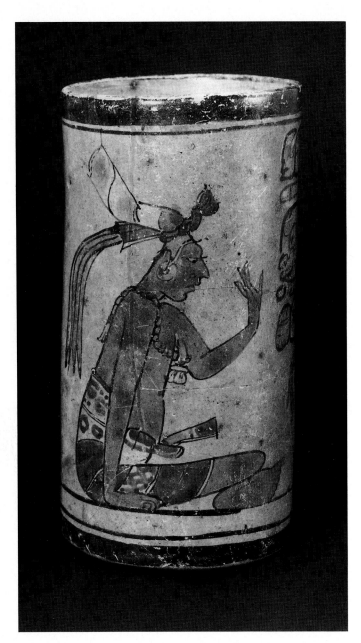

134 Cylinder with seated lords
Hokeb Ha, Belize; Blue Creek Cave
Ceramic; slipped black, red, orange, white, and pink on orange
H. 21 cm.
Late Classic (A.D. 750–800)
Belize Department of Archaeology, Belmopan 28/179-5:7

Found on the floor of a cave which is the source of Blue Creek, this polychrome cylinder was one of an offering of forty-two vessels. On the wall of the vessel two lords are engaged in conversation. The seated figure, seen here, gestures expansively toward a man on his right. They are barefoot in this interior scene, and dressed simply in kilts, with necklaces, earflares, and feathered white-cloth headdresses. Four boldly painted glyphs fill the space between the two figures. These are heavily outlined in black and, like the white headdresses, have clouds of specular pink hematite pigment shading. As is often the case on polychrome vessels, this inscription may have been painted by someone other than the artist who executed the figures. Two of the four glyphs probably derive from the sequence commonly found on ceramics: a human head with a verbal affix, and what may be a wing-fish head. The prefixed Cauac at the end might refer to a watery place, possibly even the cave where the vessel was discovered. CCC

Palacio, 1977

135 Two earflares
Lamanai, Belize; Structure N10-66, Burial N10-66/9
Chank shell
D. 4.9 cm.
Terminal Classic (A.D. 850–900)
Lamanai, LA 666/2a, b

These elegant, polished shell earflares with dentate rims have extensions that would have projected backward through a hole in the lobe of the ear. Although not as numerous as jade in the archaeological record, the more perishable shell ear ornaments were probably very common; white earflares are often shown on polychrome ceramics and, by Terminal Classic times, jade had become scarce. CCC

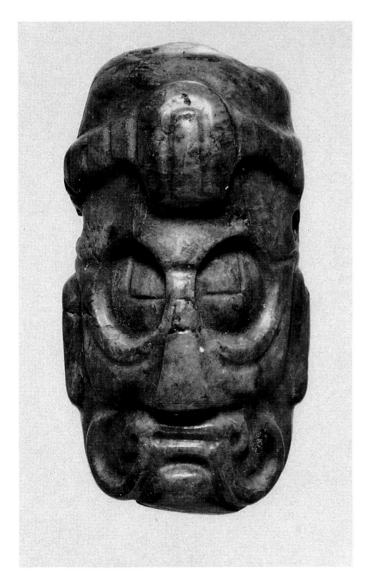

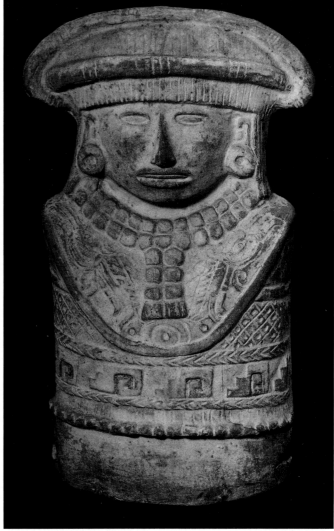

136 Sun God pendant
Southwest Maya region
Jade; resin
H. 4.2 cm.
Late to Terminal Classic (c. A.D. 750–850)
Dumbarton Oaks, Washington, D.C. B-163.MAJ

Blue jade, admired and worked by the ancient Olmec, was no longer available in Late Classic times, and this pendant may have been reworked from an earlier piece. It has bars in place of earflares (a Preclassic trait), but otherwise the portrait of the Sun God is stylistically Late Classic. This Kinich Ahau, Sun-eyed Lord, has oversized solar eyes with inturned pupils and an outlining fillet; long, curling ribbons at the corners of the mouth; and a circular element at the front of the headband with hair (?) drawn forward through it. This strange device probably derives from the smoking tube shown in the forehead of the Early Classic Old God effigy censer (No. 34). An unusual concentrically drilled depression on the back may have secured this jade to another object. Traces of resinous material, probably copal incense, remain on the back. CCC

Lothrop, Foshag, and Mahler, 1957, no. 110, p. 250, pl. 65, 2nd row, right

137 Molded figurine
Jaina, Campeche
Ceramic; slipped white, traces of blue pigment
H. 28 cm.
Late to Terminal Classic (c. A.D. 600–900)
Museo Nacional de Antropología, Mexico 5-1752

Originally this figure was provided with movable arms and legs. Holes at the upper and lower sides of the torso would have held the cord that tied the limbs in place. Christopher Corson considers molded, articulated figures as a late innovation in the Classic tradition of figurine production. Other characteristics of this particular type are the serpent eyes on the *quechquemitl* (the biblike top), the banded, ovular headdress, and the white slip applied to the front of the image. On this female figure one can also see traces of blue in the necklace tassels and in the stepped-fret border of the skirt. The careful attention given to the textile designs on the woman's skirt and *quechquemitl*, the sculptural definition of her face, the high cheekbones, and the slightly open, generous mouth are unusual for molded pieces of this late date where, generally, the detailing appears haphazard. FC

Corson, 1976, fig. 30c

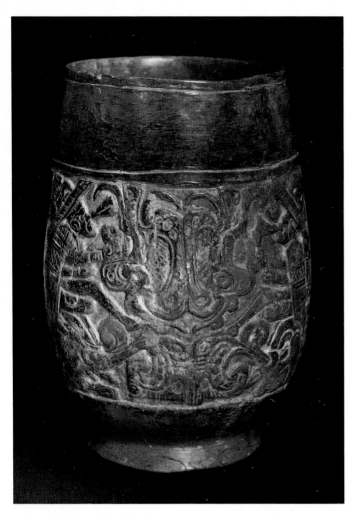

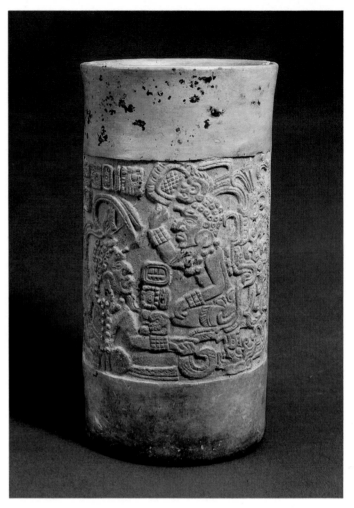

138 Molded pedestal vase
Seibal, Petén, Guatemala; Structure A-14, Burial 1
Ceramic; slipped orange
H. 16 cm.
Terminal Classic (A.D. 800–900)
Museo Nacional de Arqueología y Etnología, Guatemala 8244

Fine Orange ceramics like this were made with an unusually fine, temperless paste which lent itself to molding and thus to the duplication of designs; copies of this vessel have been found in a number of places in the southern Maya lowlands, where they were widely traded in the Terminal Classic period during increased commercial and military activity. There are slightly variant scenes on each side and every scene is itself almost a mirror image, since a central axis divides the symmetrical halves. At either side a male figure is seated on a large skeletal Long Nose Head that emits plumes from its bony nostrils. Each figure has a wide-brimmed headdress with a bird head on top and wears what may be a basketry cape. All gesture toward a large, vertical serpentine upper jaw with crosshatched elements which substitute for the lower jaws. These figures have cartouches ("god marks") on their thighs, indicating a supernatural identity, and the skeletal heads describe an Underworld location for the scene. *Kin*-sign earflares and wrinkled faces suggest the male figures may be associated with the sun. CCC

Sabloff, 1975, pp. 195, 196, figs. 384, 386

139 Molded cylinder
Zacapa (?), Guatemala
Ceramic; slipped buff and orange
H. 23 cm.
Late to Terminal Classic (A.D. 750–850)
Museo Nacional de Arqueología y Etnología, Guatemala 8455

The two scenes on this tall cylindrical vessel are molded and thus identical; this technique, in combination with this style and form, is rare, but it fits into the monochrome ceramic tradition found in the southeastern Maya region. Molded with precision, the figures on this vessel have several identifying characteristics of unknown meaning. On the right, a bearded man has a bar or tube inserted through the skin of his forehead and wears a close-fitting beaded cap while he holds a fan up in his right hand. He is seated within the elaborated open jaws of a short double-headed serpent which has its tail facing up at the bottom right corner of the scene. The man has a monkey head at the front of his headdress, and a monkey-head glyph at the end of the short inscription probably identifies him. On the left, the secondary figure is similarly bearded and capped, with a bar through his forehead, while the head of a deer tops his headdress and perhaps identifies him. CCC

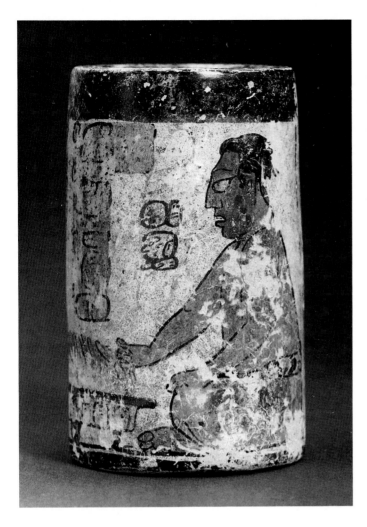

141 Glyph panel
Usumacinta River area
Limestone
H. 26.3 cm.
Late Classic (A.D. 550–800)
Art Institute of Chicago, Claire B. Zeisler Foundation,
 Restricted Gift 1970.10

This panel is an excellent example of the delicate graphic detailing rendered by Maya scribes in carving glyphs. An enormous amount of attention was given to these small and intricate forms. Now removed from its original context, this piece probably belongs with a group of eight similarly styled and shaped panels that are in various collections in the United States and France. The group of panels are devoted to glyphic statements, like this example, and to narrative scenes of the ballgame. Given the size of these panels, they may have been the carved risers of an important stairway. At Yaxchilán, a site on the Usumacinta River, a hieroglyphic stairway, fronting Structure 33, depicts scenes of the ballgame. Although the glyphic style of the Chicago panel, along with its mates, does not belong to Structure 33, it does reflect the same conception. The glyphs are part of a longer statement, and are to be read top to bottom and left to right, ending with the glyph for the day 4 *Caban*. Michael Coe gives the day name as *Cauac*, but this seems unlikely. The glyph immediately preceding the day is a "distance number" that records the span of time from one stated date (now missing) to another. This number represents seventeen days and two months. Since *Caban* is the seventeenth day in the Maya month, the missing first date would have been the day *Ahau*, seventeen days (and two months) earlier in time. In the Maya calendar, whole periods of time—months (*uinales*), years (*tuns*), and so forth—always ended on the day *Ahau*. FC

M. D. Coe, 1973; I. Graham, 1980; Mayer, 1978; Wardell, 1967

140 Miniature vase
Tayasal, Petén, Guatemala; Structure T7-B, .Burial T7B-3
Ceramic; slipped black, orange, red, and pink on buff
H. 10.8 cm.
Terminal Classic (A.D. 800–900)
Museo Nacional de Arqueología y Etnología, Guatemala 9967

Each of the three individuals painted on this miniature vessel is identified by a brief inscription. The two wearing sarongs on the left are women, possibly relatives of the child with whom the cylinder was buried; they are taking part in a ceremony with a burly lord (shown here), who is seated to the right wearing a jaguar-skin loincloth. Two faint lines signifying speech curl from his mouth, and all three figures gesture toward a large Moan-bird-feather tripod bowl at the center of the scene. Such vessels had a funerary role in Late and Terminal Classic Maya culture, and this one may be related to a bloodletting ritual associated with the death of an important child. CCC

A. F. Chase, 1984a

185

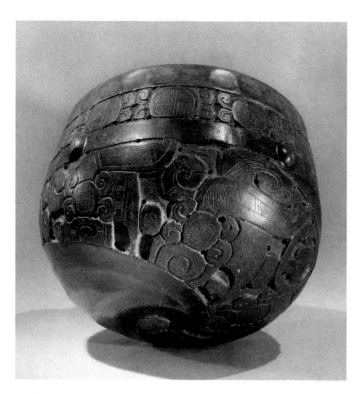

143 Cylinder tripod with ring-handled lid
Santa Rita, Belize; Special Deposit P2, B-1
Ceramic; slipped brown on cream
H. 20.8 cm.
Late Classic (A.D. 600–675)
Belize Department of Archaeology, Belmopan 35/203-2:9

Cylinder tripods are a hallmark of Early Classic ceramics and usually they are austerely black-slipped with carved or incised decoration. However, this later example, while maintaining a tradition of austerity, has glyphic cartouches that are painted in dark brown on a cream slip. The same two glyphic forms are repeated, joined by tabbed, twisted ropes, on the ring-handled lid and on the wall of the vessel. One of the cartouches has an animal head with glyphic affixes, the other is a more abstract composite form. When excavated, this vessel was badly smashed and has been reconstructed from numerous sherds. CCC

D. Z. Chase, 1981*a*

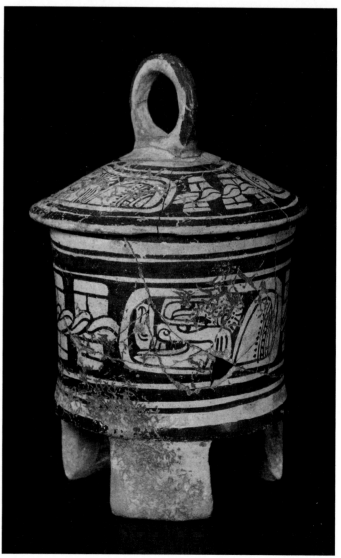

142 Carved rattle bowl
Quiché (?), Guatemala
Ceramic; slipped dark brown
H. 12.5 cm.
Late Classic (A.D. 700–800)
Dumbarton Oaks, Washington, D.C. B-554.60.MAP

This striking vessel is best appreciated when held, as it has a double wall and is filled with pellets that rattle; furthermore, the design is only completely visible when the vessel is upside down. At the rim there is a row of depressions in the polished surface above a glyphic band. Below this, a plain band with four equidistant knobs borders the perforated, spirally decorated lower section. A glyphic element with doubled scrolls is repeated eleven times in the rim band and appears once in the carved spiral. This glyph is quartered with opposing plain and cross-hatched sections, and like the *olin* sign, which is also present on the vessel, suggests a contrast or interaction between opposites. Such a contrast also characterizes the two interlocking spiral designs. CCC

Von Winning, 1967

144 Standing ballplayer
Jaina (?), Campeche
Ceramic
H. 14.9 cm.
Late Classic (A.D. 550–800)
Museo Nacional de Antropología, Mexico 5-3020

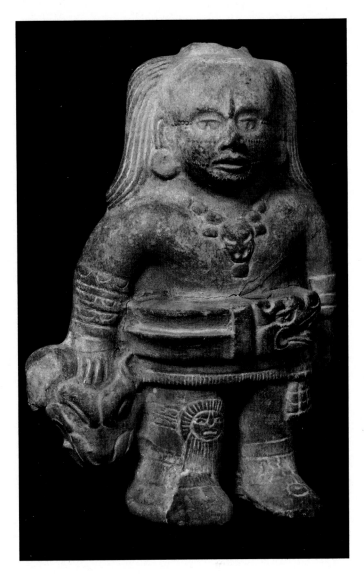

The ball used in the Mesoamerican ballgame was made of solid rubber and could—probably did—inflict real harm if it struck unprotected flesh as it bounced off the walls of the ballcourt. As in our game of soccer, players could not throw the ball with their hands, but had to control it with the other parts of their body.

Protective clothing, then, is the iconographic hallmark for a ballplayer; this figure wears a padded arm guard on his right arm and a knee guard in the shape of a human face over his right knee. He also wears what appears to be a stone yoke, a U-shaped belt carved with a reptile's head. (Actual stone yokes have been found throughout Mesoamerica, but only in Veracruz is there any kind of concentration of such artifacts.) His long hair stands out like wings on the sides of his head, and his forehead and pate are either shaved or bald. The hole in the top of the head may have originally secured a headdress. Christopher Corson points out that in the Jaina figurine tradition the headdress of a ballplayer is almost always a deer head. In this case, the ballplayer holds a deer head in his right hand, and it can be questioned whether this motif was repeated as his headdress.

Stylistically, this piece could as easily have originated in the Tuxtla region of Veracruz. Corson suggests that ballplayers depicted wearing stone yokes do not belong to the Jaina style and may be from southern Veracruz. In fact, in 1964 Fondo Editorial published this piece as coming from Veracruz. In addition, the treatment of the eyes and the shape of the head, with the forehead wider than the cheekbones, are qualities associated with Mexican rather than Maya depictions of faces. Still, the distinctions are either subtle or mutable. It may be that during the Late Classic period the Maya figurine tradition became diffused, and conjoined with the ancient figurine tradition of Veracruz, making our identification of original locations difficult. Two distinctive stylistic features, thick ankles and large feet, are shared with other Jaina mold-made figurines. FC

Corson, 1973, p. 64; *Fondo Editorial*, 1964, illus. 105

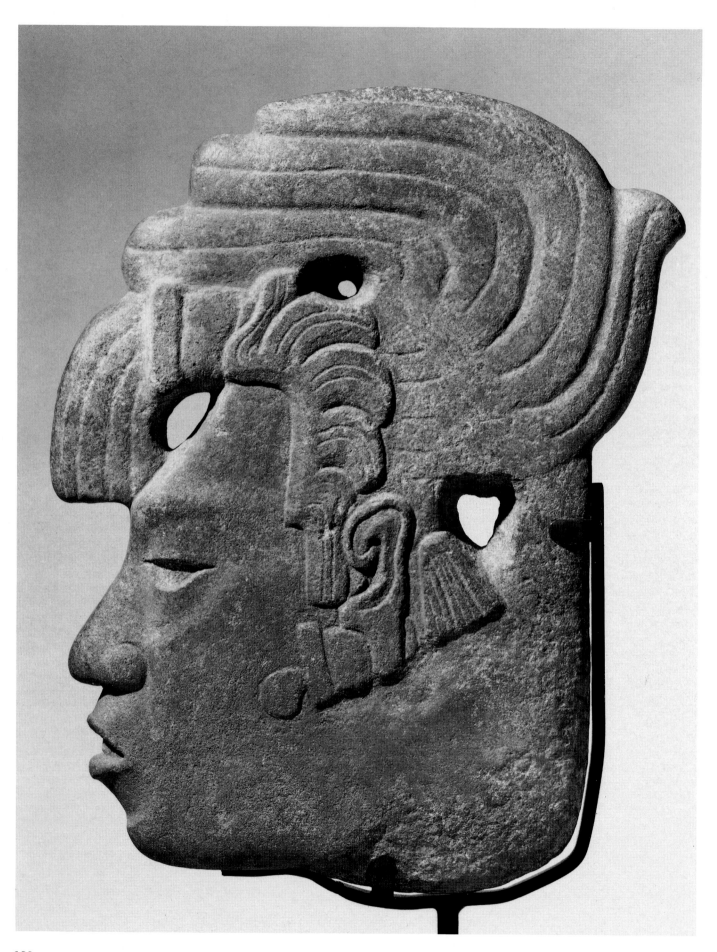

145 Hacha
Site unknown
Sandstone
H. 30 cm.
Late Classic (A.D. *550–800*)
Art Institute of Chicago, Ada Turnbull Hertle Fund 1970.423

Hachas surely belong to the paraphernalia of the ballgame, but just what use they served is difficult to say. Whatever their function, it probably was ceremonial, since it is hard to imagine how one could have been used as practical equipment for the game. An *hacha* is so named because its shape resembles an ax. Invariably, it is a thin slab that thickens slightly toward the back. The image appears on the front and sides of the slab which, like this piece, is often a head.

Regardless of its function, this *hacha* is visually interesting. It is conceived as a combination of sculpture in the round and two-dimensional relief carving. A complete head is carved, using the thin edge of the *hacha* as the center line of the face, and all background is cut away in the same way as sculpture in the round. However, the thinness of the slab precludes the fullness of a three-dimensional form, and basically the image is made up of two silhouetted profiles.

Although *hachas* are more commonly found in Veracruz, there is little question that this piece is of Maya manufacture. For stylistic and iconographic reasons, it could be either from the western Maya area or the far eastern region. The subtle but well-observed facial modeling is close to the artistic styles of Palenque and Copán. The hairstyle—short, flamelike bangs and long hair looped forward over the head—is found at both sites, usually worn by a god. The forelock plug in the center of the forehead suggests that this very human face is fused with attributes of God K, a deity often depicted as a manikin scepter. FC

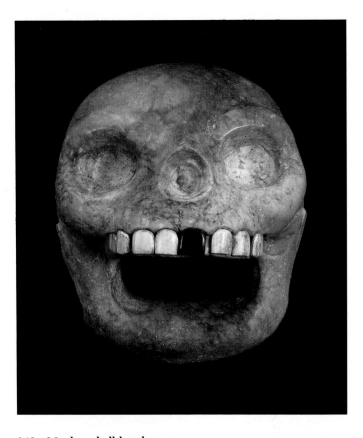

146 Monkey-skull handstone
Caracol, Belize; Tomb B/2 Sub.
Limestone, shell; iron pyrite, red pigment
H. 14.5 cm.
Late Classic (A.D. *550–700*)
Royal Ontario Museum, Toronto 971.466

The handle of this monkey-skull handstone is carved to represent a lower jaw, while the eye sockets were once inlaid with reflective golden iron pyrite and most of the teeth were made of shell. These superficial embellishments make it seem unlikely that the stone was actually used in any rough pursuit, such as playing the Mesoamerican ballgame, but the handle is polished from some kind of use. This ballgame, though well represented archaeologically by playing courts, stone belts, and other paraphernalia—and by abundant illustrations of the players in action—is still not well understood in terms of either its rules or cultural significance. Nevertheless, a rule that appears to have been widespread was one that forbade touching the rubber ball with the hands. Instead, the ball was supposed to be propelled by the hip or belt of a player, who meanwhile fell to the opposite knee. It has, however, been suggested that handstones like this were used to bat the ball, or possibly to steady the player on the ground while striking with the opposite hip. CCC

Anderson, 1958, pp. 496, 497

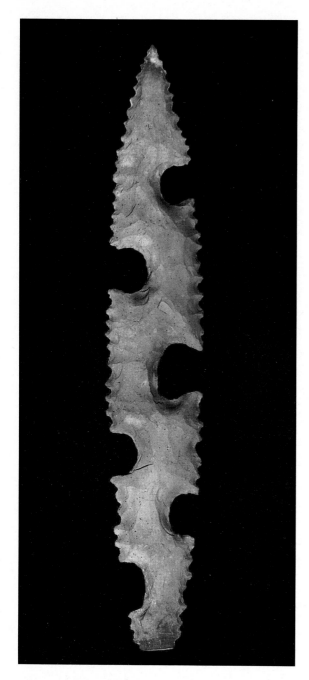

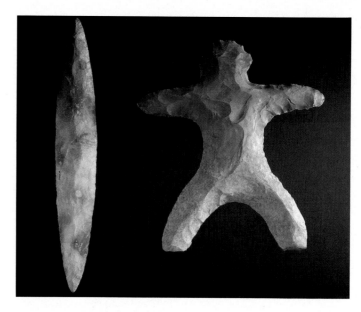

148 Two ceremonial flints
Altun Ha, Belize; Structure E-1, Tomb E-1/3
Chert
L. 29.5 cm.; 39 cm.
Late Classic (A.D. 700–800)
Royal Ontario Museum, Toronto RP 38/50, RP 38/52

Accompanied by eighteen more ceremonial flints, this flaked yellow chert figure and the simple blade were placed as ritual offerings in the southeast corner of Tomb E-1/3, in a small mound located 250 meters south of the large structures and plazas at the center of Altun Ha. This complex had been constructed specifically for three important tombs. CCC

Pendergast, 1965, fig. 10

147 Ceremonial flint
Lamanai, Belize; Structure N10-18, Cache N10-18/5
Chert
L. 77.5 cm.
Late Classic (A.D. 600–650)
Lamanai, LA 629/1

This is the largest ceremonial flint ever found. Such objects are well known archaeologically in northern Belize, where a fine quality of chert was abundantly available and its exploitation, especially for tools, was an important industry. Usually a number of ceremonial flints are found together in caches and burials, but this extraordinary example was cached alone with paired red basins on the axis of the residential Structure N10-18. The small notches of this bifacial serpentine form have been sharpened on one side, although it is unlikely that such a heavy but fragile object could have served any functional purpose. CCC

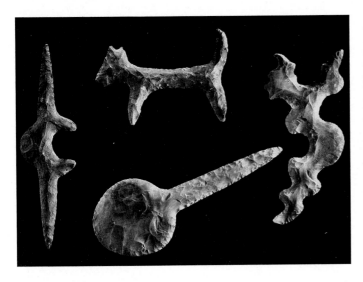

149 Four ceremonial flints
Altun Ha, Belize; Tomb A-1/1
Chert
L. 29.9 cm.; 35.9 cm.; 34.6 cm.; 22.7 cm.
Early to Late Classic (A.D. 550–600)
Royal Ontario Museum, Toronto RP 200/387, RP 200/393,
 RP 200/395, RP 200/403

Large flaked chert objects like these are characteristic of later
Classic caches and burials in northern Belize. Piles of such flints
in many different shapes were found at diagonally opposite cor-
ners of Tomb A-1/1 at Altun Ha. The dog flint, one like it, and
six other forms were found in the northwest, while thirteen
flints were in the southeast corner, including the notched bifur-
cate form, the double-pointed blade with crescent, and the one
that resembles a stingray. Ceremonial flints do not show signs
of wear, and it is probable that the actual production of such
objects was as important ritualistically as their ultimate
deposition. CCC

Pendergast, 1979, p. 76, figs. 22d, m, 23a, d

150 Ceremonial flint
Altun Ha, Belize; Structure B-4, Tomb B-4/3
Chert
L. 24.4 cm.
Terminal Classic (A.D. 800–850)
Royal Ontario Museum, Toronto RP 175/6

This thick-bodied animal differs in its rounded form from two
thinner animal shapes among the sixteen ceremonial flints asso-
ciated with the desecrated Tomb B-4/3 at Altun Ha. Since they
were near the surface of Structure B-4, the latest tombs were
more accessible to ancient spoilers, who apparently had little
appreciation of the sanctity of the burials. CCC

Pendergast, 1982b, p. 122, fig. 76n

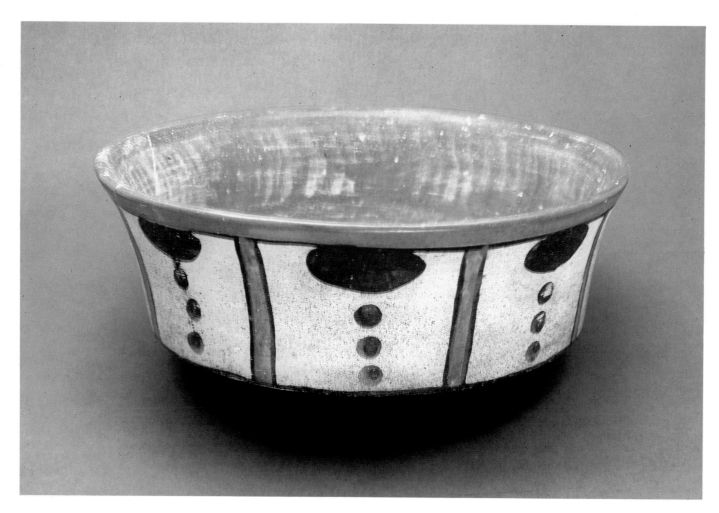

151 Moan-bird-feather bowl
Tikal, Petén, Guatemala; Structure 5D-73, Burial 196
Ceramic; slipped black and red on cream
D. 24 cm.
Late Classic (c. A.D. 750)
Museo Sylvanus G. Morley, Tikal 117A-26/36

The black-on-white design which encircles this bowl in nine
panels represents the Moan-feather headdress of one of the two
old gods of the Underworld; thus it has an unmistakably funer-
ary significance. The design was present on thirteen of the for-
ty-eight vessels in this rich tomb, ten of them tripod plates. A
single Moan feather is worn in the headdress of the lord depict-
ed on the large cylinder vessel from the somewhat earlier tomb
of Ah Cacau (No. 70). These ceremonial bowls, usually with
"red bar" patterning visible on the interior, as here, continued
to be made and used at Tikal for another century. CCC

152 Fluted cylinder vessel
Tikal, Petén, Guatemala; Structure 5D-11, Burial 77
Ceramic; slipped black and red on orange
H. 13.3 cm.
Late Classic (A.D. 750–800)
Museo Sylvanus G. Morley, Tikal 41F-6/4

By the end of the eighth century, Tikal's always conservative
polychrome ceramic industry was producing a limited number
of decorative motifs; these tended to be simple and boldly de-
signed, like the nine evenly spaced, four-petaled elements that
contrast with the ribbed orange wall of this vessel. While this
woman's tomb had the proper elite ceramic assemblage of tri-
pod plates, cylinders, and bowls, these were all locally made
and there were no vessels with figural decoration. This may
have been because of the late date of the burial, or it may have
been because she was a woman. CCC

W. R. Coe, 1967, p. 23

153 Cylinder with lid
Tikal, Petén, Guatemala; Structure 7F-30, Burial 150
Ceramic; slipped red and black on orange; lid, black and
* orange on cream*
H. 23.4 cm.
Late Classic (A.D. 650–700)
Museo Sylvanus G. Morley, Tikal 3B-65/17a, b

In this vessel the later ceramic styles of Tikal are previewed.
The body of the cylinder is an orange polychrome painted in
the overlapping "red bar" pattern that later became popular; at
the center of the wall there is an undeciphered inscription
which has no clear relationship to the text commonly found on
ceramics. The lid, decorated with a striking basketry pattern, is
black and orange on cream—the second important Late Classic
color scheme—although the mismatching lid was probably not
made for this vessel. CCC

Arts Mayas du Guatemala, 1968, no. 76

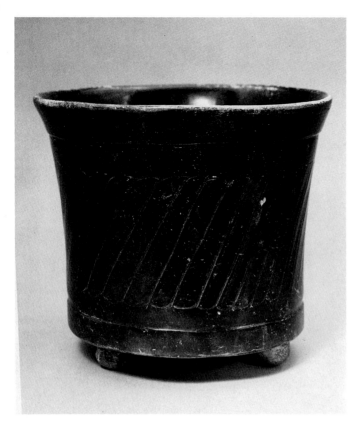

154 Fluted tripod vessel
Cayo, Belize; Pot Hunter's Cave
Ceramic; slipped black
H. 15.5 cm.
Late Classic (A.D. 700–800)
Belize Department of Archaeology, Belmopan 31/189-3:3

The sober elegance of a glossy black surface, most successfully achieved by potters of the Maya lowlands, is exemplified in this diagonally fluted vessel which follows the Early Classic prescription for a black cylinder tripod vessel. However, it is clear that in Late Classic times the formula could vary, as can be seen in this cylinder with a flaring wall and tiny tripod feet. CCC

155 Black-banded cylinder
Tikal, Petén, Guatemala; Structure 5D-11, Burial 77
Ceramic; slipped black on orange
H. 20.4 cm.
Late Classic (A.D. 750–800)
Museo Sylvanus G. Morley, Tikal 41F-4/4

This strikingly simple bichrome vessel comes from the burial of a woman excavated at the center of Tikal—the latest tomb. The three circular and two diagonal black bands which austerely decorate this locally made vessel must have had a very specific significance, since there is a similarly black-striped orange cylinder in each of the two other known eighth-century tombs at Tikal. CCC

W. R. Coe, 1967, p. 23

156 Cylinder vase with flying figures
North of Tikal, Petén, Guatemala
Ceramic; slipped black and dark red on buff
H. 14.8 cm.
Late Classic (A.D. 750–800)
Museo Sylvanus G. Morley, Tikal 394-83

Exquisitely painted, this small polychrome cylinder seems to portray four charming flying figures, but they are actually infernal anthropomorphic insects which flap their black-marked wings against a blood-red ground. They wear the "death eye" collars of Underworld inhabitants and emit scrolls, perhaps sounds, from their skeletal mouths and tails. Seven of the eleven glyphs at the rim of the vessel belong to the common ceramic text. CCC

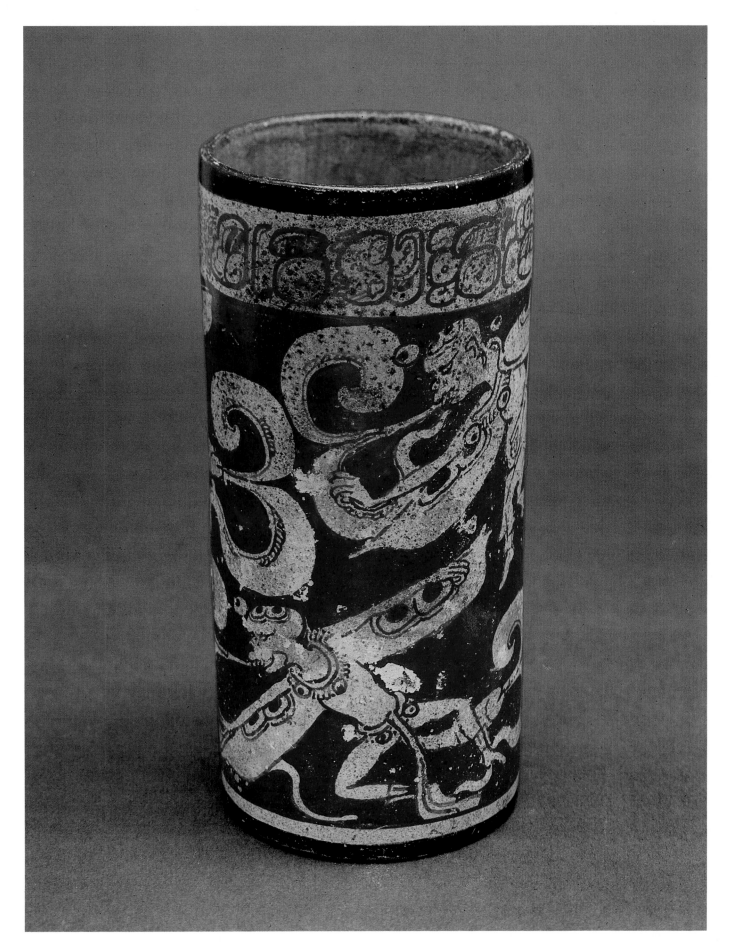

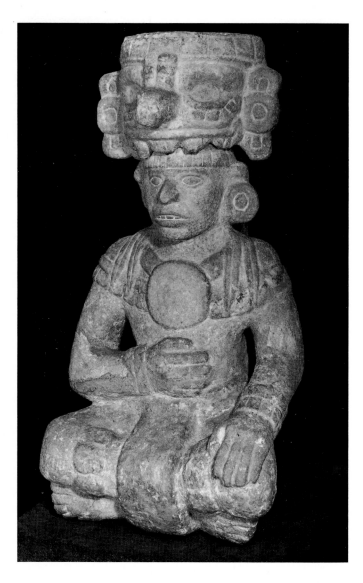

157 Seated figure with detachable headdress
Chichén Itzá, Yucatán
Limestone; traces of blue, red, and ocher
H. 86.5 cm.
Late to Terminal Classic ('A.D. 700–1000)
Museo Regional de Antropología, Mérida

This piece has a tenon-like plug at its back and was probably attached to an architectural feature. Although the headdress is detachable (an unusual attribute of architectural sculpture), it too has a mounting plug. Sylvanus Morley states that this piece was from the cornice of the facade of the northwest colonnade that fronted the Temple of the Warriors. The figure has been much repaired. Morley's illustrations show a crack running across the entire midsection of the sculpture and a missing right elbow. Not quite life-size, this full, round sculpture of a male figure seated cross-legged is in some ways reminiscent of miniature-scaled figurines. Traces of paint—the blue of the loincloth, the red and ocher of the capelet—suggest an original coloration much like the clay figurines and effigy censers of Mayapán. The headdress further suggests such a comparison, since removable costume parts are featured on some of these figurines. In this case, the headdress is a mask with the characteristics of the long-nosed deity Chac, the rain god, and the Chac mask commonly embellishes Puuc-style architecture. It is interesting, then, that while the formal characteristics of this figure can be compared with miniature clay figurines and censers, the iconography is closely associated with architecture. FC

Morley and Brainerd, 1956, pl. 74a, b, illus. opp. p. 74

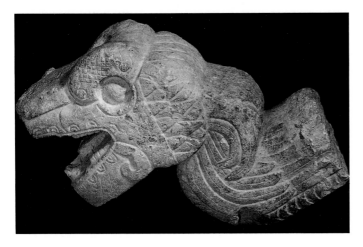

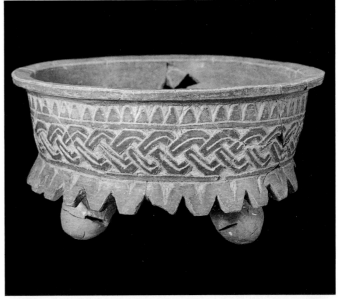

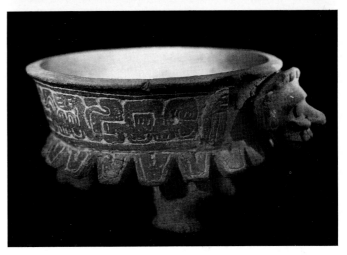

158 Feathered serpent
Chichén Itzá, Yucatán (?)
Limestone; traces of red and blue paint
H. 67 cm.
Terminal to Postclassic (A.D. 800–1500)
Museo Regional de Antropología, Mérida 31-6-31-5

Feathered serpents are the animal incarnation of the god Ku-kulcán, the Maya equivalent of the Mexican deity Quetzalcóatl. According to both historical and mythological sources, the persona of Quetzalcóatl was gentle and peaceful, and he was associated with the planet Venus. He may well have been the patron deity of Chichén Itzá. The sinuous serpent form can be found as an architectural embellishment throughout Chichén Itzá. It frames stairways and the edges of walls and cornices. Its body, carved as columns, holds up lintels. The scales of the serpent are inevitably rendered as feathers, and his mouth is opened to expose his split tongue, teeth, and sometimes an emergent human head.

There are still traces of red paint on the head, and feathers were once red and blue. Although the body is broken off, it probably served an architectural function, and the hole in the top of the snake's head may have held the rod of a banner. As an icon, the feathered serpent represents an interesting combination of opposites and equivalents. Snakes and birds are creatures of the opposing realms of earth and air. One slithers; one flies—and they are predatory enemies. They are equivalent, however, in that they are both "twice-born," first as an egg, and only after hatching are their differences manifest. It is also interesting to note that reptile scales are the direct biological prototype for feathers. FC

159 Two carved tripod bowls
Lamanai, Belize; Structures N10-2, N10-43; Burial N10-2/20,
 Cache N10-43/1
Ceramic; slipped orange
D. 24 cm.; 19 cm.
Early Postclassic (A.D. 1150–1300)
Lamanai, LA 127/2; LA 318/1

Carved zigzag basal flanges skirt both of these tripod bowls. The larger has only two round, rattle feet, the third having been removed before interment in the burial. A crisply excised mat pattern encircles the wall of this vessel, whereas the smaller one, from a cache, has an incised design with scrolled forms—both were decorated after firing. A modeled human face animates this bowl, which has two human feet immediately below, and a bird's head serving as the third foot. CCC

Pendergast, 1981a, pp. 44–51, fig. 26g

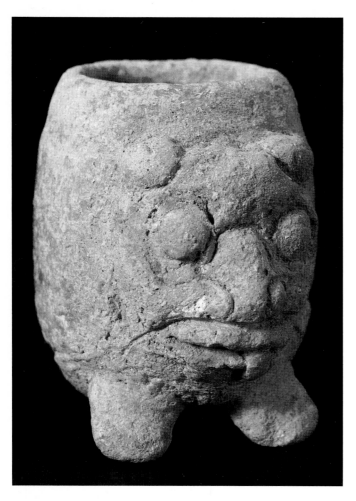

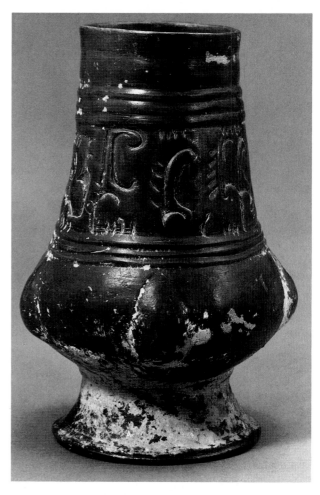

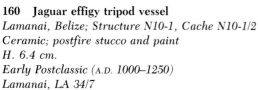

160 Jaguar effigy tripod vessel
Lamanai, Belize; Structure N10-1, Cache N10-1/2
Ceramic; postfire stucco and paint
H. 6.4 cm.
Early Postclassic (A.D. *1000–1250*)
Lamanai, LA 34/7

As was the case with many Early Classic ritual vessels, the body
of this one represents a jaguar. Here the beast's front feet,
haunches, and tail serve as the tripod while only the front
haunches and an oversized head are indicated on the vessel it-
self. Another vessel found at Lamanai, dating from about 1400,
attests to the longevity of this concept in Maya religion. This
miniature jaguar vessel, excavated in front of an altar, played a
role in ritual activity. This ceremony involved the burning of
corn kernels, a bag of beans, and figurines that had been mod-
eled of clay and mud over corn stalks. CCC

Pendergast, 1981a, p. 44

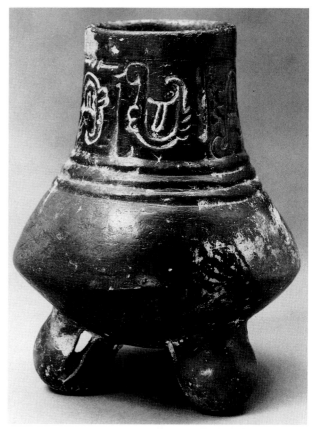

161 Pyriform vessels
Chiapas
Ceramic; Plumbate Ware
H. 20.1 cm.; 18.1 cm.
Postclassic (A.D. 1000–1500)
Museo Nacional de Antropología, Mexico 5-3028, 5-3029

Plumbate Ware was coated with a slip that had a high iron content which, when fired, gives a dark, metallic, sometimes iridescent surface. In Maya archaeology, this ware is a sure sign of the conditions that define the Postclassic. Ceramics with plumbate slips may have been made somewhere in the Guatemalan highlands, but they were widely traded. Thus vessels such as these—the pyriform pedestal base and the pyriform tripod—have been found throughout the Postclassic Maya world. They are decorated with bands of calligraphic pseudoglyphs. Michael Coe illustrates a very similar piece that is from Campeche, while Sylvanus Morley illustrates such a piece from Chichén Itzá. FC

M. D. Coe, 1966, pl. 77; Morley and Brainerd, 1956, p. 375

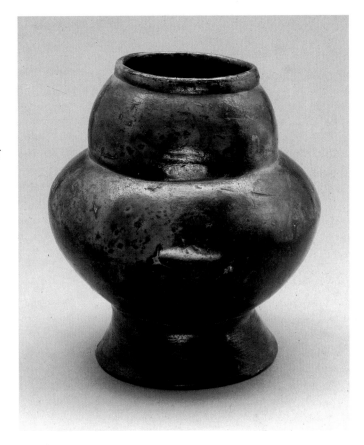

162 Pedestal-based vessel
Chiapas
Ceramic; Plumbate Ware
H. 15.6 cm.
Postclassic (A.D. 1000–1500)
Museo Nacional de Antropología, Mexico 5-821

The slip on this vessel is fired into a mottled and rather lovely array of dark grays, oranges, and gray-browns. The rounded, convex shapes create an abstract form pleasing in its simplicity and typical of the vessel shapes associated with Plumbate Ware. FC

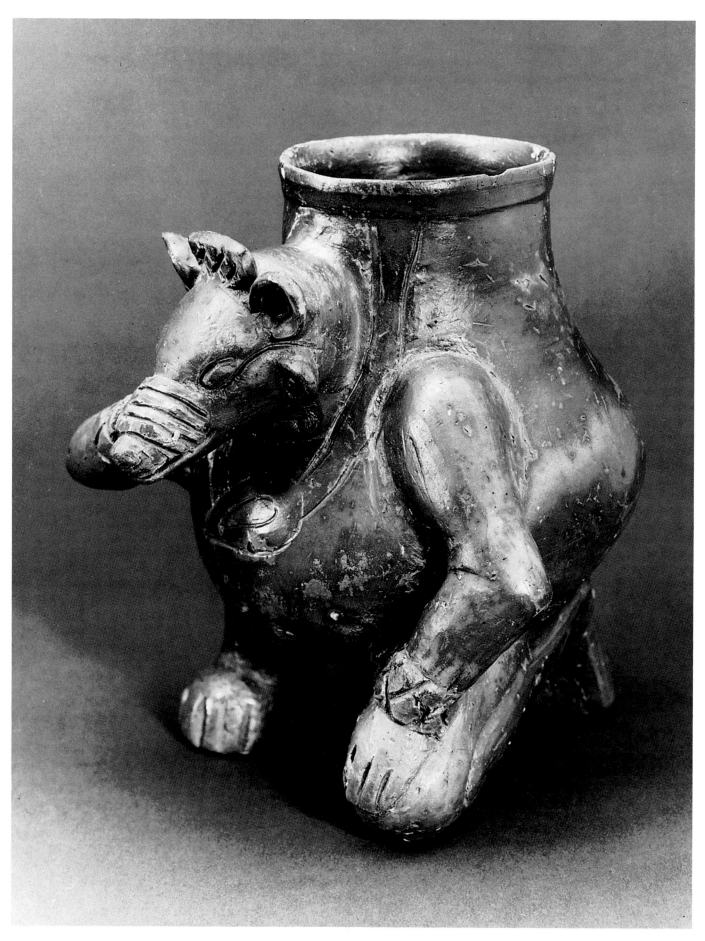

163 Effigy vessel
Northern Yucatán Peninsula
Ceramic; Plumbate Ware
H. 19 cm.
Postclassic (A.D. 1000–1500)
Museo Regional de Antropología, Mérida 389B

A charming example of Plumbate Ware, this effigy depicts an anthropomorphized animal—probably a small creature known in Yucatán as a *pisote*—resting on one knee with a hand held over the face. It wears crudely modeled amulets and an incised pectoral around its neck. TPC

164 Atlantean dwarf figure
Northern Yucatán Peninsula
Limestone
H. 54.5 cm.
Terminal to Postclassic (A.D. 800–1500)
Museo Regional de Antropología, Mérida S.E. 4, No. 43

This stone dwarf is dressed in a feathered or quilted costume. Simplified and abstracted, its small arms rise along the sides of its face, ending in knobs that look like animal ears. Similarly, its legs, separated by the plain loincloth apron, are disproportionately small. The face and torso are equal in size and are the largest parts of the body. The pudgy, simplified face seems set into a deep scowl with the chin disappearing into fat cheek jowls. Circlets on the nose, just between the eyes, decorate the face. Another Atlantean, similarly posed and dressed, comes from Xculoc, Campeche, and was published by H. E. D. Pollock. The Xculoc piece was originally in the upper cornice frieze of the Palace of the Figures. Probably the Atlantean shown here was similarly situated, as this would explain the tenon at its back. Furthermore, the little hand-knobs would not have been suited for bearing any real weight. FC

Pollock, 1980, fig. 627

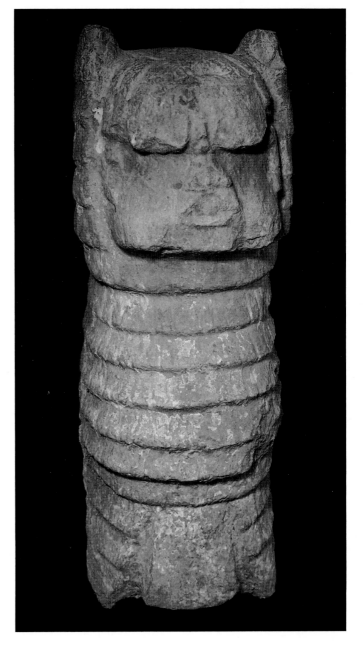

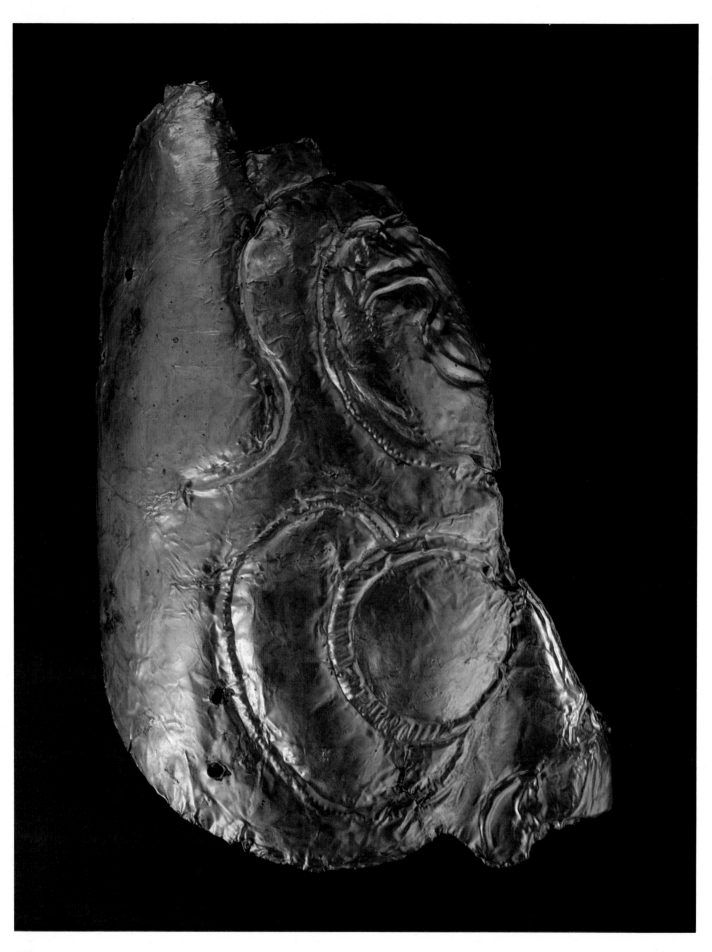

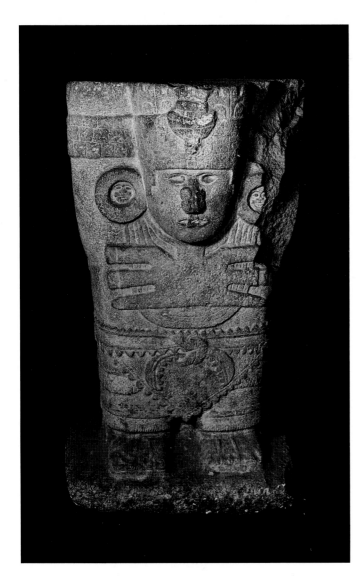

166 Atlantean figure with upraised hands
Chichén Itzá, Yucatán
Limestone; traces of red paint
H. 87 cm.
Postclassic (A.D. 1000–1500)
Museo Nacional de Antropología, Mexico 5-1114

This particular figure probably belonged to a group of fifteen Atlanteans that once supported a table altar in the portico of the upper Temple of the Jaguars, facing onto the Great Ballcourt. Small Atlantean figures such as this one, with arms upraised on either side of the head to support the slab of the table altar (probably a throne), are common at Chichén Itzá and are also found at Tula, Hidalgo (north of Mexico City).

It is the rank similarity between these Atlanteans, as well as other features of sculpture and architecture, that have led scholars to realize that such a close artistic bond between the Toltec site of Tula and Chichén Itzá probably signaled political, economic, and perhaps dynastic bonds as well. At the moment, the actual historic nature of this perceived connection is a matter of debate—who influenced whom, and when?

Realistic human body proportions apparently were not important, but there is a delicacy and clarity to the carved details of costume, especially the serrated-edge loincloth. Traces of red paint can be found on the helmet, arm and bracelet, sash and base, so perhaps the entire sculpture was once covered with red pigment. The figure wears a squared helmet-like headdress, with a diadem in the center that suggests a panache. The pectoral is an identifiable iconographic detail. Alfred Tozzer called it a conventional bird with the two upper sets of lateral extensions as the outspread wings, and the lowest, more triangular extensions as the bird's tail. Pectorals of this shape are also identified as butterflies and are thought to signify death and rebirth. Since the Maya euphemistically associated the butterfly with the sacrificial flint knife, the pectoral could also refer to sacrifice. The little faces in the center of the earplugs are curious, but they can be found on the other known examples of Atlanteans from the same group of fifteen. In this case, one is tempted to see one as a comic face and the other (the complete one) as a sad or tragic face. FC

Tozzer, 1957

165 Embossed overlay
Chichén Itzá, Yucatán; Sacred Cenote
Sheet gold
W. 17 cm.
Terminal Classic to Early Postclassic (A.D. 900–1100)
Peabody Museum of Archaeology and Ethnology,
* Harvard University 10-71-20/C10048*

A large round eye socket and collapsed nose may be embossed here, suggesting this sheet gold might have served as a skinlike overlay on a skull or some other rounded object. Such death imagery was introduced at Chichén Itzá about A.D. 800 in conjunction with the construction of the Great Ballcourt and a new emphasis on militarism—practices brought from central Mexico and Veracruz by people who eventually developed a wide trading network that brought gold to Chichén Itzá from lower Central America. Like virtually all of the gold offered in the Sacred Cenote at Chichén Itzá, this overlay was cut and crumpled— and possibly even melted along its lower edge—before it was thrown into the water of the well as a ritual offering. CCC

Lothrop, 1952, pp. 64, 65, fig. 49b

167 Incised fluted bowl
Sayil, Yucatán
Ceramic
H. 12.1 cm.
Terminal Classic to Early Postclassic (A.D. 800–1250)
Museo Regional de Antropología, Mérida 1028

This charmingly simple bowl comes from the great site of Sayil,
one of the most important centers in the Puuc district of Yuca-
tán. It makes effective use of two different design techniques
which decorate the lower portion of the vessel: grooves applied
in a crosshatch pattern, and circles punched into the triangular
shapes formed by the grooves. A red slip was used to cover the
rim and interior of the vessel. TPC

168 Mythical bird head
Chichén Itzá, Yucatán
Limestone; traces of yellow ocher, blue and red paint
H. 25.5 cm.
Terminal Classic or Early Postclassic (A.D. 800–1250)
Museo Regional de Antropología, Mérida CRY-183

This bird is very similar to the mythical bird depicted at the top
of a scene on Lintel 3 of Temple 4 at Tikal (now in the Museum
für Volkerkünde, Basel). Both have large round eyes, raptorial
beaks, and headbands with a central rosette. Although this type
of bird has been variously identified as a parrot, an owl, or the
unknown Moan bird, its mythic nature is nonetheless certain.
Originally this piece was beautifully colored. Traces of yellow
ocher can be seen on the beak and headband; the eyes were
blue with red pupils, the face was red, and the earplugs blue.
Alfred Tozzer illustrates a very similar bird head, with the same
eyes and headband, but with a larger beak. He says the large-
beaked head was from the facade of the northwest colonnade in
front of the Temple of the Warriors. FC

Tozzer, 1957, fig. 588

169 Stone feline
Mayapán, Yucatán; Structure Q156
Limestone
H. 52 cm.
Late Postclassic (A.D. 1250–1450)
Museo Regional de Antropología, Mérida CRY-126

The blockiness of this stone sculpture is like that of sculptured
jaguar thrones found at Chichén Itzá, especially in the treat-
ment of the muscular forelegs. However, this piece is tenoned
and was attached to an architectural feature, a wall, or a floor.
Rings such as this one are known to have functioned as footings
for curtain rods or as goals in the ballgame. This piece was
found within the southern range of Structure Q156 (part of the
main ceremonial center of Mayapán), and may have, if paired
with another, held a curtain rod. Nonetheless, its original place-
ment and function are questionable because the diagonal line of
the feline's back creates an unusual orientation for the large
ring he bears. FC

Proskouriakoff, 1962, fig. 8v

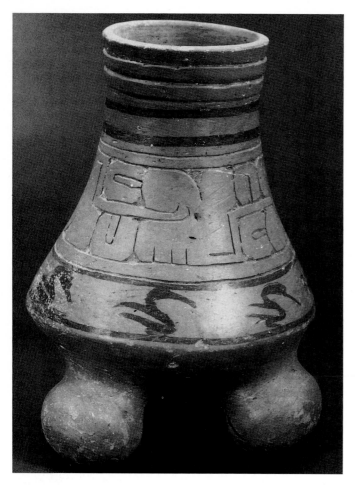

170 Pyriform tripod vessel
Yucatán (?)
Ceramic; Fine Orange Ware
H. 16.4 cm.
Terminal to Postclassic (A.D. 800–1500)
Museo Regional de Antropología, Mérida 181 39/80

Fine Orange Ware is usually associated with Postclassic culture, but may have been introduced into the Maya area somewhat earlier. Fine Orange pottery is thought to have originated somewhere in the area covered by the modern states of Veracruz and Tabasco, and was traded into the Maya region. The body shape of this piece, along with the engraved pseudoglyphs, is very similar to the Plumbate vessels from Chiapas (No. 161). The addition of the painted bands, and the row of gracefully abstracted birds, are attributes of ceramic decoration known from Chichén Itzá. FC

Brainerd, 1958, fig. 77

171 Bulbous tripod vessel
Northern Yucatán Peninsula
Ceramic; Fine Orange Ware
H. 13 cm.
Terminal to Postclassic (A.D. 800–1500)
Museo Regional de Antropología, Mérida 275

The bulbous tripod shape of this vessel and the use of a fret design, done with a free hand, are typical of many pieces of Fine Orange Ware found at Chichén Itzá. The band of glyphs at the rim is highly stylized and may have served a purely decorative function. FC

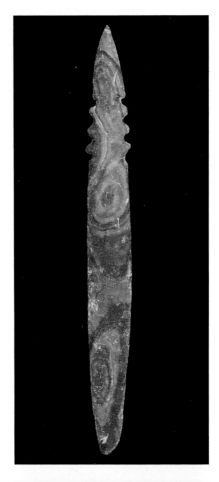

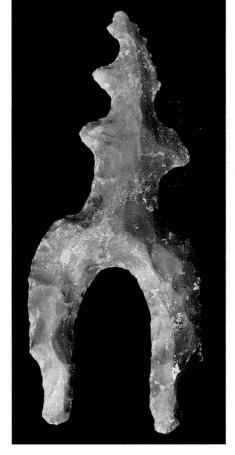

172 Three ceremonial flints
Lamanai, Belize; Structure N10-15, Cache N10-15/8
Chert
L. 42.1 cm.; 36 cm.; 49 cm.
Terminal Classic to Early Postclassic (A.D. 900–1000)
Lamanai, LA 694/34; LA 694/31; LA 694/36

These three ceremonial flints were part of an axial cache in Structure N10-15 that contained more than forty examples. As in similar deposits at Altun Ha, many different shapes were included. One was created by notching a long thin blade at one end; the double-pointed crescent is larger and more elaborately worked than the earlier ones from Altun Ha (No. 148), whereas the somewhat later human figure has a conical head similar to the other Altun Ha flint, with legs more bowed and smaller "arms." These differences may be more attributable to the quality and size of the available chert than to chronological variation or even symbolic constraints. Since there is no evidence for the functional use of these bifacially worked flints, the actual production of them at the site of ritual deposition may have been as important to the celebrants as their appearance or quantity. CCC

173 Panel of skulls
Chichén Itzá, Yucatán
Limestone
H. 31 cm.
Terminal Classic to Early Postclassic (A.D. 900–1250)
Museo Regional de Antropología, Mérida 2D2-872. 133/82

On the Great Plaza of Chichén Itzá lies a low platform called the *tzompantli*, a term taken from Náhuatl, the language of the Aztecs of central Mexico. Translated, it means skull wall or skull rack, and refers to an actual rack of skulls (those of sacrificial victims) placed in the ceremonial center of the Aztec city of Tenochtitlán. The sides of the *tzompantli* at Chichén Itzá are covered with carved relief skulls threaded on bars—a realistic depiction of the Mexican skull rack.

Indeed, such a conception is thought to have been imported into the Maya area by the more sanguinary Mexicans. But skull imagery is not new to Maya iconography, and the implicit violence behind the conception of a skull rack can be found in Maya imagery from its beginnings. Violence, though not commonly depicted, nonetheless persisted in Maya iconography for over a thousand years; a similar beheading to that at Izapa can be seen on the talus panels of the Great Ballcourt of Chichén Itzá. This polychrome fragment was once part of a longer line of skulls, and it is almost identical to the medial cornice of the *tzompantli* at Chichén Itzá. FC

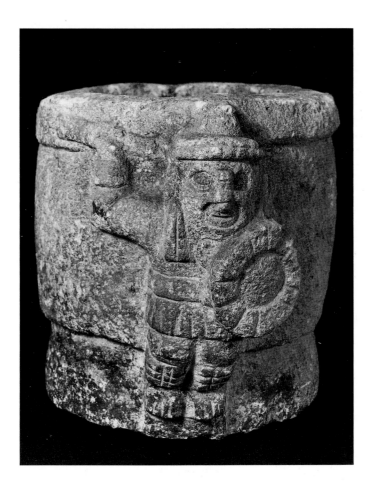

174 Stone vessel
Cave of Balankanché (?), Yucatán
Limestone
H. 25 cm.
Early Postclassic (A.D. 1000–1250)
Museo Nacional de Antropología, Mexico 5-3684

This stone vessel is rimmed at the top and has a pedestal base. Found in caves, stone vessels often functioned as water collectors. The water, filtered through the limestone cave roofs, dripped into the vessel and was considered pure or "virgin," and it had important ritual uses. The standing warrior wearing a conical helmet is carved in relief, overlapping both rim and pedestal of the vessel. He holds his circular shield close to his body and is ready to hurl the darts held in his right hand. The *xipe* mask and the pendent cloth earplugs are important in identifying this image. Xipe Totec is the Mexican god of flowers, and one of his most memorable characteristics is that he (or his priest-impersonator) wears the flayed skin of a sacrificial victim.

On this vessel, one can see the living eyes and mouth within the openings of the flayed face; and earplugs were often worn by sacrificial victims. The *xipe*-warrior may refer to a rite associated with this Mexican god. A sacrificial victim, armed with useless weapons (a club, for example, might have puffs of bird down instead of flint or obsidian edges), would fight against warriors bearing deadly weapons. J. Eric Thompson points out that there is no hard archaeological evidence that this kind of gladiatorial fight took place in Yucatán, but he considers such a thing extremely probable. Perhaps this piece bespeaks such a possibility; even the *xipe*-warrior's shield looks like a petaled flower. FC

Thompson, 1970, p. 179

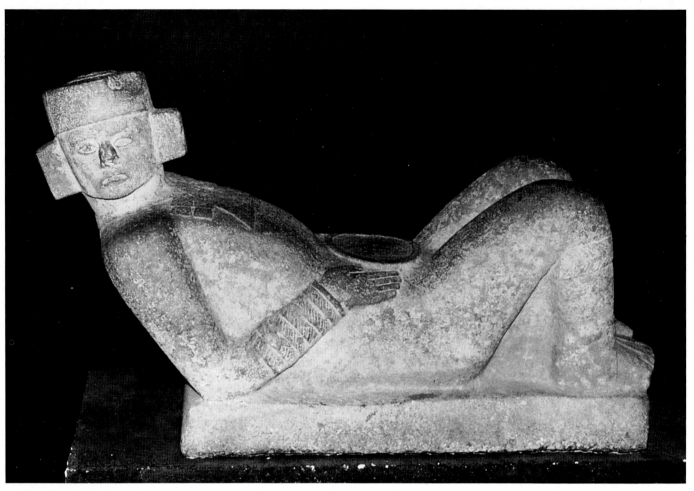

175 Chacmool
Chichén Itzá, Yucatán
Limestone
H. 87 cm.; L. 160 cm.
Terminal Classic (A.D. 800–900)
Museo Regional de Antropología, Mérida 369

Chacmool is the name given to a large group of similar monuments found throughout Mesoamerica—from the Mexican state of Michoacán to Yucatán and Central America. Although carving styles and proportions can vary greatly within this group, *chacmool* figures are made by simplified, blocky forms, and usually manifest a harsh, unyielding look. The image is always that of a male figure leaning back on his elbows, his feet drawn to his buttocks, and his knees thrust up. His head is usually turned, like this example, to a right angle from his body axis, and his hands will hold a circular plate or bowl upon his stomach. *Chacmools* have been associated with the Toltec culture of central Mexico because no example of this group can be surely dated any earlier than the late Terminal Classic—the time, certainly in the Maya area, when "Mexican" influences were strong. *Chacmools* have been found placed in front of temple entrances and therefore may have served as ritual guardians. It is also thought that they functioned in sacrificial rituals; the plate or bowl one holds is a receptacle for the hearts of the victims. This piece is said to be from the skull rack (No. 173), a low platform in the Great Plaza of Chichén Itzá. FC

176 Effigy vessel
Balankanché, Yucatán
Ceramic; painted red, blue, and white
H. 31.7 cm.
Early Postclassic (A.D. 1000–1250)
Museo Nacional de Antropología, Mexico 5-3107

All aspects of the face have been reduced to circles, lines, and flanges. The upper lip of the mouth is lifted in a snarl to expose five fanglike teeth. The little bead-eyes are framed by circular goggles and underlined by sinuous fillets that meet at the bridge of the nose. The use of color is also simplified, especially compared with the Postclassic tradition of effigy censers at Mayapán (No. 179). Unlike the censers on which the color is applied to enhance the definition or description of the motifs, color here is used more symbolically. Half the face is red and the other half blue, the line of division being the vertical center axis of the symmetrical face. The appliquéd details are painted white, as are the bottom rim and back of the vase. Only the fangs are detailed by a patch of red near the gum line. Found deep in the cave of Balankanché near Chichén Itzá, this piece was almost surely used in cave rituals. In ancient Maya thought, caves were associated with origins and ultimate endings. Symbolic of both the womb and tomb, caves were the source of rain and fertility, and embodied the mystery of life and death. The conventionalized facial features are a synthesis of the Maya *chac* (fillets under the eyes) and the Mexican *tlaloc* (the goggled eyes and fanged mouth). Both were water deities with strong chthonic aspects. FC

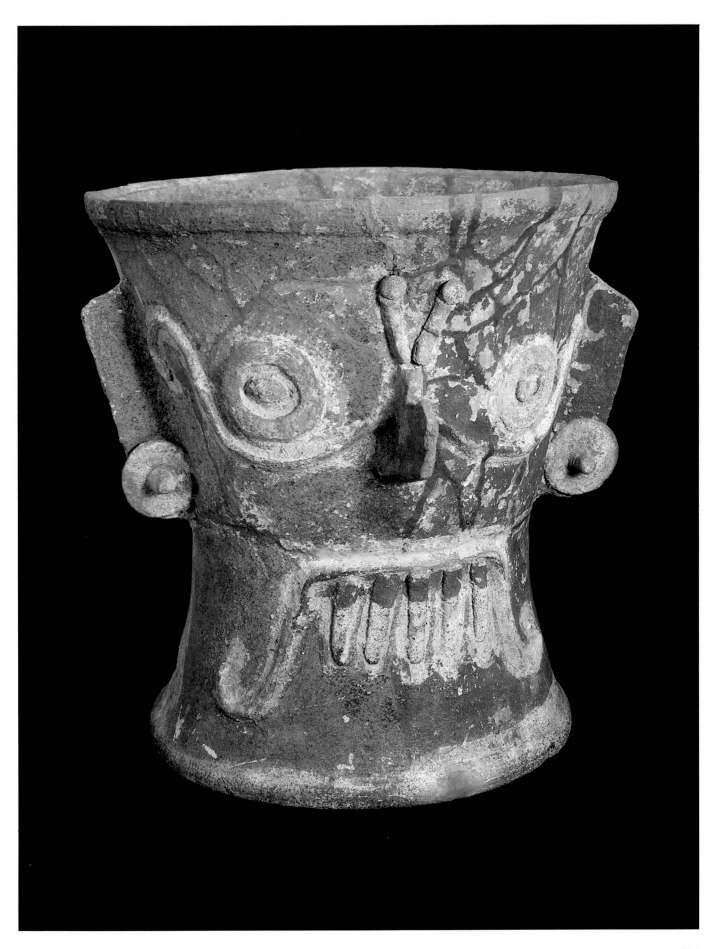

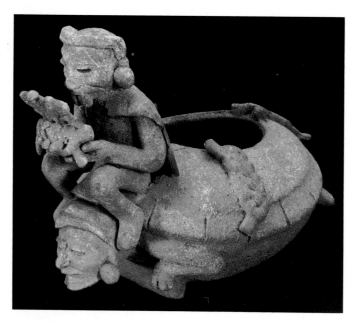

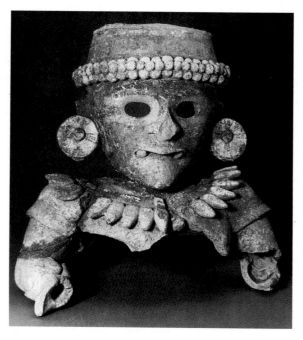

177 Turtle effigy vessel
Mayapán, Yucatán; Cache 32
Mayapán unslipped ware, with blue paint; Chen Mul Modeled
* Type*
H. 18.3 cm.
Late Postclassic (A.D. 1250–1450)
Museo Regional de Antropología, Mérida 213B

The caped man with large fangs sits on the back of the turtle's
neck and holds a knotted mat design topped by two scrolls.
Three other mat signs are placed on the turtle's carapace, one
to the rear and one on either side. A human head emerges from
the turtle's beaked mouth. The whole piece is painted blue
over a white primary coat. It was found in Cache 32, within or
near structures with clear ceremonial functions. The icons of
the turtle and the mat are suggestive. Mats are associated with
thrones and royalty. (The "mat" might have meant to the Maya
something like what the "crown" means to the British.) Turtles
were icons of benevolence, and at Mayapán they may have
been associated with lineage and ancestor worship. If so, this
blue icon is a visual metaphor for royal ancestry: the ancestor's
head is carried in the turtle's mouth, and the current royal
member of the line rides on the back of the turtle, displaying
the mat. FC

Pohl, 1983; R. E. Smith, 1971, fig. 64d

178 Merchant god effigy censer
Mayapán, Yucatán
Mayapán unslipped ware; Chen Mul Modeled Type
H. 23.5 cm.
Late Postclassic (A.D. 1250–1450)
Museo Regional de Antropología, Mérida 285B

Missing his distinctive nose, Ek Chuah, the merchant god, is
still recognizable because of his black face, the fangs that dis-
tend his mouth, and his painted eyes. His bonnet-style hat is
trimmed with a triple row of ocher beadlike forms that may
have been cacao beans. Since cacao was a form of currency, and
thus important to traders and merchants, Ek Chuah was also as-
sociated with rituals involving or centered around the mildly
narcotic cacao bean (source of chocolate and, formerly, cola
drinks). FC

M. D. Coe, 1966, pl. 74

179 Effigy censer of a deity
Mayapán, Yucatán; Cache 33
Mayapán unslipped ware, blue with yellow paint; Chen Mul
* Modeled Type*
H. 58 cm.
Late Postclassic (A.D. 1250–1450)
Museo Regional de Antropología, Mérida 273B

Once shattered, but now mended, this complete effigy censer
was found in Cache 33 as part of a ceremonial offering. The spi-
raled cross section of the conch shell worn by the figure as a
pectoral may identify him as the human aspect of the feathered
serpent Quetzalcóatl. The youthful face may have been red and
the conch shell pectoral is blue, outlined in yellow. He wears a
feline head as a helmet, above which is a funnel shape. Sur-
rounding the head and headdress are appliquéd scroll and wing-
like forms. The figure once held a yellow sphere (perhaps copal
incense) in each hand, but the right arm is now lost. FC

R. E. Smith, 1971, fig. 67a

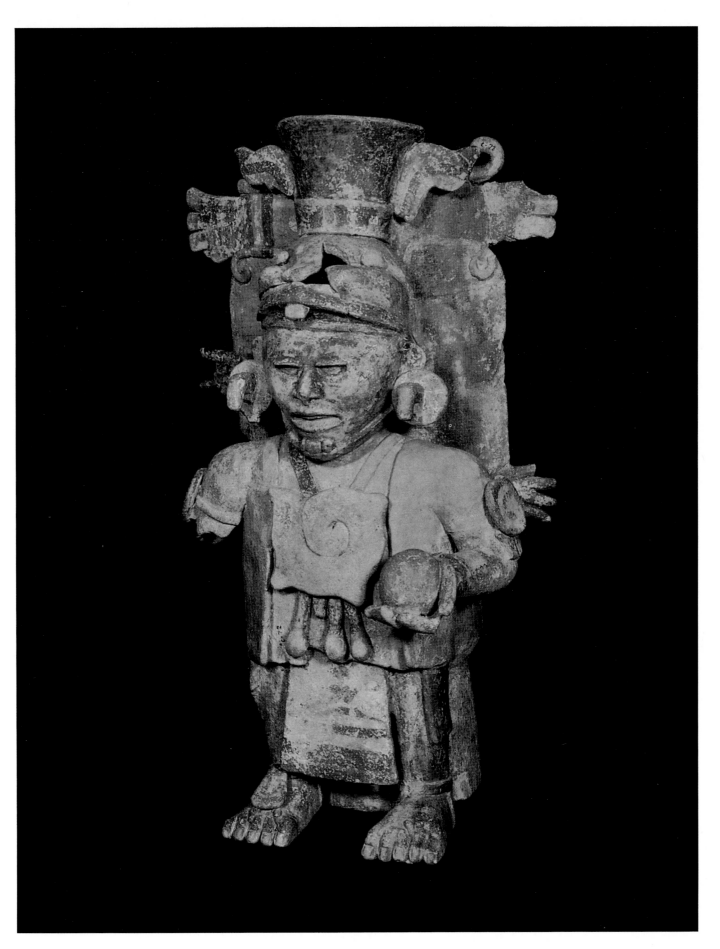

180 Effigy cup with lid
Mayapán, Yucatán; Structure Q-164, Cache 43
Mayapán unslipped ware; Chen Mul Modeled Type
H. 11.1 cm.
Late Postclassic (A.D. *1250–1450)*
Museo Regional de Antropología, Mérida 248B

The long, drooping nose may identify this molded face as a
chac, a chthonic water spirit and bringer of rain. It was found
buried alone (Cache 43) inside the central "altar" platform of
Structure Q-164, a colonnaded hall. The visual hyperbole repre-
sented—the mouth distended by fangs, the grotesque nose, and
the use of the unusual twisted cloth earplugs—is a characteristic
trait for the ceramic sculptures of Mayapán. FC

R. E. Smith, 1971, fig. 63a

181 Head of a young man
Mayapán, Yucatán; Burial 16
Mayapán unslipped ware; Chen Mul Modeled Type
H. 20.3 cm.
Late Postclassic (A.D. *1250–1450)*
Museo Regional de Antropología, Mérida 287/CRY 441

This young male wears the head and upper jaw of an alligator
or serpent as a headdress. His face is painted white, but he is
otherwise similar in facial features and expression to No. 182.
In fact, both examples were found in the same grave (Burial 16)
at Mayapán. Both heads are considered to be "unidentified"
youthful gods. As a fragment from an effigy censer, this piece
was originally full-figured and attached to a pedestal-based cy-
lindrical vase. All decorative features, including the body,
limbs, and costume details, were modeled and appliquéd onto
the vase and figure; only the face was mold-made. FC

R. E. Smith, 1971, p. 211

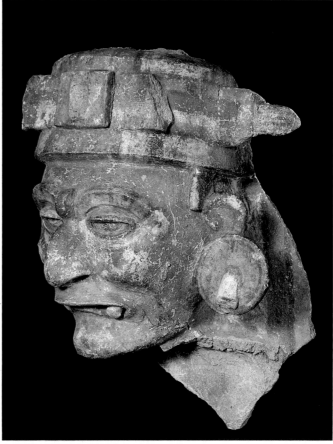

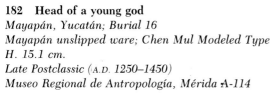

182　Head of a young god
Mayapán, Yucatán; Burial 16
Mayapán unslipped ware; Chen Mul Modeled Type
H. 15.1 cm.
Late Postclassic (A.D. 1250–1450)
Museo Regional de Antropología, Mérida A-114

At Mayapán, effigy censers were found in great abundance during the Late Postclassic. Many scholars see them as true idols, reflecting the foreign practice of idolatry brought to the Yucatán by invading Mexican peoples. Although the forms of these effigy censers are not foreign to the Maya area, much of the iconography does have Mexican associations.

This fragment, a young man's head with the remains of a banded headdress, has not been identified as any particular god—Maya or Mexican—only as a young god (so strong is the idea that effigy censers are idols). It is significant that Burial 16, in which this fragment was found, was excavated beneath the floor of a domestic dwelling and thus was associated with family rituals. This tendency toward the use of private oratorios was increasingly prevalent in Late Postclassic times. His expressive face is enhanced by many colors used to realistically portray the details of costuming. These colors were added after firing. Such a process is typical of Mayapán unslipped wares, and accounts for their matlike finish.　FC

R. E. Smith, 1971, fig. 68b

183　Head of a deity
Mayapán, Yucatán; Burial 30
Unslipped ware, red, yellow, green, blue, gray, and black pigments; Chen Mul Modeled Type
H. 22.1 cm.
Late Postclassic (A.D. 1250–1450)
Museo Nacional de Antropología, Mexico 5-1089

This face has all the attributes of God D as he is depicted in the Maya codices, and is identified by J. Eric Thompson as the aged aspect of the major god, Itzamná. His attributes are a large roman nose, a toothless mouth (except for the molars in the corners), a prominent chin, and yellow areas around the lips and chin. In this portrayal, God D, or Itzamná, is further embellished by blue eyebrows and eyelids with interior black lines. His round earplug is green with black lines, and his "bonnet-style" headdress has traces of red, yellow, green, blue, gray, and black pigments. His eyes are white with black pupils.　FC

Thompson, 1970, pp. 228–29

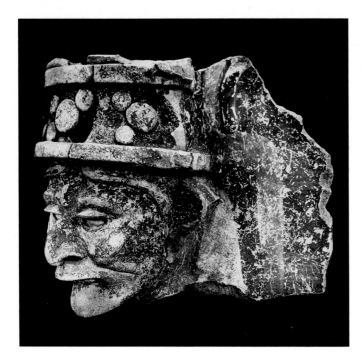

184 Fragment of an effigy censer
Mayapán, Yucatán; Burial 30
Mayapán unslipped ware; Chen Mul Modeled Type
H. 20.3 cm.
Late Postclassic (A.D. 1250–1450)
Museo Regional de Antropología, Mérida 294B, 108/80

This piece has been shattered and mended, but the face of a
god—the aged persona of Itzamná—is still clinging to a piece of
the original cylindrical vase. J. Eric Thompson believes Itzamná
to be, in his aged aspect, a deity of creation and healing, as
well as synonymous with the Old Fire God. It may be the latter
that is emphasized by his portrayal on this censer. FC

Thompson, 1970, p. 288; R. E. Smith, 1971, fig. 68b

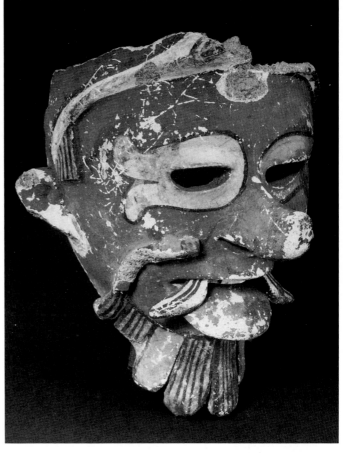

185 Fragment of an effigy censer
Mayapán, Yucatán; Burial 30
Mayapán unslipped ware; Chen Mul Modeled Type
H. 17.1 cm.
Late Postclassic (A.D. 1250–1450)
Museo Regional de Antropología, Mérida 291B

The different-colored eye patches and the Pinocchio-like nose
identifies this face as that of the merchant god, Ek Chuah. The
meaning of *chuah* is unknown, but *ek* can mean black or star.
In the surviving Maya codices, Ek Chuah is represented as the
black-skinned God M. His distinctive nose and dark skin color
(in this case, a deep red) make him one of the most easily rec-
ognized of all Maya gods. Surely he was considered a comic
character by the ancient Maya. His nose could not be any less
ideal, and in this portrayal the top of his large ears awkwardly
stick out over his headband. In addition, his gold-and-gray mus-
tache and beard are non-Maya, thereby lending weight to J.
Eric Thompson's suggestion that Ek Chuah was brought to Yu-
catán by Mexicanized traders.

The modeled effigy censers of Mayapán (in fact, most aspects
of Mayapán culture) have been considered debased in compari-
son to the artistic traditions of the Classic or the Early Postclas-
sic Maya of Chichén Itzá. But the Mayapán tradition allowed a
rare boldness in the expressive use of form and color. It seems
to embody a quality of satiric expression born of objectivity and
irony, and in comparison to the earlier artistic traditions, Maya-
pán ceramics express not so much the decadence of a declining
culture, but the irreverence of sophistication. FC

Thompson, 1970; R. E. Smith, 1971, fig. 68b, No. 9

186 Censer vase

Xmarta, Yucatán
Mayapán unslipped ware, traces of blue and brown pigment;
 Cehac-Hunacti Composite Type (?)
H. 70 cm.
Late Postclassic (A.D. 1250–1450)
Museo Regional de Antropología, Mérida 111/81

This vessel is especially notable for its massive size and unusual
shape. Traces of blue and brown pigments can still be seen,
particularly on the pedestal base. The mat sign, surrounded by
four appliquéd circles, two on each side, carries either the
meaning of royalty or of time: the most important graphic ele-
ment in the Maya sign for the month *Pop* is the mat. FC

187 Miniature shell effigy vessel

Lamanai, Belize; Structure P8/26, Cache P8-26/1
Ceramic; postfire stucco; red paint
H. 8.8 cm.
Late Postclassic (A.D. 1400–1500)
Lamanai, LA 411/1

An old man (often identified as God N) emerging from a conch (?)
shell is a common Late Postclassic subject for ceramic effigies,
just as centuries before, in Late Classic times, the theme was
painted on ceramic vessels. In these images the convoluted gas-
tropod shell represents the earth and its access through caves to
the Underworld, the dwelling place of the aged earth deities.
This modeled fifteenth-century effigy vessel was cached in a
much earlier Classic period structure at Lamanai, where its un-
usual close-fitting lid helped to preserve an organic substance of
which traces remain. CCC

Pendergast, 1982a, pp. 7–12

188 Miniature effigy vessel
Lamanai, Belize; Structure N9-59, Cache N9-59/1
Ceramic; postfire red and blue paints
H. 8.5 cm.
Late Postclassic (A.D. 1300–1400)
Lamanai, LA 391/3

The figure of an old man is attached to the front of this minia-
ture vessel. Prominent canines, a beak nose, and pouched
cheeks identify him as aged, perhaps an Old God. He holds a
flat round object on top of his loincloth, which was once painted
blue, and the fringe of a kilt remains on his right thigh. His
flaring cylindrical headdress has a headband with flanking verti-
cal projections and once had flaps hanging to the ears at either
side. CCC

Pendergast, 1981*a*, p. 51

189 Nested effigy vessels
Santa Rita, Belize; Structure 36, Special Deposit P9 B-1
Ceramic; postfire stucco, painted blue-green, black, red, and
* white*
H. 17.5 cm.
Late Postclassic to Conquest (A.D. 1450–1530)
Belize Department of Archaeology, Belmopan 35/203-2:33, 34

This modeled effigy is complex both symbolically and in its
physical structure. The outermost vessel is the head of a mytho-
logical animal that seems to combine characteristics of a seal
with the eyes, fangs, and flexible snout of Postclassic Maya ser-
pentine forms. Within the open jaws of its hollow head there is
a lidded effigy vessel in the shape of a conch shell. A modeled
horned jaguar emerges from this shell, and the head of an old
man emerges in turn from the jaguar's open jaws. This theme of
an Old God emerging from a gastropod shell was also found
contemporaneously at Lamanai, not far to the southwest, as was
jaguar imagery. Both themes relate to denizens of the Under-
world—the Old Earth God and the Sun-at-Night Jaguar—
whereas the shell refers to the earth itself. What the outer en-
closing head signifies is unclear. CCC

D. Z. Chase, 1981*a*, p. 31

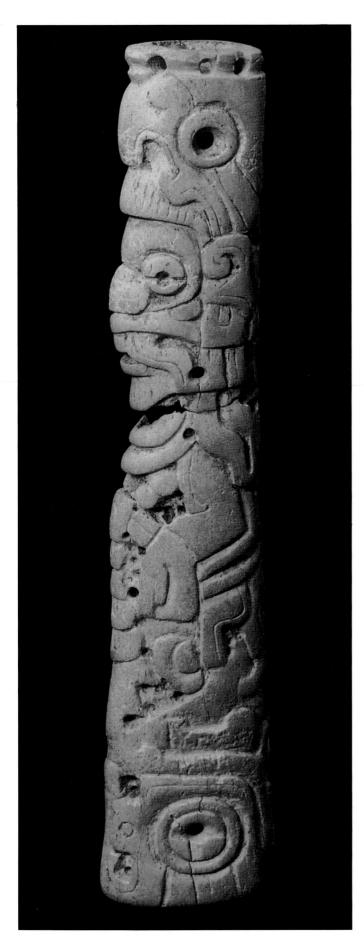

190 Carved bone tube
Lamanai, Belize; Structure N10-4, Burial N10-4/46
Bone; red pigment
H. 15 cm.
Late Postclassic to Conquest (A.D. *1400–1530*)
Lamanai, LA 247/1

Perhaps a human shin bone, this tibia was carved with the figure of an elaborately bedecked, bearded, and mustached man—surely not an image of the adolescent from whose rich burial it was excavated. The man's large parrot headdress is balanced beneath his feet by another equally massive bird head above which his tiny legs dangle at the back of the carving. The figure becomes smaller toward the feet, with the greatest emphasis placed on prominent facial features with a wraparound nose bar and round eyes that are bisected horizontally. A complex object that may be partly cloth is worn through his ears, which are scrolled at the top, and the man wears layered rounded collars and a tiered necklace that falls in front to the bird head below. In his right hand he holds a spear thrower, or *atlatl*. The bone is carved in a rounded relief with incised details and undercutting—with small drilled pits and perforations that enliven the surface visually—although some of the latter might have been intended for attachments like the row of holes in the rim at the top. The style resembles that of contemporary Mixteca-Puebla woodcarving, as do some of the details; for instance, the ears with long ornaments and the bisected eyes, which also occur in foreign-influenced contemporary wall paintings at Santa Rita, Belize, northeast of Lamanai. CCC

Pendergast, 1981*b*, pp. 9–10

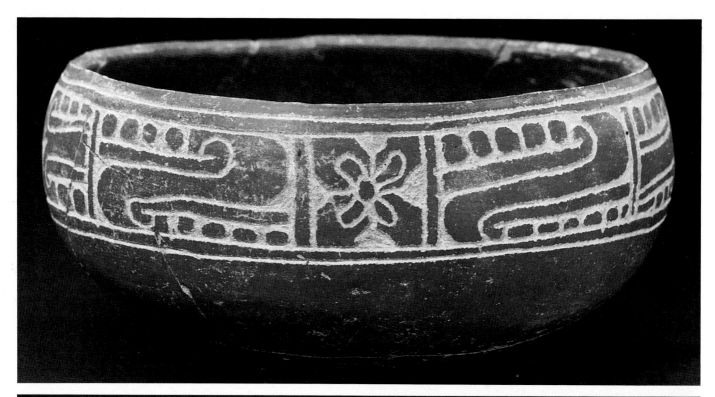

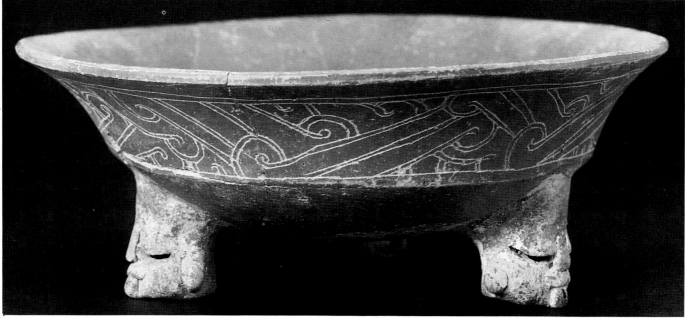

191 Two incised vessels
Lamanai, Belize; Structure N10-4, Burial N10-4/46
Ceramic; slipped redware
D. 15 cm.; 25.3 cm.
Late Postclassic to Conquest (A.D. *1400–1530*)
Lamanai, LA 247/22; LA 247/43

Along with the carved bone tube (No. 190), gold objects, and a copper bell, these vessels were found among the burial goods of an adolescent who was accompanied in death by at least four other individuals. These postfire decorated vessels, although quite orange, are a "redware" which closely resembles ceramics at Tulúm, Quintana Roo, to the north, on the east coast of the Yucatán Peninsula.

The round-sided bowl was found inside a large redware pedestal-base censer. Eight panels, carved around the rim after firing, contain a floral motif and reverse scrolls that alternate with double-ended "ram horn" scrolls. The tripod plate is one of a matched pair from this burial, both with rattle tripod feet consisting of two puffy-cheeked heads and one short-beaked bird. A prevailing Late Postclassic interest in modeled-clay effigy forms is combined on this vessel with abstract scroll designs, also typical of the Tulúm Red ceramic period. Here, filling the exterior wall of the bowl, there is a continuous band of laddered and reverse scrolls which resemble the scrolls of earlier Classic sculpture at El Tajín, Veracruz. CCC

Pendergast, 1981*b*, pp. 7–9

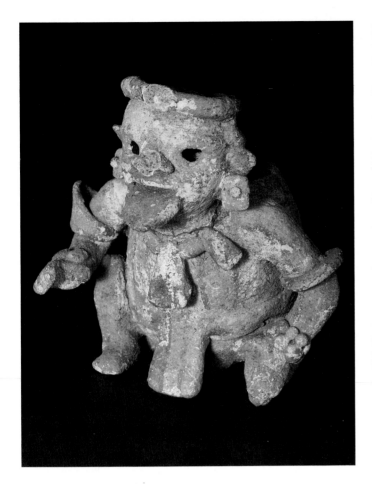

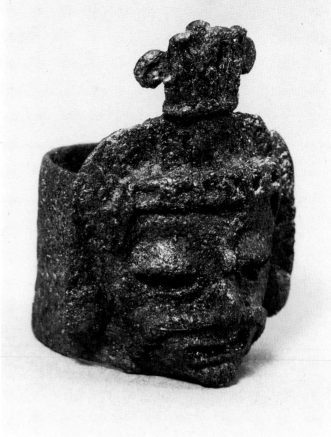

192 Merchant god effigy vessel
Mayapán, Yucatán
Mayapán unslipped ware, with white, yellow, red, and
 blue paint; Chen Mul Modeled Type
H. 14.2 cm.
Late Postclassic (A.D. 1250–1450)
Museo Regional de Antropología, Mérida 421B

This little piece was part of a cache found in a secular dwelling. Because of the nose, now broken, and the colored eye patches, this figure, which also has a grotesque lower lip, has been identified as Ek Chuah, the merchant god. He wears a ropelike turban, which may be another attribute for Ek Chuah, as he is often depicted wearing his merchant's tumpline as a headdress. There is a comic quality in this portrayal, signaled by his enlarged lower lip, his rotund torso (the vessel itself), and his informal pose of resting on one knee. When seen in profile, the vessel form of his midsection makes him look hunchbacked. Unlike the more common representations of the merchant god, this Ek Chuah is not dark-skinned. His body is white with yellow stripes outlined in red. His face is red with a white forehead and blue earplugs; the beads of his necklace and wristlets are red and blue; and his loincloth and apron are striped red, yellow, and blue. FC

R. E. Smith, 1971, fig. 64a

193 Face ring
Santa Rita, Belize; Burial P3B-3
Cast copper
H. 3.5 cm.
Late Postclassic to Conquest (A.D. 1450–1530)
Belize Department of Archaeology, Belmopan 35/203-2:17

Worn on the right hand of a woman buried at Santa Rita, this cast copper ring shows the face of a man with a feather headdress, aquiline nose, mustache, and a short beard. Cast in the lost-wax process, such rings were probably made in the Oaxaca-Puebla region of Mexico. CCC

D. Z. Chase, 1981a, p. 32

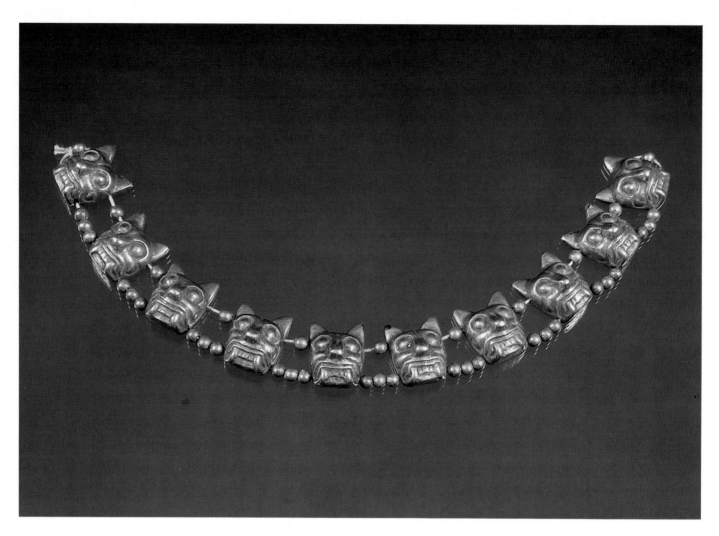

194 Jaguar mask necklace
Iximché, Guatemala; Burial 27-A
Cast gold
L. 27 cm.
Late Postclassic (c. A.D. 1500)
Museo Nacional de Arqueología y Etnología, Guatemala 9097

"Jaguar" was a title given to rulers in the Guatemalan highlands
and it may have designated the man who wore this jaguar neck-
lace in the richest burial excavated at Iximché, capital of the
Cakchiquel Maya. The ten gold masks and thirty-eight gold
beads were cast, unlike the hammered gold tiara and disk that
were also worn by the man in the tomb. Most lost-wax gold ob-
jects vary in shape because the wax forms are melted, or "lost,"
in the casting process, but these thin gold masks are identical
because they cover clay-and-charcoal forms that had been
pressed into a single mold before being covered with a layer
of wax; these forms still remain behind the gold, with
perforations for stringing that were part of the original
design. CCC

Guillemin, 1967, p. 34

222

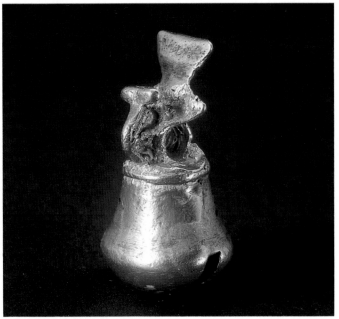

195 Two ceremonial flints
Altun Ha, Belize; Structure A-5, Cache A5/2
Chert
L. 33.5 cm.; W. 17.4 cm.
Late Postclassic (A.D. 1200–1400)
Royal Ontario Museum, Toronto RP 163/4; RP 163/8

This serrated crescent and the cone-headed anthropomorphic figure were part of a group of eight ceremonial flints of different shapes cached in the ruined Structure A-5 after the abandonment of Altun Ha. There is amazing continuity in the forms—though not in the size—into which chert was flaked in the Classic and the Postclassic periods, but what they represent and what their ritual significance may have been are as yet unknown. CCC

Pendergast, 1979, p. 170, fig. 68n, r

196 Bell surmounted by bird
El Pozíto, Belize; Structure A-1
Cast gold
H. 3.4 cm.
Early Postclassic (A.D. 1000–1250)
Belize Department of Archaeology, Belmopan 32/198-1:15

This gold bell was probably cast in lower Central America, but it was found—along with a jade bead and a polishing stone—in a burial intruded into a Classic structure, the largest at El Pozíto. Bells like this were thrown into the Sacred Cenote at Chichén Itzá, but otherwise they are unknown archaeologically in Mesoamerica. Mary Neivens, excavator of El Pozíto, reports there was nothing in this burial that could reliably date it. At Lamanai, twenty-five kilometers to the south, gold foil is known in Late Postclassic contexts, but at that time cast copper bells were prevalent and cast gold was rare. In view of the abundance of cast gold bells in the *cenote* at Chichén Itzá, it is possible this solitary bell was on its way to Chichén Itzá and was buried with its trader, or was included in the otherwise poor burial of a local entrepreneur or dignitary. CCC

Bray, 1977, fig. 5(21)

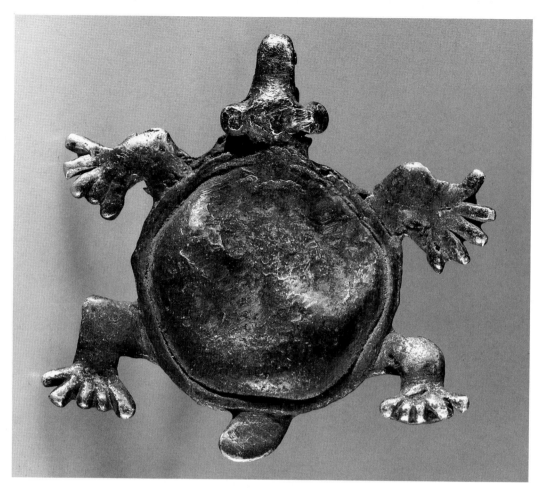

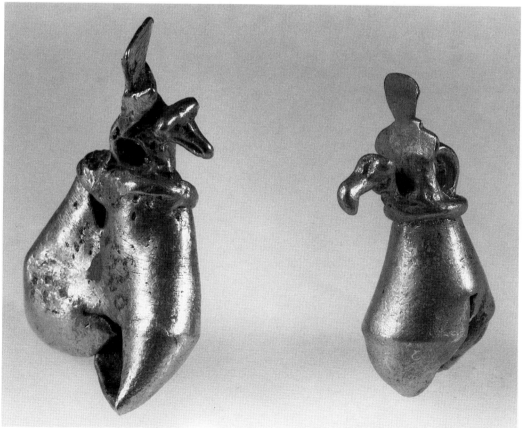

197 Gold turtle bell
Chichén Itzá, Yucatán; Sacred Cenote
Cast gold
L. 4.4 cm.
Early Postclassic (A.D. *1000–1250*)
Peabody Museum of Archaeology and Ethnology,
 Harvard University 10-71-20/C7711B

Lost-wax castings are all different because the wax in which the form was originally modeled is melted and replaced by molten gold. Few cast gold pendants or bells found in the Sacred Cenote are even similar to each other, but this turtle is exactly like another dredged from the *cenote*, except that it is slightly larger and has been more seriously crushed and burned. Both turtles are simply formed, with a ridge encircling the domed shell, realistic feet, short tails, and a long, beaked head with globular projecting eyes. These stylistic details appeared very early in the long history of Central American gold casting. CCC

Lothrop, 1952, p. 104, fig. 104h

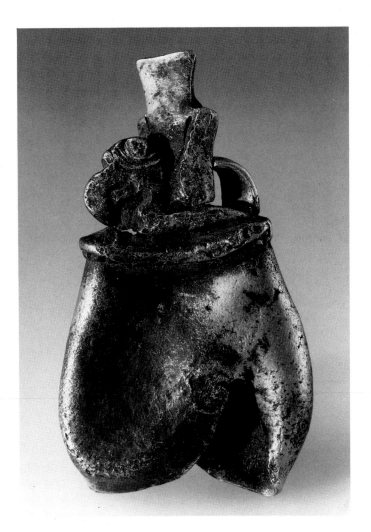

198 Two bells surmounted by birds
Chichén Itzá, Yucatán; Sacred Cenote
Cast gold
H. 3.9 cm.; 3.4 cm.
Early Postclassic (A.D. *1000–1250*)
Peabody Museum of Archaeology and Ethnology,
 Harvard University 10-71-20/C7660A, C7660B

The flattened tails and wings of these birds are characteristic of the "eagle" pendants made in Veraguas, Panama, where the bells were probably cast. They were traded to Chichén Itzá and crushed in a final offering ceremony, unlike the similar solitary bell which was found intact in a grave in Belize (No. 196), which was perhaps diverted en route from a Central American goldsmith to its ultimate destination in the Sacred Cenote. Each lost-wax casting is unique, and it is interesting to note the variation in the forms of the birds and platforms, and in the quality of the gold used in these three bells. CCC

Lothrop, 1952, pp. 101, 102, fig. 99b, d

199 Gold bell surmounted by parrot
Chichén Itzá, Yucatán; Sacred Cenote
Cast gold
H. 7.9 cm.
Early Postclassic (A.D. *1000–1250*)
Peabody Museum of Archaeology and Ethnology,
 Harvard University 10-71-20/C7658C

Large, heavy, cast gold bells with descending parrots on them were probably thrown into the Sacred Cenote later than the small bells with longer-beaked birds (No. 198). A foreign warrior-elite depicted at Chichén Itzá wore descending raptorial birds on their headdresses, but these imported gold parrots may have had more Maya connotations and signified Kinich Kakmo, the sun-eyed fiery macaw, who was believed to descend from the sun and consume sacrifices. CCC

Lothrop, 1952, pp. 101, 102, fig. 99j

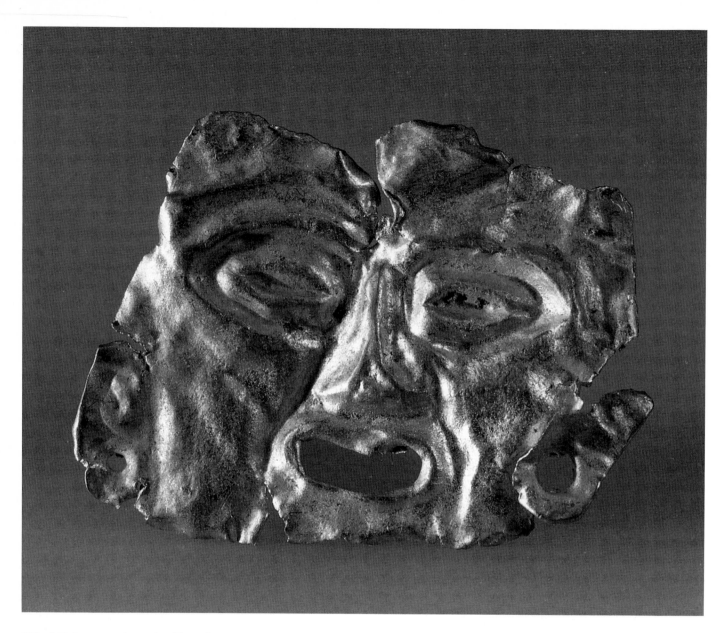

200 Miniature embossed gold mask
Chichén Itzá, Yucatán; Sacred Cenote
Sheet gold
W. 2.3 cm.
Early Postclassic (A.D. 1000–1250)
Peabody Museum of Archaeology and Ethnology,
 Harvard University 10-71-20/C76911

This is one of fifteen tiny gold masks dredged from the Sacred
Cenote at Chichén Itzá by Edward H. Thompson at the begin-
ning of this century. Like the others, it was intentionally dam-
aged before it was thrown into the well as an offering. The eyes
are outlined, the mouth cut out, and the perforations made in
the earlobes may have been used to sew the mask to a backing.
Most, if not all, of the sheet gold found in the *cenote* was im-
ported from lower Central America, although it may have been
worked at Chichén Itzá by craftsmen who cut and embossed it
for local use. CCC

Lothrop, 1952, p. 66, fig. 50

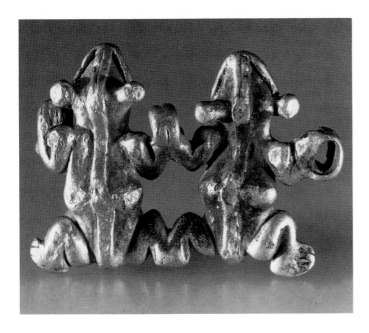

201 Double frog gold pendant
Chichén Itzá, Yucatán; Sacred Cenote
Cast gold
W. 4.1 cm.
Early Postclassic (A.D. *1000–1250*)
Peabody Museum of Archaeology and Ethnology,
Harvard University 10-73-20/C7737

This pendant was smashed and burned before it was thrown into the Sacred Cenote, probably early in the Postclassic. Frogs, especially those with flattened feet and spiral tongues, were among the most common pendants made in the gold-working regions of lower Central America, where this one was cast, but none of the other four cast gold frog pendants found in the *cenote* has those characteristics. Instead, this pair has raised globular eyes, diamond-shaped bodies with a raised band running from nose to tail, and a ridge across the back at its widest point. The *cenote* frogs may have been made earlier, or in a different place from the more common type, but they were still cast somewhere in lower Central America. Frogs were symbolically important in Colonial Maya rain-making ceremonies, and these imported gold frogs might have assumed such a role. CCC

Lothrop, 1952, p. 101, fig. 98c

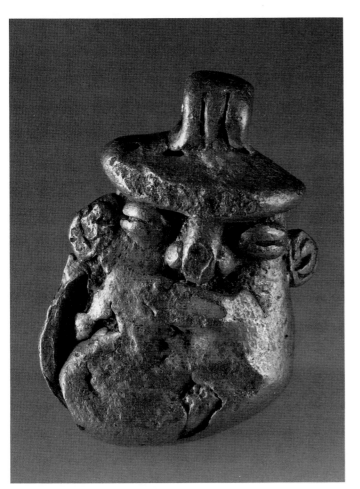

202 Gold head bell
Chichén Itzá, Yucatán; Sacred Cenote
Cast gold
H. 3.2 cm.
Early Postclassic (A.D. *900–1200*)
Peabody Museum of Archaeology and Ethnology,
Harvard University 10-73-20/C7732

Three head effigy bells like this, made of heavy cast gold, were found in the Sacred Cenote and all probably came from the same unknown gold-working region in lower Central America. This bell, representative of the three, has "coffee bean" eyes and mouth, nose and nostrils made separately, and coiled ear flanges that were originally made of rolled wax pellets and ropes before molten gold replaced the modeled wax in the casting. CCC

Lothrop, 1952, pp. 102, 103, fig. 104c

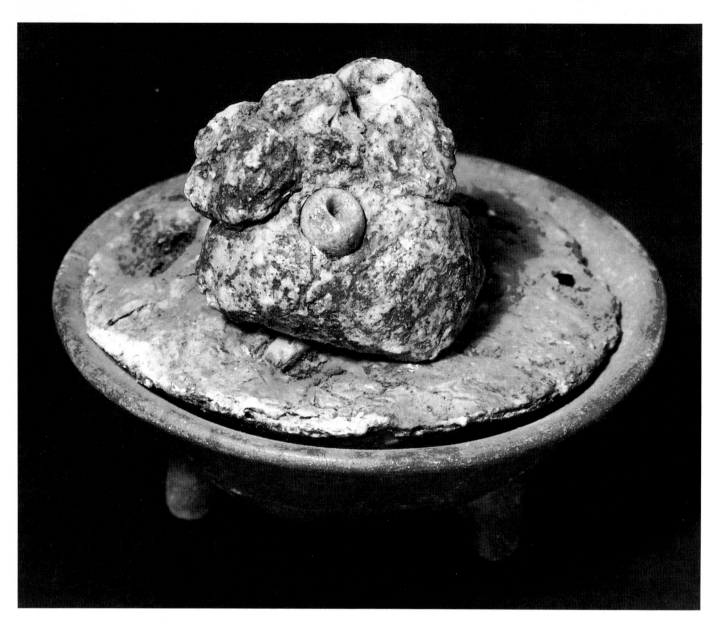

203 Tripod bowl with copal and a bead
Chichén Itzá, Yucatán; Sacred Cenote
Ceramic; copal
H. 13.2 cm.
Postclassic (A.D. 1000–1500)
Museo Nacional de Antropología, Mexico 5-4381

Copal is an incense whose smoke has a distinctive and pervasive
odor. Smoke and prayers were thought to be analogous in that
each lacks material substance and rises skyward. Its use in reli-
gious ritual probably dates back to the Preclassic. This tripod
bowl with its offering of copal and one jade bead was found in
the Sacred Cenote at Chichén Itzá. FC

204 Standing figure
Chichén Itzá, Yucatán; Sacred Cenote
Wood
H. 18.2 cm.
Postclassic (A.D. 1000–1500)
Museo Nacional de Antropología, Mexico 5-4098

This small carving crudely and simply represents the human figure. It was found during explorations (1967–1968) of the Sacred Cenote of Chichén Itzá. It is interesting because it may be a rare example of prehistoric folk art, and therefore unlike most of the examples of art in this exhibition catalogue, which are clearly the products of professional artisans. Unfortunately, as folk art, it is impossible to place it stylistically because traditions change at a very different and usually much slower rate than those of professional artists. This piece therefore could have been made any time from the Early Classic to the Colonial period. FC

Piña Chán, 1968*a*

205 Crocodile effigy vessel
Lamanai, Belize; Structure N11-4, Cache N11-4/1
Ceramic; postfire blue pigment
L. 11.6 cm.
Post-Conquest (A.D. 1575–1625)
Lamanai, LA 833/1

The inhabitants of Lamanai continued to model effigy censers and to pursue native religious practices even after a Christian church was built at the site by Spanish priests. This small vessel embodies the millennial Maya worldview. Here the Old God emerges from the gaping jaws of the fish-tailed, horned crocodile of the waters of the Underworld—waters that were continuous with the great lagoon of the New River at Lamanai. This reptilian imagery is also emblematic of the name of the site itself, Lamanai, thought to mean "submerged crocodile." CCC

206 Jaguar effigy vessel
Lamanai, Belize; Structure N12-11, Cache LA N12-11/1
Ceramic; postfire stucco, red paint
H. 5.5 cm.
Early Post-Conquest (late 16th century)
Lamanai, LA 739/1

This miniature pot with a stopper was cached in a platform beneath the Catholic church at Lamanai as it was being built about 1565. While it does not exactly follow the Classic Maya conventions of jaguar imagery, the animal does have the characteristically rounded ears and fangs. This tiny modeled effigy vessel resembles others known from two Late Postclassic sites—Santa Rita, Belize, to the northeast, and Mayapán, Yucatán, far to the north—suggesting that this ceramic tradition and the associated beliefs persisted as Christianity was introduced to Lamanai. CCC

207 Bearded mask appliqué
Lamanai, Belize; Structure N10-42
Ceramic; postfire red paint
H. 9.9 cm.
Early Post-Conquest (16th century)
Lamanai, LA 735/1

The facial conventions of this mask are entirely different from those of Postclassic effigy figures at Lamanai or elsewhere in Belize and Yucatán. Instead, they emphasize European characteristics that might have seemed unusual to the Maya: round eyes, prominent chin, a full beard, and a pointed nose. These could be the features of Ek Chuah, the merchant god, but a second equally un-Maya mask from a similar vessel apparently wears a bishop's miter and does not resemble Ek Chuah. It is therefore possible these are among the earliest known indigenous American impressions of Europeans. This large mask once adorned the side of a low pedestal bowl made of coarse buff clay that had been daubed with opaque dark red paint after low-temperature firing. The vessel was part of a superficial offering found in an area of Late Postclassic construction. CCC

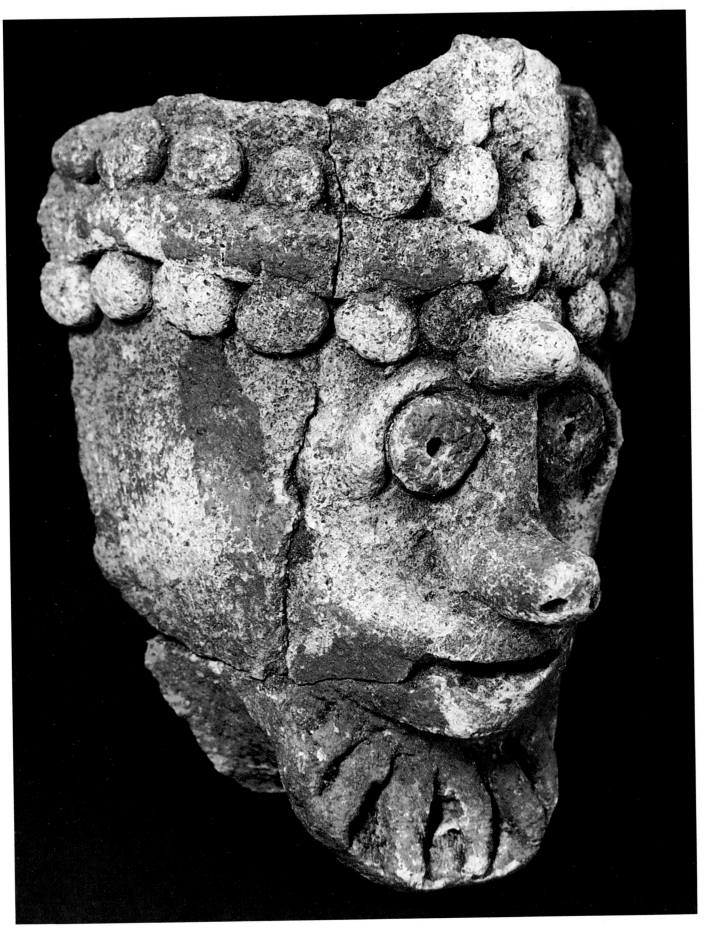

Bibliography

ADAMS, RICHARD E. W.
1971 "The Ceramics of Altar de Sacrificios." *Papers of the Peabody Museum of Archaeology and Ethnology*, Vol. 63, No. 1. Harvard University, Cambridge.
1977 "Comments on the Glyphic Texts of the 'Altar Vase.'" In N. Hammond, ed., *Social Process in Maya Prehistory*, 412–20. Academic Press, New York.
1977 *The Origins of Maya Civilization.* ed. School of American Research, University of New Mexico Press, Albuquerque.
————, W. E. Brown, Jr., and T. Patrick Culbert
1981 "Radar Mapping, Archaeology, and Ancient Maya Land Use." *Science* 213, 1457–63.

ANDERSON, A. H.
1958 "Recent Discoveries at Caracol Site, British Honduras." *Proceedings of the 32nd International Congress of Americanists*: 494–99. Copenhagen.

ANDREWS, ANTHONY P.
1983 *Maya Salt Production and Trade.* University of Arizona Press, Tucson.

ANDREWS, E. WYLLYS IV, and E. WYLLYS ANDREWS V
1980 *Excavations at Dzibilchaltún, Yucatán, Mexico.* Middle American Research Institute, Pub. 48. Tulane University, New Orleans.

ANDREWS, E. WYLLYS V
1979 "Some Comments on Puuc Architecture of the Yucatán Peninsula." In L. Mills, ed., *The Puuc: New Perspectives*: 1–17. *Scholarly Studies in the Liberal Arts*, No. 1. Central College, Pella, Iowa.

ANDREWS, GEORGE F.
1975 *Maya Cities: Placemaking and Urbanization.* University of Oklahoma Press, Norman.

ARTS MAYAS DU GUATEMALA
1968 Réunion des Musées Nationaux. Ministère d'Etat Affaires Culturelles. Paris.

ASHMORE, WENDY, ed.
1981 *Lowland Maya Settlement Patterns.* School of American Research, University of New Mexico Press, Albuquerque.

BALL, JOSEPH W.
1974 "A Teotihuacán-Style Cache from the Maya Lowlands." *Archaeology* 27:1, 2–9.
1975 "Cui Orange Polychrome: A Late Classic Funerary Type from Central Campeche, Mexico." In *Contributions of the University of California Archaeological Research Facility*, 27: 32–39. University of California, Berkeley.
1979a "Ceramics, Culture History and the Puuc Tradition: Some Alternative Possibilities." In L. Mills, ed., *The Puuc: New Perspectives*: 18–35. *Scholarly Studies in the Liberal Arts*, No. 1. Central College, Pella, Iowa.
1979b "The 1977 Central College Symposium on Puuc Archaeology: A Summary View." In L. Mills, ed., *The Puuc: New Perspectives*: 46–51. *Scholarly Studies in the Liberal Arts*, No. 1. Central College, Pella, Iowa.

BARDAWIL, LAWRENCE W.
1976 "The Principal Bird Deity in Maya Art—An Iconographic Study of Form and Meaning." In Merle Greene Robertson, *Second Palenque Round Table*, Part III, 195–209. Pre-Columbian Research, Robert Louis Stevenson School, Pebble Beach, Cal.

BECQUELIN, PIERRE, and CLAUDE BAUDEZ
1979 "Tonina, Une Cité Maya du Chiapas." *Etudes Mesoaméricaines*, Vol. VI, Book I. Mission Archéologique et Ethnologique Française au Mexique. Mexico.

BERLIN, HEINRICH
1958 "El Glifo 'Emblema' en las Inscripciones Mayas." *Journal de la Société des Américanistes* 47, 111–19. Paris.

BRAINERD, GEORGE W.
1958 "The Archaeological Ceramics of Yucatán." *Anthropological Records*, No. 19, University of California Press, Berkeley.

BRAY, WARWICK
1977 "Maya Metalwork and its External Connections." In N. Hammond, ed., *Social Process in Maya Prehistory*: 365–403. Academic Press, New York.

BROOKLYN MUSEUM ANNUAL
1964-65 VI, p. 27.

CHASE, ARLEN F.
1984a "Contextual Implications of Pictorial Vases from Tayasal, Petén." In Elizabeth Benson, ed., *Fourth Palenque Round Table*, Vol. 5. University of Texas Press, Austin.
1984b "Archaeology in the Maya Heartland: The Tayasal-Paxcamán Zone, Lake Petén, Guatemala." *Archaeology* 37:6.
————, and Prudence M. Rice, eds.
In Press *The Lowland Maya Postclassic: Questions and Answers.* University of Texas Press, Austin.

CHASE, DIANE Z.
1981a "The Maya Postclassic at Santa Rita Corozál." *Archaeology* 34:1, 25–33.
1981b *Mexicon* 3:5, cover.
————, and Arlen F. Chase
1982 "Yucatec Influence in Terminal Classic Northern Belize." *American Antiquity*, 47, 596–613.

COE, MICHAEL D.
1966 *The Maya* (revised and enlarged edition, 1980). Thames & Hudson, New York.
1973 *The Maya Scribe and His World.* The Grolier Club, New York.
1975 *Classic Maya Pottery at Dumbarton Oaks.* Dumbarton Oaks, Washington, D.C.
1978 *The Lords of the Underworld.* Princeton University Press.

COE, WILLIAM R.
1965a "Tikal, Guatemala, and Emergent Maya Civilization." *Science*, 147: 1401–19.
1965b "Tikal." *Expedition*, 8:1, 1–56. Philadelphia.
1967 *Tikal: A Handbook of the Ancient Maya Ruins.* University Museum, University of Pennsylvania, Philadelphia.
1975 "Resurrecting the Grandeur of Tikal." *National Geographic*, 148:6, 792–97. Washington, D.C.

———, and J. J. McGinn
1963 "Tikal: The North Acropolis and an Early Tomb." *Expedition* 5:2, 24–32. Philadelphia.

———, and William A. Haviland
1982 "Introduction to the Archaeology of Tikal, Guatemala." University Museum, University of Pennsylvania, Monograph 46, *Tikal Report* No. 12. Philadelphia.

COGGINS, CLEMENCY C.
1974 "Kunst der Maya." In Gordon R. Willey, ed., *Das Alte Amerika, Propylaean Kunstgeschichte*, 18: 230–44. Propylaean Verlag, Berlin.
1975 "Painting and Drawing Styles at Tikal: An Historical and Iconographic Reconstruction." Doctoral dissertation, Harvard University. University Microfilms, Ann Arbor.
1983 *The Stucco Decoration and Architectural Assemblage of Structure 1-sub, Dzibilchaltún, Yucatán, Mexico*. Middle American Research Institute, Pub. 49. Tulane University, New Orleans.

———, and Orrin C. Shane III, eds.
1984 *Cenote of Sacrifice: Maya Treasures from the Sacred Well at Chichén Itzá*. University of Texas Press, Austin.

CORSON, CHRISTOPHER
1973 "Iconographic Survey of Some Principal Figurine Subjects from the Mortuary Complex of Jaina, Campeche." In John Graham, ed., *Contributions of the University of California Archaeological Research Facility*, 18, 51–75. Studies in Ancient America. Berkeley.
1976 *Maya Anthropomorphic Figurines from Jaina Island, Campeche*. Ballena Press, Ramona, Cal.

CULBERT, T. PATRICK, ed.
1973 *The Classic Maya Collapse*. School of American Research, University of New Mexico Press, Albuquerque.
1974 *The Lost Civilization: The Story of the Classic Maya*. Harper & Row, New York.

EASBY, ELIZABETH K.
1964 "The Squier Jades from Toniná, Chiapas." In S. K. Lothrop et al., *Essays in Pre-Columbian Art and Archaeology*, 60–80. Harvard University Press, Cambridge.

———, and John F. Scott
1970 *Before Cortés: Sculpture of Middle America*. Catalogue for the Metropolitan Museum of Art. New York Graphic Society Ltd., New York.

EDMONSON, MUNRO S.
1971 *The Book of Counsel: The Popol Vuh of the Quiché Maya of Guatemala*. Middle American Research Institute, Pub. 35. Tulane University, New Orleans.

FONDO EDITORIAL DE LA PLASTICA MEXICANA
1964 *Flor y Canto del Arte Prehispanico de México*. Banco Nacional de Comercio Exterior, S.A. México D.F.

FREIDEL, DAVID A.
1979 "Culture Areas and Interaction Spheres: Contrasting Approaches to the Emergence of Civilization in the Maya Lowlands." *American Antiquity*, 44, 36–54.

———, Robin Robertson, and Maynard B. Cliff
1982 "The Maya City of Cerros." *Archaeology*, 35:4 12–21.

GALLENKAMP, CHARLES
1981 *Maya: The Riddle and Rediscovery of a Lost Civilization* (3rd revised edition, 1985). Viking Press, New York.

GARZA T. DE GONZALES, SILVIA, and E. B. KURJACK
1980 *Atlas Arqueológico del Estado de Yucatán*. Instituto Nacional de Antropología e Historia, Mexico.

GIFFORD, JAMES C.
1976 "Prehistoric Pottery Analysis and the Ceramics of Barton Ramie in the Belize Valley." *Memoirs of the Peabody Museum of Archaeology and Ethnology*, Vol. 18. Harvard University, Cambridge.

GORDON, G. B.
1896 "Prehistoric Ruins of Copán, Honduras." *Memoirs of the Peabody Museum of Archaeology and Ethnology*, Vol. 1, No. 1. Harvard University, Cambridge.

GOSSEN, GARY H.
1974 *Chamulas in the World of the Sun: Time and Space in a Maya Oral Tradition*. Harvard University Press, Cambridge.

GRAHAM, IAN
1980 *Corpus of Maya Hieroglyphic Inscriptions*, Vol. 3, Pt. 3. Peabody Museum, Harvard University, Cambridge.

GRAHAM, JOHN A.
1979 "Maya, Olmecs and Izapans at Abaj Takalik." *42nd International Congress of Americanists*. Acts 8, 179–88.

GREIDER, TERENCE
1964 "Representation of Space and Form in Maya Painting on Pottery." *American Antiquity* 29:4, 442–48. Salt Lake City.

GUILLEMIN, GEORGE F.
1967 "The Ancient Cakchiquel Capital of Iximché." *Expedition* 9:2, 22–35. Philadelphia.

HAMMOND, NORMAN
1977 ed., *Social Process in Maya Prehistory*. Academic Press, New York.
1977 "The Earliest Maya." *Scientific American* 236:3, 116–33.
1982 *Ancient Maya Civilization*. Rutgers University Press, New Brunswick, N.J.

———, Duncan Pring, Rainer Berger, V. R. Switsur, and A. P. Ward
1976 "Radiocarbon Chronology for Early Maya Occupation at Cuello, Belize." *Nature* 260: 579–81.

———, et al.
1979 "The Earliest Lowland Maya: Definition of the Swasey Phase." *American Antiquity* 44, 92–110.

HANDBOOK OF THE ROBERT WOODS BLISS COLLECTION OF PRE-COLUMBIAN ART.
1963 Dumbarton Oaks, Washington, D.C.

SUPPLEMENT TO THE HANDBOOK OF THE ROBERT WOODS BLISS COLLECTION OF PRE-COLUMBIAN ART.
1969 Dumbarton Oaks, Washington, D.C.

HARRISON, PETER D., and B. L. TURNER, eds.
1978 *Pre-Hispanic Maya Agriculture*. University of New Mexico Press, Albuquerque.

HAVILAND, WILLIAM A.
1970 "Tikal, Guatemala, and Mesoamerican Urbanism." *World Archaeology* 2, 186–98.
1977 "Dynastic Genealogies from Tikal, Guatemala: Implications for Descent and Political Organization." *American Antiquity* 42, 61–67.

HEYDEN, DORIS, and PAUL GENDROP
1973 *Pre-Columbian Architecture of Mesoamerica*. Harry N. Abrams, New York.

HENDERSON, JOHN S.
1981 *The World of the Ancient Maya*. Cornell University Press, Ithaca, N.Y.

HOSLER, DOROTHY, JEREMY A. SABLOFF, and DALE RUNGE
1977 "Simulation Model Development: A Case Study of the Classic Maya Collapse." In N. Hammond, ed., *Social Process in Maya Prehistory*, 553–90. Academic Press, New York.

JONES, CHRISTOPHER
1975 "A Painted Capstone from the Maya Area." In *Contributions of the University of California Archaeological Research Facility*,

233

No. 27, 83–110. University of California, Department of Anthropology, Berkeley.
1977 "Inauguration Dates of Three Late Classic Rulers of Tikal, Guatemala." *American Antiquity*, 42, 28–60.

KELEMAN, PAL
1969 *Medieval American Art* (3rd revised edition), Dover, New York.

KELLEY, DAVID H.
1976 *Deciphering the Maya Script.* University of Texas Press, Austin.

KIDDER, ALFRED V.
1947 "The Artifacts of Uaxactún, Guatemala." *Notes of Middle American Archaeology and Ethnology* 576. Carnegie Institution, Washington, D.C.
1954 "Miscellaneous Archaeological Specimens from Mesoamerica." *Notes of Middle American Archaeology and Ethnology* 117, 5–26. Carnegie Institution, Washington, D.C.

KOSAKOWSKY, LAURA J.
1983 "Intra-site Variability of the Formative Ceramics from Cuello, Belize: An Analysis of Form and Function." Doctoral dissertation, University of Arizona. University Microfilms, Ann Arbor.

KUBLER, GEORGE A.
1962a *Shape of Time.* Yale University Press, New Haven.
1962b *The Art and Architecture of Ancient America* (2nd revised edition, 1975). Penguin Books, New York.
1969 "Studies in Classic Maya Iconography." *Memoirs of the Connecticut Academy of Arts and Sciences*, Vol. XVIII. New Haven.

LONGYEAR III, JOHN M.
1952 *Copán Ceramics: A Study of Southeastern Maya Pottery.* Carnegie Institution, Pub. 597. Washington, D.C.

LOTHROP, SAMUEL K.
1952 "Metals from the Cenote of Sacrifice, Chichén Itzá, Yucatán." *Memoirs of the Peabody Museum of Archaeology and Ethnology*, Vol. 10, No. 2. Harvard University, Cambridge.
———, W. F. Foshag, and Joy Mahler
1957 *Pre-Columbian Art: Robert Woods Bliss Collection.* Garden City, New York.
———, et al.
1964 *Essays in Pre-Columbian Art and Archaeology.* Harvard University Press, Cambridge.

MALER, TEOBERT
1903 "Researches in the Central Portion of the Usumatsintla Valley." *Memoirs of the Peabody Museum of Archaeology and Ethnology*, Vol. 2, No. 2. Harvard University, Cambridge.

MARCUS, JOYCE
1976a "The Origin of Mesoamerican Writing." *Annual Review of Anthropology* 5, 35–67.
1976b *Emblem and State in the Classic Maya Lowlands.* Dumbarton Oaks, Washington, D.C.

MATHENY, RAYMOND T., ed.
1980 "El Mirador, Petén, Guatemala: An Interim Report." *New World Archaeological Foundation*, Paper 45.

MAYER, KARL H.
1978 *Maya Monuments: Sculptures of Unknown Provenance in Europe.* Trans. by Sandra L. Brizee. Acoma Books, Ramona, Cal.

MERCER, HENRY C.
1896 *The Hill-Caves of Yucatán.* J. B. Lippincott, Philadelphia.

MERWIN, RAYMOND E., and **GEORGE C. VAILLANT**
1932 "The Ruins of Holmul, Guatemala." *Memoirs of the Peabody Museum of Archaeology and Ethnology*, Vol. 3, No. 2, Harvard University, Cambridge.

MILES, SUZANNE
1965 "Sculpture of the Guatemala-Chiapas Highlands and Pacific Slopes, and Associated Hieroglyphs." In Robert Wauchope, ed., *Handbook of Middle American Indians*, 2, 237–75. University of Texas Press, Austin.

MILLER, ARTHUR G.
1982 *On the Edge of the Sea: Mural Painting at Tancah-Tulúm, Quintana Roo, Mexico.* Dumbarton Oaks, Washington, D.C.

MORLEY, SYLVANUS
1938–39 *The Inscriptions of Petén.* Carnegie Institution, Pub. 437 (5 vols.). Washington, D.C.
1946 *The Ancient Maya.* Stanford University Press.
———, and George Brainerd
1956 *The Ancient Maya* (3rd edition). Stanford University Press.
———, G. W. Brainerd, and R. J. Sharer
1983 *The Ancient Maya* (4th edition). Stanford University Press.

NORMAN, B. M.
1843 *Rambles in Yucatán.* J. and H. G. Langley, New York.

NORMAN, V. GARTH
1973 "Izapa Sculpture." *Papers of the New World Archaeological Foundation*, No. 30. Provo, Utah.

PALACIO, JOSEPH O.
1977 "Excavation at Hokheb Ha, Belize." *Institute for Social Research and Action*, Pub. 3. Belize.

PARSONS, LEE
1983 "Altars 9 and 10, Kaminaljuyú, and the Evolution of the Serpent-Winged Deity." In Richard M. Leventhal and Alan L. Kolata, eds., *Civilization in the Ancient Americas, Essays in Honor of Gordon Willey*, 145–56. University of New Mexico Press and Peabody Museum of Archaeology and Ethnology. Harvard University, Cambridge.

PENDERGAST, DAVID M.
1965 "Maya Tombs at Altun Ha." *Archaeology* 18:3, 210–17.
1969 "Altun Ha, British Honduras (Belize): The Sun God's Tomb." *Royal Ontario Museum*, Paper 19. Toronto.
1971 "Evidence of Early Teotihuacán-Lowland Maya Contact at Altun Ha." *American Antiquity* 36:4, 455–60.
1979 *Excavations at Altun Ha, Belize, 1964–70*, Vol. 1. Royal Ontario Museum, Toronto.
1981a "Lamanai, Belize: Summary of Excavation Results, 1974-80." *Journal of Field Archaeology*, 8:1: 29-53. Boston.
1981b "An Ancient Maya Dignitary." *Rotunda*, 13:4: 5-11. Royal Ontario Museum, Toronto.
1982a "The Old Man and the Moon," *Rotunda*, 14:4, 7-12. Royal Ontario Museum, Toronto.
1982b *Excavations at Altun Ha, Belize, 1964–70*, Vol. 2. Royal Ontario Museum, Toronto.

PINA CHAN, ROMAN
1968a *Exploración del Cenote de Chichén Itzá: 1967–1968.* Bulletin No. 32, 1–5. Instituto Nacional de Antropología e Historia, Mexico D.F.
1968b *Jaina, La Casa en el Agua.* Instituto Nacional de Antropología e Historia. Mexico D.F.
1972 *Historia, Arqueología y Arte Prehispanico.* Fondo de Cultura Económica. Mexico D.F.

POHL, MARY
1983 "Maya Ritual Fauna." In Richard M. Leventhal and Alan L. Kolata, eds., *Civilization in the Ancient Americas, Essays in Honor of Gordon Willey*, 55–103. University of New Mexico Press and Peabody Museum of Archaeology and Ethnology. Harvard University, Cambridge.

POLLOCK, H. E. D.

1970 "Anthropological Notes on Some Chenes Ruins." In *Monographs and Papers in Maya Archaeology*, Wm. R. Bullard, Jr., ed., *Papers of the Peabody Museum of Archaeology and Ethnology*, Vol. 61, 1–87, Harvard University, Cambridge.

1980 "The Puuc; An Architectural Survey of the Hill Country of Yucatán and Northern Campeche, Mexico." *Memoirs of the Peabody Museum of Archaeology and Ethnology*, Vol. 19. Harvard University, Cambridge.

———, R. L. Roys, T. Proskouriakoff, and A. L. Smith

1962 *Mayapán, Yucatán, Mexico.* Carnegie Institution, Pub. 619. Washington, D.C.

PORTILLA, MIGUEL LEON

1973 *Time and Reality in the Thought of Maya.* Beacon Press, Boston.

PROSKOURIAKOFF, TATIANA

1950 *A Study of Classic Maya Sculpture.* Carnegie Institution, Pub. 593. Washington, D.C.

1960 "Historical Implications of a Pattern of Dates at Piedras Negras, Guatemala." *American Antiquity* 25:4, 454–75.

1962 "Civic and Religious Structures of Mayapán." Carnegie Institution, Pub. 619, Pt. 2, 87–163. Washington, D.C.

1965 "Sculpture and Art: Maya Lowlands." In Robert Wauchope, gen. ed., *Handbook of Middle American Indians*, Vol. II, 469–97. University of Texas Press, Austin.

1974 "Jades from the Cenote of Sacrifice, Chichén Itzá. Yucatán." *Memoirs of the Peabody Museum of Archaeology and Ethnology*, Vol. 10, No. 1. Harvard University, Cambridge.

RANDS, ROBERT L., and B. C. RANDS

1965 "Pottery Figurines of the Maya Lowlands." In Robert Wauchope, gen. ed., *Handbook of Middle American Indians*, Vol. II, 535–60. University of Texas Press, Austin.

———, Ronald L. Bishop, and Garman Harbottle

1979 "Thematic and Compositional Variation in Palenque Region Incensarios," in Merle Greene Robertson and Donnan C. Jeffers, eds. *Third Palenque Round Table*, Vol. IV. Pre-Columbian Art Research Center, Monterey, Cal.

RATHJE, WILLIAM L.

1970 "Socio-Political Implications of Lowland Maya Burials: Methodology and Tentative Hypotheses." *World Archaeology 1*, 359–74.

1973 "Classic Maya Development and Denouement: A Research Design." In T. Patrick Culbert, ed., *The Classic Maya Collapse*, 405–56. University of New Mexico Press, Albuquerque.

1975 "The Last Tango in Mayapán: A Tentative Trajectory of Production-Distribution Systems." In Jeremy A. Sabloff and C. C. Lamberg-Karlovsky, eds., *Ancient Civilization and Trade*, 409–48. School of American Research. University of New Mexico Press, Albuquerque.

ROBERTSON, MERLE GREENE, ROBERT RANDS, and JOHN A. GRAHAM

1972 *Maya Sculpture.* Lederer, Street and Zeus, Berkeley, Cal.

ROBICSEK, FRANCIS, and D. F. HALES

1981 *The Maya Book of the Dead: The Ceramic Codex.* University of Virginia Art Museum, Charlottesville.

ROYS, RALPH

1933 *The Book of Chilam Balam of Chumayel.* Carnegie Institution of Washington, Publicaton 438. Washington, D.C.

1967 *The Book of Chilam Balam of Chumayel* (new edition). University of Oklahoma Press, Norman.

RUZ, ALBERTO L.

1959 *Uxmal: Official Guide of the Instituto Nacional de Antropología e Historia*, Mexico.

1968 *Costumbres funerarias de los Mayas.* Seminario de Cultura Maya, UNAM. Mexico D.F.

SABLOFF, JEREMY A.

1975 "Ceramics." In Gordon R. Willey, ed., "Excavations at Seibal, Department of Petén, Guatemala." *Memoirs of the Peabody Museum of Archaeology and Ethnology*, Vol. 13, No. 2. Harvard University, Cambridge.

1977 "Old Myths, New Myths: The Role of Sea Traders in the Development of Ancient Maya Civilization." In E. Benson, ed., *The Sea in the Pre-Columbian World*, 67–97. Dumbarton Oaks, Washington, D.C.

1983 "Classic Maya Settlement Pattern Studies: Past Problems, Future Prospects." In E. Z. Vogt and R. M. Leventhal, eds., *Prehistoric Settlement Pattern Studies: Retrospect and Prospect*, 413–22. University of New Mexico Press, Albuquerque.

———, and Gordon R. Willey

1967 "The Collapse of Maya Civilization in the Southern Lowlands: A Consideration of History and Process." *Southwestern Journal of Anthropology* 23, 311–36.

———, and William L. Rathje, eds.

1975 "A Study of Changing Pre-Columbian Commercial Systems. The 1972–1973 Seasons at Cozumel, Mexico." *Monographs of the Peabody Museum of Archaeology and Ethnology*, No. 3. Harvard University, Cambridge.

1975 "The Rise of a Maya Merchant Class." *Scientific American* 233:4, 72–82.

———, and E. Wyllys Andrews V, eds.

1985 *Late Lowland Maya Civilization: Classic to Post-Classic.* School of American Research. University of New Mexico Press, Albuquerque.

SAUL, FRANK P.

1972 "The Human Skeletal Remains of Altar de Sacrificios, an Osteobiographic Analysis." *Papers of the Peabody Museum of Archaeology and Ethnology*, Vol. 63, No. 2. Harvard University, Cambridge.

SAYRE, EDWARD V., LUI-HEUNG CHAN, and JEREMY A. SABLOFF

1971 "High-resolution Gamma Ray Spectroscopic Analyses of Fine Orange Pottery." In R. H. Brill, ed., *Science and Archaeology*, 165–81. MIT Press, Cambridge.

SCHAPIRO, MEYER

1953 "Style." In A. L. Kroeber, ed., *Anthropology Today*, 287–312. University of Chicago Press.

SCHELE, LINDA

1976 "Accession Iconography of Chan-Bahlum in the Group of the Cross at Palenque." In Merle Greene Robertson, ed., *Second Palenque Round Table*, Part III, 9–34. Pre-Columbian Research, Robert Louis Stevenson School, Pebble Beach, Cal.

———, and Jeffrey H. Miller

1983 "The Mirror, the Rabbit, and the Bundle: 'Accession' Expressions from the Classic Maya Inscriptions." *Studies in Pre-Columbian Art and Archaeology*, No. 25. Dumbarton Oaks, Washington, D.C.

SCHOLES, F. V., and R. L. ROYS

1948 *The Maya Chontol Indians of Acalan-Tixchel.* Carnegie Institution, Pub. 560. Washington, D.C.

SHARER, ROBERT J., ed.

1978 *The Prehistory of Chalcuapa, El Salvador* (3 vols.). University of Pennsylvania Press, Philadelphia.

SHEETS, PAYSON D.

1979 "Maya Recovery from Volcanic Disasters, Ilopango and Ceren." *Archaeology* 32: 3, 32–42.

SHEPARD, ANNA O.
1948 *Plumbate, a Mesoamerican Trade Ware.* Carnegie Institution, Pub. 73. Washington, D.C.

SMITH, A. L.
1950 *Uaxactún, Guatemala: Excavations of 1931–37.* Carnegie Institution, Pub. 588. Washington, D.C.

————, and Alfred V. Kidder
1943 "Explorations in the Motagua Valley, Guatemala," Contributions to *American Anthropology and History,* Vol. 41. Carnegie Institution, Washington, D.C.

1951 *Excavations at Nebaj, Guatemala.* Carnegie Institution, Pub. 594. Washington, D.C.

SMITH, ROBERT E.
1952 "Pottery from Chipoc Alta Verapáz, Guatemala." Contributions to *American Anthropology and History,* Vol. 56. Carnegie Institution, Pub. 596. Washington, D.C.

1955 *Ceramic Sequence at Uaxactún, Guatemala.* Middle American Research Institute, Pub. 20. Tulane University, New Orleans.

1971 "The Pottery of Mayapán." *Papers of the Peabody Museum of Archaeology and Ethnology,* Vol. 66. Harvard University, Cambridge.

SOUSTELLE, JACQUES
1967 "Mexico." In *Archaeologia Mundi.* World Publishing, Cleveland.

SPINDEN, HERBERT J.
1913 "A Study of Maya Art." *Memoirs of the Peabody Museum of Archaeology and Ethnology,* Vol. 6. Harvard University, Cambridge.

STIERLIN, HENRI
1981 *Art of the Maya.* Rizzoli, New York.

THOMPSON, J. ERIC S.
1950 *Maya Hieroglyphic Writing: An Introduction.* Carnegie Institution, Pub. 589. Washington, D.C.

1954 *The Rise and Fall of Maya Civilization.* University of Oklahoma Press, Norman.

1960 *Maya Hieroglyphic Writing: An Introduction* (new edition). University of Oklahoma Press, Norman.

1970 *Maya History and Religion.* University of Oklahoma Press, Norman.

TOZZER, ALFRED M.
1941 "Landa's Relación de la Cosas de Yucatán." *Papers of the Peabody Museum of Archaeology and Ethnology.* Harvard University, Cambridge.

1957 "Chichén Itzá and Its Cenote of Sacrifice." *Memoirs of the Peabody Museum of Archaeology and Ethnology,* Vols. XI (text) and XII (plates). Harvard University, Cambridge.

TRIK, AUBREY S.
1963 "The Splendid Tomb of Temple I at Tikal, Guatemala." *Expedition* 6:1, 2–17. Philadelphia.

VILLACORTA, J. ANTONIO
1938 *Prehistoria e Historia Antigua de Guatemala.* Guatemala.

VON EUW, ERIC
1977 "Corpus of Maya Hieroglyphic Inscriptions," *Papers of the Peabody Museum of Archaeology and Ethnology,* Vol. 4. Harvard University, Cambridge.

VON WINNING, HASSO
1967 "Una Vasija-sonaja Maya de Doble Fondo." *Estudios de Cultura Maya* 6, 243–50. Mexico.

WARDELL, ALLEN
1967 "A Maya Ball Game Relief." In *Museum Studies,* Vol. 2, 62–73. Art Institute of Chicago.

WEAVER, MURIEL PORTER
1981 *The Aztecs, Maya, and Their Predecessors* (2nd edition). Academic Press, New York.

WILLEY, GORDON R.,
1975 "Excavations at Seibal, Department of Petén, Guatemala." *Memoirs of the Peabody Museum of Archaeology and Ethnology,* Vol. 13. Harvard University, Cambridge.

————, William R. Bullard, Jr., John B. Glass, and James C. Gifford
1965 "Prehistoric Maya Settlements in the Belize Valley." *Papers of the Peabody Museum of Archaeology and Ethnology,* Vol. 54. Harvard University, Cambridge.

Index